ADOBE PHOTOSHOP
ELEMENTS 8.0

the photoshop®
elements 8
book

for digital photographers

Scott Kelby *and* Matt Kloskowski

The Photoshop Elements 8 Book for Digital Photographers Team

CREATIVE DIRECTOR
Felix Nelson

TECHNICAL EDITORS
Cindy Snyder
Kim Doty

TRAFFIC DIRECTOR
Kim Gabriel

PRODUCTION MANAGER
Dave Damstra

GRAPHIC DESIGNER
Jessica Maldonado

COVER PHOTOS
COURTESY OF
Scott Kelby
Matt Kloskowski
iStockphoto.com

Published by
New Riders

Copyright ©2010 by Scott Kelby

First edition: October 2009

Composed in Frutiger, Lucida, and Apple Garamond Light by Kelby Media Group, Inc.

Trademarks
All terms mentioned in this book that are known to be trademarks or service marks have been appropriately capitalized. New Riders cannot attest to the accuracy of this information. Use of a term in the book should not be regarded as affecting the validity of any trademark or service mark.

Photoshop Elements is a registered trademark of Adobe Systems, Inc.
Windows is a registered trademark of Microsoft Corporation.
Macintosh is a registered trademark of Apple Inc.

Warning and Disclaimer
This book is designed to provide information about Photoshop Elements for digital photographers. Every effort has been made to make this book as complete and as accurate as possible, but no warranty of fitness is implied.

The information is provided on an as-is basis. The authors and New Riders shall have neither the liability nor responsibility to any person or entity with respect to any loss or damages arising from the information contained in this book or from the use of the discs or programs that may accompany it.

THIS PRODUCT IS NOT ENDORSED OR SPONSORED BY ADOBE SYSTEMS INCORPORATED, PUBLISHER OF ADOBE PHOTOSHOP ELEMENTS 8

ISBN 13: 978-0-321-66033-6
ISBN 10: 0-321-66033-1

9 8 7 6 5 4 3 2 1

www.newriders.com
www.kelbytraining.com

For our friends Joseph and Molly Bail,
who've dedicated their lives to
feeding and caring for homeless children.
—SCOTT

To my mom and dad, for giving me
such a great start to a wonderful life,
and for a lifetime of support and love.
—MATT

ACKNOWLEDGMENTS (SCOTT)

In every book I've ever written, I always thank my amazing wife Kalebra first, because I couldn't do any of this without her. In fact, I couldn't do *anything* without her. She's just an incredible woman, an inspiration to me every day, and the only thing more beautiful than how she looks on the outside is what's inside. As anyone who knows me knows, I am the luckiest guy in the world to have made her my wife 20 years ago this year. Thank you, my love, for saying "Yes."

I want to thank my wonderful son Jordan, and the most adorable little girl in the world, my daughter Kira, for putting a smile on my face and a song in my heart, each and every day. Thanks to my big brother Jeff for continuing to be the type of guy I'll always look up to.

A very special thanks to my good friend Matt Kloskowski. I'm truly honored to have shared these pages with you, and I can't thank you enough for working so hard to make this the best edition of the book yet. As a company, we're very lucky to have you on our team, and personally, I'm even luckier to count you among my best friends.

My heartfelt thanks go to the entire team at Kelby Media Group, who every day redefine what teamwork and dedication are all about. In particular, I want to thank my friend and Creative Director Felix Nelson, and my in-house Editor Kim Doty and way cool Tech Editor Cindy Snyder, for testing everything, and not letting me get away with anything. To Dave Damstra for giving the book such a tight, clean layout; to Kim Gabriel for keeping the trains running on time; and to Jessica Maldonado, the duchess of book design, for making everything look really cool.

Thanks to my best buddy Dave Moser, whose tireless dedication to creating a quality product makes every project we do better than the last. Thanks to my friend and partner Jean A. Kendra for everything she does. A special thanks to my Executive Assistant Kathy Siler for all her hard work and dedication, and for handling so many things so well that I have time to write books.

Thanks to my Publisher Nancy Aldrich-Ruenzel, my Editor Ted Waitt, marketing madman Scott Cowlin, Sara Jane Todd, and the incredibly dedicated team at Peachpit Press. It's an honor to work with people who just want to make great books.

I want to thank all the photographers and Photoshop experts who've taught me so much over the years, including Jim DiVitale and Kevin Ames (who helped me develop the ideas for the first edition of this book), Joe McNally, Jack Davis, Deke McClelland, Ben Willmore, Julieanne Kost, Moose Peterson, Vincent Versace, Doug Gornick, Bill Fortney, Manual Obordo, Dan Margulis, Helene Glassman, Eddie Tapp, David Ziser, Peter Bauer, Joe Glyda, Russell Preston Brown, and Bert Monroy.

Thanks to my friends at Adobe Systems: Terry White, Kevin Connor, John Loiacono, Cari Gushiken, John Nack, Dave Story, Yoko Nakagawa, Mala Sharma, Sharon Doherty, and Mark Dahm.

Thanks to my mentors whose wisdom and whip-cracking have helped me immeasurably, including John Graden, Jack Lee, Dave Gales, Judy Farmer, and Douglas Poole.

Most importantly, I want to thank God, and His son Jesus Christ, for leading me to the woman of my dreams, for blessing us with such a special little boy and little girl, for allowing me to make a living doing something I truly love, for always being there when I need Him, for blessing me with a wonderful, fulfilling, and happy life, and such a warm, loving family to share it with.

ACKNOWLEDGMENTS (MATT)

Of course, there are many people behind the scenes that helped make this book happen. One of my favorite parts of writing a book is that I get to thank them publicly in front of the thousands of people who read it. So here goes:

To my wife, Diana: You've been my best friend for 10 years, and I've had the time of my life with you as we enjoy watching our family grow. No matter what the day brings, you always have a smile on your face when I come home. I could never thank you enough for juggling our lives, being such a great mom to our kids, and for being the best wife a guy could ever want.

To my oldest son, Ryan (my little golf buddy in training): Your inquisitive personality amazes me and I love the little talks that we have. Plus, the Nintendo Wii battles that we have give me just the break that I always need (even though you always win).

To my youngest son, Justin: I have no doubt that you'll be the class clown one day. No matter what I have on my mind, you always find a way to make me smile.

To my mom and dad: Thanks for giving me such a great start in life and always encouraging me to go for what I want.

To Ed, Kerry, Kristine, and Scott (my brothers and sisters): Thanks for supporting me and always giving me someone to look up to.

To Scott Kelby: Having my name on a cover with yours is an honor, but becoming such good friends has truly been a privilege and the ride of my life. I've never met anyone as eager to share their ideas and encourage success in their friends as you are. You've become the greatest mentor and source of inspiration that I've met. More importantly, though, you've become one heck of a good friend. Thanks man!

To the folks that make this book look like the awesome book that you see: Felix Nelson, Jessica Maldonado, and Dave Damstra.

To my two favorite editors in the world: Cindy Snyder and Kim Doty. You guys do so much work on your end, so I can continue writing and working on all the techniques (which is really the fun stuff) on my end. I can't tell you how much I appreciate the help you guys give me and the effort you put into making me look good.

To Paul Wilder, Todd Willis, and Keith Lyons, our in-house IT gurus: Thanks for making sure I have a great computer and the software I need, when I need it.

I'd also like to thank the Web team here at Kelby Media: Aaron Westgate, Fred Maya, Tommy Maloney, Justin Finley, Andrew Kurz, Karey Johnson, Chelsea Beachem, and Leslie Montenegro. I write only a few books a year, but I create literally hundreds of videos, tutorials, and podcasts that go up on the Web each year. It's because of these guys that I'm able to do that quickly and easily and get back to writing when I need to.

To Dave Moser, my boss and my buddy: Your militaristic, yet insightful, comments throughout the day help motivate me and sometimes just make me laugh (a little of both helps a lot). Thanks for continuing to push me to be better each day.

To Dave Cross, Corey Barker, and Rafael (RC) Concepcion: Thanks for the ideas you guys generate and the friends you've become. You guys rock!

To Bob Gager (Elements Product Manager) at Adobe: Thanks for taking the time to go over this new version of Elements (with a fine-toothed comb) with me. It helped more than you know to see your perspective and how you and your team are constantly pushing Elements to be better each year.

To all my friends at Peachpit Press: Ted Waitt, Scott Cowlin, Gary Prince, and Sara Jane Todd. It's because you guys are so good at what you do that I'm able to continue doing what I love to do.

To you, the readers: Without you, well…there would be no book. Thanks for your constant support in emails, phone calls, and introductions when I'm out on the road teaching. You guys make it all worth it.

OTHER BOOKS BY SCOTT KELBY

The Adobe Photoshop Lightroom Book for Digital Photographers

Scott Kelby's 7-Point System For Adobe Photoshop CS3

The Digital Photography Book, volumes 1, 2 & 3

The Adobe Photoshop CS4 Book for Digital Photographers

The Photoshop Channels Book

Photoshop CS4 Down & Dirty Tricks

Photoshop Killer Tips

Photoshop Classic Effects

The iPod Book

Mac OS X Leopard Killer Tips

Getting Started with Your Mac and Mac OS X Tiger

The iPhone Book

OTHER BOOKS BY MATT KLOSKOWSKI

Layers: The Complete Guide to Photoshop's Most Powerful Feature

The Photoshop Elements 5 Restoration & Retouching Book

Photoshop CS2 Speed Clinic

The Windows Vista Book

Illustrator CS2 Killer Tips

ABOUT THE AUTHORS

Scott Kelby

Scott is Editor, Publisher, and co-founder of *Photoshop User* magazine, Editor and Publisher of *Layers* magazine (the how-to magazine for everything Adobe), and is the co-host of the top-rated weekly video podcast *Photoshop User TV*.

Scott is President and co-founder of the National Association of Photoshop Professionals (NAPP), the trade association for Adobe® Photoshop® users, and he's President of the software training, education, and publishing firm Kelby Media Group.

Scott is a photographer, designer, and an award-winning author of more than 50 books, including *The Digital Photography Book*, volumes 1, 2 & 3, *The Adobe Photoshop Lightroom Book for Digital Photographers*, *The Photoshop Channels Book*, *Scott Kelby's 7-Point System for Adobe Photoshop CS3*, and *The Adobe Photoshop CS4 Book for Digital Photographers*.

For the past five years, Scott has been honored with the distinction of being the world's #1 best-selling author of all computer and technology books, across all categories. His books have been translated into dozens of different languages, including Chinese, Russian, Spanish, Korean, Polish, Taiwanese, French, German, Italian, Japanese, Dutch, Swedish, Turkish, and Portuguese, among others, and he is a recipient of the prestigious Benjamin Franklin Award.

Scott is Training Director for the Adobe Photoshop Seminar Tour and Conference Technical Chair for the Photoshop World Conference & Expo. He's featured in a series of Adobe Photoshop training DVDs and has been training Adobe Photoshop users since 1993.

For more information on Scott, visit www.scottkelby.com.

Matt Kloskowski

Matt Kloskowski is a full-time Photoshop guy for the National Association of Photoshop Professionals (NAPP). His books, videos, and classes have simplified the way thousands of people work on digital photos and images. Author of nine books on Photoshop, Elements, and Illustrator, Matt teaches Photoshop and digital photography techniques to thousands of people around the world each year. He co-hosts the top-rated video podcast *Photoshop User TV*, as well as hosting two other podcasts, *Adobe Photoshop Lightroom Killer Tips* and *Photoshop Killer Tips*. You can find Matt's DVDs and online training courses at www.kelbytraining.com, and a large library of his weekly videos and written articles in *Photoshop User* magazine and on its website at www.photoshopuser.com.

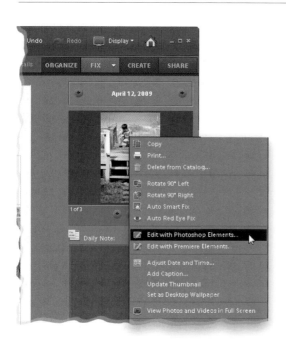

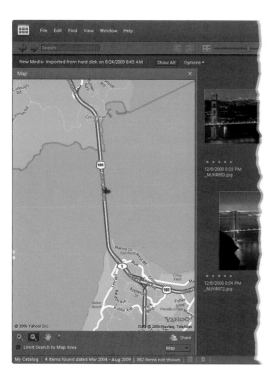

The Mask
Selection Techniques

Faces
Retouching Portraits

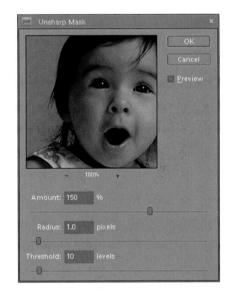

Q. So why am I going to wish I read this first?
A. Because there's a bunch of important stuff found only in here (like where to download the practice files so you can follow along), and if you skip this short Q&A, you'll keep saying things to yourself like, "I wish they had made these photos available for download" or "I wonder if there's a website where I can download these photos?" and stuff like that. But there's more here than that—in fact, this whole section is just to help you get the most out of the book. So, take two minutes and give it a quick read.

Q. Is Matt new to this book?
A. Actually, this is the third edition of the book with Matt as my co-author, and I'm thrilled to have him on board (mostly because I gave him all the hard stuff. Okay, that's not the real reason. Just a perk). Matt's one of the leading experts on Elements, was a featured columnist for the *Adobe Photoshop Elements Techniques* newsletter, and along with his online Elements classes, articles, and well…he's "the man" when it comes to Elements 8 (by the way, throughout the book, we just call it "Elements" most of the time—it's just shorter). So, I asked (read as: begged) him to be my co-author, and the book is far better because of his involvement.

Q. How did you split things up?
A. I (Scott) wrote the chapters on Camera Raw, printing, photographic special effects, sharpening, resizing and cropping, and the special workflow tutorial at the end of the printing chapter. Matt provided the chapters on organizing, color correction, image problems, selections, retouching, removing unwanted objects, and showing your work (including using the Create functions).

Q. Is this book for Windows users, Mac users, or both?
A. Until now, Adobe hadn't released a version of Elements for the Mac since Elements 6 (Elements 7 was only available on the Windows platform), but Elements 8 is available for both Windows and Macintosh (wild cheers ensue), and the two versions are nearly identical. However, there are three keys on the Mac keyboard that have different names from the same keys on a PC keyboard, but don't worry, we give you both the Windows and Mac shortcuts every time we mention a short-cut (which we do a lot).

Q. I noticed you said "nearly identical." What exactly do you mean by "nearly?"
A. Well, here's the thing: the Editor in Photoshop Elements 8 is the same on both platforms, but the Organizer (where we sort and organize our images) is different. In Windows, it's the latest version of the Elements Organizer—the same one you may be used to if you've been using Elements for a while. However, since the Macintosh version is just getting up to date with the Windows version, it uses Adobe Bridge (which is what comes with Adobe Photoshop CS4). So, we created a separate PDF chapter for the Mac Bridge and placed on the book's companion website, and you only need to read that chapter if you have the Macintosh version of Elements 8 (instead of reading Chapter 1 on the Organizer). Otherwise, just skip it (unless you're just really nosey).

Q. What's the deal with the chapter intros?
A. They're actually designed to give you a quick mental break, and honestly, they have little to do with the chapters. In fact, they have little to do with anything, but writing these off-the-wall chapter intros is kind of a tradition of mine (so don't blame Matt—it's not his fault), but if you're one of those really "serious" types, you can skip them because they'll just get on your nerves.

Q. How did you develop the original content for this book?

A. Each year, I'm fortunate enough to train literally thousands of professional digital photographers around the world at my live seminars, and although I'm doing the teaching, at every seminar I always learn something new. Photographers love to share their favorite techniques, and during the breaks between sessions or at lunch, somebody's always showing me how they "get the job done." It's really an amazing way to learn. Plus, and perhaps most importantly, I hear right from their own lips the problems and challenges these photographers are facing in their own work in Elements, so I have a great insight into what photographers really want to learn next. Plus, I'm out there shooting myself, so I'm constantly dealing with my own problems in Elements and developing new ways to make my digital workflow faster, easier, and more fun. That's because (like you) I want to spend less time sitting behind a computer screen and more time doing what I love best—shooting! So as soon as I come up with a new trick, or if I learn a slick new way of doing something, I just can't wait to share it with other photographers. It's a sickness, I know.

Q. So what's not in this book?

A. We tried not to put things in this book that are already in every other Elements book out there. For example, we don't have a chapter on the Layers palette or a chapter on the painting tools or a chapter showing how each of Elements' 110 filters look when applied to the same photograph. We just focused on the most important, most asked-about, and most useful things for digital photographers. In short—it's the funk and not the junk.

Q. So where are the photos and online chapter we can download?

A. You can download the photos and the special Adobe Bridge chapter just for Mac users from **www.kelbytraining.com/ books/elements8**. Of course, the whole idea is that you'd use these techniques on your own photos, but if you want to practice on ours, we won't tell anybody. Although Matt and I shot most of the images you'll be downloading, I asked our friends over at iStockphoto.com to lend us some of their work, especially for the portrait retouching chapter (it's really hard to retouch photos of people you know, and still be on speaking terms with them after the book is published). So, I'm very grateful to iStockphoto.com for lending us (you, we, etc.) their images, and I'm particularly thankful they let us (you) download low-res versions of their photos used here in the book, so you can practice on them, as well. Please visit their site—they've got a really unique community going on there, and it wouldn't hurt if you gave them a great big sack of money while you're there. At the very least, make a stock shot of a big stack of money and upload that. It might turn into an actual big stack of money.

Q. Okay, so where should I start?

A. You can treat this as a "jump-in-anywhere" book because we didn't write it as a "build-on-what-you-learned-in-Chapter-1" type of book. For example, if you just bought this book, and you want to learn how to whiten someone's teeth for a portrait you're retouching, you can just turn to Chapter 7, find that technique, and you'll be able to follow along and do it immediately. That's because we spell everything out. So if you're a more advanced Elements user, don't let it throw you that we say stuff like "Go under the Image menu, under Adjust Color, and choose Levels" rather than just writing "Open Levels." We did that so everybody could follow along no matter where they are in the Elements experience. Okay, that's the scoop. Thanks for taking a few minutes to read this, and now it's time to turn the page and get to work.

Organized Chaos
managing photos using the organizer

"Organized Chaos" is the perfect name for this chapter because not only is it a song title (by the band Benediction), it's also apparently a marketing directive put forth by a super-secret department at Adobe who, from what I gather, is charged with giving features and functions within Elements multiple names. Now, I must point out that this department is not as active in Elements 8, as they were back in Elements 4. Back then, they actually had two different names for what is now just called the Organizer. That's right, Elements 4 had buttons named "Photo Browser" and "Photo Organizer," but regardless of which one you clicked on, it opened the Organizer.

This led to untold hours of fun for new users of the product, and probably some sort of cash bonus for that department at Adobe. However, those lucrative bonuses are pretty much over in Elements 8 because now the Organizer is just called "The Organizer." However, if you're wondering if the hard-working people in that super-secret department are going to have to get part-time jobs to make up for the gap in their income, you only have to look as far as the Elements 8 Organizer's preview area, which is now called Media Browser, and tacitly lets you know their Porsche payments will be made on time. Whew! That was a close one.

Importing Your Photos

One of the major goals of Adobe Photoshop Elements is simply to make your life easier and the Photo Downloader is there to help do just that. Adobe has not only made the process of getting your photos from your digital camera into the Elements Organizer much easier, they also included some automation to make the task faster. Why? So you can get back to shooting faster. (Mac users, go to the book's download website for a special version of Chapter 1 that covers Adobe Bridge.) Here's how to import your photos and take advantage of this automation:

Step One:
When you attach a memory card reader to your computer (or attach your camera directly using a USB cable), the Elements Organizer – Photo Downloader standard dialog appears onscreen (shown here; by the way, it will also download photos from your mobile phone). The first thing it does is it searches the card for photos, and then it tells you how many photos it has found, and how much memory (hard disk space) those photos represent.

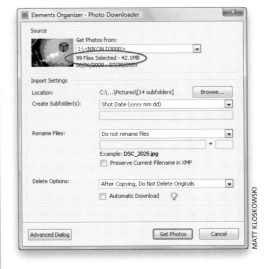

Step Two:
The Import Settings section is where you decide how the photos are imported. You get to choose where (on your hard disk) they'll be saved to, and you can choose to create subfolders with photos sorted by a custom name, today's date, when they were shot, and a host of attributes you can choose from the Create Subfolder(s) pop-up menu (as shown here).

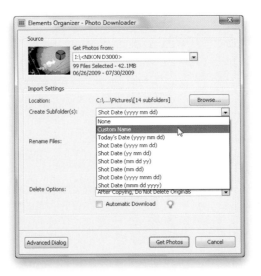

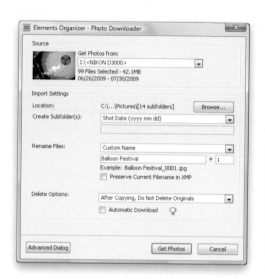

Step Three:

If you want to rename files as they're imported, you can do that in the next field down. You can use the built-in naming conventions, but I recommend choosing Custom Name from the Rename Files pop-up menu, so you can enter a name that makes sense to you. You can also choose to have the date the photo was shot appear before your custom name. Choosing Custom Name reveals a text field under the Rename Files pop-up menu where you can type your new name (you get a preview of how it will look). By the way, it automatically appends a four-digit number starting with 0001 after your photo to keep each photo from having the same name.

TIP: Storing the Original Name

If you're fanatical (or required by your job) and want to store the original filename, turn on the Preserve Current Filename in XMP checkbox and your original filename will be stored in the photo's metadata.

Step Four:

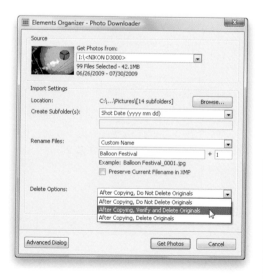

The last setting here is Delete Options. Basically, it's this: do you want the photos deleted off your memory card after import, or do you want to leave the originals on the card? What's the right choice? There is no right choice—it's up to you. If you have only one memory card, and it's full, and you want to keep shooting, well...the decision is pretty much made for you. You'll need to delete the photos to keep shooting. If you've got other cards, you might want to leave the originals on the card until you can make a secure backup of your photos, then erase the card later. Now, about that Automatic Download checkbox near the bottom....

Continued

Step Five:

The Automatic Download feature is designed to let you skip the Photo Downloader. When you plug in a memory card reader, or camera, it just downloads your photos using your default preferences, with no input from you (well, except it asks whether you want to erase the original photos on the card or not). Now, where are these default preferences set? They're set in the Organizer's Preferences. Just go under the Organizer's Edit menu, under Preferences, and choose Camera or Card Reader. This brings up the Preferences dialog you see here.

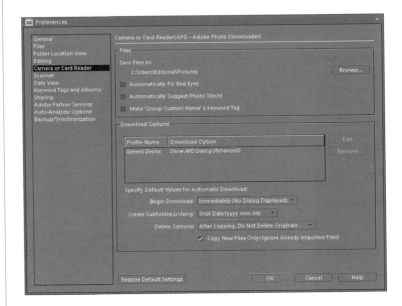

Step Six:

Here is where you decide what happens when you turn on the Automatic Download checkbox in the Photo Downloader. You get to choose a default location to save your photos (like your Pictures folder), and whether you want it to automatically fix any photos that it detects have red eye. You can also choose to have it automatically suggest photo stacks (it groups photos it thinks belong together), or make a keyword tag. You can have settings for specific cameras or card readers (if you want separate settings for your mobile phone, or a particular camera). At the bottom, you've got some other options (when to begin the downloading, if you're going to have subfolders, and your delete options). Click OK when the preferences are set the way you want them.

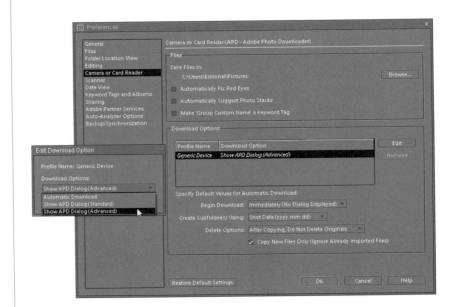

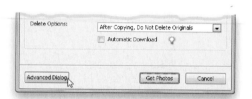

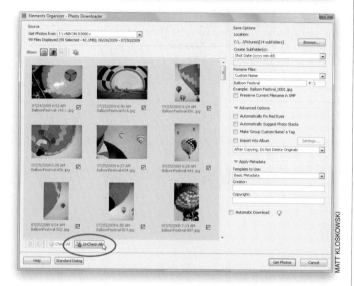

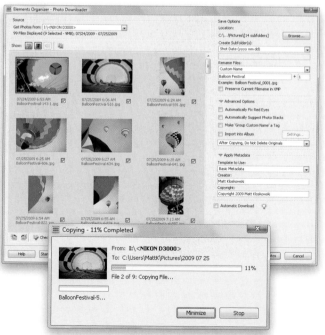

MATT KLOSKOWSKI

Step Seven:

Okay, back to the Photo Downloader. Now, at this point, all the photos on the card will be imported, but if you want to import just a few selected photos, then you'll need to click on the Advanced Dialog button at the bottom-left corner of the dialog (as shown here). That expands the dialog and displays thumbnails of all the photos on the card. By default, every photo has a checkbox turned on below it, indicating that every photo will be imported. If you just want some of these photos imported, then you'll need to click the UnCheck All button at the bottom left of your thumbnails. This turns off all the photos' checkboxes, which enables you to then go and turn on the checkboxes below only the photos you actually want imported.

Step Eight:

When you look at the right side of the advanced Photo Downloader dialog, you'll see some familiar Save Options (the subfolder choice, renaming files), and in the Advanced Options section, you'll see choices to automatically fix red eyes, suggest photo stacks, make a tag, import into an album, and delete options. Another nice feature is the ability to embed metadata (like your name and your copyright info) directly into the digital file, just like your camera embeds information into your digital camera images. So, just type in your name and your copyright info, and these are embedded into each photo automatically as they're imported. This is a good thing. When you click Get Photos, your photos are imported (well, at least the photos with a checkmark under them). If you want to ignore these advanced features and just use the standard dialog, click on the Standard Dialog button.

Backing Up Your Photos to a Disc or Hard Drive

When you think about backing up, I'd like you to consider this: it's not a matter of *if* your hard drive will crash, it's a matter of *when*. I've personally had new and old computers crash. So many times that now I'm totally paranoid about it. Sorry, but it's a harsh fact of computer life. You can protect yourself, though, by backing up your entire catalog to a disc or hard drive, and/or using an online backup, so your photos are protected in an off-site location. So even if your hard drive dies or your computer is lost, stolen, damaged in a fire, flood, or hurricane, you can retrieve your images.

Step One:

To back up your catalog to a hard drive or disc, you simply go under the Organizer's File menu and choose Backup Catalog to CD, DVD or Hard Drive (as shown here).

TIP: Back Up to an External Hard Drive

We recommend backing up to an external hard drive. They're much larger than a CD, or even a DVD, and easier to manage. Plus, you can always take them with you or to a nice off-site location to really keep your backups safe.

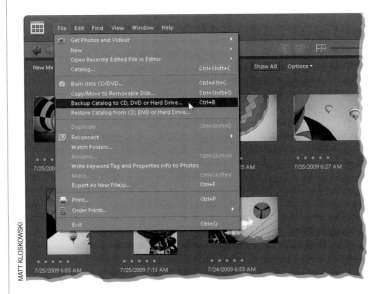

Step Two:

This brings up a dialog where you decide whether to do a Full Backup (you choose this the first time you back up your catalog), or an Incremental Backup (which is what you'll choose after your first backup, as it only backs up the files that have changed since your last backup, which is a big time saver). In this case, since this is your first time, choose Full Backup (as shown here), then click the Next button.

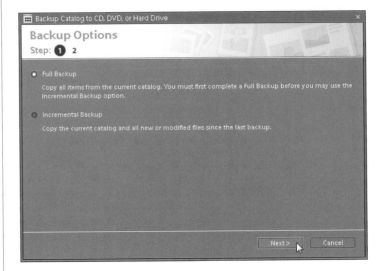

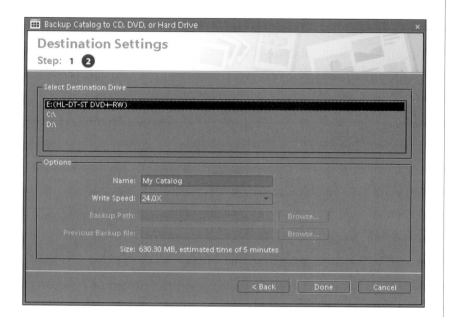

Step Three:
When you click Next, the Destination Settings screen appears, which is basically where you tell Elements to back up your stuff to. If it's a DVD or CD, just insert a blank DVD or CD into your DVD/CD drive and choose that drive from the list. Give your disc a name and click the Done button, and it does its thing. Same thing for a hard drive—just choose it from the list and click the Done button.

Importing Photos from Your Scanner

If you're reading this and thinking: "But this is supposed to be a book for digital photographers. Why is he talking about scanning?" Then ask yourself this: "Do I have any older photos lying around that I wish were on my computer?" If the answer is "Yes," then this tutorial is for you. We'll look at importing scanned images into the Organizer.

Step One:
To scan images and have them appear in your Organizer, click on the Organizer button in the Elements Editor's menu bar (at the top right of the window) to launch the Organizer. Then in the Organizer, go under the File menu, under Get Photos and Videos, and choose From Scanner. By the way, once the Organizer is open, you can also use the shortcut **Ctrl-U** to import photos from your scanner.

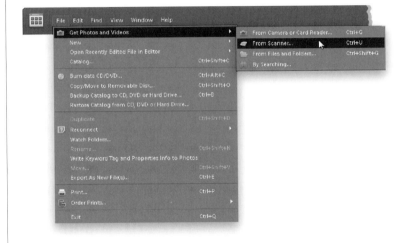

Step Two:
Once the Get Photos from Scanner dialog is open, choose your scanner from the Scanner pop-up menu. Choose a high Quality setting (I generally choose the highest quality unless the photo is for an email to my insurance company for a claim—then I'm not as concerned). Then click OK to bring in the scanned photo. See, pretty straightforward stuff.

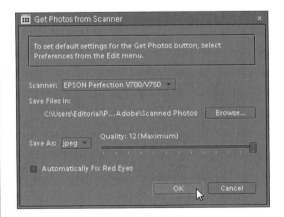

If you're the type that likes to squeeze every ounce of productivity out of your computer, then try this tutorial out. Elements lets you choose a folder that is "watched" by the Organizer. So whenever you put photos into that watched folder, they'll automatically be added into the Organizer. Yep, no interaction from you is needed at all. Here's how it works:

Automating the Importing of Photos by Using Watched Folders

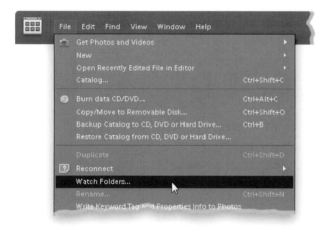

Step One:
Go under the Organizer's File menu and choose Watch Folders.

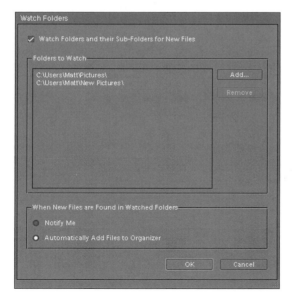

Step Two:
When the Watch Folders dialog appears, make sure the Watch Folders and Their Sub-Folders for New Files checkbox is turned on. In the Folders to Watch section, click the Add button, and then in the resulting dialog, navigate to any folders you want the Organizer to "watch" for the addition of new photos. Select the folder you want to watch, and then click OK. Continue to click the Add button and select more folders to watch. When you've selected all your folders, they will appear in the Folders to Watch section of the Watch Folders dialog. In the When New Files are Found in Watched Folders section, you have the choice of having the Organizer alert you when new photos are found in the watched folders (meaning you can choose to add them) or you can have them added automatically, which is what this feature is really all about. But if you're fussy about what gets added when (i.e., you're a control freak), at least you get an option.

Changing the Size of Your Photo Thumbnails

We all have our personal preferences. Some people like to cram as many photos onscreen at once as they can, while others like to see the photos in the Organizer's Media Browser at the largest view possible. Luckily, you have total control over the size they're displayed at.

Step One:
The size of your thumbnails is controlled by a slider at the top of the Media Browser. Click-and-drag the slider to the right to make them bigger and to the left to make them smaller. To jump to the largest possible view, just click on the Single Photo View icon to the right of the slider. To jump to the smallest size, click on the Small Thumbnail Size icon to the left of the slider.

TIP: Jumping Up a Size
To jump up one size at a time, press-and-hold the **Ctrl key** and press the **+ (plus sign) key**. To go down in size, press **Ctrl–** (minus sign).

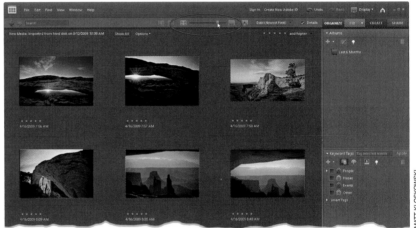

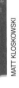

Step Two:
Another shortcut to jump to the largest view is to just double-click on your thumbnail. At this large view, you can enter a caption directly below the photo by clicking on the placeholder text (which reads "Click here to add caption") and typing in your caption.

If you like seeing a super-big view of your photos, then use Elements' Full Screen View. It shows you a huge preview of a selected thumbnail without having to leave the Organizer. Here's how:

Seeing Full-Screen Previews

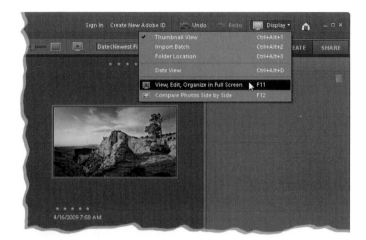

Step One:
To see a full-screen preview of your currently selected photo(s), click on the Display button (it looks like a tiny monitor) at the right side of the menu bar up top and choose View, Edit, Organize in Full Screen (or press **F11**, or just click on the View, Edit, Organize in Full Screen icon in the Options Bar [it's to the right of the Single Photo View icon]).

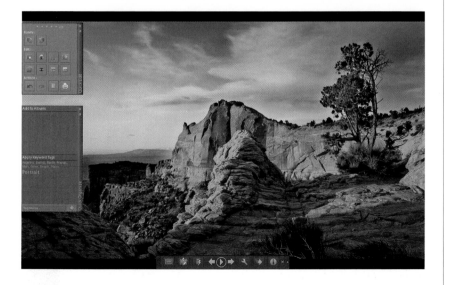

Step Two:
This brings you into Full Screen view, and your photo should appear large onscreen with everything else black around it. This is really a way to launch into a slide show, but if you don't do anything here, you're simply just viewing your photos in a larger view. If you want to return to the Media Browser, press the **Esc key** on your keyboard. But wait, there's more.

Continued

Step Three:

Once your photo(s) appears full screen, there's a control palette at the bottom of the screen where you can control your viewing options—click the Play button to start moving through your photos and click the Pause button to stop. You can also click the Right Arrow and Left Arrow buttons to view the next or previous photo.

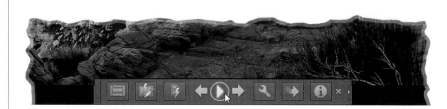

Step Four:

One more thing: Try clicking the Toggle Film Strip button (or just press **Ctrl-F**) at the left side of the control palette. This opens a filmstrip view of your photos on the right side of the screen. So you don't necessarily have to hit the Right Arrow button a bunch of times to get to a photo that's 25 photos into your list. You can just scroll the filmstrip until you see it and click on it. Nifty huh?

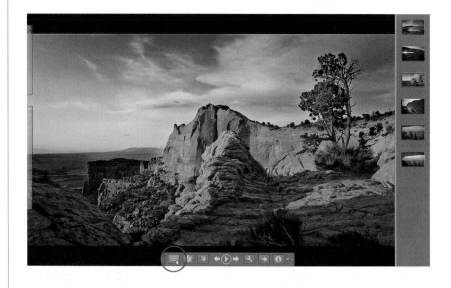

When photos are imported into the Organizer, the Organizer automatically sorts them by date. How does it know on which dates the photos were taken? The time and date are embedded into the photo by your digital camera at the moment the photo is taken (this info is called EXIF data). The Organizer reads this info and then sorts your photos automatically by date, putting the newest ones on top. You can change that, though.

Sorting Photos by Date

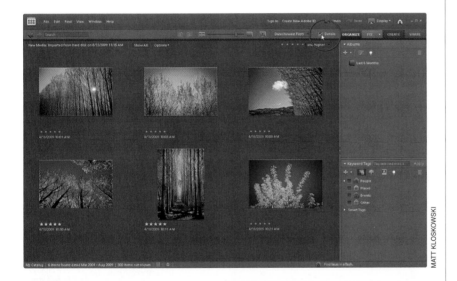

MATT KLOSKOWSKI

Step One:
By default, the newest photos are displayed first, so basically, your last photo shoot will be the first photos in the Organizer. Also, by default, the exact date and time each photograph was taken is shown directly below each photo's thumbnail (if you don't want this extra detail about each photo to be visible, just turn off the Details checkbox at the top-right side of the Media Browser, shown circled here in red).

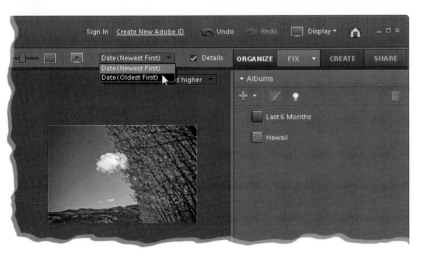

Step Two:
If you'd prefer to see your photos in reverse order (the oldest photos up top), then choose Date (Oldest First) from the pop-up menu above the top right of the Media Browser. There you have it!

Adding Scanned Photos? Enter the Right Time and Date

Let's say that you have a scanner and you scan in a bunch of photos and import them into the Organizer. They're all going to show up on the date you scanned them, not the date they were taken. That's when you'll need to manually go in and enter the date. I know, you're wondering how you'll know what date the photos were taken. It could have been decades ago. Well, just getting close is a start. For example, if you see a guy wearing a tie-dyed shirt and socks pulled up to his knees, you can pretty much bet it was taken in the late '70s (at least you hope).

Step One:
First, get the photos from your scanner (see the "Importing Photos from Your Scanner" tutorial earlier in this chapter). Select all the photos you want to set the date for by Ctrl-clicking on each image (or Shift-clicking on the first and last images if they are contiguous) in the Media Browser. Then, go under the Organizer's Edit menu and choose Adjust Date and Time of Selected Items (or press **Ctrl-J**).

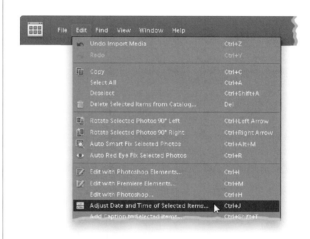

Step Two:
This brings up a dialog asking how you want to handle the date and time for these photos. For this example, select Change to a Specified Date and Time and click OK.

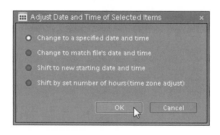

Step Three:
This brings up the Set Date and Time dialog, where you can use the pop-up menus to set your selected photos' date and time. Now these photos will appear sorted by the date you entered, rather than the date you imported them.

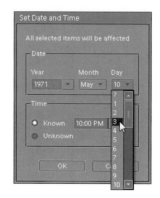

By default, the Organizer sorts your photos by date and time, with the most recent photos appearing at the top. You know and I know that it's hard to always remember when you took some of your favorite photos, though. With the Timeline, you can at least get pretty close. Let's say you're trying to find photos from a photo shoot you did last summer. You may not remember exactly whether it was June or July, but by moving a slider you can hone in and find them really fast.

Finding Photos Fast by Their Month and Year

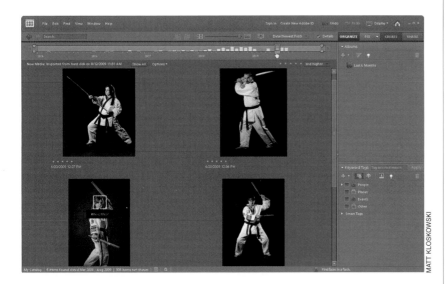

MATT KLOSKOWSKI

Step One:
First things first. You need to display the Timeline to use it. Go under the Window menu and choose Timeline (or just press **Ctrl-L**). It'll appear right above the Media Browser. We're going to assume you're trying to find photos from a shoot you did over the summer (as mentioned above). You see those bars along the Timeline that look like the little bar charts from Microsoft Excel? Well, the higher the bar, the more photos that appear in that month. So click on any month in 2009 and only the photos taken in that month will appear in the Media Browser. As you slide your cursor to the left (or right), you'll see each month's name appear. When you get to June, only photos taken in June 2009 will appear. Take a quick look and see if any of those photos are the ones from your shoot. If they're not in June, scroll on the Timeline to July, and only those photos will be visible.

Tagging Your Photos (with Keyword Tags)

Although finding your photos by month and year is fairly handy, the real power of the Organizer appears when you assign tags (keywords) to your photos. This simple step makes finding the exact photos you want very fast and very easy. The first step is to decide whether you can use the pre-made tags that Adobe puts there for you or whether you need to create your own. In this situation, you're going to create your own custom tags.

Step One:
Start by finding the Keyword Tags palette in the Organizer (it's on the right side of the window on the Organize tab in the Task pane). Adobe's default set of keyword tag catagories will appear in a vertical list. Now, there are a few different ways to tag photos, so let's take a look at them all. In the end, they all do the same thing, just in a different way.

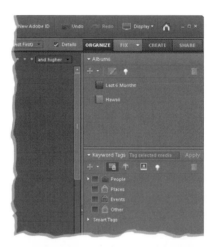

Step Two: The Really Easy Way
Let's start by tagging the really easy way (which is new in Elements 8, by the way). Type a tag name in the Keyword Tags text field at the top of the Keyword Tags palette. Then in the Media Browser, click on the photo (Ctrl-click to select multiple photos) you want to assign this tag to and click the Apply button to the right of the text field. The tag will automatically be created and applied to the selected photo(s).

TIP: Use an Existing Keyword Tag
Since the Keyword Tags text field dynamically displays existing keyword tags based on the letters you type, you can use it to assign an existing keyword tag to your photos instead of creating a brand new one.

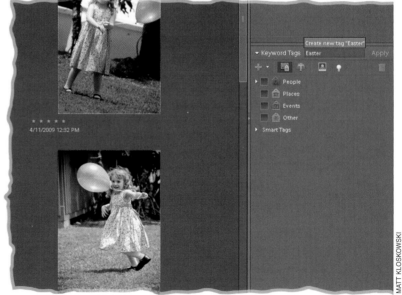

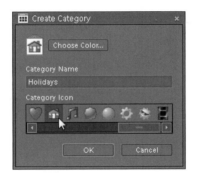

Step Three: **The More Customized and Visual Way**

The thing about Step Two is that it automatically creates your tag in the Other category. As you start tagging, you may want to categorize your tags and even create your own categories. So, let's start by creating a custom category (in this case, we're going to create a category of all the holiday shots taken of family). Click on the Create New Keyword Tag button (the little green plus sign) at the top left of the Keyword Tags palette and choose New Category from the pop-up menu. This brings up the Create Category dialog. Type in "Holidays." Now choose an icon from the Category Icon list and then click OK. (The icon choices are all pretty lame, but we can use the house icon here.)

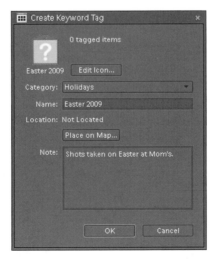

Step Four:

To create your own custom tag, click on the Create New Keyword Tag button again and choose New Keyword Tag. This brings up the Create Keyword Tag dialog. Choose Holidays from the Category pop-up menu (if it's not already chosen), then in the Name field, type in a name for your new tag (here I entered "Easter 2009"). If you want to add additional notes about the photos, you can add them in the Note field, and you can choose a photo as an icon by clicking the Edit Icon button (there's more on choosing icons later in this chapter). Now click OK to create your tag.

Continued

Step Five:

Next, you'll assign this tag to all the photos from this shoot. In the Media Browser, scroll to the photos from that shoot. We'll start by tagging just one photo, so click on your new tag that appears in your Keyword Tags list and drag-and-drop that tag onto any one of the photos. That photo is now "tagged." If you have the photo's Details visible (if not, turn on the Details checkbox at the top-right corner of the Media Browser), you'll see a small tag icon appear below the photo's thumbnail (in this case, the house icon).

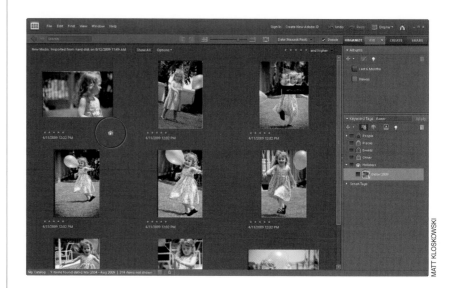

Step Six:

So at this point, we've only tagged one photo from this shoot. Drag-and-drop that same tag onto five more photos from the shoot, so a total of six photos are tagged. Now, in the Keyword Tags palette, click in the small box to the left of your new tag (a tiny binoculars icon will appear in that box), and in-stantly, only the photos with that tag will appear in the Media Browser. To see all your photos again, click on the Show All button that appears at the top left of the Media Browser.

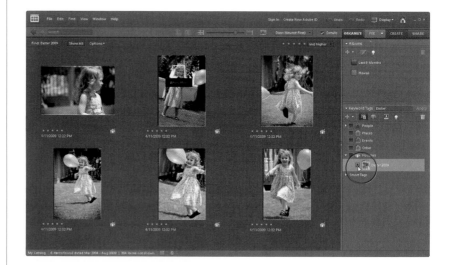

Step Seven: The Keyword Tag Cloud (the Text-Based Way to Add Keywords)

The Keyword Tag Cloud is another new way of tagging in Elements 8. Start out by clicking on the View Keyword Tag Cloud button at the top of the Keyword Tags palette. This shows you an alphabetized list of your keywords. What's really different about this view is that the keywords that appear larger mean that you've assigned those keyword tags to more photos than other keywords that appear smaller.

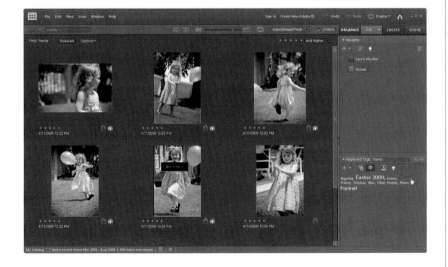

Step Eight:

To tag photos using this view, all you have to do is click on one of the keyword tags in the Keyword Tag Cloud, drag it over your photo, and it's tagged. If you wanted to only see photos with, say, the Family tag, you could click on that keyword tag in the Keyword Tag Cloud and Elements would display only those photos that have been tagged with Family.

Auto Tagging with Smart Tags

You saw how to tag your photos in the previous tutorial and I won't lie to you—it takes a little bit of time. However, there is a feature called Smart Tagging (new in Elements 8) that does some auto-tagging for you. Now, it can't figure out that you were at Disney World and tag your photos with Disney tags, but there are a few useful Smart Tags to help you get started.

Step One:
Take a look at the Keyword Tags palette and, at the bottom of the tag category list, you'll see Smart Tags. When you click on the right-facing arrow and expand it, you'll see there are tags named High Quality, Faces, Too Bright, Too Dark, etc. There are also tags named Audio and Shaky, which are actually meant for video, if you're using Premier Elements.

Step Two:
To use Smart Tags, you've got to first let Elements analyze your photos. It's a snap, though. Just Ctrl-click on the photos in the Media Browser that you want to select, Right-click on any of the ones you just selected, and choose Run Auto-Analyzer from the contextual menu. A progress bar will appear, so you'll know the Auto-Analyzer is doing something. This may take a few minutes depending on how many photos you select.

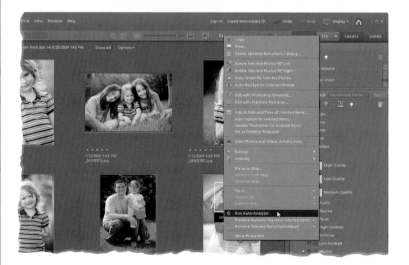

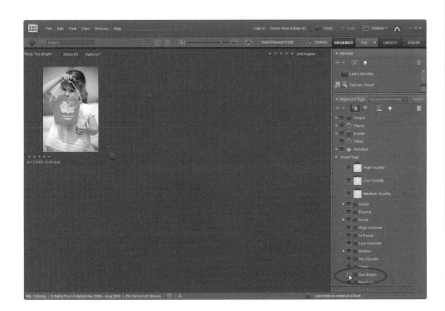

Step Three:
When the Auto-Analyzer is done running, go back to the Smart Tags in the Keyword Tags palette. Click next to one of the Smart Tags (I'll choose the Too Bright tag here) and you'll see the photos that Elements has deemed are too bright. Like I said in the intro, the Smart Tags aren't the solution to everything, but they do give you a good starting point.

Tagging Multiple Photos

Okay, if you had to tag any more than a few photos, you've probably realized that dragging-and-dropping the tag onto each photo is a pain in the neck. If you had a whole photo shoot, that process would take forever and you'd probably be getting ready to send Adobe (or us for even showing you this feature) a nasty email. You'll be happy to know there are faster ways than this one-tag-at-a-time method. For example…

Step One:
To tag all the photos from your shoot at the same time, try this: First, click on any photo from the shoot. Then press-and-hold the Ctrl key and click on other photos from that particular shoot. As you click on them, they'll become selected (you'll see a thin blue box around each selected photo). Or, if all the photos are contiguous, click on the first image in the series, press-and-hold the Shift key, and then click on the last image in the series to select them all.

Step Two:
Now drag-and-drop your chosen tag onto any one of those selected photos, and all of the selected photos will have that tag. If you want to see just the photos from that shoot, you can click in the box to the left of that tag in the Keyword Tags palette and only photos with that tag will appear. By the way, if you decide you want to remove a tag from a photo, just Right-click on the tag below the photo and from the contextual menu that appears, choose Remove Keyword Tag. If you have more than one tag applied (like the Easter 2009 keyword tag and the Family keyword tag), you can choose which tag you want removed.

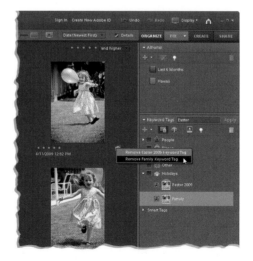

Okay, what if you want to assign a keyword tag to a photo, but you also want to assign other keyword tags (perhaps an "Upload to Website" tag and a "Make Prints" tag) to that photo, as well? Here's how:

Assigning Multiple Tags to One Photo

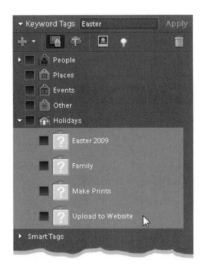

Step One:
To assign multiple tags at once, first, of course, you have to create the tags you need, so go ahead and create two new tags by clicking on the Create New Keyword Tag button and choosing New Keyword Tag from the pop-up menu. Name one "Upload to Website" and the other "Make Prints." Now you have four tags you can assign. To assign all four tags at once, just press-and-hold the Ctrl key, then in the Keyword Tags palette, click on each tag you want to assign (Easter 2009, Family, Make Prints, and Upload to Website).

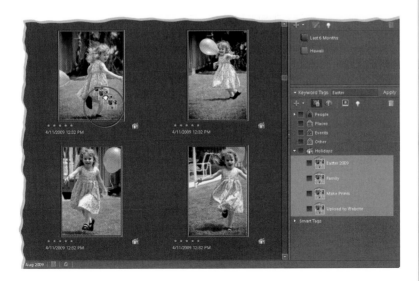

Step Two:
Now click-and-drag those selected tags, and as you drag, you'll see you're dragging four tag icons as one group. Drop them onto a photo, and all four tags will be applied at once. If you want to apply the tags to more than one photo at a time, first press-and-hold the Ctrl key and click on all the photos you want to have all four tags. Then, go to the Keyword Tags palette, press-and-hold the Ctrl key again, and click on all the tags you want to apply. Drag those tags onto any one of the selected photos, and all the tags will be applied at once. Cool.

Tagging Images of People

You're either going to think this is the coolest, most advanced technology in all of Elements, or you're going to think it's creepy and very Big Brother-ish (from the book by George Orwell, not the TV show). Either way, it's here to help you tag people easier because the Organizer can automatically find photos of people for you—as it has some sort of weird science, facial-recognition software built in (that at one point was developed for the CIA, which is all the more reason it belongs in Elements).

Step One:

Let's say you want to quickly find all the photos of your daughter. In the Organizer, select the group of photos you want to search through (you can press **Ctrl-A** to Select All, click on an album, or just Ctrl-click on as many images as you want to sort through). Then go under the Find menu and choose Find People for Tagging, or just click on the Start People Recognition button at the top of the Keyword Tags palette.

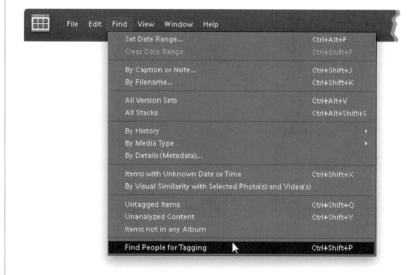

Step Two:

This brings up the People Recognition – Full Size View dialog. Within just a few moments (depending on how many photos you have), it will sort through your selected images and separate out those that contain a human face. Once an image appears in the dialog, you'll see a white rectangle around the face(s) that Elements has recognized. If you see a rectangle around a face (sometimes it picks things that aren't a face), move your cursor over it, and click on the black rectangle that asks "Who is this?" Type in a name to tag this photo with and press Enter. If this tag doesn't already exist, this will create a new one.

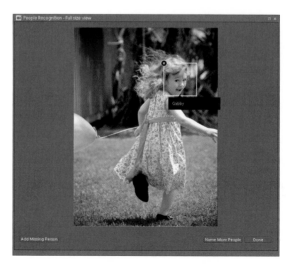

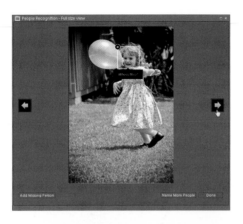

Step Three:
After you're done tagging the face(s) in that photo, click on the Next Image (right arrow) button to the right of the photo to move to the next photo with a face or click the Done button (at the bottom right) to go back to the Media Browser. If Elements found something that isn't a face in a photo, just click the X in the black circle at the top left of the rectangle to dismiss that specific guess.

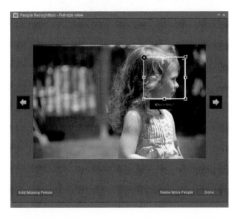

Step Four:
If Elements didn't recognize a face, you can always add your own. Click the Add Missing Person button at the bottom left of the dialog and a new face-tagging rectangle will appear. Click-and-drag the rectangle over the person's face, resize it by dragging any of the corner handles, and give 'em a name.

TIP: Train Elements to Find Faces
If Elements didn't find a face, it almost seems easier to just close the dialog and drag one of your regular tags over the photo, right? That may be a quick fix, but the more you tag and the more you use this face tagging technology, the better you train Elements to find faces. That way, the next time you tag faces, it gets more and more accurate.

ANOTHER TIP: Find Similar Photos
As cool as this technology is, it doesn't stop there. Say you have a photo of a tall building, and you want to find all the similar photos that have a tall building. Just click on one of your building photos, go under the Find menu, and choose By Visual Similarity with Selected Photo(s) and Video(s). It will look for photos that have similar attributes (such as a building, similar colors, or orientation) to what you've already chosen.

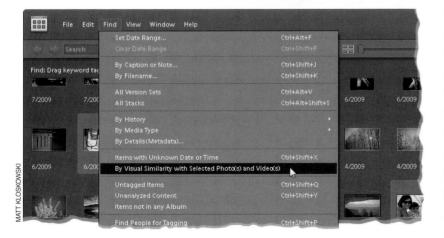

Combining (Merging) Keyword Tags

It's easy to go "keyword tag crazy," and if that happens (and you've got dozens of different tags applied to your photos), you may want to simplify by merging some of your keyword tags together. For example, if you shot the Olympics, and you have tags for the 100-meter dash, 400-meter dash, 600-meter dash, and a half dozen more dashes, you may want to combine all those separate tags into just one tag. Here's how:

Step One:
To combine (merge) multiple keyword tags into just one convenient tag, start by pressing-and-holding the Ctrl key and clicking on all the tags that you want to combine in the Keyword Tags palette on the right side of the Organizer. Then Right-click on any of your selected tags, and from the contextual menu that appears, choose Merge Keyword Tags.

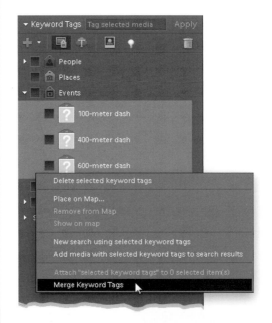

Step Two:
This brings up a dialog that asks you which of the selected tags will be the surviving tag (in other words, which tag will remain after the rest are merged into this one). Choose the tag that will remain from the list of tags, then click OK. The tags will be merged into that one. Every photo that had any one of those selected tags will now have the one combined tag.

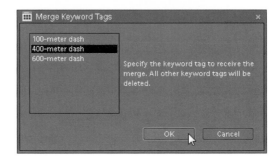

Let's say you went to the Super Bowl with a group of photographers, and they're using Elements, too. If you've created a nice set of keyword tags for identifying images, you can export these tags and share them with the other photographers from that trip. That way, they can import them and start assigning tags to their Super Bowl photos without having to create tags of their own.

Sharing Your Keyword Tags with Others

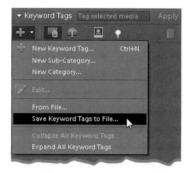

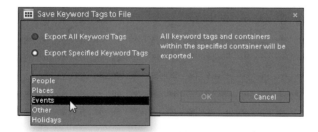

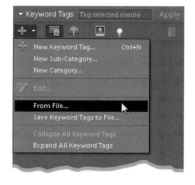

Step One:
To export your keyword tags to share with others, start by going to the Keyword Tags palette (on the right side of the Organizer), then click on the Create New Keyword Tag button and, from the pop-up menu, choose Save Keyword Tags to File.

Step Two:
When the Save Keyword Tags to File dialog appears, you can choose to Export All Keyword Tags or, better yet, click on the Export Specified Keyword Tags radio button, then you can choose which tag category you want to export from the pop-up menu, and just click OK. A standard Windows Save dialog will appear, so you can choose where you want your file saved. Name your file, click Save, and now you can email your exported tags to your friends.

Step Three:
Once your friends receive your tags, tell them they can import them by going to the Keyword Tags palette, clicking on the Create New Keyword Tag button, and from the pop-up menu, choosing From File. Now they just locate the file on their hard drive and click Open. The new tags will appear in their Keyword Tags palette. (*Note:* You can export your albums in a similar way from the Albums palette. See the next page for more on albums.)

Albums: It's How You Put Photos in Order One by One

Once you've tagged all your photos, you may want to create a collection of just the best photos (the ones you'll show to your friends, family, or clients). You do that by creating an "album" (which used to be called a collection in earlier versions of Elements). An advantage of albums is that once photos are in an album, you can put the photos in the order you want them to appear (you can't do that with tags). This is especially important when you start creating your own slide shows and Web galleries.

Step One:
To create an album, go to the Albums palette on the top-right side of the Organizer (it's above the Keyword Tags palette we just looked at). You create a new album by clicking on the Create New Album button (the green plus sign), and from the pop-up menu, choosing New Album. When the Album Details pane appears, enter a name for your album, and then click Done.

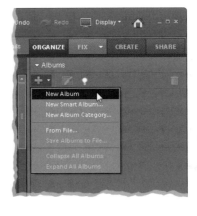
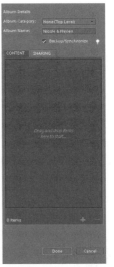

Step Two:
Now that your album has been created, you can either (a) drag the album icon onto the photos you want in your album, or (b) Ctrl-click on photos to select them and then drag-and-drop them onto your album icon in the Albums palette. Either way, the photos will be added to your album. To see just the photos in your album, click on your album name. Now, to put the photos in the order you want, just click on any photo and drag it into position. The Organizer automatically numbers the photos for you in each thumbnail's top-left corner, so it's easy to see what's going on as you click-and-drag. To return to all of your images, click the Show All button in the top-left corner of the Media Browser.

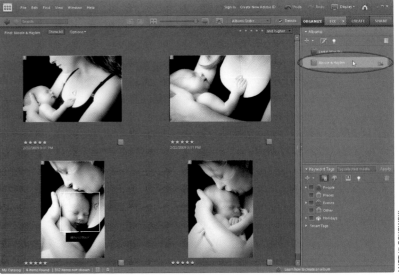

MATT KLOSKOWSKI

As we saw in the previous tutorial, albums are the way to go, right? They're such an easy way to get to your best photos. But let's say you find yourself always searching for photos of two people together in one shot (maybe a father and his daughter). You could tag each photo separately and then create an album of those photos, so you could get to them quickly. However, what happens when you add more photos to your photo library with dad and daughter together? You'd have to manually tag them and then add them to the album to keep it up to date. Or, you could use this handy little feature in Elements 8 called Smart Albums to do it automatically.

Using Smart Albums for Automatic Organization

MATT KLOSKOWSKI

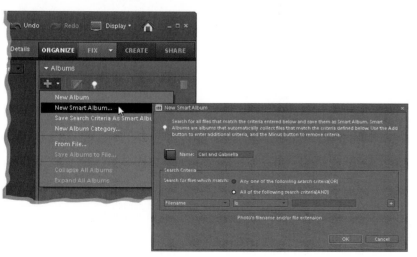

Step One:
Here's a good scenario: I've got some photos of a girl (Gabriella) and others that her father (Carl) appears in, as well. They've all been tagged with either one or both tags (a Gabriella tag and a Carl tag). What I want is an easy way to find photos of the two of them. I could: (1) Turn on both tags in the Keyword Tags palette to see just those photos, but that's a pain to do every time I want to see them. (2) Create an album named "Carl and Gabriella" and put the photos of the two of them in it, but what happens when I import more photos of them? I'd have to manually add them to the album each time. (3) Use a Smart Album that watches my photo library for a specified set of criteria (in this case, a Gabriella tag *and* a Carl tag). In case you haven't realized it yet, this is the better option.

Step Two:
At the top of the Albums palette, click on the Create New Album button and choose New Smart Album. In the New Smart Album dialog, give it a descriptive name (like "Carl and Gabriella," since they'll be in the photos we'll be including here). Next, choose what criteria the photos match. Since we want our photos to match two criteria, not just one or the other, I'm going to set Search for Files Which Match to All of the Following Search Criteria [AND].

Continued

Step Three:

Now, click on Filename and, from the pop-up menu, choose Keyword Tags, then from the pop-up menu that appears on the right, choose the keyword tag you want to search by.

TIP: Search By Other Criteria

If you scroll through the first pop-up menu, you'll see there are a ton of things you can search by instead of just Keyword Tags. For example, you can search by a certain focal length. So, if you wanted an album of all photos shot at 85mm, no problem.

Step Four:

Let's add to this. Click the little + (plus sign) icon to the right of the second pop-up menu to create another line of criterion. Choose Keyword Tags from the first pop-up menu, just like last time, but here I've set it to include Carl. You can go on and on and add more criteria by clicking the little + icon, but let's stop with two names and click OK to create the Smart Album.

Step Five:

Notice that without you doing anything else, Elements has already populated the Smart Album with some photos. You'll see that all of the photos in it are tagged with the tags you just chose (for me, it was the Gabriella tag and the Carl tag). But that's not the really super cool part. The really super cool part is that Elements monitors your photo library, and the next time you add both tags to a photo, it will automatically add that photo to the Smart Album. You don't have to lift a finger to make it happen because you've already created that Smart Album. It does all the work of staying updated for you as long as you do your job of tagging as you go along.

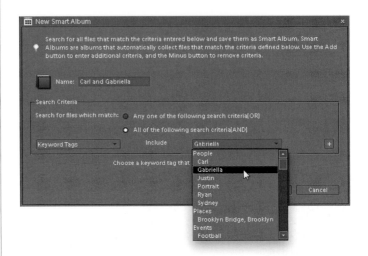

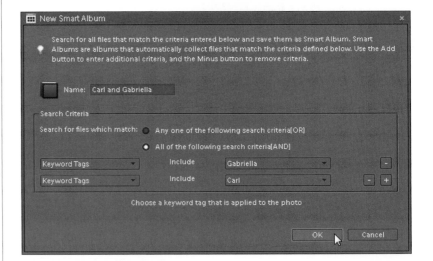

By default, a keyword tag uses the first photo you add to that tag as its icon. Most of the time, these icons are so small that you probably can't tell what the icon represents. That's why you'll probably want to choose your own photo icons instead.

Choosing Your Own Icons for Keyword Tags

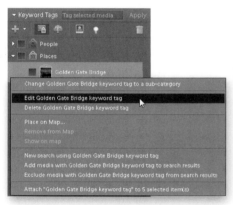

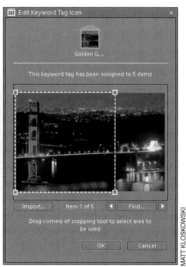

Step One:
It's easier to choose an icon once you've created a keyword tag and tagged a few photos. Once you've done that, Right-click on your tag, and choose Edit Keyword Tag from the contextual menu. This brings up the Edit Keyword Tag dialog. In this dialog, click on the Edit Icon button to launch the dialog you see here.

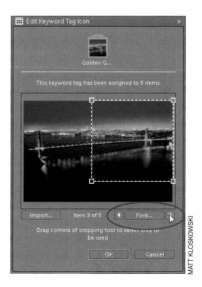

Step Two:
You'll see the first photo you tagged with this keyword in the preview window (this is why it's best to edit the icon *after* you've added tags to the photos). If you don't want to use this first photo, click the arrow buttons under the bottom-right corner of the preview window to scroll through your photos. Once you find the photo you want to use, click on the little cropping border (in the preview window) to isolate part of the photo. This gives you a better close-up photo that's easier to see as an icon. Then click OK in the open dialogs and that cropped image becomes your icon.

Deleting Keyword Tags or Albums

There will be plenty of times when you create a keyword tag or an album and later decide you don't want it anymore. Here's how to get rid of them:

Step One:
To delete a keyword tag or album, start by clicking on the keyword tag or album you want to delete in the Keyword Tags or Albums palette on the right side of the Organizer.

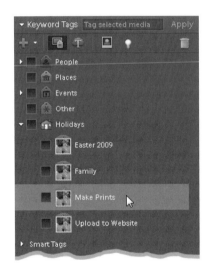

Step Two:
Once you've selected the tag or album you want to delete, just click on the Trash icon at the top right of the Keyword Tags (or Albums) palette. If you're deleting a tag, when you click on the Trash icon, it brings up a warning dialog letting you know that deleting the tag will remove it from all your photos and Smart Albums, and if you used this keyword to tag a person, it will be removed from the People Recognition System. If you want to remove that tag, click OK. If you've got an album selected when you click on the Trash icon, it asks if you're sure you want to delete the album, and lets you know that if you used that album in a Smart Album, it'll be removed from there, as well. Click OK and it's gone. However, it does not delete these photos from your main catalog—it just deletes that album.

When you take a photo with a digital camera, a host of information about that photo is embedded into the photo by the camera itself. It contains just about everything, including the make and model of the camera that took the photo, the exact time the photo was taken, what the f-stop setting was, what the focal length of the lens was, and whether or not the flash fired when you took the shot. You can view all this info (called Exchangeable Image File [EXIF] data—also known as metadata) from right within the Organizer. Here's how:

Seeing Your Photo's Metadata (EXIF Info)

MATT KLOSKOWSKI

Step One:
To view a photo's EXIF data, click on the image in the Media Browser and then from the Window menu, choose Properties. The Properties palette will appear as a floating palette. To nest it below the Keyword Tags palette (as shown here), click the double arrows at the top right.

TIP: Properties Palette Shortcut
You can also just press **Alt-Enter** to open and close the palette.

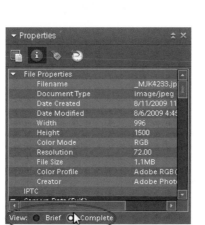

Step Two:
When the Properties palette appears, click the Metadata button at the top of the palette (it's the second button from the left). This shows an abbreviated version of the photo's EXIF data (basically, the make, model, ISO, exposure, f-stop, focal length of the lens, and the status of the flash). Of course, the camera embeds much more info than this. To see the full EXIF data, in the View section at the bottom of the palette, just select Complete and you'll get more information on this file than you'd probably ever want to know.

Adding Your Own Info to Photos

As soon as you press the shutter button, your digital camera automatically embeds information into your photos. But you can also add your own info if you want. This includes simple things like a photo caption (that can appear onscreen when you display your photos in a slide show), or you can add notes to your photos for your personal use, either of which can be used to help you search for photos later.

Step One:
First, click on the photo in the Media Browser that you want to add your own info to, and then from the Window menu, choose Properties to open the Properties palette (or you can use the keyboard shortcut **Alt-Enter**).

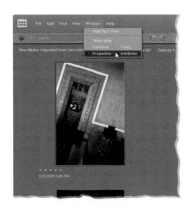

Step Two:
This brings up the Properties palette. At the top of the palette are four buttons for the four different sections of your photo's properties. By default, the General section is selected. In the General section, the first field is for adding captions (I know, that's pretty self-explanatory), and then the photo's filename appears below that. It's the third field down—Notes—where you add your own personal notes about the photo.

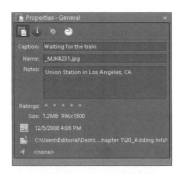

Step Three:
If you want to see other info about your photo (for example, which keyword tags have been added to your photo; the date when you imported the photo or when you last printed, emailed, or posted the photo on the Web; or the info embedded into the photo by your digital camera), just click on the various buttons at the top of the palette.

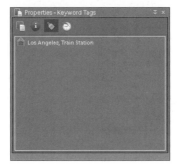

Aside from actually doing things to fix your photos, finding them will be the most common task you do in Elements. If you've tagged them, then it's easy to find groups of photos. But finding just one photo can be a little harder (not really too hard, though). You first have to narrow the number of photos to a small group. Then you'll look through that group until you find the one you want. I know, it sounds complicated but it's really not. Here are the most popular searching methods:

Finding Photos

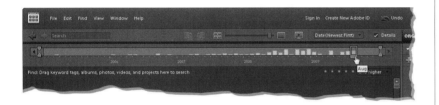

From the Timeline:
We saw this one earlier. The Timeline (from the Window menu, choose Timeline to see it), which is a horizontal bar across the top of the Media Browser, shows you all the photos in your catalog. Months and years are represented along the Timeline. The years are visible below the Timeline; the small light blue bars above the Timeline are individual months. If there is no bar visible, there are no photos stored in that month. A short blue bar means just a few photos were taken that month; a tall bar means lots of photos. If you hover your cursor over a blue bar, the month it represents will appear. To see the photos taken in that month, click on the bar and only those photos will be displayed in the Media Browser. Once you've clicked on a month, you can click-and-drag the locator bar to the right or left to display different months.

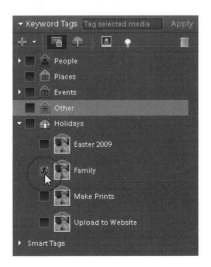

Using Keyword Tags:
If there's a particular shot you're looking for, and you've tagged all your shots with a particular tag, then just go to the Keyword Tags palette and click on the empty box to the left of that tag. Now only shots with that tag will appear in the Media Browser.

Continued

Using the Keyword Tag Cloud:

If your Keyword Tag list starts getting large, it becomes hard to find the tag you want to search with. But if you wanted to find your photos using some of the most popular keyword tags, then try the Keyword Tag Cloud. It shows all of your keyword tags in a text view and it shows the ones that have been used the most as larger text than the others that are less used. Go to the Keyword Tags palette and click the View Keyword Tag Cloud button at the top of the palette. Then click the keyword tag that you want and you'll only see those photos.

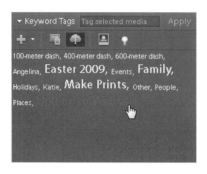

By Date Ranges:

Let's say you're looking to find a particular photo you shot on vacation. If you can remember approximately when you went on vacation, you can display photos taken within a certain date range (for example, all the photos taken between June 1 and June 30, 2009). Here's how: Go under the Organizer's Find menu and choose Set Date Range. This brings up a dialog where you can enter start and end dates. Click OK and only photos taken within that time frame will be visible. Scroll through those images to see if you can find your photo.

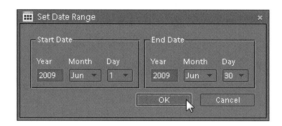

By Caption or Note:

If you've added personal notes within tags or you've added captions to individual photos, you can search those fields to help you narrow your search. Just go under the Organizer's Find menu and choose By Caption or Note. Then, in the resulting dialog, enter the word that you think may appear in the photo's caption or note, and click OK. Only photos that have that word in a caption or note will appear in the Media Browser.

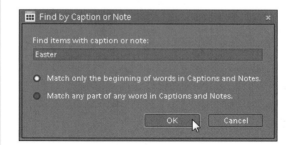

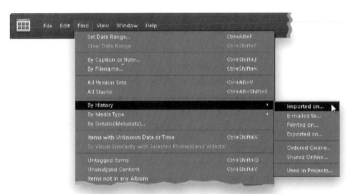

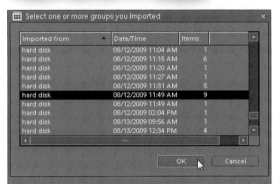

By History:

The Organizer keeps track of when you imported each photo and when you last shared it (via email, print, webpage, etc.); so if you can remember any of those dates, you're in luck. Just go under the Organizer's Find menu, under By History, and choose which attribute you want to search under in the submenu. A dialog with a list of names and dates will appear. Click on a date and name, click OK, and only photos that fit that criterion will appear in the Media Browser.

By Textual Information:

Elements 8 has a new search field that basically lets you search all text information in a photo—not just keyword tags, but all of the metadata and stuff that gets stored with your photos. In fact, it's probably one of the most powerful and easiest ways to search, since you don't have to worry as much about what you're looking for and where to look for it. Just go to the search field in the top left of the Organizer window (right under the File menu) and type in your search terms. Here, I entered D300 and it found all of the photos taken with my Nikon D300. I could have just as easily typed a keyword tag or even part of a filename.

Finding Photos Using the Date View

Okay, I have to admit, this particular feature is probably going to be your least-used Organizer feature because it seems so…I dunno…cheesy (for lack of a better word). When you use it, you see a huge calendar, and if photos were created on a particular day in the currently visible month, you'll see a small thumbnail of one of those images on that date. Personally, when I see this view, I feel like I've just left a professional-looking application and entered a "consumer" application, so I avoid it like the plague, but just in case you dig it (hey, it's possible), here's how it works:

Step One:
To enter the Date View in the Organizer, click the Display button on the right side of the Organizer's menu bar. Then choose Date View from the pop-up menu.

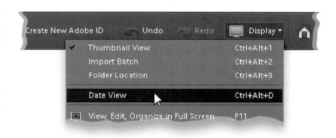

Step Two:
This brings up the Date View calendar with the Month view showing by default (if you're not in Month view, click the Month button along the bottom center of the window). If you see a photo on a date, it means there are photos that were taken (or you scanned or imported) on that day. To see a photo, click on it within the calendar and a larger version will appear at the top right of the window. To see the rest of the photos on this day, click the Next Item on Selected Day button found directly under this preview window. Each time you click this button, the window displays a preview of the next photo taken on that day.

TIP: Returning to Media Browser
You can always get back to the Media Browser by clicking the Media Browser button at the bottom-center of the window.

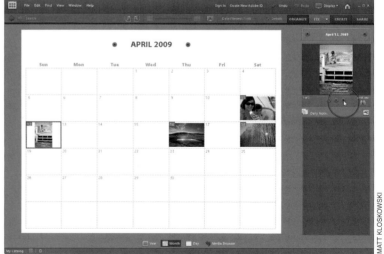

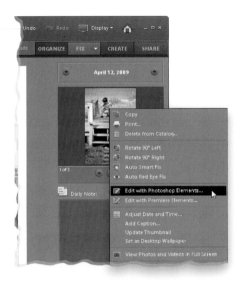

Step Three:

If you find the photo you're looking for (I'm assuming that if you're searching around in the Date View, you're looking for a particular photo) and you want to edit that photo, Right-click on the photo's preview and choose Edit with Photoshop Elements from the contextual menu (or just press **Ctrl-I**). The Elements Editor will launch with your photo open and ready to edit.

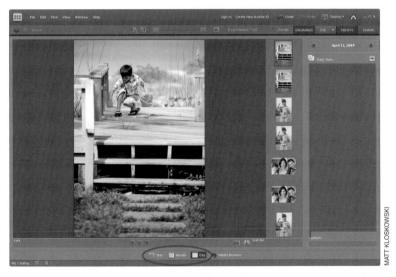

MATT KLOSKOWSKI

Step Four:

Return to the Organizer in Date View. While we're here, I want to show you a couple of the other features. Although the Month view is shown by default, there are buttons at the bottom center of the window for viewing the entire year (where days that have photos appear as solid-color blocks) or an individual day (where all the photos from that day appear in a slide-show-like view, as shown here).

Step Five:

While in the Date View, you can add a Daily Note, which is a note that doesn't apply to only the current photo—it applies to every photo taken on that calendar day. In all three views (Year, Month, and Day), a field for adding a Daily Note to the currently displayed photo will appear along the right side of the window. Now, when you're in Day view, you can not only see your Daily Note for your photo, but you can also see the caption for your photo, too.

Seeing an Instant Slide Show

Here's a scenario: You get back from a photo shoot and download your photos into the Organizer. You know you got some great shots and you just want to see them in a quick full-screen slide show. Nothing fancy. Just your photos, big onscreen. That's where the Full Screen option comes in. FYI...later in the book, we'll look at how to create a rich, fully-featured slide show using another feature in Elements, but this one is a good trick to know.

Step One:
First, open the Organizer. Now press-and-hold the Ctrl key and click on each photo you want to appear in your slide show (if the photos are contiguous, you can click on the first photo, hold the Shift key, click on the last photo, and all the photos in between will be selected). Once the photos you want are selected, click on the Display button (on the right side of the Organizer's menu bar) and choose View, Edit, Organize in Full Screen from the pop-up menu (or just press **F11**).

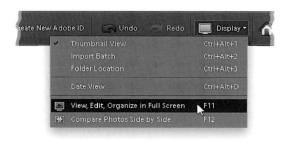

Step Two:
This brings you into Full Screen view, where you'll see your photo large onscreen with a few pop-up palettes on the left and bottom of the screen. The Quick Edit and Quick Organize palettes on the left side will slide in and out of the screen as you hover your cursor over them. They're basically there in case you want to make some quick edits or organizational changes as you see your photos large onscreen during the slide show.

MATT KLOSKOWSKI

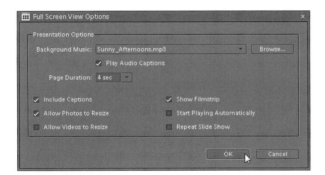

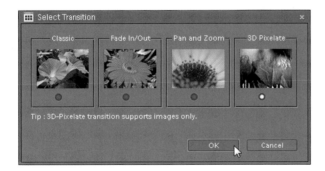

Step Three:
Your slide show won't start until you click the Play button in the control palette at the bottom of the screen (or press the **Spacebar**, or **F5**). To stop your slide show (to pause), click the Pause button (the Play button toggles to the Pause button), and then to resume it, click Play/Pause again.

Step Four:
If you want to change the presentation options for your slide show, click the Open Settings Dialog button (the little wrench) in the control palette. This brings up the Full Screen View Options dialog, where you choose the music for your slide show from the Background Music pop-up menu and how long each photo will appear onscreen from the Page Duration pop-up menu. It assumes you want any captions included, but you can turn that off by clicking on the Include Captions checkbox, and you can also have your slide show loop when it reaches the end by turning on the Repeat Slide Show checkbox. Click OK to close the dialog when you're done.

Step Five:
Okay, if you get anything out of this tutorial, this needs to be it: Next to the Open Settings Dialog button is the Transitions button. This is new in Elements 8 and when you click the button, it opens the Select Transition dialog. The first three are pretty self explanatory (to me at least) but if you want to see a quick preview of them, just hover your cursor over the thumbnail and you'll see a quick animation of what the transition from slide to slide will look like. It's the last one, 3D Pixelate, that's crazy. You'll have to see it full screen to really appreciate it, so go ahead and click on the 3D Pixelate radio button, and then click OK.

Continued

Step Six:

Now click the Play button or hit the Spacebar or F11 key to start the slide show. Then watch in amazement as one photo transitions to another. I gotta warn you, though, if you've been drinking (alcohol, that is) it's really going to freak you out, and if you haven't been drinking, well, it's probably going to make you feel like you have been. After you kill an hour watching this (I'm serious, it's mesmerizing), go ahead and press the **Esc key** to get out of slide show mode (if you chose the Pan and Zoom or 3D Pixelate transition) or click on the Exit button at the right end of the control palette (if you chose the Classic or Fade In/Out transition) to go back to Full Screen view.

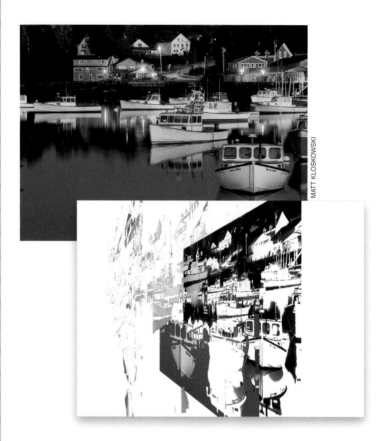

Step Seven:

There are extra controls at the right side of the control palette (click on the tiny left-facing arrow on the far right of the palette to reveal them) for comparing still images, but they are not used during your slide show. I usually keep them hidden and just display the slide show controls.

Step Eight:

To get out of Full Screen view and return to the Organizer, press the **Esc key** again on your keyboard, or click the Exit button in the control palette.

When you see a great photo opportunity do you take just one shot? Probably not, right? Most times you snap off a few (or 10, if you're like me), just to make sure you have several to choose from. But when you get back to your computer, you've got to make sure you do just that—choose the best ones and delete the rest. Because if you don't, you'll then have a bunch of similar-looking photos cluttering your screen, and you'll never really know which one to go to. Here's a way to help:

Comparing Photos

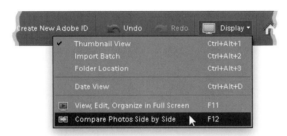

Step One:
First, open the Organizer. To compare (or review) photos side by side, press-and-hold the Ctrl key and click on all the photos you want to compare. Then click the Display button on the right side of the menu bar and choose Compare Photos Side by Side from the pop-up menu (or just press the **F12 key** on your keyboard). This brings up the same Full Screen view we saw in the last tutorial.

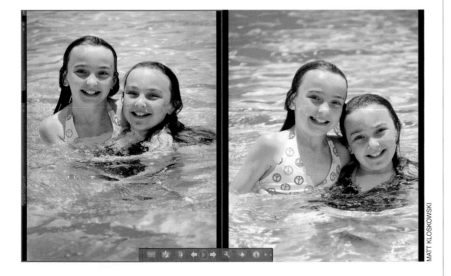

Step Two:
Full Screen View mode will open, placing the first and second photos you selected side by side onscreen. You'll also see the control palette at the bottom of your screen, and the Quick Edit and Quick Organize palettes tucked away on the left. The first photo (on the left) has the number 1 in its upper left-hand corner, and the second photo (the one being compared) is noted as number 2 when clicked on.

Continued

Step Three:
Visually compare these two photos. You want the one that looks best to remain onscreen so you can compare other selected photos to it, right? To do that, click on the "bad" photo, and a blue highlight will appear around that photo, indicating that this is the one that will change. In this example, I thought the first photo looked better, so I clicked on photo number 2 (on the right).

Step Four:
Now go to the control palette, click on the Next Photo button, and the photo on the right will be replaced with your next photo in that series. Again, review which of these two looks the best, then click on the photo that looks worst (that way, you can replace it with another photo you want to compare). Click the Next Photo button to compare the next photo (and so on). To back up and re-view a previous photo, click the Previous Photo button in the control palette.

Step Five:
Besides this side-by-side mode, there's also an option that lets you see your photos stacked one on top of the other (which you might like for comparing photos in landscape orientation). To change to that mode, click on the right-facing arrow at the right end of the control palette to get the other view options, then click on the down-facing arrow to the immediate right of the Side by Side View button in the control palette, and from the pop-up menu that appears, choose Above and Below. Cycle through the images as you did before—just repeat Steps Three and Four until you find the photo you like best. When you're finished, press the **Esc key** on your keyboard or click the Exit (X) button in the control palette.

MATT KLOSKOWSKI

This isn't exactly an Organizer technique, but there's also a way to compare photos in the Elements Editor. This is a cool feature that Elements borrows from Photoshop—the ability to arrange and view multiple images at once (for comparison purposes)—but more importantly, to be able to view each one at the same magnification (even when changing zoom magnifications). You can scroll around (pan) to inspect images and have all the images pan at the same location and rate. This is one you need to try to really appreciate.

Comparing Photos by Zooming and Panning

DIANA KLOSKOWSKI

Step One:
Open the multiple photos you want to compare in the Editor. (In this instance, we'll compare four photos, so open four photos, which will appear in the Project Bin at the bottom of the Editor window. The power of this feature will be more apparent if you open four similar images, like four portraits of the same person at one sitting, etc.)

DIANA KLOSKOWSKI

Step Two:
In the menu bar, click on the Arrange button (it appears right after Help and is new in Elements 8) and, in the pop-up menu, click on one of the options that corresponds to the number of photos you opened in Step One. Here, I selected the 4 Up option. This will tile each photo (in its own separate window) across your screen, so you can see all four photos at once.

Continued

Step Three:

Now that your photos are tiled, return to the Arrange pop-up menu and choose Match Zoom. Then, press-and-hold the Shift key, press **Z** to switch to the Magnifying Glass tool (okay, it's called the Zoom tool, but its icon looks like a magnifying glass), and while still holding the Shift key, click on a person or object in one of the active image windows. You'll notice that all four photos jump to the same zoom.

Step Four:

Go under the Arrange pop-up menu again, and choose Match Location. Press **H** to switch to the Hand tool (it's right under the Zoom tool in the Toolbox), press-and-hold the Shift key, then click within your image and drag to pan around your photo. If you don't hold the Shift key first, it will just pan around the front-most active window. By holding Shift, all the windows pan at the same time and speed, enabling you to compare particular areas of your photos at the same time.

I love stacks, because as much as I try to compare my photos and get rid of the ones that I have duplicates of, I inevitably wind up with several photos that look the same. Well, there's a feature called stacking and it works just like its real-world counterpart does—it stacks several photos on top of each other and you'll just see the top one. So if you have 20 shots of the same scene, you don't have to have all 20 cluttering up your Media Browser. Instead, you can have just one that represents all of them with the other 19 underneath it.

Reducing Clutter by Stacking Your Photos

Step One:
With the Organizer open, press-and-hold the Ctrl key on your keyboard and click on all the photos you want to add to your stack (or if the images are contiguous, simply click on the first image in the series, press-and-hold the Shift key, and click on the last image in the series). Once they're all selected, go under the Organizer's Edit menu, under Stack, and choose Stack Selected Photos in the submenu.

Step Two:
No dialog appears, it just happens— your other photos now are stacked behind the first photo you selected (think of it as multiple layers, and on each layer is a photo, stacked one on top of another). You'll know a photo thumbnail contains a stack because a Stack icon (which looks like a little blue stack of paper) will appear in the upper-right corner of your photo. You'll also see a right-facing arrow to the right of the image thumbnail.

Continued

Step Three:

Once your photos are stacked, you can view these photos at any time by clicking on the photo with the Stack icon, and then going under the Edit menu, under Stack, and choosing Expand Photos in Stack, or just click on the right-facing arrow to the right of the image thumbnail. This is like doing a Find, where all the photos in your stack will appear in the Media Browser within a gray shaded area so you can see them without unstacking them. Then, to collapse the stack, just click on the left-facing arrow that appears to the right of the last image thumbnail in the stack.

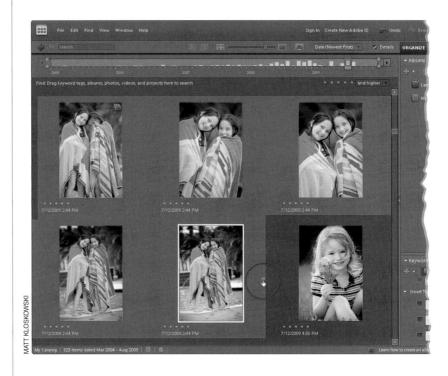

MATT KLOSKOWSKI

Step Four:

If you do want to unstack the photos, select the photo with the Stack icon in the Media Browser, then go under the Edit menu, under Stack, and choose Unstack Photos. If you decide you don't want to keep any of the photos in your stack, select the photo with the Stack icon in the Media Browser, go back under the Edit menu, under Stack, and choose Flatten Stack. It's like flattening your layers—all that's left is that first photo. However, when you choose to flatten, you will have the choice of deleting the photos from your hard disk or not.

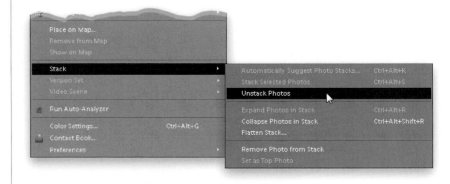

If this isn't cool, I don't know what is. Imagine being able to send friends or relatives to an online customized version of Yahoo! Maps, and when they click on a map pin, they see your photos and the exact location where they were taken on the map. Seriously, is that cool or what? A totally interactive online map you create and link to your own photos at the spot where they were taken. Now, come on, if it doesn't sound that cool, then you've got to try it once and you'll be totally hooked.

Putting Your Photos on a Map

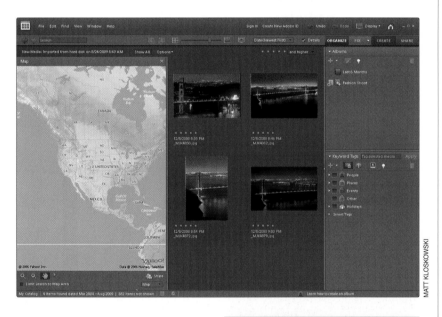

MATT KLOSKOWSKI

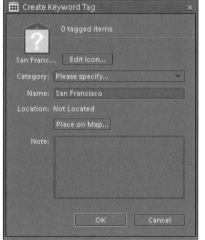

Step One:
You start by going to the Organizer and switching it into Map mode by going under the Window menu and choosing Show Map. This splits the Media Browser, and shows your photos on the right side, and a Yahoo! map of North America on the left side. (By the way, since this whole Yahoo! Maps thing is Internet-based, I guess it goes without saying that you need to have an Internet connection, right? Right.)

Step Two:
Now let's create a custom tag for the photos you want to appear on a certain city on the map. For example, let's say that you've got a number of photos taken from your vacation in San Francisco. You'd start by creating a new tag (in the Organizer portion of the screen) and then link that tag to a particular city on the map (don't worry, it's easier than it sounds). Start by going to the Keyword Tags palette on the right side of the Organizer. Then click the Create New Keyword Tag button and choose New Keyword Tag from the pop-up menu. When the Create Keyword Tag dialog appears, name this tag San Francisco (as shown here), but don't click OK yet.

Continued

Step Three:
Now click on the Place on Map button, which brings up a dialog asking you to enter the location where the photos were taken (in this case, I just typed in San Francisco, CA), then click the Find button (as shown here).

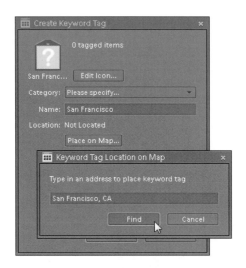

Step Four:
This brings up the Look Up Address dialog, where it queries its database to find a match on the map. Luckily, San Francisco is a pretty popular place, so in less than a second it popped up with "San Francisco, CA, US." If that's the city you're looking for (and we are), click OK. However, you can get a lot more exact than just this. I typed in my home address, and it pinpointed it exactly on the map, so don't be afraid to get really precise if you know the exact address of where the photos were taken. In fact, let's go ahead and enter a more exact address for the Golden Gate Bridge: Golden Gate Bridge, San Francisco, CA. Click on the Place on Map button again, but this time enter that new address, and then click the Find button. It will find it right away, so once it appears (in about two seconds), just click OK, and you'll notice that the map on the left side of the window zooms into the exact location of the Golden Gate Bridge. Pretty slick. But we're not done yet. Change the name of your tag to Golden Gate Bridge, San Francisco, and then click OK. When you do this, you'll see a red pin appear, marking the exact location you entered on the map.

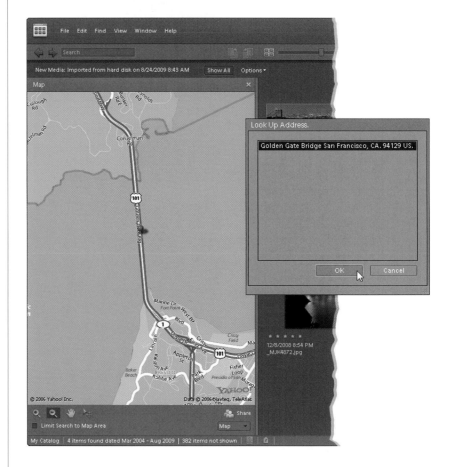

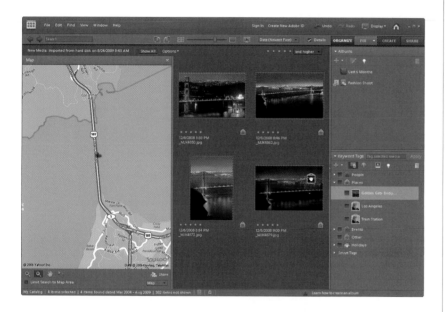

Step Five:
Now, in the Organizer, select the photos you want to tag with your Golden Gate Bridge, San Francisco tag (press-and-hold the Ctrl key and click on each photo you want selected), then click directly on the tag in your list of tags, and drag-and-drop that tag onto one of your selected photos. (By the way, if you previously tagged images with a tag that contains an exact address, you can simply click-and-drag the photos with that tag to a spot on the map.)

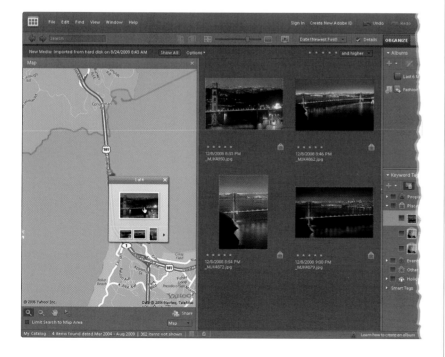

Step Six:
Want to make sure this process really worked? Then move your cursor over the red pin on the map, and click once. A mini slide show viewer will appear, and you can click on the tiny thumbnails below the main photo to see individual photos, but that's not the cool feature. Go ahead and click on the main photo, and you jump straight into an instant full-screen slide show of the photos you tagged with that tag, and that are pinned at that map location (see, I told you this was cool). To leave the slide show and return to the Organizer, just press the **Esc key** on your keyboard. Seeing the photos on your own computer is one thing, but now let's get these up on the Web so other people can see them. That's when it gets really fun.

Continued

Step Seven:
To share these map photos (and the map itself), just click on the Share button below the bottom-right corner of the map. You'll get a dialog that asks if you want to share through an Online Album that Photoshop Elements creates. If you choose this option, you can upload the album to your own website or you can share it through Adobe's online sharing services. When you click Share in the Sharing Your Map and Photos dialog, on the right side of the Organizer window, you'll see the Share To options, where you'll choose where you want to share this album to (to the free Photoshop.com website, to a CD/DVD, to your FTP server, or to a hard disk). Make your choice and then click Next to fill in the details about your album. In the Album Details pane, just give your album a name, and then click on the Sharing tab below the Album Name field (your photos will need to have GPS embedded to share them on a map). Click on the Slideshow Settings dialog to fill out this information, then set your map and slide show template on the left, enter your Sharing settings in the Sharing tab, click Done, and you're all set.

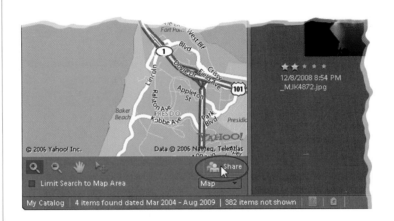

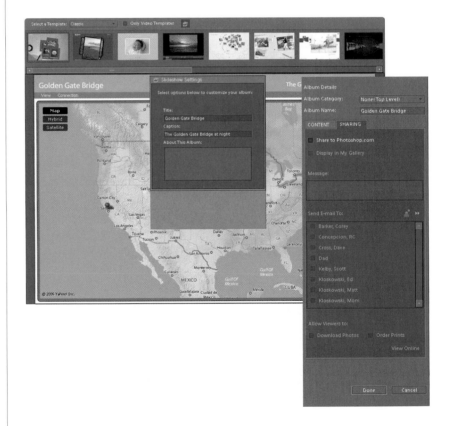

Step Eight:

If you choose the Share Photos on a Map Using Flickr option in the Sharing Your Map and Photos dialog, then click Share, you'll get another dialog. This one lets you know that you'll need to authorize Elements to interact with your Flickr account first (which also means you'll need a free Flickr account if you want to do this). Just click Authorize and your Web browser will open and you'll be taken to the Flickr login page. Once you log in, you'll need to click the OK, I'll Authorize It button to let the Adobe Photo Sharing Service link up to your Flickr account.

Step Nine:

After you click the OK, I'll Authorize It button, you can close your Web browser and you'll be right back inside the Organizer. The Flickr dialog should still be open, and you'll see a Complete Authorization button on the screen. Click on that, and the next screen will ask you if you want to upload to an existing photo set or create a new one (Flickr groups photos into "sets," so you'll need to have one or create one here). Once you choose a set to upload to, or create a new one and give it a descriptive name, click Upload and the photos will go straight to your Flickr.com account. Once they're there, you can access, change, or do anything else with them that you'd normally be able to do on the Flickr site.

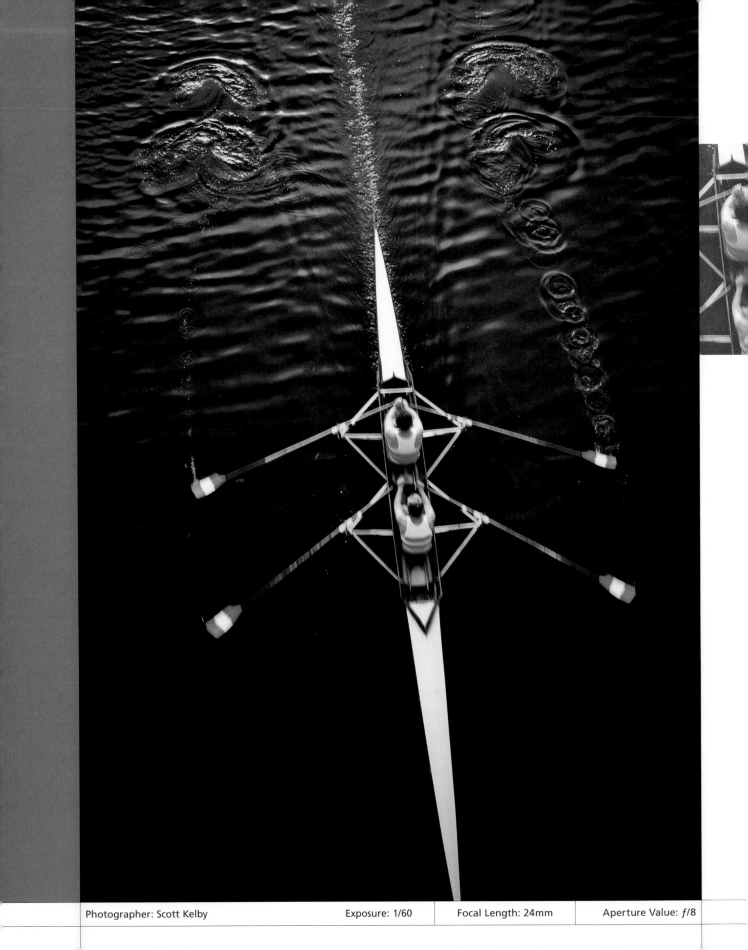

Raw Deal
processing your images using camera raw

Okay, this title is actually taken from a movie starring California Governor Arnold Schwarzenegger called *Raw Deal*. I found the movie poster for it online, and I must admit it was the movie's tag line that sold me on using it as my chapter title. The tag line was: "The system gave him a Raw Deal. Nobody gives him a Raw Deal." The word "Nobody" was underlined. Like this: <u>Nobody</u>. So here's the weird thing: shouldn't it have been, "Nobody gives <u>him</u> a Raw Deal!" with the "him" either italicized or underlined? But the "Nobody" was underlined instead. Makes you stop and think, doesn't it? Anyway, on the movie poster itself, Arnold is holding a really large automatic weapon (I know—how unusual) while wearing a small white undershirt, so his arms and chest look really huge. Ya know, if I had arms and a chest the size of Arnold's, I'm not sure I'd even own a shirt. I'd go shirtless every-

where, and I don't think anyone would give me even an ounce of heat about it. I think restaurants and grocery stores would quickly ease their "no shirt—no service" policy and welcome me right in. Especially if I was carrying that large automatic weapon like he is. Why, I'll bet people get right out of his way. Now, this movie was released in 1986 (I think I was about six months old then), and at that time there was no shooting in RAW, so this was years before the RAW wars broke out. (Everybody thought one day we'd have a huge war over oil reserves in the Middle East. But no one had anticipated that long before that, the entire world would be embroiled in a bitter RAW vs. JPEG war that would threaten to take neighboring TIFF and PSD right into the conflict with it. I can't believe you're still reading this. You're my kind of people— ya know, for just one person.)

Getting RAW, JPEG, and TIFF Photos into Camera Raw

Although Adobe Camera Raw was created to process photos taken in your camera's RAW format, it's not just for RAW photos, because you can process your JPEG and TIFF photos in Camera Raw, as well. So even though your JPEG and TIFF photos won't have all of the advantages of RAW photos, at least you'll have all of the intuitive controls Camera Raw brings to the table.

Step One:

We'll start with the simplest thing first: opening a RAW photo from the Organizer on a PC or from Bridge on a Mac. If you click on a RAW photo to select it in the Organizer, then click on the orange Fix button (at the top of the Palette Bin on the right side of the window) and choose any of the options from the pop-up menu, it automatically takes the photo over to the Editor and opens it in Camera Raw. In Bridge, just double-click on the image. I know, you were probably expecting something sexier than that, but that's all there is to it—select it, and choose an Edit option (or double-click on it), it recognizes that it's a RAW file, and opens it in Camera Raw. So far, so good.

Step Two:

To open more than one RAW photo at a time, go to the Organizer (Mac: Bridge), Ctrl-click (Mac: Command-click) on all the photos you want to open, then click on the Fix button and choose an option from the pop-up menu (as shown here, or just press **Ctrl-I**. On a Mac, press **Command-R**). It follows the same scheme—it takes them over to the Elements Editor and opens them in Camera Raw. On the left side of the Camera Raw dialog, you can see a filmstrip with all of the photos you selected.

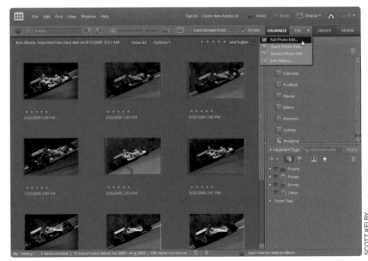

Step Three:

Okay, so opening RAW photos is pretty much a no-brainer, but what if you want to open a JPEG or TIFF photo in Camera Raw? Go under the Editor's File menu and choose Open As (Mac: Open). In the Open As (Mac: Open) dialog, navigate to the JPEG or TIFF photo you want to open and click on it once. When you click on a JPEG or TIFF photo, the Open As (Mac: Format) pop-up menu at the bottom will show JPEG or TIFF and it will open in the Elements Editor like any other JPEG or TIFF. So to open this JPEG or TIFF photo in Camera Raw instead, you have to choose Camera Raw from the Open As pop-up menu (as shown here).

Step Four:

When you click the Open button, that JPEG or TIFF photo is opened in the Camera Raw interface, as shown here (notice how JPEG appears up in the title bar, just to the right of Camera Raw 5.5?). *Note:* When you make adjustments to a JPEG or TIFF photo in Camera Raw and you click either the Open Image button (to open the adjusted photo in Elements) or the Done button (to save the edits you made in Camera Raw), unlike when editing RAW photos, you are now actually affecting the pixels of the original photo. Of course, there is a Cancel button in Camera Raw and even if you open the JPEG or TIFF photo in Elements, if you don't save your changes, the original photo remains untouched.

Miss the Look of JPEGs? Try Camera Profiles for That JPEG-Processed Look

If you've ever looked at a JPEG photo on the LCD screen on the back of your digital camera, and then wondered why your RAW image doesn't look as good, it's because your camera adds color correction, sharpening, contrast, etc., to your JPEG images while they're still in the camera. But when you choose to shoot in RAW, you're telling the camera, "Don't do all that processing—just leave it raw and untouched, and I'll process it myself." But, if you'd like that JPEG-processed look as a starting place for your RAW photo editing, you can use Elements' Camera Profiles to get you close.

Step One:
As I mentioned above, when you shoot in RAW, you're telling the camera to pretty much leave the photo alone, and you'll do all the processing yourself using Camera Raw. Each camera has its own brand of RAW and so Adobe Camera Raw applies a Camera Profile based on the camera that took the shot (it reads the embedded EXIF data, so it knows which camera you used). Anyway, if you click on the Camera Calibration icon (the icon on the right above the right-side Panel area), you'll see the built-in default Camera Profile (Adobe Standard) used to interpret your RAW photo.

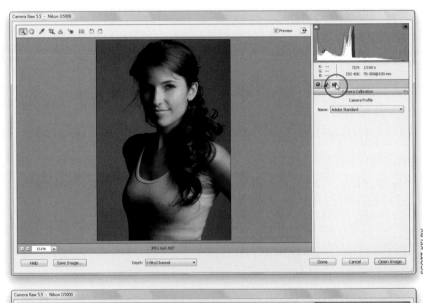

Step Two:
If you click-and-hold on the Name pop-up menu at the top of the panel, a menu pops up with a list of profiles for the camera you took the shot with (as seen here, for images taken with a Nikon digital camera). Adobe recommends that you start by choosing Camera Standard (as shown here) to see how that looks to you.

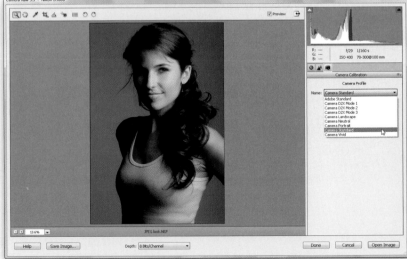

SCOTT KELBY

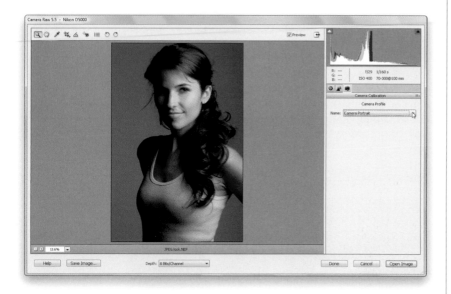

Step Three:

If you have a Nikon or Canon DSLR camera, Adobe also included camera-matching profiles, which are designed to replicate the different color shooting modes that are available in your camera. There are five camera-matching profiles for Canon DSLRs, and eight for Nikon DSLRs. (*Note:* If you don't shoot Canon or Nikon, then you'll only have Adobe Standard, and possibly one or two others, to choose from, but you can create your own custom profiles using Adobe's free DNG Profile Editor utility, available from Adobe at http://labs.adobe.com.)

Step Four:

Here's a before/after with only one thing done to this photo: I chose Camera Portrait (as shown in the pop-up menu in Step Three). Again, this is designed to replicate color looks you could have chosen in the camera, so if you want to have Camera Raw give you a similar look as a starting point, this is how it's done. Personally, I use this when I want my starting point to be closer to the JPEG image I saw on the back of my camera. *Note:* Although the difference is hard to see here, try this with some of your own photos. You'll see the difference more onscreen.

Before: Using the default Adobe Standard profile

After: Using the Camera Portrait profile

The Essential Adjustments: White Balance

If you've ever taken a photo indoors, chances are the photo came out with kind of a yellowish tint. Unless, of course, you took the shot in an office, and then it probably had a green tint. Even if you just took a shot of somebody in a shadow, the whole photo probably looked like it had a blue tint. Those are white balance problems. If you've properly set your white balance in the camera, you won't see these distracting tints (the photos will just look normal), but most people shoot with their cameras set to Auto White Balance, and well…don't worry, we can fix it really easily in Camera Raw.

Step One:

On the right side of the Camera Raw window, there's a section for adjusting the white balance. Think of this as "the place we go to get rid of yellow, blue, or green tints that appear on photos." There are three ways to correct this, and we'll start with choosing a new white balance from the White Balance pop-up menu. By default, Camera Raw displays your photo using your camera's white balance setting, called As Shot. Here, my camera's white balance was set to Auto, and this shot was taken on an overcast day, which made the photo look too cool with a strong blue tint.

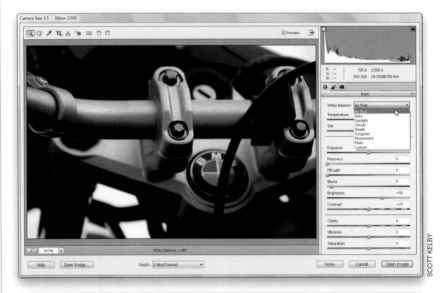

Step Two:

To change the white balance, click on the White Balance pop-up menu and choose a preset. As I mentioned, the white balance in my camera was set to Auto, and I was shooting outdoors using just the available light, so you could choose Cloudy (as shown here), which removes some of the blue tint, although to me it still looks a little cool (the handlebar should be grayer). *Note:* You will only get this complete list of white balance presets (Cloudy, Shade, etc.) when working with RAW images. If you open a JPEG or TIFF image in Camera Raw, your only preset choice (besides As Shot and creating a custom white balance) is Auto.

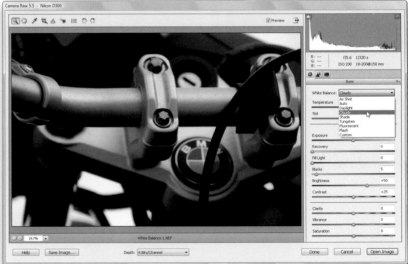

SCOTT KELBY

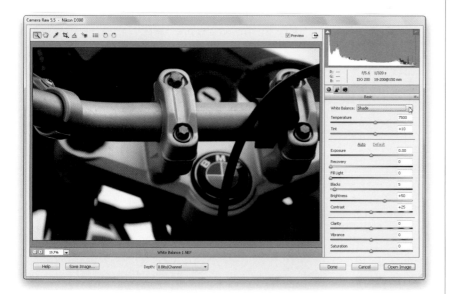

Step Three:

This is going to sound pretty simplistic, but it works—just take a quick look at the seven different white balance presets and see if any of them look more natural to you (less blue). This process takes around 14 seconds (I just timed it). Some will be way off base immediately (like Tungsten, which looks way too blue, or Fluorescent, which also looks way too blue). The preset that looked best (to me anyway) was Shade (as shown here). Anyway, this is why it pays to take a quick look at all seven presets. Notice how the handlebar looks less blue, and the cool tint is mostly gone? Notice I said "mostly?"

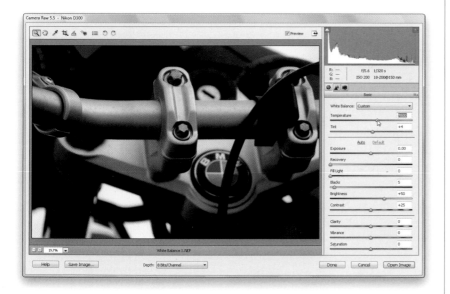

Step Four:

Although the Shade setting is the best of the built-in presets here, if you don't think it's right on the money, then you can simply use it as a starting point (hey, at least it gets you in the ballpark, right?). So, I would choose Shade first, and if I thought there was a bit of blue tint still lingering around, I would then drag the Temperature slider to the right (toward the yellow side of the slider) to warm the photo up just a little bit. In the example shown here, I dragged the Temperature slider over to 7800, which adds yellow, and fights off that blue tint. It seemed a little red, too, so I dragged the Tint slider to the left a little, to 4.

Continued

Step Five:

The second method of setting your white balance is to simply use just the Temperature and Tint sliders (although most of the time you'll only use the Temperature slider, as most of your problems will be too much [or too little] yellow or blue). The sliders themselves give you a clue on which way to drag (on the Temperature slider, blue is on the left and it slowly transitions over to yellow). This makes getting the color you want so much easier—just drag in the direction of the color you want. By the way, when you adjust either of these sliders, your White Balance pop-up menu changes to Custom (as shown).

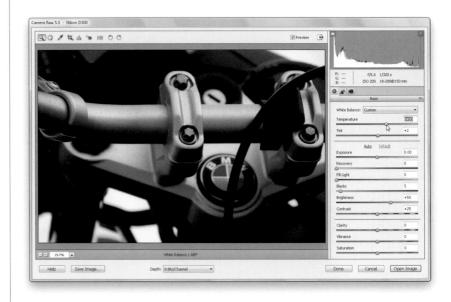

Step Six:

The third method, using the White Balance tool, is perhaps the most accurate because it takes a white balance reading from the photo itself. You just click on the White Balance tool (I) in the toolbar at the top left (it's circled in red here), and then click it on something in your photo that's supposed to be a light gray (that's right—you properly set the white balance by clicking on something that's light gray). So, take the tool and click it once on the ignition (as shown here) and it sets the white balance for you. If you don't like how it looks (maybe it's still too blue), then just click on a different light gray area (try along the top of the handlebar) until it looks good to you.

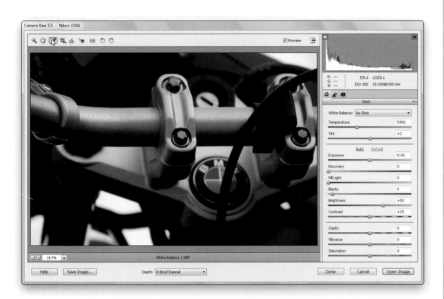

Step Seven:

Now, here's the thing: although this can give you a perfectly accurate white balance, it doesn't mean that it will look good (for example, people usually look better with a slightly warm white balance). White balance is a creative decision, and the most important thing is that your photo looks good to you. So don't get caught up in that "I don't like the way the white balance looks, but I know it's accurate" thing that sucks some people in—set your white balance so it looks right to you. You are the bottom line. You're the photographer. It's your photo, so make it look its best. Accurate is not another word for good. Okay, I'm off the soapbox, and it's time for a tip: Want to quickly reset your white balance to the As Shot setting? Just double-click on the White Balance tool up in the toolbar (as shown here).

Step Eight:

One last thing: once you have the White Balance tool, if you Right-click within your photo, a White Balance preset contextual menu appears under your cursor (as shown here), so you can quickly choose a preset.

TIP: Using a Swatch Card

To help you find the neutral light gray color in your images, we've included a swatch card for you in the back of this book (it's perforated so you can tear it out), and it has a special Camera Raw white balance light gray swatch area. Just put this card into your scene (or have your subject hold it), take the shot, and when you open the image in Camera Raw, click the White Balance tool on the neutral gray area on the swatch card to instantly set your white balance.

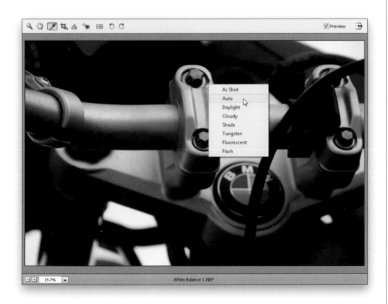

The Essential Adjustments #2: Exposure

The next thing I fix (after adjusting the white balance) is the photo's exposure. Now, some might argue that this is the most essential adjustment of them all, but if your photo looks way too blue, nobody will notice if the photo's under-exposed by a third of a stop, so I fix the white balance first, then I worry about exposure. In general, I think of exposure as three things: highlights, shadows, and midtones. So in this tutorial, I'll address those three, which in Camera Raw are the exposure (highlights), blacks (shadows), and brightness (midtones).

Step One:
The Exposure slider (circled here in red) affects the overall exposure of the photo (dragging to the right makes your overall exposure lighter; dragging to the left makes it darker). Now, be-fore you start dragging the Exposure slider around, there is one thing you're going to want to avoid: losing detail in the brightest parts of your image. This is called "clipping the highlights." When you clip your photo's highlights, the very brightest parts of your photo turn solid white, so you lose all detail in these clipped areas (which is bad, since your goal is to retain as much important detail as possible).

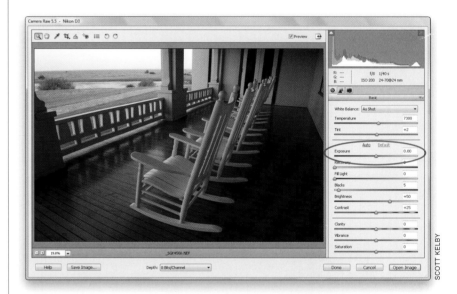

Step Two:
Luckily, Camera Raw can give you a clip-ping warning so you don't accidentally lose highlight detail. In the top-right corner of the Camera Raw window, you'll see a histogram (like the one on your digital camera), and do you see the triangle in the top-right corner of that histogram? It should stay black. If it becomes white (like you see here), that's warning you that some parts of your highlights are now clipping (if the triangle becomes red [like you see in Step One], blue, or green, it means you're only clipping highlights in that color).

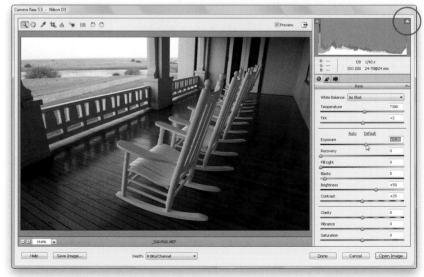

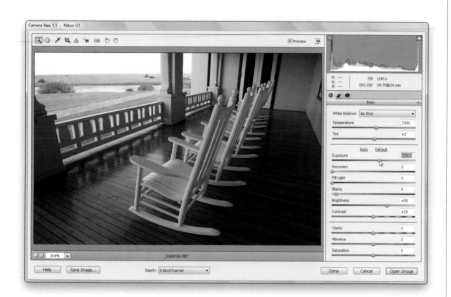

Step Three:

Okay, now that you know what you want to avoid (clipping the highlights and losing highlight detail), the original image looks underexposed (meaning it's too dark). To make the image brighter, you use the Exposure slider (drag the slider to the left, toward the black end of the slider, and the image gets darker; drag it to the right, it gets brighter. Easy enough). The Exposure slider controls the highlights in your photo, and has the most effect on the overall brightness of your photo. So, go ahead and drag it to the right until the exposure looks right to you. To me, on my monitor, it looked right once I dragged the Exposure slider over to a reading of +0.55, but that still clipped the highlights a bit (I could tell by looking at the clipping warning triangle at the top right of the histogram, as seen here).

Step Four:

Before we go any further, there are two other methods you need to know for keeping an eye on highlight clipping (so you can choose which one works best for you). When you move the Exposure slider, you can turn on a warning that lets you know not only if, but exactly where, your highlights are clipping. Just press-and-hold the Alt (Mac: Option) key, then drag the Exposure slider. This turns your entire preview area black, and any clipped areas will appear in their color (so if the Blue channel is clipping, you'll see blue) or, worse, in solid white (which means all the colors are clipping, as seen here). By the way, this warning will stay on as you drag as long as you have the Alt key held down. So if you see areas appear in color (or white), you know you need to drag the Exposure slider to the left until they go away.

Continued

Step Five:

Now, if you don't like the whole-screen-turns-black clipping warning, there is another warning method. You turn it on by clicking once on that little clipping warning triangle at the top right of the histogram (it's shown circled here in red, again), and now any clipped highlights will appear as solid red (as shown here). The nice thing about this method is you don't have to hold down any keys—the warning stays on until you click on that triangle again to turn it off. It also updates live as you make adjustments. So if you drag the Exposure slider back to the left, darkening the exposure, you'll see the red clipping warning areas go away. These warnings (the highlight triangle, and the black preview window) do exactly the same thing—warn you about clipping. It's up to you which of them you like using best.

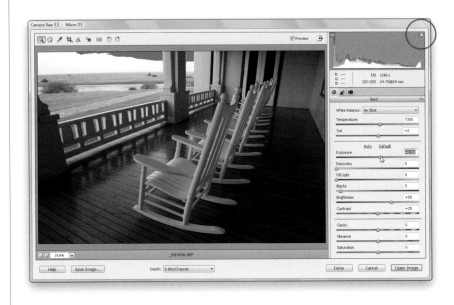

Step Six:

So, now you know how to spot a clipping problem, but what do you do to fix it? Well, in previous versions of Camera Raw, there was really only one thing you could do—drag the Exposure slider back to the left until the clipping warnings went away (which stinks, because that usually made the whole photo underexposed again). But thankfully, in Elements 6, Adobe added the Recovery slider (for recovering clipped highlights). Start by setting the Exposure slider first until the exposure looks right to you—if you see some small areas are clipping, don't worry about it. Now, drag the Recovery slider to the right and as you do, just the very brightest highlights are pulled back (recovered) from clipping. Here I still have that clipping warning turned on, and from just dragging the Recovery slider to the right, you can see that most of the red clipped areas are now gone.

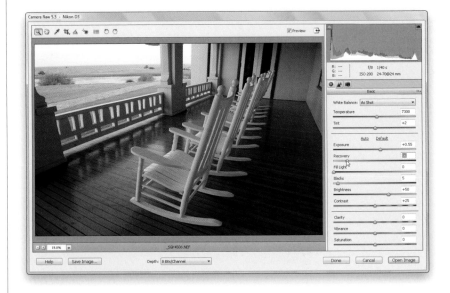

Step Seven:

Like the Exposure slider, you can use that same press-and-hold-the-Alt-key trick while you're dragging the Recovery slider, and the screen will turn black, revealing just the clipped areas (as shown here). As you drag to the right, you'll actually see the clipped areas go away.

TIP: Toggle the Warning On/Off

You can toggle the red highlight clipping warning preview on and off by pressing the letter **O** on your keyboard.

Step Eight:

Next, I adjust the shadow areas using the Blacks slider. Dragging to the right (as shown here) increases the amount of black in the darkest shadow areas of your photo. Dragging to the left opens up (lightens) the shadow areas. See how the slider bar goes from white on the left to black on the right? That lets you know that if you drag to the right, the blacks will be darker. Increasing the blacks will usually saturate the colors in your photo, as well, so if you have a really washed out photo, you may want to start with this slider first instead of the Exposure slider.

Continued

Step Nine:

Although, in digital photography, our main concern is clipping off highlights, you can also see if you're clipping any shadow areas by using the same tricks—the triangle, turning on the clipping warning (but the clipped shadows appear in blue), or the ol' press-and-hold-the-Alt-key trick with the Blacks slider (but the preview area turns solid white, and any areas that are solid black have lost detail. If you see other colors, like red, green, or blue, they're getting clipped, too). Personally, I'm not nearly as concerned about a little bit of clipping in the shadows, especially since the only fix is to drag the Blacks slider to the left to reduce the amount of blacks in the shadows.

Step 10:

Again, my main concern is highlight clipping, but in some cases some highlight clipping is perfectly acceptable. For example, clipping specular highlights, like a bright reflection on a car's bumper or the center of the sun, isn't a problem—there wouldn't be important detail (or any detail for that matter) there anyway. So, as long as we make sure important areas aren't clipped off, we can adjust the photo until it looks right to us. Here the exposure is set by using the Exposure and Recovery sliders, my shadows are set by using the Blacks slider, and while there is still a bit of shadow clipping, I don't care because these aren't areas of really important detail (to me, anyway).

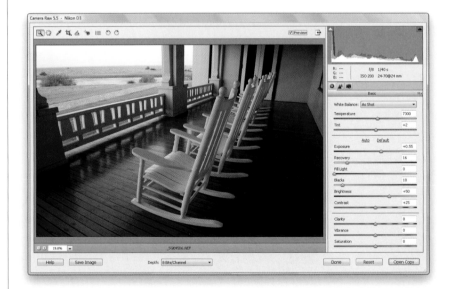

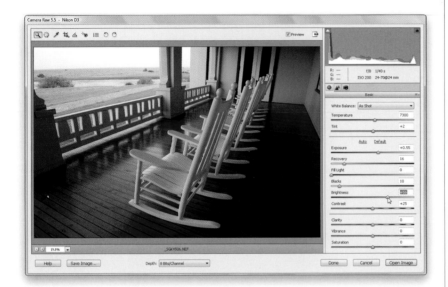

Step 11:

The next slider down is Brightness. Since you've already adjusted the highlights (Exposure slider) and the shadows (Blacks slider), the Brightness slider adjusts everything else (I relate this slider to the midtones slider in Elements' Levels dialog, so that might help in understanding how this slider differs from the Exposure or Blacks sliders). Of the three main adjustments (Exposure, Blacks, and Brightness), this one I personally use the least—if I do use it, I usually just drag it a very short amount to the right to open up some of the midtone detail. In this case, I dragged it a little to the right to keep the photo from looking too dark. There are no clipping warnings for midtones, but if you push it far enough to the right, it can sometimes create some highlight clipping, so be careful.

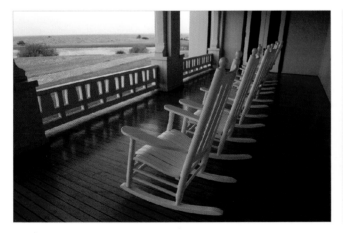

Before

After

The Fix for Shadow Problems: Fill Light

This is a control you're not going to need to use every time (well, at least hopefully not. If you do, we have bigger problems to discuss). You'll generally only use the Fill Light slider in situations where your subject is in the shadows, like when your subject is backlit (and you should have used a fill flash when you took the shot).

Step One:
When you open a photo where your subject is in the shadows, the Fill Light slider can do a remarkable job of fixing your problem. In this image, the subject, shot in the afternoon, is shadowed by the building opposite it. If you drag the Exposure slider to the right, it overexposes the top part of the building and the sky, but the bottom part of both buildings remain in the shadows.

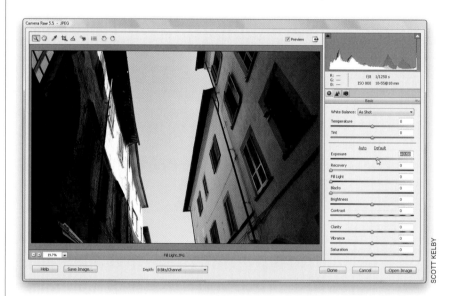

Step Two:
To open up the detail in those dark lower-midtone areas, just drag the Fill Light slider to the right (as seen here, where I dragged it over to 80, which opens up that area big time).

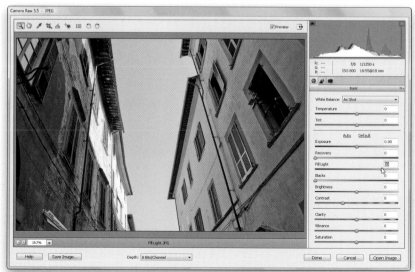

SCOTT KELBY

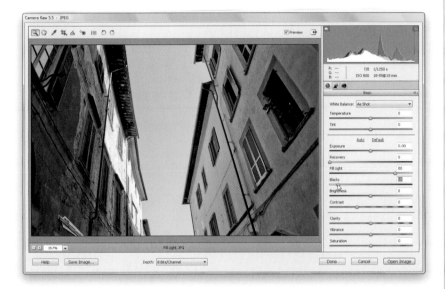

Step Three:

If you don't wind up dragging it too far to the right, you're done. However, if you wind up dragging it quite a bit to the right (like I did here), it can sometimes cause the photo to look a little washed out. In those situations, I go to the Blacks slider and drag it just a little to the right (as shown here) to bring back some of the richness and color saturation in the deep shadow areas. Now, there is a difference if you're working with RAW or JPEG/TIFF images. With RAW images, the default setting for the Blacks will be 5, and generally all you'll need to do is move them over to 7 or 8. However, on JPEG or TIFF images, your default is 0, and I tend to drag them a little farther (in the example shown here, I started at 0 and dragged up to 10 to get to where it looked right to me). Of course, every image is different, but either way, you shouldn't have to move the Blacks slider too far (just remember—the farther you move your Fill Light slider to the right, the more you'll have to compensate by adding more Blacks).

Before

After

Making Your Colors More Vibrant

Besides the White Balance control, there's only one other adjustment for color that you want to use to make your colors more vibrant, and that's the Vibrance slider. Rather than making all your colors more saturated (which is what the Saturation slider does), the Vibrance slider is smarter—it affects the least saturated colors the most, it affects the already saturated colors the least, and it does its darndest to avoid flesh tones as much as possible. It's one very savvy slider, and since it came around, I avoid the Saturation slider at all costs.

Step One:
Here's an image where the colors are kind of flat and dull. If I used the Saturation slider, every color in the image would get the same amount of saturation, so I do my best to stay away from it (in fact, the only time I use the Saturation slider anymore is when I'm removing color to create a color tint effect or a black-and-white conversion).

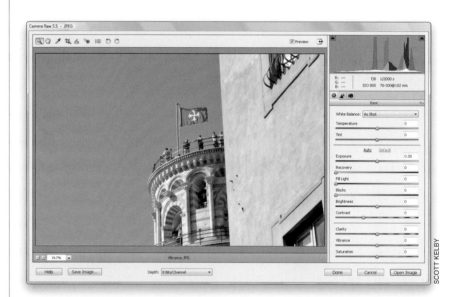

Step Two:
Drag the Vibrance slider to the right, and you'll notice the colors become more vibrant (it's a well-named slider), but without the color becoming cartoonish, which is typical of what the Saturation slider would do. You'll notice in the image here that the color isn't "over the top" but rather subtle, and maybe that's what I like best about it.

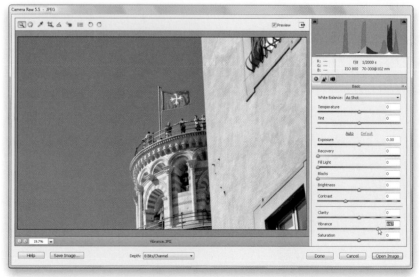

SCOTT KELBY

If you're not quite comfortable with manually adjusting each image, Camera Raw does come with a one-click Auto function, which takes a stab at correcting the overall exposure of your image (including shadows, fill light, contrast, and recovery). If you like the results, you can set up Camera Raw's preferences so every photo, upon opening in Camera Raw, will be auto adjusted using that same feature. Ahhh, if only that Auto function worked really well.

Letting Camera Raw Auto Correct Your Photos

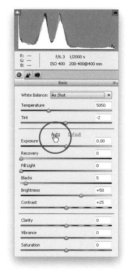

Step One:
To have Camera Raw auto adjust your image, click on the Auto button (it's the underlined word Auto that appears just below the Tint slider). Sometimes this works, sometimes it does very little (other than adjusting the Exposure and Recovery sliders to eliminate highlight clipping), but most times, to me it seems to way overexpose the photo. It usually pushes the Exposure slider as far to the right as it can without clipping the highlights, which I guess in theory gives you a full range of exposure, but in reality gives you what looks like (to me anyway) an overexposed photo. If you don't like the Auto results, you can click on the Default button (to the immediate right of the Auto button) to reset the photo to what it looked like when you first opened it in Camera Raw.

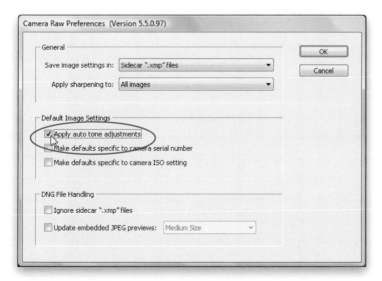

Step Two:
To have Camera Raw apply this Auto adjustment to every photo you open, just click on the Preferences icon up in Camera Raw's toolbar (the third from the right), and turn on the checkbox for Apply Auto Tone Adjustments (shown circled in red here), then click OK. Again, if you don't like the Auto correction, just click on the Default button (the Auto button will be grayed out because it's already been applied).

Adding "Snap" to Your Images Using the Clarity Slider

This is one of my favorite features in Camera Raw, and whenever I show it in a live class, it never fails to get "Ooohhs" and "Ahhhhs." I think it's because it's just one simple slider, yet it does so much to add "snap" to your image. The Clarity slider (which is well-named) basically increases the midtone contrast in a way that gives your photo more punch and impact, without actually sharpening the image.

Step One:
The Clarity slider (circled in red here) is found in the bottom section of the Basic panel in Camera Raw, right above the Vibrance and Saturation sliders. (Although its official name is Clarity, I heard that at one point Adobe engineers considered naming it "Punch" instead, as they felt using it added punch to the image.) To clearly see the effects of Clarity, first zoom in to a 100% view by double-clicking on the Zoom tool up in the toolbar (it looks like a magnifying glass).

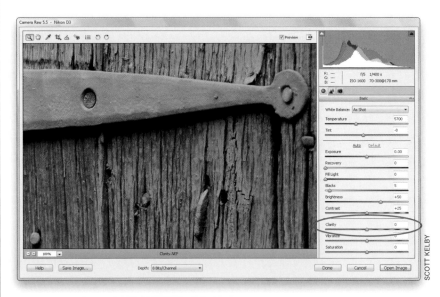

Step Two:
Using the Clarity control couldn't be easier—drag the slider to the right to increase the amount of snap (midtone contrast) in your image (compare the top and bottom images shown here). Almost every image I process gets between +25 and +50 Clarity. If the image has lots of detail, like a cityscape, or a sweeping landscape shot, or something with lots of little details like a motorcycle, or the feathers of a bird, or really weathered wood, then I'll go as high as +75 to +80, as seen here. If the subject is of a softer nature, like a portrait of a child, then in that case, I don't generally apply any Clarity at all.

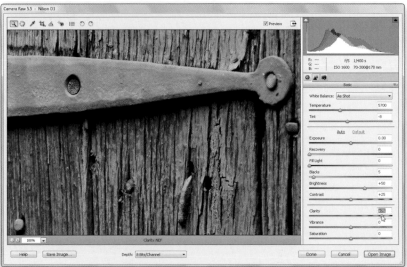

SCOTT KELBY

There are some distinct advantages to cropping your photo in Camera Raw, rather than in Elements itself, and perhaps the #1 benefit is that you can return to Camera Raw later and return to the uncropped image. (Here's one difference in how Camera Raw handles RAW photos vs. JPEG and TIFF photos: this "return to Camera Raw later and return to the uncropped image" holds true even for JPEG and TIFF photos, as long as you haven't overwritten the original JPEG or TIFF file. To avoid overwriting, when you save the JPEG or TIFF in Elements, change the filename.)

Cropping and Straightening

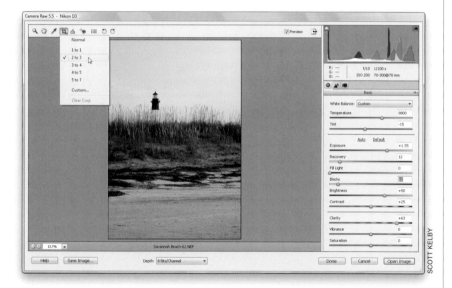

SCOTT KELBY

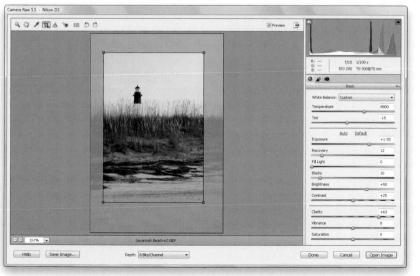

Step One:
The fourth tool in Camera Raw's toolbar is the Crop tool. By default, it pretty much works like the Crop tool in Elements (you click-and-drag it out around the area you want to keep), but it does offer some features that Elements doesn't—like access to a list of preset cropping ratios. To get them, click-and-hold on the Crop tool and a pop-up menu will appear (as shown here). The Normal setting gives you the standard drag-it-where-you-want-it cropping. However, if you choose one of the cropping presets, then your cropping is constrained to a specific ratio. For example, choose the 2-to-3 ratio, click-and-drag it out, and you'll see that it keeps the same aspect ratio as your original uncropped photo.

Step Two:
Here's the 2-to-3-ratio cropping border dragged out over my image. The area that will be cropped away appears dimmed, and the clear area inside the cropping border is how your final cropped photo will appear. If you reopen this RAW photo later and click on the Crop tool, the cropping border will still be visible onscreen, so you can move it, resize it, or remove it altogether by simply pressing the **Esc key** or the **Backspace (Mac: Delete) key** on your keyboard (or by choosing Clear Crop from the Crop tool's pop-up menu).

Continued

Step Three:

If you want your photo cropped to an exact size (like 8x10", 13x19", etc.), choose Custom from the Crop tool's pop-up menu. You can choose to crop by pixels, inches, centimeters, or a custom ratio. In our example, we're going to create a custom crop so our cropped photo winds up being exactly 8x10", so choose Inches from the pop-up menu (as shown here), then type in your custom size. Click OK, click-and-drag out the Crop tool, and the area inside your cropping border will be exactly 8x10".

Step Four:

Once you click on the Open Image button in Camera Raw, the image is cropped to your specs and opened in Elements (as shown here). If instead, you click on the Done button, Camera Raw closes and your photo is untouched, but it keeps your cropping border in position for the future.

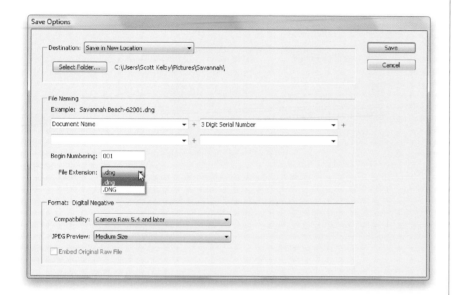

Step Five:
If you save a cropped JPEG or TIFF photo out of Camera Raw (by clicking on the Save Image button on the bottom left of the Camera Raw window), the only option is to save it as a DNG (Digital Negative) file. DNG files open in Camera Raw, so by doing this, you can bring back those cropped areas if you decide to change the crop.

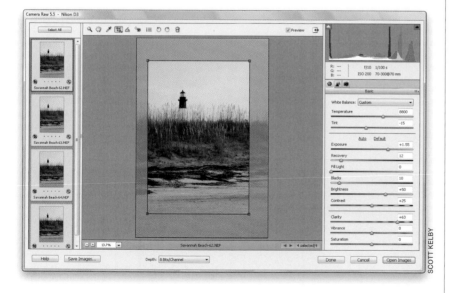

Step Six:
If you have a number of similar photos you need to crop the same way, you're going to love this: First, select all the photos you want to crop (either in the Organizer, in Bridge, or on your computer), then open them all in Camera Raw. When you open multiple photos, they appear in a vertical filmstrip along the left side of Camera Raw (as shown here). Click on the Select All button (it's above the filmstrip) and then crop the currently selected photo as you'd like. As you apply your cropping, look at the filmstrip and you'll see all the thumbnails update with their new cropping instructions. A tiny Crop icon will also appear in the bottom-left corner of each thumbnail, letting you know that these photos have been cropped in Camera Raw.

Continued

Step Seven:
Another form of cropping is actually straightening your photos using the Straighten tool. It's a close cousin of the Crop tool because what it does is essentially rotates your cropping border, so when you open the photo it's straight. In the Camera Raw toolbar, choose the Straighten tool (it's immediately to the right of the Crop tool, and shown circled here in red). Now, click-and-drag it along the horizon line in your photo (as shown here). When you release the mouse button, a cropping border appears and that border is automatically rotated to the exact amount needed to straighten the photo.

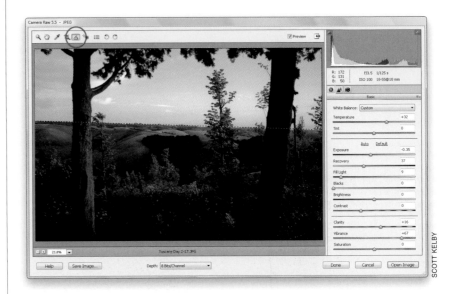

Step Eight:
You won't actually see the rotated photo until you click on another tool (which I've done here) or open it in Elements (which means, if you click Save Image or Done, Camera Raw closes, and the straightening information is saved along with the file. So if you open this file again in Camera Raw, that straightening crop border will still be in place). If you click Open Image instead, the photo opens in Elements, but only the area inside the cropping border is visible, and the rest is cropped off. Again, if this is a RAW photo (or you haven't overwritten your JPEG or TIFF file), you can always return to Camera Raw and remove this cropping border to get the original uncropped photo back.

TIP: Canceling Your Straightening
If you want to cancel your straightening, just press the **Esc key** on your keyboard, and the straightening border will go away.

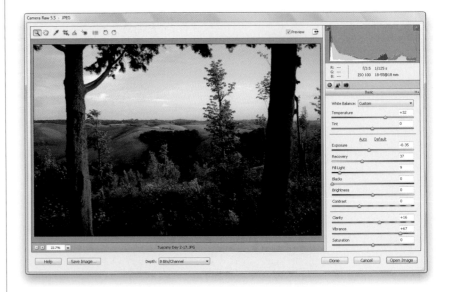

One of the coolest things about Camera Raw is the ability to apply changes to one photo, and then have those same changes applied to as many other similar images as you'd like. It's a form of built-in automation, and it can save an incredible amount of time in editing your shoots.

Editing Multiple Photos at Once

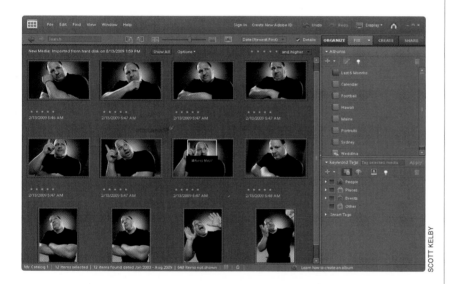

SCOTT KELBY

Step One:
Start off in the Organizer (Mac: Bridge) by selecting a group of photos that were shot in the same, or very similar, lighting conditions (click on one photo, press-and-hold the Ctrl [Mac: Command] key and click on the other photos), then open these images in Camera Raw (see the first tutorial in this chapter on how to open RAW, JPEG, and TIFF photos in Camera Raw).

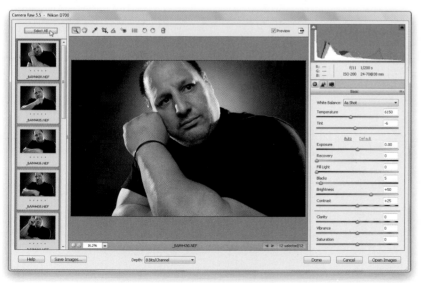

Step Two:
The selected photos will appear along the left side of the Camera Raw window. First, click on the photo you want to edit (this will be your target photo—the one all the adjustments will be based upon), then click the Select All button at the top left of the window to select all the other images (as shown here).

Continued

Step Three:

Go ahead and adjust the photo the way you'd like. In our example, I started by increasing the exposure a little bit, and raising the Recovery amount to tame the bright light on his cheek. You'll notice that the changes you make to the photo you selected first are being applied to all the photos in the Camera Raw filmstrip on the left (you can see their thumbnails update as you're making adjustments).

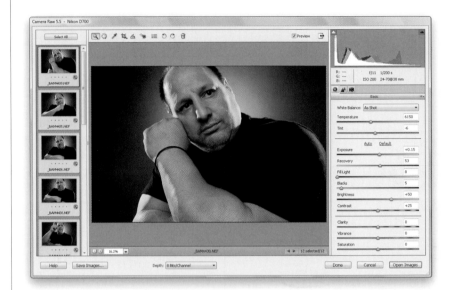

Step Four:

When you're done making adjustments, you have a choice to make: (a) if you click the Open Images button, all of your selected images will open in the Elements Editor (so if you're adjusting 120 images, you might want to give that some thought before clicking the Open Images button), or (b) you can just click the Done button, which applies all your changes to the images without opening them in Elements. So, your changes are applied to all the images, but you won't see those changes until you open the images later (I usually choose [b] when editing lots of images at once). That's it—how to make changes to one image and have it applied to a bunch of images at the same time.

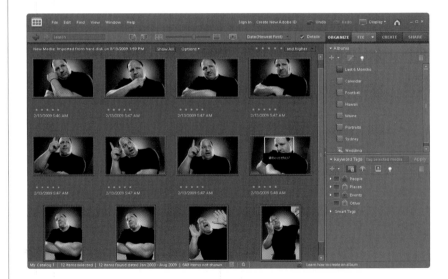

At this point in time, there's a concern with the RAW file format because there's not a single, universal format for RAW images—every digital camera manufacturer has its own. That may not seem like a problem, but what happens if one of these camera companies stops supporting a format or switches to something else? Seriously, what if a few years from now there was no easy way to open your saved RAW photos? Adobe recognized this problem and created the Digital Negative (DNG) format for long-term archival storage of RAW images.

Saving RAW Files in Adobe's Digital Negative (DNG) Format

SCOTT KELBY

Step One:
As of the writing of this book, only a few major camera manufacturers have built in the ability to save RAW files in Adobe's DNG format (although we believe it's only a matter of time before they all do); so if your camera doesn't support DNG files yet—no sweat—you can save your RAW files to Adobe DNG format from right within the Camera Raw window. Just open your image in Camera Raw and hit the Save Image button at the bottom left of the window. This brings up the Save Options dialog, which saves your RAW file to DNG by default.

Step Two:
At the bottom of this dialog, you have some additional DNG options: You can choose to embed the original RAW file into your DNG (making the file larger, but your original is embedded for safekeeping in case you ever need to extract it. If you have the hard disk [or CD] space, go for it!). There's a Compatibility option (you can save it for earlier versions of Camera Raw or choose Custom for compression options). You can also choose to include a JPEG preview. That's it—click Save and you've got a DNG archival-quality file that can be opened by Photoshop Elements (or the free DNG utility from Adobe).

Sharpening in Camera Raw

In Elements, we have pro-level sharpening within Camera Raw. So when do you sharpen here, and when in Elements? I generally sharpen my photos twice—once here in Camera Raw (called "capture sharpening"), and then once in Elements at the very end of my editing process, right before I save the final image for print or for the Web (called "output sharpening"). Here's how to do the capture sharpening part in Camera Raw:

Step One:
When you open a RAW image in Camera Raw, by default it applies a small amount of sharpening to your photo (not the JPEGs or TIFFs—only RAW images). You can adjust this amount (or turn if off altogether, if you like) by clicking on the Detail icon, as shown here, or using the keyboard shortcut **Ctrl-Alt-2 (Mac: Command-Option-2)**. At the top of this panel is the Sharpening section, where by a quick glance you can see that sharpening has already been applied to your RAW photo. If you don't want any sharpening applied at this stage (it's a personal preference), then simply click-and-drag the Amount slider all the way to the left, to lower the amount of sharpening to 0 (zero), and the sharpening is removed.

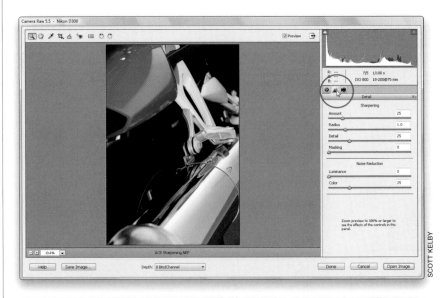

Step Two:
If you want to turn off this "automatic-by-default" sharpening (so image sharpening is only applied if you go and manually add it yourself), first set the Sharpening Amount slider to 0 (zero), then go to the Camera Raw flyout menu and choose Save New Camera Raw Defaults (as shown here). Now, RAW images taken with that camera will not be automatically sharpened.

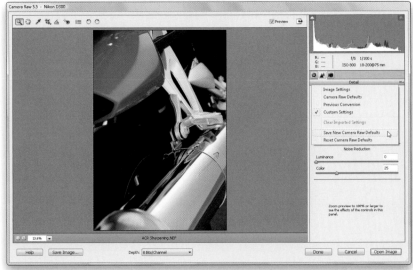

SCOTT KELBY

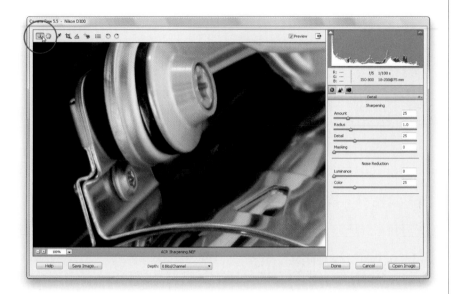

Step Three:
This may seem kind of obvious (since it tells you this right at the bottom of the Detail panel, as seen in Step Two), but so many people miss this that I feel it's worth repeating: before you do any sharpening, you need to view your image at a 100% size view, so you can see the sharpening being applied. A quick way to get to a 100% size view is simply to double-click directly on the Zoom tool (the one that looks like a magnifying glass) up in Camera Raw's toolbar. This zooms you right to 100% (you can double-click on the Hand tool later to return to the normal Fit in Window view).

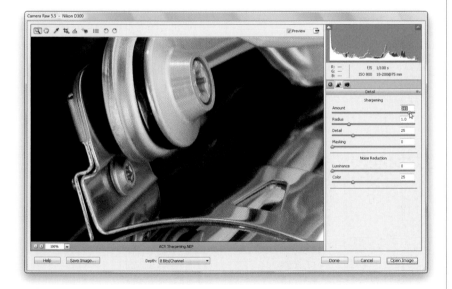

Step Four:
Now that you're at a 100% view, just for kicks, drag the Amount slider all the way to the right so you can see the sharpening at work (then drag it back to its default of 25). Again, dipping into the realm of the painfully obvious, dragging the Amount slider to the right increases the amount of sharpening. Compare the image shown here, with the one in Step Three (where the Sharpening Amount was set to the default of 25), and you can see how much sharper the image now appears, since I dragged it to 141.

TIP: Switch to Full Screen
To have Camera Raw expand to fill your entire screen, click the Full Screen icon to the right of the Preview checkbox, at the top of the window.

Continued

Step Five:

The next slider down is the Radius slider, which determines how far out the sharpening is applied from the edges being sharpened in your photo. I leave my Radius set at 1 most of the time. I use less than a Radius of 1 if the photo I'm processing is only going to be used on a website, in video editing, or something where it's going to be at a very small size or resolution. I only use a Radius of more than 1 when the image is visibly blurry and needs some "emergency" sharpening. If you decide to increase the Radius amount above 1 (unlike the Unsharp Mask filter, you can only go as high as 3 here), just be careful, because your photo can start to look oversharpened. You want your photo to look sharp, not sharpened, so be careful out there.

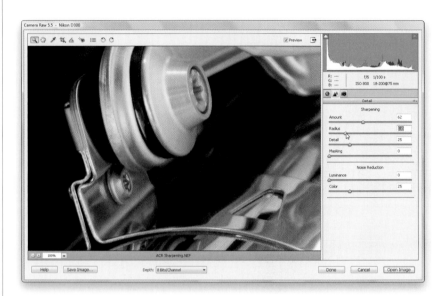

Step Six:

The next slider down is the Detail slider, which is kind of the "halo avoidance" slider (halos occur when you oversharpen an image and it looks like there's a little halo, or line, traced around your subject or objects in your image, and they look pretty bad). The default setting of 25 is good, but you would raise the Detail amount (dragging it to the right) when you have shots with lots of tiny important detail, like in landscape or architectural photos. Otherwise, I leave it as is. By the way, if you want to see the effect of the Detail slider, make sure you're at a 100% view, then press-and-hold the Alt (Mac: Option) key, and you'll see your preview window turn gray (as shown here). As you drag the Detail slider to the right, you'll see the edges start to become more pronounced, because the farther you drag to the right, the less protection from halos you get (those edges are those halos starting to appear).

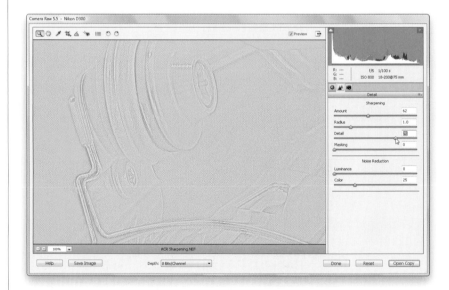

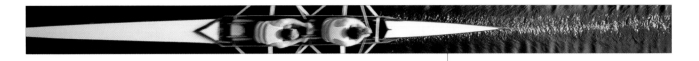

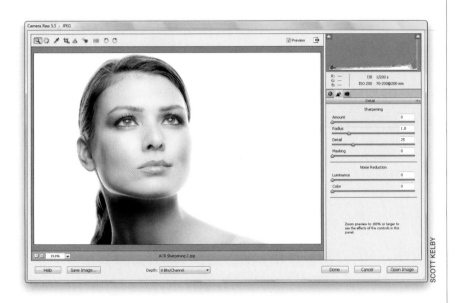

SCOTT KELBY

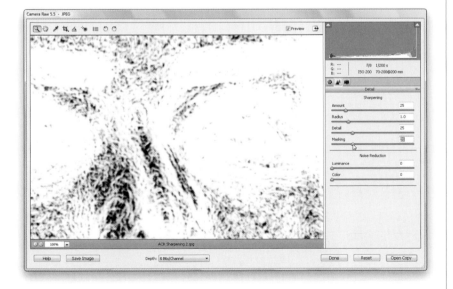

Step Seven:

The last Sharpening slider—Masking— is easier to understand, and for many people I think it will become invaluable. Here's why: generally speaking, sharpening gets applied to everything fairly evenly. But what if you have an image where there are areas you'd like sharpened, but other areas of softer detail you'd like left alone? For example, when sharpening portraits of women or children, you'd like their hair, eyes, teeth, etc., sharp, but their skin to remain soft, right? Well, that's kind of what the Masking slider here in Camera Raw does—as you drag it to the right, it reduces the amount of sharpening on non-edge areas (like the skin). So for portraits of women and children, I always raise the Masking amount quite a bit. I'm switching photos here to a portrait, so you can better see what I mean.

Step Eight:

For you to see the sharpening (and especially to be able to use another preview effect to see how the sharpening is being applied), you need to first zoom to a 100% view (remember that double-click-on-the-Zoom-tool trick?). Now that you're at 100%, here's the deal: the default Masking setting is 0 (zero), so sharpening is applied evenly to everything with an edge to be sharpened. As you drag to the right, the non-edge areas are masked (protected) from being sharpened. Seeing this visually will help, so press-and-hold the Alt (Mac: Option) key, and then drag the Masking slider to the right until it reads 25 (as shown here). You'll see that the preview window turns solid white at first (that means the sharpening is applied to everything), then some little areas start to turn black. Those black areas aren't being sharpened.

Continued

Step Nine:

Keep holding that Alt key down, then drag way over—to around 95—and you'll see most of the skin is turning black, and only the detail edge areas (like her eyes, eyelashes, etc.) are still solid white. So, in short, you'd drag far to the right for softer looking portraits. Here are the two settings I use most often for my Camera Raw sharpening:

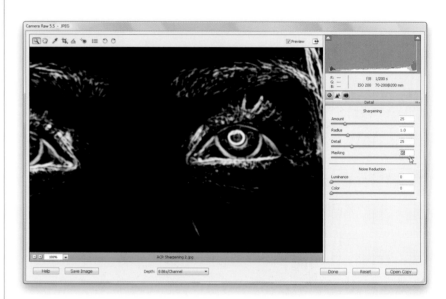

For Landscapes:
Amount: 40
Radius: 1
Detail: 50
Masking: 0

For Portraits:
Amount: 35
Radius: 1.2
Detail: 20
Masking: 70

Below is a before and after of our original shot (the motorcycle), with no sharpening applied (Before), and then with a nice crisp amount applied (After) using these settings—Amount: 70, Radius: 1, Detail: 40, Masking: 25.

Before

After

If you wind up shooting in low light (at night, indoors, at a concert, etc.), then you're probably used to cranking up your ISO to 800 or more, so you can hand-hold the shots, right? The downside of a high ISO is the same with digital as it was with film—the higher the ISO, the more visible the noise (those annoying red and green spots or splotchy patches of color), especially in shadows, and it gets even worse when you try to lighten them. Here's what you can do in Camera Raw to lessen the noise. (By the way, the answer is: not much.)

Camera Raw's Noise Reduction

CINDY SNYDER

Step One:

Open an image in Camera Raw that has a digital noise issue, and double-click on the Zoom tool to zoom in to 100%, so the noise is easily visible. There are two types of noise you can deal with in Camera Raw: (1) high ISO noise, which often happens when you're shooting in low-light situations using a high ISO setting (like the photo shown here); and (2) color noise, which can happen even in normal situations (this noise is more prevalent in some cameras than others). When you see this junk, click on the Detail icon (the middle one) and get to work.

Step Two:

To decrease color noise, drag the Noise Reduction Color slider to the right. It does a fair job of removing at least some of the color noise (the default setting of 25 for RAW files does a pretty decent job), though it does tend to desaturate your overall color just a bit. If the problem is mostly in shadow areas, then drag the Luminance slider to the right instead. Be careful, as it can tend to make your photo look a bit soft. Now, to be honest with you, Camera Raw's noise reduction is…well…it ain't great (that's being kind). I use an inexpensive Elements-compatible plug-in called Noiseware Professional (from Imagenomic) that works absolute miracles. It's really all I use for noise.

Removing Red Eye in Camera Raw

Camera Raw has its own built-in Red Eye Removal tool, and there's a 50/50 chance it might actually work. Of course, my own experience has been a little less than that (more like 40/60), but hey—that's just me. Anyway, if it were me, I'd probably be more inclined to use the regular Red Eye tool in Elements itself, which actually works fairly well, but if you're charging by the hour, this might be a fun place to start. Here's how to use this tool, which periodically works for some people, somewhere. On occasion. Perhaps.

Step One:
Open a photo in Camera Raw that has the dreaded red eye (like the one shown here). To get the Red Eye Removal tool, you can press the letter **E** or just click on its icon up in Camera Raw's toolbar (as shown here).

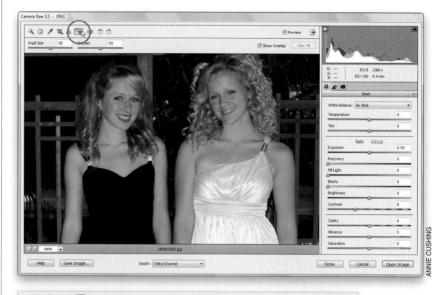

ANNIE CUSHING

Step Two:
You'll want to zoom in close enough so you can see the red-eye area pretty easily (as I have here, where I just simply zoomed to 300%, using the zoom level pop-up menu in the bottom-left corner of the Camera Raw window). The way this tool works is pretty simple—you click-and-drag the tool over one eye (as shown here) and as you drag, it makes a box over the eye (seen here). That tells Camera Raw where the red eye is located.

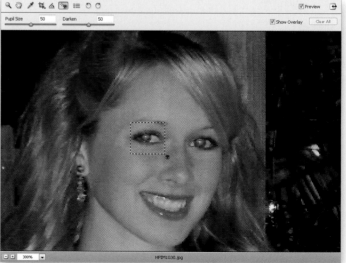

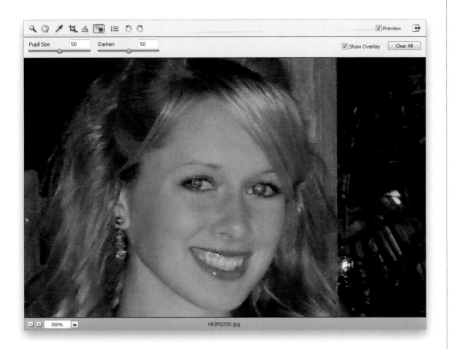

Step Three:
When you release the mouse button, theoretically it should snap down right around the pupil, making a perfect selection around the area affected by red eye (as seen here). You'll notice the key word here is "theoretically." In our real example, it worked just fine, but if it does not work for you, then press **Ctrl-Z (Mac: Command-Z)** to undo that attempt, and try again. Before you do, try to help the tool along by increasing the Pupil Size setting (in the options section) to around 100.

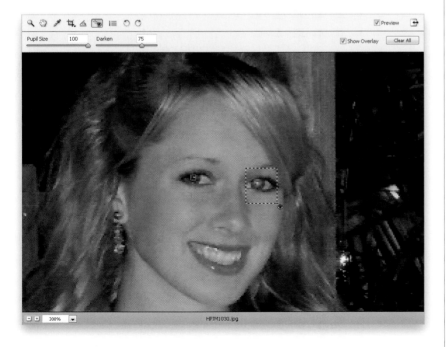

Step Four:
Once that eye looks good, go over to the other eye, drag out that selection again (as shown here), and it does the same thing (the before and after are shown on the next page). One last thing: if the pupil looks too gray after being fixed, then drag the Darken amount to the right (as I have here). Give it a try on a photo of your own. It's possible it might work.

Continued

Before

After

As good as today's digital cameras are, there are still some scenes they can't accurately expose for (like backlit situations, for example). Even though the human eye automatically adjusts for these situations, your camera is either going to give you a perfectly exposed sky with a foreground that's too dark, or vice versa. Well, there's a very cool trick (called double processing) that lets you create two versions of the same photo (one exposed for the foreground, one exposed for the sky), and then you combine the two to create an image beyond what your camera can capture!

The Trick for Expanding the Range of Your Photos

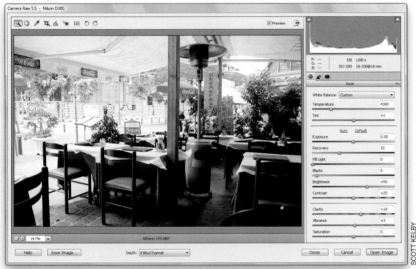

SCOTT KELBY

Step One:
Open an image with an exposure problem in Camera Raw. In our example, the camera properly exposed for the tables, so the bright light outside the awning is totally blown out. Of course, or goal is to create something our camera can't—a photo where both the inside and outside are exposed properly. You can tweak the white balance, recovery, fill light, etc., a little (as I did here), then just click Open Image to create the first version of your photo.

Step Two:
In the Editor, go under the File menu, choose Save As, and rename and save this adjusted image. Then go back under the File menu, and under Open Recently Edited File, choose the same photo you just opened. It will reopen in Camera Raw. The next step is to create a second version of this image that exposes for the background outside the awning, even though it will blow out everything inside.

Continued

Step Three:

Drag the Exposure slider way over to the left, until you can see more detail outside the awning. Here, I dragged to –1.00, and you can see the buildings and fencing. When it looks good to you, click the Open Image button to open this version of the photo in the Elements Editor.

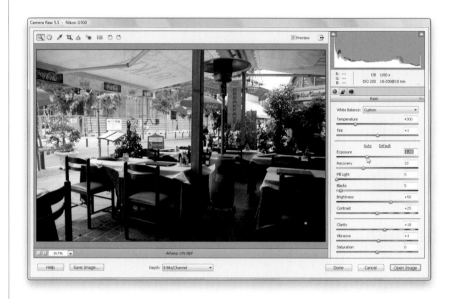

Step Four:

Now you should have both versions of the image open in the Elements Editor: one exposed for the tables under the awning and one exposed for the background outside the awning. Arrange the image windows so you can see both onscreen at the same time (with the darker photo in front). Press **V** to get the Move tool, press-and-hold the Shift key, and drag-and-drop the darker version on top of the good tables exposure version. The key to this part is holding down the Shift key while you drag between documents, which perfectly aligns the darker image (that now appears on its own layer in the Layers palette) with the brighter version on the Background layer. (This exact alignment of one identical photo over another is referred to as being "pin-registered.") You can now close the darker document without saving, as both versions of the image are contained within one document.

Step Five:

Go to the Layers palette, press-and-hold the Ctrl (Mac: Command) key, and click on the Create a New Layer icon at the bottom. This creates a new blank layer directly beneath the photo exposed for the view outside the awning. Now, in the Layers palette, click on the photo exposed for the outside view (it should be the top layer), and then press **Ctrl-G (Mac: Command-G)**. This groups your image with the blank layer, creating a clipping mask and covering it so you now only see the version of the photo that's exposed for the tables (which is on the Background layer).

Step Six:

It's time to "reveal" the view outside the awning on the darker version of the photo. Here's how: First, in the Layers palette, click on the blank layer between the two image layers. Then press the letter **B** to get the Brush tool, and click on the down-facing arrow next to the Brush thumbnail in the Options Bar. Choose a medium-sized, soft-edged brush from the Brush Picker that appears. Press the letter **D** to set your Foreground color to black, and start painting over the areas of the photo that you want to be darker (in this case, everything outside the awning). As you paint, the street is revealed. Just be careful not to paint over the supports, tables, etc. (*Note:* If you make a mistake, press **E** to switch to the Eraser tool and begin erasing.)

Continued

Step Seven:
Continue painting in black over the areas that you want to be darker. You may need to make your brush smaller (or larger) as you paint—just press the **Left Bracket key ([)** to make your brush smaller and the **Right Bracket key (])** to make it larger. If the area you just painted in looks too dark, simply click on the top layer in the Layers palette, and lower the Opacity of the layer until it looks right. Below are a before and after showing the double-processing effect.

Before

After

One of the easiest ways to make great black-and-white photos (from your color images) is to do your conversion completely within Camera Raw. You're basically just a few sliders away from a stunning black-and-white photo, and then all you have left to do is finish off the image by opening it in Photoshop Elements and adding some sharpening. Here's how it's done:

Black & White Conversions in Camera Raw

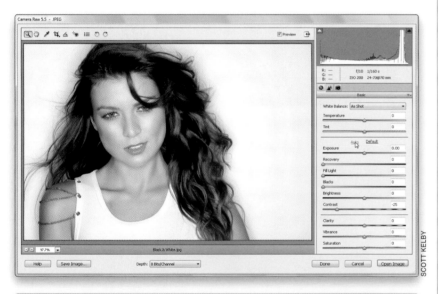

SCOTT KELBY

Step One:

Start by opening a photo you want to convert to black and white. This is one of the rare times I start by clicking the Auto button (you know, the button beneath the Tint slider that looks like a Web link), because it usually pumps up the exposure about as high as it can go without too much clipping (if any). So, start there—click the Auto button. Here, it adjusted the Contrast setting.

Step Two:

Now we're going to work from the bottom of the Basic panel up. The next step in converting to black and white is to remove the color from the photo. Go to the Saturation slider and drag it all the way to the left. Although this removes all the color, it usually makes for a pretty flat-looking (read as: lame) black-and-white photo. Now go up two sliders to the Clarity slider and drag it over quite a bit to the right to really make the midtones snap (I dragged over to +91).

Continued

Step Three:

Now you're going to add extra con-trast by (you guessed it) dragging the Contrast slider to the right until the photo gets real contrasty (as shown here). It's important that you set this slider first—before you set the Blacks slider—or you'll wind up setting the blacks, then adjusting the contrast, and then lowering the Blacks slider back down. That's because what the Contrast slider essentially does is makes the darkest parts of the photo darker, and the brightest parts brighter. If the blacks are already very dark, then you add contrast, it makes them too dark, and you wind up backing them off again. So, save yourself the extra step and set the contrast first.

Step Four:

Lastly, drag the Brightness slider to 0, then go to the Blacks slider and drag it to the right until you get very rich-looking shadows. One of the character-istics of great black-and-white prints is that they have deep, rich blacks and bright, crisp whites, so don't be shy when you're dragging this slider to the right. Now head up to the Exposure slider and drag it a ways over to the right until the highlights lighten up a bit. That's it—the quickest way to convert to black and white (and get a nice high-contrast look) right within Camera Raw.

TIP: Change the White Balance

Another thing you might try for RAW images is going through each of the White Balance presets (in the White Balance pop-up menu) to see how they affect your black-and-white photo. You'll be amazed at how this little change can pay off (make sure you try Fluorescent and Tungsten—they often look great in black and white).

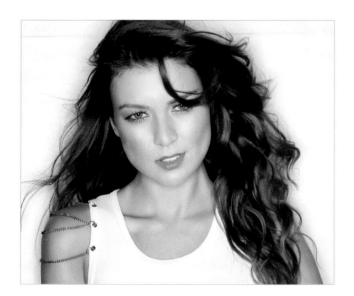

Before

After

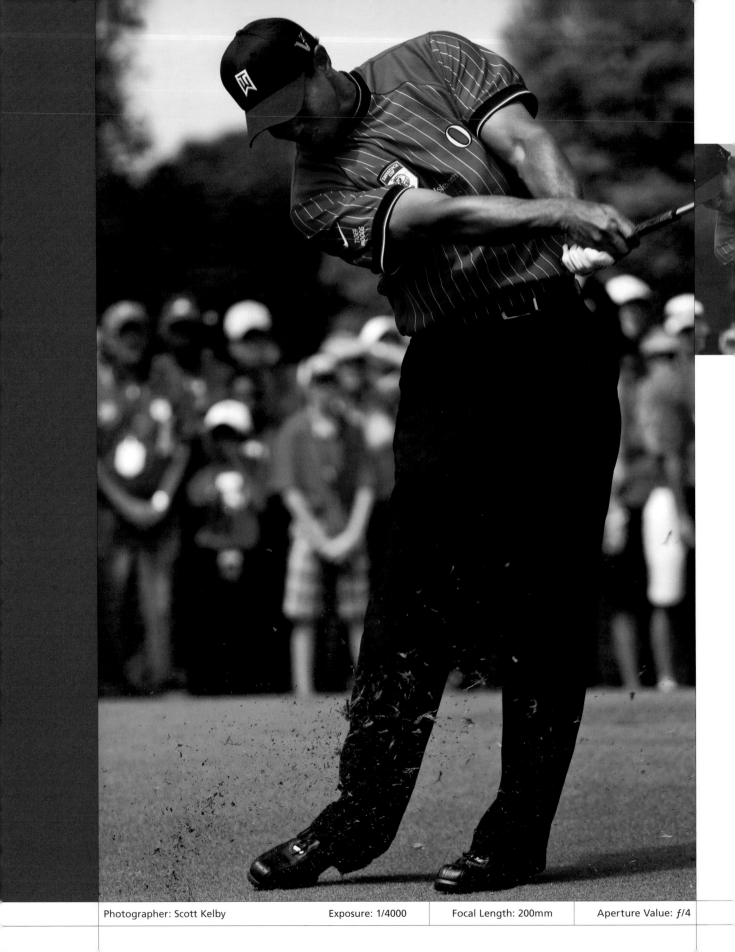

Photographer: Scott Kelby Exposure: 1/4000 Focal Length: 200mm Aperture Value: ƒ/4

Resized
resizing and cropping your images

I could only find one song with the title "Resized," and I think it's a perfect fit for a chapter on resizing and cropping your photos. The song is by a band called Bungle and this particular song features Laura Pacheco. It's from their album *Down to Earth*. I'm telling you this like you're going to go and buy the CD, but trust me—you're not. That's because I'm going to try and talk you out of doing just that. Here's why: the full-length song is six minutes and 19 seconds. After hearing just the free 30-second preview of it on Apple's iTunes Store, I imagine there are some people (not you, mind you, but some people) who might become somehow adversely affected by its super-fast-paced hypnotic beat and might do things that they might not normally do while listening to selections from the Eagles or James Taylor.

In fact, I would advise against even listening to the 30-second free preview if any of these conditions are present: (1) it's late at night and you have all the lights out, (2) the lights are out and you have a strobe light flashing, (3) the lights are out, a strobe is flashing, and you're holding a large butcher knife, or (4) the lights are out, a strobe is flashing, you're holding a large butcher knife, and you've just been fired from your job. "Resized" would make a great background track for *House of the Dead VII*, because it's not one of those gloomy Metallica songs—it actually has a fast pop-like beat, but at the same time, it makes you want to grab a butcher knife (not me, of course, and certainly not you, but you know… people like that one really quiet guy who works in accounting. I'd keep him away from that song. Especially if he ever gets fired).

Cropping Photos

After you've sorted your images in the Organizer or Bridge, one of the first editing tasks you'll probably undertake is cropping a photo. There are a number of different ways to crop a photo in Elements. We'll start with the basic garden-variety options, and then we'll look at some ways to make the task faster and easier.

Step One:
Open the image you want to crop in the Elements Editor, and then press the letter **C** to get the Crop tool (you could always select the tool directly from the Toolbox, but I only recommend doing so if you're charging by the hour).

Step Two:
Click within your photo and drag out a cropping border. The area to be cropped away will appear dimmed (shaded). You don't have to worry about getting your cropping border right when you first drag it out, because you can edit it by dragging the control handles that appear in each corner and at the center of each side.

TIP: Turn Off the Shading
If you don't like seeing your photo with the cropped-away areas appearing shaded (as in the previous step), you can toggle this shading feature off/on by pressing the **Forward Slash key (/)** on your keyboard. When you press the Forward Slash key, the border remains in place but the shading is turned off.

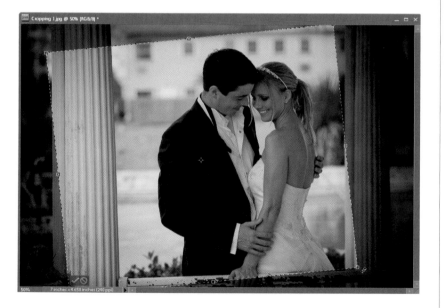

Step Three:
While you have the cropping border in place, you can rotate the entire border. Just move your cursor outside the border, and your cursor will change into a double-headed arrow. Then, click-and-drag, and the cropping border will rotate in the direction that you drag. (This is a great way to save time if you have a crooked image, because it lets you crop and rotate at the same time.)

Continued

Step Four:
Once you have the cropping border where you want it, click on the green checkmark icon at the bottom corner of your cropping border, or just press the **Enter (Mac: Return) key** on your keyboard. To cancel your crop, click the red international symbol for "No Way!" at the bottom corner of the cropping border, or press the **Esc key** on your keyboard.

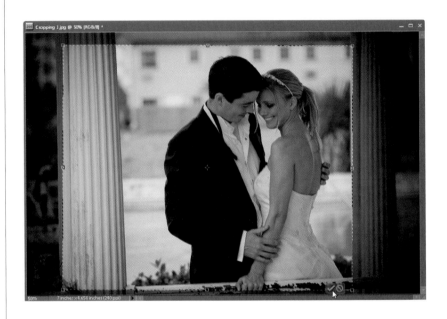

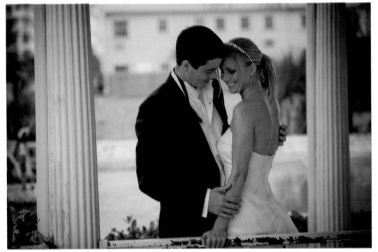

Before

After

The "rule of thirds" is a trick that photographers sometimes use to create more interesting compositions. Basically, you visually divide the image you see in your camera's viewfinder into thirds, and then you position your horizon so it goes along either the top imaginary horizontal line or the bottom one. Then, you position the subject (or focal point) at the center intersections of those lines. But if you didn't use the rule in the viewfinder—no sweat! Here's how to crop your image using the rule of thirds to create more appealing compositions in Elements:

Cropping Using the "Rule of Thirds"

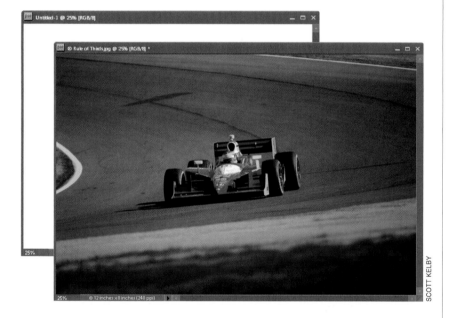

Step One:
Open the photo to which you want to apply the rule-of-thirds cropping technique (the shot here is poorly composed, with the race car smack dab in the center of the image—it just screams "snapshot!"). Since this is a cropping technique, you realize that the dimensions of your photo are going to get smaller, right? Good. So create a new document that is somewhat smaller than the photo you want, but using the same resolution and color mode (this is very important, otherwise your image won't fit properly in this new document). In the example here, my original photo is about 12x8", so the new document I created is only 9x7"; that way, there's room to play with my cropping (you'll see how in just a moment).

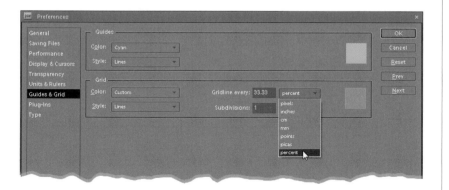

Step Two:
While your new document is active, go under the Edit menu (on a Mac, go under the Photoshop Elements menu), under Preferences, and choose Guides & Grid. In the resulting dialog, in the Grid section, enter 33.33 in the Gridline Every field, and then choose Percent from the pop-up menu on the right. In the Subdivisions field, change the default setting of 4 to just 1, and then click OK. You won't see anything in your document yet.

Continued

Step Three:

Go under the View menu and choose Grid. When you do this, the nonprinting grid you created in the previous step (the one divided into horizontal and vertical thirds) will appear in your image area as a visual representation of the rule-of-thirds grid, which you'll use for visual composition cropping.

Step Four:

Return to your image document, press **V** to switch to the Move tool, and click-and-drag your image onto your blank document. Here's where you create a better composition: Using the Move tool, position your image's horizon along one of the horizontal grid lines (here I used the back of the race car and the top line), and be sure your focal point (the race car, in this case) falls on one of the intersecting points (the top-right intersection, in this example). Because your image is larger than the new document, you have plenty of room to position your photo.

Step Five:

You can now crop away the sides of your image. Press the letter **C** to switch to the Crop tool and click-and-drag around your entire image. With your cropping border in place, press **Enter (Mac: Return)** to complete your crop. Now just hide the grid lines by returning to the View menu and deselecting Grid—then enjoy your new, cropped image.

Before

After

Auto-Cropping to Standard Sizes

If you're outputting photos for clients, chances are they're going to want them in standard sizes so they can easily find frames to fit. If that's the case, here's how to crop your photos to a predetermined size (like a 5x7", 8x10", etc.):

Step One:
Open an image in the Elements Editor that you want to crop to be a perfect 5x7" for a vertical image, or 7x5" if your image is horizontal. Press **C** to get the Crop tool, then go to the Options Bar, and from the Aspect Ratio pop-up menu, click on the words "No Restriction." When the list of preset crop sizes appears, click on 5x7 in.

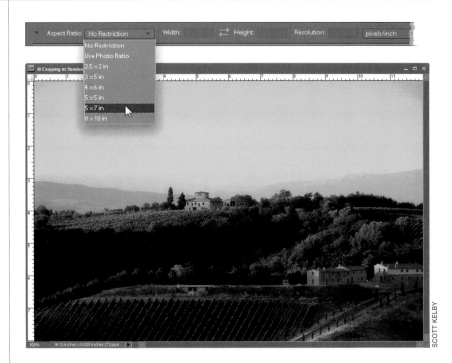

TIP: Swapping Fields
The Width and Height fields are populated based on the type of image you open—7x5" for horizontal images and 5x7" for vertical images. If you opened a horizontal image, but your crop is going to be vertical (tall), you'll need to swap the figures in the Width and Height fields by clicking on the Swaps icon between the fields in the Options Bar (as shown here).

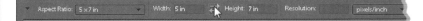

Step Two:
Now click-and-drag the Crop tool over the portion of the photo that you want to be 7x5" (or if your image is vertical, Elements will automatically adjust your border to 5x7"). While dragging, you can press-and-hold the Spacebar to adjust the position of your border.

Step Three:
Once it's set, press the **Enter (Mac: Return) key** and the area inside your cropping border will become 7x5"(as shown here).

Cropping to an Exact Custom Size

Okay, now you know how to crop to Elements' built-in preset sizes, but how do you crop to a nonstandard size—a custom size that you determine? Here's how:

Step One:
Open the photo that you want to crop in the Elements Editor. (I want to crop this image to 8x6".) First, press **C** to get the Crop tool. In the Options Bar, you'll see fields for Width and Height. Enter the size you want for Width, followed by the unit of measure you want to use (e.g., enter "in" for inches, "px" for pixels, "cm" for centimeters, "mm" for millimeters, etc.). Next, press the **Tab key** to jump over to the Height field and enter your desired height, again followed by the unit of measure.

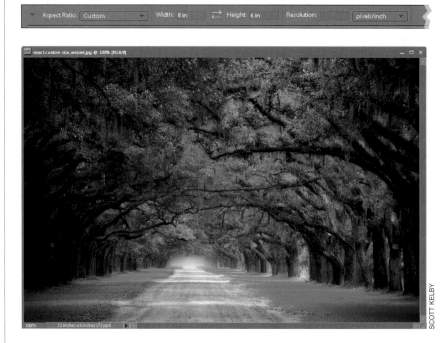

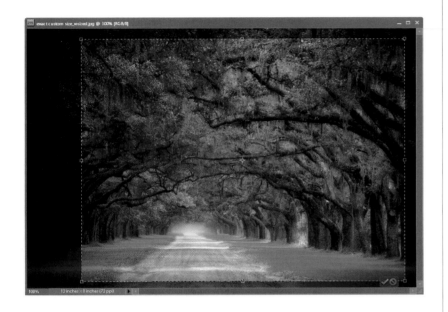

Step Two:

Once you've entered these figures in the Options Bar, click within your photo with the Crop tool and drag out a cropping border. You'll notice that as you drag, the border is constrained to an 8x6" aspect ratio; no matter how large of an area you select within your image, the area within that border will become your specified size. When you release your mouse button, you'll still have both side handles and corner handles visible, but the side handles will act like corner handles to keep your size constrained.

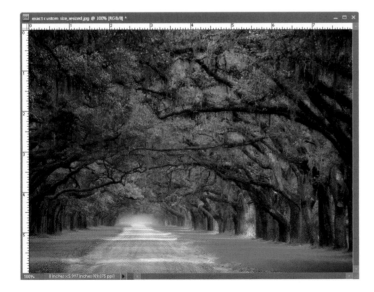

Step Three:

Once your cropping border is onscreen, you can resize it using the corner handles or you can reposition it by moving your cursor inside the border. Your cursor will change to a Move arrow, and you can now click-and-drag the border into place. You can also use the **Arrow keys** on your keyboard for more precise control. When it looks right to you, press **Enter (Mac: Return)** to finalize your crop or click on the checkmark icon in the bottom-right corner of your cropping border. Here, I made the rulers visible **(Ctrl-Shift-R [Mac: Command-Shift-R])** so you could see that the image measures exactly 8x6".

Continued

TIP: Clearing the Fields

Once you've entered a Width and Height in the Options Bar, those dimensions will remain there. To clear the fields, just choose No Restriction from the Aspect Ratio pop-up menu. This will clear the Width and Height fields, and now you can use the Crop tool for freeform cropping (you can drag it in any direction—it's no longer constrained to your specified size).

COOLER TIP: Changing Dimensions

If you already have a cropping border in place, you can change your dimensions without re-creating the border. All you have to do is enter the new sizes you want in the Width and Height fields in the Options Bar, and Elements will resize your cropping border.

Before

After

Elements has a cool feature that lets you crop your photo into a pre-designed shape (like putting a wedding photo into a heart shape), but even cooler are the edge effects you can create by cropping into one of the pre-designed edge effects that look like old Polaroid transfers. Here's how to put this feature to use to add visual interest to your own photos (of course, you can use the heart shape and do the whole wedding photo thing, but that's so "five-minutes-ago").

Cropping into a Shape

Step One:
In the Elements Editor, open the photo you want to crop into a pre-designed shape, and press the letter **Q** to get the Cookie Cutter tool.

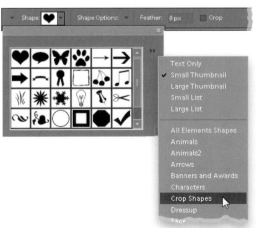

Step Two:
Now, go up to the Options Bar and click on the down-facing arrow to the right of the Shape thumbnail. This brings up the Custom Shape Picker, which contains the default set of 30 shapes. To load more shapes, click on the right-facing arrows at the top right of the Picker and a list of built-in shape sets will appear. From this list, choose Crop Shapes to load the edge-effect shapes, which automatically crop away areas outside your custom edges.

Continued

Step Three:
Once you select the custom edge shape you want to use in the Custom Shape Picker, just click-and-drag it over your image to the size you want it. When you release the mouse button, your photo is cropped to fit within the shape. *Note:* I like Crop Shape 10 (which is shown here) for something simple, and Crop Shape 20 for something a little wilder. The key thing here is to experiment and try different crop shapes to find your favorite.

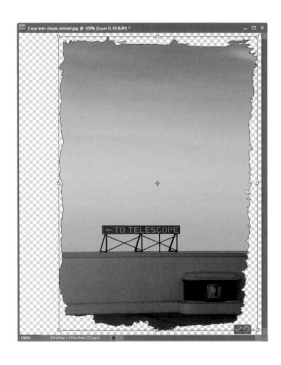

Step Four:
You'll see a bounding box around the shape, which you can use to resize, rotate, or otherwise mess with your shape. To resize your shape, press-and-hold the Shift key (or turn on the Constrain Proportions checkbox in the Options Bar) to keep it proportional while you drag a corner handle. To rotate the shape, move your cursor outside the bounding box until your cursor becomes a double-sided arrow, and then click-and-drag. As long as you see that bounding box, you can still edit the shape. When it looks good to you, press **Enter (Mac: Return)** and the parts of your photo outside that shape will be permanently cropped away.

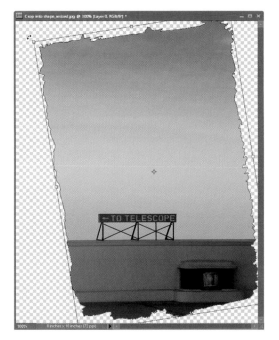

TIP: Tightly Crop Your Image
If you want your image area tightly cropped, so it's the exact size of the shape you drag out, just turn on the Cookie Cutter's Crop checkbox (up in the Options Bar) before you drag out your shape. Then when you press Enter to lock in your final shape, Elements will tightly crop the entire image area to the size of your shape. *Note:* The checkerboard pattern you see around the photo is letting you know that the background around the shape is transparent. If you want a white background behind the shape, click on the Create a New Layer icon at the bottom of the Layers palette, and then drag your new layer below the Shape layer. Press **D**, then **X** to set your Foreground to white, then press **Alt-Backspace (Mac: Option-Delete)** to fill this layer with white.

Before

After

Using the Crop Tool to Add More Canvas Area

I know the heading for this technique doesn't make much sense—"Using the Crop Tool to Add More Canvas Area." How can the Crop tool (which is designed to crop photos to smaller sizes) actually make the canvas area (white space) around your photo larger? That's what I'm going to show you.

Step One:
In the Elements Editor, open the image to which you want to add additional blank canvas area. Press the letter **D** to set your Background color to its default white.

Step Two:
If you're in Maximize Mode or tabbed viewing, press **Ctrl-–** (minus sign; **Mac: Command-–**) to zoom out a bit (so your image doesn't take up your whole screen). If your image window is floating, click-and-drag out the bottom corner of the document window to see the gray desktop area around your image. (To enter Maximize Mode, click the Maximize Mode icon in the top-right corner of the image window. To enter tabbed viewing, go under the Window menu, under Images, and choose Consolidate All to Tabs.)

Step Three:
Press the letter **C** to switch to the Crop tool and drag out a cropping border to any random size (it doesn't matter how big or little it is at this point).

Step Four:
Now, grab any one of the side or corner handles and drag outside the image area, out into the gray area that surrounds your image. The cropping border extending outside the image is the area that will be added as white canvas space, so position it where you want to add the blank canvas space.

Step Five:
Now, just press the **Enter (Mac: Return) key** to finalize your crop, and when you do, the area outside your image will become white canvas area.

Auto-Cropping Gang-Scanned Photos

A lot of photographers scan photos using a technique called "gang scanning." That's a fancy name for scanning more than one picture at a time. Scanning three or four photos at once with your scanner saves time, but then you eventually have to separate these photos into individual documents. Here's how to have Elements do that for you automatically:

Step One:
Place the photos you want to "gang scan" on the bed of your flatbed scanner, and scan the images into Elements using the Organizer on a PC or using your scanner's software on a Mac (they should appear in one Elements document). In the Organizer, you can scan the images by going under the File menu, under Get Photos and Videos, and choosing From Scanner. In the dialog that appears, select where and at what quality you want to save your scanned document.

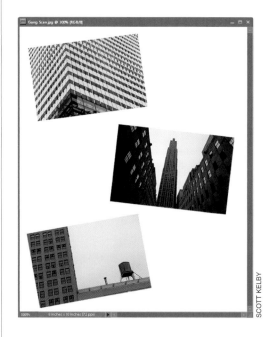

SCOTT KELBY

Step Two:
Once your images appear as one document in the Editor, go under the Image menu and choose Divide Scanned Photos. It will immediately find the edges of the scanned photos, straighten them if necessary, and then put each photo into its own separate document. Once it has "done its thing," you can close the original gang-scanned document, and you'll be left with just the individual documents.

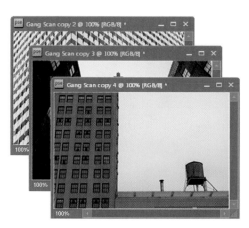

Straightening Photos with the Straighten Tool

In Elements, there's a simple way to straighten photos, but it's knowing how to set the options for the tool that makes your job dramatically easier. Here's how it's done:

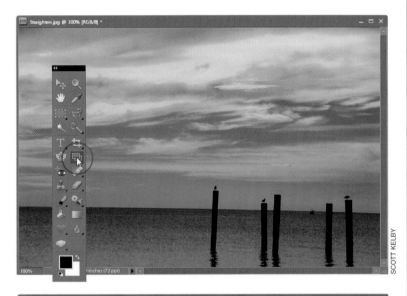

SCOTT KELBY

Step One:
Open the photo that needs straightening (the photo shown here looks like the horizon is sloping down to the right). Then, choose the Straighten tool from the Toolbox (or just press the **P key**).

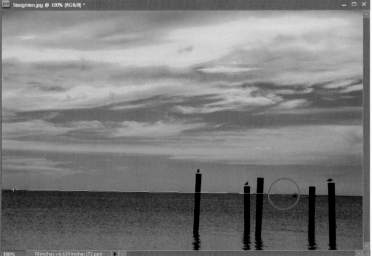

Step Two:
Take the Straighten tool and drag it along an edge in the photo that you think should be perfectly horizontal, like a horizon line (as shown here).

Continued

Step Three:

When you release the mouse button, the image is straightened, but as you see here, the straightening created a problem of its own—the photo now has to be re-cropped because the edges are showing a white background (as the image was rotated until it was straight). That's where the options (which I mentioned in the intro to this technique) come in. You see, the default setting does just what you see here—it rotates the image and leaves it up to you to crop away the mess. However, Elements can do the work for you (as you'll see in the next step).

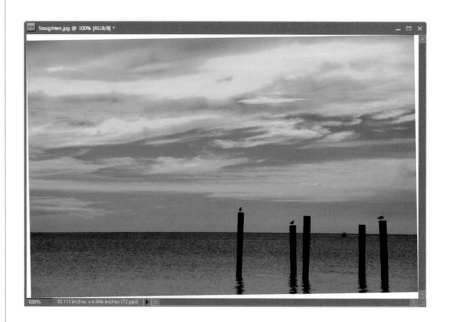

Step Four:

Once you click on the Straighten tool, go up to the Options Bar, and in the Canvas Options pop-up menu, choose Crop to Remove Background.

Step Five:

Now when you drag out the tool and release the mouse button, not only is the photo straightened, but the annoying white background is automatically cropped away, giving you the clean result you see here.

TIP: Straightening Vertically

In this example, we used the Straighten tool along a horizontal plane, but if you wanted to straighten the photo using a vertical object instead (like a column or light pole), just click with the Straighten tool, then press-and-hold the Ctrl (Mac: Command) key before you drag it, and that will do the trick.

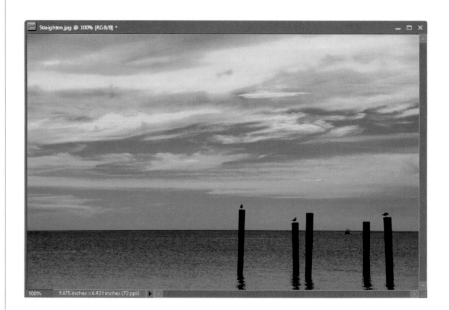

If you're more familiar with resizing scanned images, you'll find that resizing images from digital cameras is a bit different, primarily because scanners create high-resolution scans (usually 300 ppi or more), but the default setting for most digital cameras usually produces an image that is large in physical dimension, but lower in ppi (usually 72 ppi). The trick is to decrease the physical size of your digital camera image (and increase its resolution) without losing any quality in your photo. Here's the trick:

Resizing Digital Camera Photos

Step One:
Open the digital camera image that you want to resize. Press **Ctrl-Shift-R (Mac: Command-Shift-R)** to make Elements' rulers visible. Check out the rulers to see the approximate dimensions of your image. As you can see from the rulers in the example here, this photo is around 12x18".

Step Two:
Go under the Image menu, under Resize, and choose Image Size to bring up the Image Size dialog. Under the Document Size section, the Resolution setting is 72 pixels/inch (ppi). A resolution of 72 ppi is considered "low resolution" and is ideal for photos that will only be viewed onscreen (such as Web graphics, slide shows, etc.). This res is too low to get high-quality results from a color inkjet printer, color laser printer, or for use on a printing press.

Continued

Step Three:

If we plan to output this photo to any printing device, it's pretty clear that we'll need to increase the resolution to get good results. I wish we could just type in the resolution we'd like it to be in the Resolution field (such as 200 or 300 ppi), but unfortunately, this "resampling" makes our low-res photo appear soft (blurry) and pixelated. That's why we need to make sure the Resample Image checkbox is turned off (as shown here). That way, when we type in the setting that we need in the Resolution field, Elements automatically adjusts the Width and Height fields for the image in the exact same proportion. As your Width and Height decrease (with Resample Image turned off), your Resolution increases. Best of all, there's absolutely no loss of quality. Pretty cool!

Step Four:

Here I've turned off Resample Image, then I typed 150 in the Resolution field (for output to a color inkjet printer—I know, you probably think you need a lot more resolution, but you usually don't). At a resolution of only 150 ppi, I can actually print a photo that is almost 9 inches wide by almost 6 inches high.

Step Five:
Here's the Image Size dialog for my source photo, and this time I've increased the Resolution setting to 212 ppi (for output to a printing press; again, you don't need nearly as much resolution as you'd think). As you can see, the Width and Height fields for my image have changed.

Step Six:
When you click OK, you won't see the image window change at all—it will appear at the exact same size onscreen. But now look at the rulers—you can see that your image's dimensions have changed. Resizing using this technique does three big things: (1) It gets your physical dimensions down to size (the photo now fits on an 8x10" sheet); (2) it increases the resolution enough so you can even output this image on a printing press; and (3) you haven't softened or pixelated the image in any way—the quality remains the same—all because you turned off Resample Image. *Note:* Do not turn off Resample Image for images that you scan on a scanner—they start as high-res images in the first place. Turning off Resample Image is only for photos taken with a digital camera at a low resolution.

Resizing and How to Reach Those Hidden Free Transform Handles

What happens if you drag a large photo onto a smaller photo in Elements? (This happens all the time, especially if you're collaging or combining two or more photos.) You have to resize the photo using Free Transform, right? Right. But here's the catch—when you bring up Free Transform, at least two (or, more likely, all four) of the handles that you need to resize the image are out of reach. You see the center point, but not the handles you need to reach to resize. Here's how to get around that hurdle quickly and easily:

Step One:
Open two different-sized photos in the Elements Editor. Use the Move tool **(V)** to drag-and-drop the larger photo on top of the smaller one (if you're in tabbed viewing, drag one image onto the other image's thumbnail in the Project Bin). To resize a photo on a layer, press **Ctrl-T (Mac: Command-T)** to bring up the Free Transform command. Next, press-and-hold the Shift key to constrain your proportions (or turn on the Constrain Proportions checkbox in the Options Bar), grab one of the Free Transform corner handles, and (a) drag inward to shrink the photo, or (b) drag outward to increase its size (not more than 20%, to keep from making the photo look soft and pixelated). But wait, there's a problem. The problem is—you can't even see the Free Transform handles in this image.

Step Two:
To instantly have full access to all of Free Transform's handles, just press **Ctrl-0** (zero; **Mac: Command-0**), and Elements will instantly zoom out of your document window and surround your photo with gray desktop, making every handle well within reach. Try it once, and you'll use this trick again and again. *Note:* You must choose Free Transform first for this trick to work.

There is a different set of rules we use for maintaining as much quality as possible when making an image smaller, and there are a couple of different ways to do just that (we'll cover the two main ones here). Luckily, maintaining image quality is much easier when sizing down than when scaling up (in fact, photos often look dramatically better—and sharper—when scaled down, especially if you follow these guidelines).

Making Your Photos Smaller (Downsizing)

Downsizing photos where the resolution is already 300 ppi: Although earlier we discussed how to change image size if your digital camera gives you 72-ppi images with large physical dimensions (like 24x42" deep), what do you do if your camera gives you 300-ppi images at smaller physical dimensions (like a 10x6" at 300 ppi)? Basically, you turn on Resample Image (in the Image Size dialog, under the Image menu, under Resize), then simply type the desired size (in this example, we want a 4x6" final image size), and click OK (don't change the Resolution setting, just click OK). The image will be scaled down to size, and the resolution will remain at 300 ppi. IMPORTANT: When you scale down using this method, it's likely that the image will soften a little bit, so after scaling you'll want to apply the Unsharp Mask filter to bring back any sharpness lost in the resizing (look at the sharpening chapter [Chapter 10] to see what settings to use).

Continued

Making one photo smaller without shrinking the whole document:
If you're working with more than one image in the same document, you'll resize a bit differently. To scale down a photo on a layer, first click on that photo's layer in the Layers palette, then press **Ctrl-T (Mac: Command-T)** to bring up Free Transform. Press-and-hold the Shift key to keep the photo proportional (or turn on the Constrain Proportions checkbox in the Options Bar), grab a corner handle, and drag inward. When it looks good to you, press the **Enter (Mac: Return) key**. If the image looks softer after resizing it, apply the Unsharp Mask filter (again, see the sharpening chapter).

Resizing problems when dragging between documents:
This one gets a lot of people, because at first glance it just doesn't make sense. You have two documents, approximately the same size, side-by-side onscreen. But when you drag a 72-ppi photo (of a sunset, in this case) onto a 300-ppi document (Untitled-1), the photo appears really small. Why is that? Simply put: resolution. Although the documents appear to be the same size, they're not. The tip-off that you're not really seeing them at the same size is found in the title bar of each photo. For instance, the photo of the sunset is displayed at 100%, but the Untitled-1 document is displayed at only 25%. So, to get more predictable results, make sure both documents are at the same viewing size and resolution (check in the Image Size dialog under the Image menu, under Resize).

Elements has a pretty slick little utility that lets you take a folder full of images and do any (or all) of the following automatically at one time: (1) rename them; (2) resize them; (3) change their resolution; (4) color correct and sharpen them; and (5) save them in the file format of your choice (JPEG, TIFF, etc.). If you find yourself processing a lot of images, this can save a ton of time. Better yet, since the whole process is automated, you can teach someone else to do the processing for you, like your spouse, your child, a neighbor's child, passersby, local officials, etc.

Automated Saving and Resizing

Step One:
In the Elements Editor, go under the File menu and choose Process Multiple Files.

Step Two:
When the Process Multiple Files dialog opens, the first thing you have to do is choose the folder of photos you want to process by clicking on the Source Browse button in the first section of the dialog. Then navigate to the folder you want and click OK. If you already have some photos open in Elements, you can choose Opened Files from the Process Files From pop-up menu (or you can choose Import to import files). Then, in the Destination field, you decide whether you want the new copies to be saved in the same folder (by turning on the Same as Source checkbox), or copied into a different folder (in which case, click on the Destination Browse button and choose that folder).

Continued

Step Three:
The second section is File Naming. If you want your files automatically renamed when they're processed, turn on the Rename Files checkbox, then in the fields directly below that checkbox, type the name you want these new files to have and choose how you want the numbering to appear after the name (a two-digit number, three-digit, etc.). Then, choose the number with which you want to start numbering images. You'll see a preview of how your file naming will appear just below the Document Name field (shown circled here).

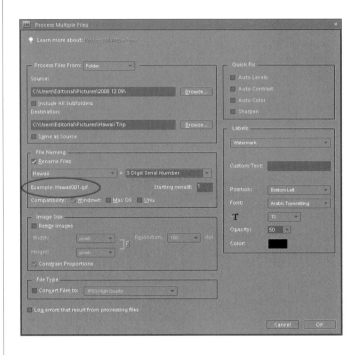

Step Four:
In the Image Size section, you decide if you want to resize the images (by turning on the Resize Images checkbox), and you enter the width and height you want for your finished photos. You can also choose to change the resolution. If you want to change their file type (like from RAW to JPEG High Quality), you choose that in the bottom section—File Type. Just turn on the Convert Files To checkbox, and then choose your format from the pop-up menu. On the top-right side of the dialog, there is a list of Quick Fix cosmetic changes you can make to these photos, as well, including Auto Levels (to adjust the overall color balance and contrast), Auto Contrast (this is kind of lame if you ask me), Auto Color (it's not bad), and Sharpen (it works well). Now, just click OK and Elements does its thing, totally automated based on the choices you made in this dialog. How cool is that!

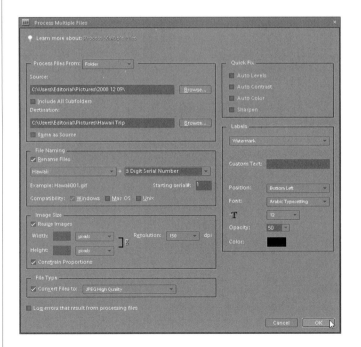

You really have to see this new feature in action but, in a nutshell, you can resize one part of your image, while the important parts stay intact. For example, let's say you took a photo of a motorcycle race that you want to print out as an 8x10. But when you go to print it, you realize you're going to have to crop it (since the 8x10 aspect ratio is not what your camera shoots in) and cut out a key part of the photo. With the Recompose tool, you can resize the background, without resizing the motorcycles. Like I said, you gotta see it in action.

Resizing Just Parts of Your Image Using the Recompose Tool

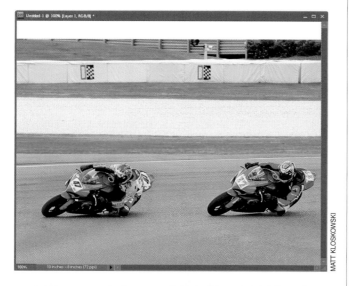

Step One:
One of the things I use the Recompose tool for most is making digital camera images fit in traditional photography sizes (like 8x10", 5x7", etc.). You always have to crop the image, or leave white space at the top and bottom, when resizing it to fit in one of these standard sizes (as shown here, where I dragged a digital camera image into an 8x10" document and then used Free Transform **[Ctrl-T; Mac: Command-T]** to position it). When you position it so you see the full image, it leaves a huge gap at the top.

Step Two:
Rather than leaving the gap, most folks try to just resize the photo (again, using Free Transform), so it fills the full 8x10" area, but you can see what happens when you do that—you no longer see the full image as you composed it. In our case—worse yet—it clips off part of the motorcycle on the right.

Continued

Step Three:
Since the resizing from Step Two doesn't work, we'll go back to what we did in Step One, which at least gives you the full image, as you shot it. You could try just stretching the image by, again, using Free Transform—when the resizing handles appear, grab the center handle and drag upward, as shown here—but that distorts everything and now you have a stretched-looking pair of motorcycles, so this really isn't an option for most images.

Step Four:
This is where the Recompose tool comes in handy. Select the Recompose tool from the Toolbox (it's nested with the Crop tool, or just press **C** until you have it). The way the tool works is you tell Elements which areas of the photo you want to make sure it preserves and which areas of the photo are okay to remove/squish/expand/get rid of. This is all done using the four tools at the left end of the Options Bar.

Step Five:

First, switch back over to your original image, then click on the Mark for Protection tool (the first icon on the left), and paint some loose squiggly lines over the areas of the photo you want to make sure Elements protects. These are the important areas that you don't want to see transformed in any way (here I painted over the motorcycles and parts of the background). If you make a mistake and paint on something you didn't want to, just use the tool's corresponding Erase tool to the right of the Mark for Protection tool.

Step Six:

Now you have to tell Elements what parts of the photo are okay to get rid of. Click on the Mark for Removal tool in the Options Bar (the third icon from the left) and paint some lines over the non-essential areas of the photo. No need to go crazy here, a couple of quick brush strokes does just fine.

Continued

Step Seven:
Click on the left-side handle and drag inward, until the Width setting in the top Options Bar reads 10 inches. You'll notice that it scrunches the space between the two motorcycles, but pretty much leaves the motorcycles intact, without squeezing or squishing them together. Now, if you keep dragging inward (beyond what we've dragged here), it will start dragging the motorcycles, so you can't just drag forever. Luckily, you see a live onscreen preview as you're dragging, so you'll know right away how far you can drag. Next, drag the top-middle handle downward until the Height setting in the Options Bar reads 8 inches. When you've dragged far enough, press the **Enter (Mac: Return) key** to lock in your change and you've got your 8x10. Now, let's look at another way to use the Recompose tool.

TIP: Use the Preset Pop-Up Menu
The Recompose tool has a Preset pop-up menu in the Options Bar, at the top of the window, with some common print sizes, so when you select one of them, it automatically recomposes your photo to that specific size.

©ISTOCKPHOTO/MIKE DABELL

Step Eight:

Since you can make the Recompose tool aware of your subject, you can use it in other ways. For example, let's say you wanted this couple on bicycles to be closer together (this could be for artistic reasons, or maybe you have a photo book or some other layout that needs a portrait [vertical] image instead of a landscape [horizontal] one). Choose the Mask for Protection tool in the Options Bar, and paint over the couple and their bicycles and on the right side of the photo. Then choose the Mark for Removal tool and paint between them. You'll notice that I also marked the tree to the right of the man for protection. Normally, I'd let Elements remove it, but since part of the man's body overlaps the tree, I marked it for protection, so half the tree doesn't get cut off.

Step Nine:

Now, click on the right-side handle and drag over toward the left to squeeze the photo, bringing the couple closer together. Again, Elements does a good job of removing the space between the couple without making them look like they were squished. As you can see, I can get away with plenty of squeezing here in this example, but even if you can't, I've got a trick for you in the next step.

Continued

TIP: Protecting Skin Tones

I wanted to point out another Recompose tool option and that is a button up in the Options Bar with a little person (shown circled here in red). You turn this Highlight Skintones option on when you have people in the photo you're about to resize and it tells the Recompose tool to automatically highlight people's skin tones for protection so they don't get, well, recomposed. Now, Elements will try to avoid those areas. It doesn't always work, but it usually helps.

Step 10:

Press **Enter (Mac: Return)** to lock in your recomposition, then press the **C key** to switch to the regular Crop tool, and crop away the excess background. Now, if you look closely enough, you'll see the Recompose tool made some of the branches in the tree look a little deformed, as well as the area on the dirt path between the couple. If this ever happens to you, don't feel like you have to abandon the Recompose tool altogether because of a small area. Instead, we can always try some of the retouching tools to clean that area up.

Step Eleven:

I think the Clone Stamp tool will work great here, so go ahead and select it from the Toolbox (or just press the **S key**). Now, Alt-click (Mac: Option-click) in a clear area next to the tree branch (that looks like it's emerging from nowhere) and sample from the background. Release the Alt key and paint over the branch to remove it. Do the same thing for the dirt path and grass right next to the bicycle wheel. You may need to Alt-click a few times and really zoom in while cloning, but you should be able to get rid of the deformed areas and clean things up pretty nicely. Now the couple looks really close and you've got more of a vertical image than a horizontal one.

Before

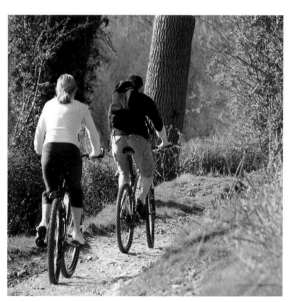

After

Photographer: Matt Kloskowski Exposure: 1/200 Focal Length: 18mm Aperture Value: ƒ/11

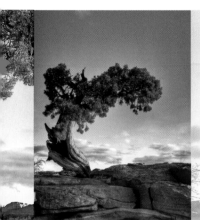

Color Me Badd
color correction for photographers

The subtitle for this chapter is "Color Correction for Photographers," which invites the question "How is color correction for photographers different from color correction for anybody else?" Actually, it's quite a bit different, because photographers generally work in RGB or black and white. And in reality, digital photographers mostly work in RGB because, although we can manage to build reusable spacecraft and have GPS satellites orbiting in space so golfers here on earth know how far it is from their golf cart to the green, for some reason creating a color inkjet printer that prints a decent black-and-white print is still apparently beyond our grasp. Don't get me started. Anyway, this chapter isn't entirely about black-and-white prints, and now that

I think about it, I'm sorry I brought it up in the first place. So forget I ever mentioned it, and let's talk about color correction. Why do we even need color correction? Honestly, it's a technology thing. Even with traditional film cameras, every photo needs some sort of color tweaking (either during processing or afterward in Elements), because if it didn't need some correction, we'd have about 30-something pages in this book that would be blank, and that would make my publisher pretty hopping mad. So, for the sake of sheer page count, let's all be glad that we don't live in an ideal world where every photo comes out perfect and 6-megapixel cameras are only 200 bucks and come with free 1-GB memory cards.

Before You Color Correct Anything, Do This First!

Okay, before you start along your merry color correcting way, there are a couple of settings that you should consider changing. These settings can definitely affect the results you get, so make sure you read this first. Also, keep in mind that these changes will remain as your defaults until you change them again, so you don't have to do this each time you open Elements.

Step One:
From the Edit menu, choose Color Settings (or press **Ctrl-Shift-K [Mac: Command-Shift-K]**).

Step Two:
In the Color Settings dialog, choose from the four options: No Color Management, Always Optimize Colors for Computer Screens, Always Optimize for Printing, or Allow Me to Choose. To a large degree, your choice will depend on your final output; but for photographers, I recommend using Always Optimize for Printing because it reproduces such a wide range (a.k.a. gamut) of colors using the Adobe RGB profile (if your photos don't already have a profile assigned), and it's ideal if your photos will wind up in print. *Note:* For more on color management, see Chapter 12.

Step Three:
Now we're moving to a completely different area. Press the letter **I** to switch to the Eyedropper tool. In the Options Bar, the default Sample Size setting for this tool (Point Sample) is fine for using the Eyedropper to steal a color from within a photo and make it your Foreground color. However, Point Sample doesn't work well when you're trying to read values in a particular area (such as flesh tones), because it gives you the reading from just one individual pixel, rather than an average reading of the surrounding area under your cursor.

Step Four:
For example, flesh tones are actually composed of dozens of different colored pixels (just zoom way in and you'll see what I mean); and if you're color correcting, you want a reading that's representative of the area under your Eyedropper, not just a single pixel within that area, which could hurt your correction decision-making. That's why you need to go to the Options Bar, under the Sample Size pop-up menu, and choose 3 by 3 Average. This changes the Eyedropper to give you a reading that's the average of 3 pixels across and 3 pixels down in the area that you're sampling. Once you've completed the changes on these two pages, it's safe to go ahead with the rest of the chapter and start correcting your photos.

The Advantages of Adjustment Layers in Elements 8

Before we really dive into color, we need to spend two minutes with the Adjustments palette. Of all the new enhancements in Elements 8, the new Adjustments palette is at the top of the list, because it streamlines our workflow so dramatically that even if you've never used adjustment layers before, you've got to start working with them now. In fact, from this point in the book on, we're going to try to use adjustment layers every chance we get, because of all the advantages they bring. Here's a quick look at them and why we need them:

Advantage One:
Undos That Live Forever

By default, Elements keeps track of the last 50 things you've done in the Undo History palette (shown here), so if you need to undo a step, or two, or three, etc., you can press **Ctrl-Z (Mac: Command-Z)** up to 50 times. But, when you close your document, all those undos go away. However, when you make an edit using an adjustment layer (like a Levels adjustment), you can save your image as a layered file (just save it in Photoshop format), and your adjustment layers are saved right along with it. You can reopen that document days, weeks, or even years later, click on that adjustment layer, and either undo or change that Levels (or whatever other one you used) adjustment. It's like an undo that lives forever.

Advantage Two:
Built-In Masks

Each adjustment layer comes with a built-in layer mask, so you can easily decide which parts of your photo get the adjustment just by painting. If you want to keep an area of your photo from having the adjustment, just get the Brush tool **(B)** and paint over it in black. There's more on layer masks to come. They offer tremendous flexibility, and since they don't actually affect the pixels in your image, they're always undoable.

Advantage Three:
Blend Modes

When you apply an adjustment layer, you get to use the layer blend modes. So if you want a darker version of your adjustment, you can just change the layer blend mode of your adjustment layer to Multiply. Want a brighter version? Change it to Screen. Want to make a Levels adjustment that doesn't affect the skin tone as much? Change it to Luminosity. Sweet!

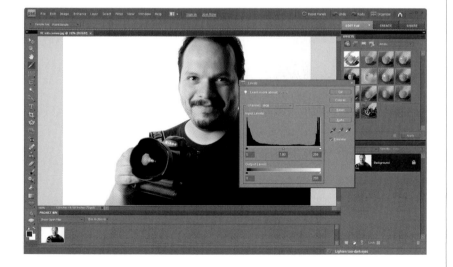

Advantage Four:
Everything Stays Live

Back in previous versions of Elements, when you created an adjustment layer (let's say a Levels adjustment layer, for example), it would bring up the floating Levels dialog (as seen here). While it was onscreen, the rest of Elements was frozen—you couldn't make changes or do anything else until you closed the Levels dialog by either applying your adjustment or clicking Cancel. But thanks to the Adjustments palette, everything stays live—you just go to the Adjustments palette and make your changes there. There is no OK or Apply button, so you can change anything anytime. This will make more sense in the next step.

Continued

Step One:

The best way to understand this whole "live" thing is to try it, so go open any photo (it really doesn't matter which one), then click on the Create New Adjustment Layer icon at the bottom of the Layers palette (it's the half-black/half-white circle) and choose Levels from the pop-up menu to open the Adjustments palette. Rather than bringing up the Levels dialog in front of your image (and freezing everything else), the Adjustments palette displays the Levels controls, so you can make your adjustments while everything stays live—you can adjust your Levels sliders, go up to the Layers palette and change the blend mode of a layer, or paint a few brush strokes, then grab another slider and adjust it. There's no OK button, and again, everything stays live. This is bigger than it sounds (ask anyone who has used an earlier version of Elements).

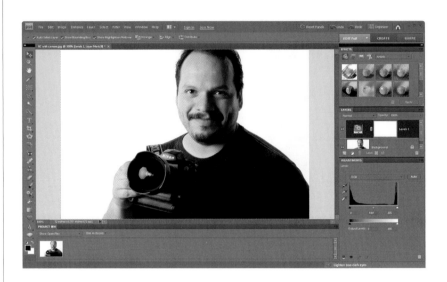

Step Two:

Let's delete our Levels adjustment layer by clicking-and-dragging it onto the Trash icon at the bottom of the Layers palette and then let's add a Hue/Saturation adjustment layer by clicking on the Create New Adjustment Layer icon at the bottom of the palette again, but this time choose Hue/Saturation from the pop-up menu. When the Hue/Saturation controls appear in the Adjustments palette, drag the Saturation slider all the way over to the left to remove the color, for the look you see here.

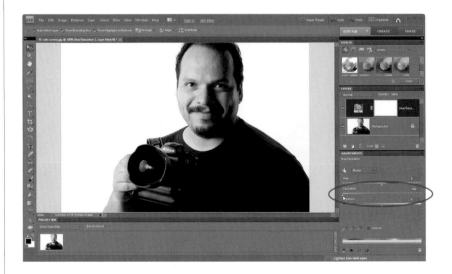

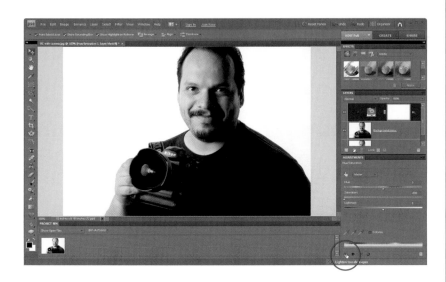

Step Three:

Now, the way adjustment layers work is this: they affect every layer below them. So, if you have five layers below your active layer, all five layers will have their color desaturated like this. However, if you want this adjustment layer to just affect the one single layer directly below the active layer (and not the others), then click on the clipping icon (it's the first icon on the left at the bottom of the Adjustments palette, shown circled here in red). This clips the adjustment layer to the layer directly beneath it and now the adjustment layer will only affect that layer.

Step Four:

There are a some other options when working with adjustment layers: To edit any adjustment layer you've already created, just click on it once in the Layers palette and its controls will appear in the Adjustments palette. To hide any adjustment layer you've created, click on the Eye icon (either at the bottom of the Adjustments palette, or to the left of the adjustment layer itself in the Layers palette). To reset any adjustment layer controls to their default settings, click the round arrow icon (the fourth from the left) at the bottom of the Adjustments palette. To see a before/after of just your last adjustment layer change, click the icon to the left of the Reset icon.

Photo Quick Fix

Elements' Quick Fix does exactly what it says. It quickly fixes your photos and it's a great tool if you don't have a lot of experience with color correction or fixing lighting and tonal issues. Basically, if you know that something is wrong but you're not sure where to go, then give Quick Fix a try first. As you become more comfortable in Elements, you'll outgrow Quick Fix and want to use Levels and Unsharp Mask and all that cool stuff, but if you're new to Elements, Quick Fix can be a fantastic place to start.

Step One:
Open the photo that needs color correcting (in the example we'll use here, our photo [shown below] needs the works—color correction, more contrast, and some sharpening). So, choose EDIT Quick from the Edit tab's pop-up menu at the top of the Palette Bin to go to Quick Fix mode.

Step Two:
The Quick Fix window shows you side-by-side, before-and-after versions of the photo you're about to correct (before on the top or left, after on the bottom or right). If you don't see this view, go to the View pop-up menu in the bottom left of the window and select Before & After (Horizontal or Vertical). To the right of your side-by-side preview is a group of nested palettes offering tonal and lighting fixes you can perform on your photo. Start with the Smart Fix palette at the top. Click the Auto button and Smart Fix will automatically analyze the photo and try to balance the overall tone (adjusting the shadows and highlights), fixing any obvious color casts while it's at it. In most cases, this feature does a surprisingly good job. There's also an Amount slider within Smart Fix that you can use to increase (or decrease) the effect of the Smart Fix.

MATT KLOSKOWSKI

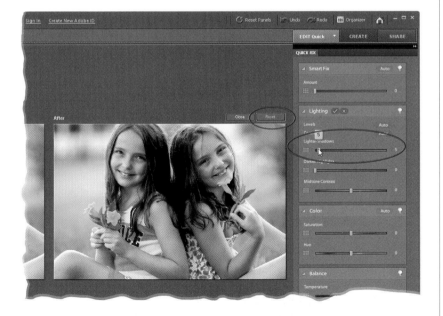

TIP: Auto Smart Fix
By the way, you can also access the Auto Smart Fix command without entering Quick Fix mode by going under the Enhance menu and choosing Auto Smart Fix (or just press the keyboard shortcut **Ctrl-Alt-M [Mac: Command-Option-M]**). However, there are two advantages to applying the Smart Fix here in Quick Fix mode: (1) you get the Amount slider, which you don't get by just applying it from the menu or the shortcut; and (2) you get a side-by-side, before-and-after preview so you can see the results as you're making your edits. So if it turns out that you need additional fixes (or Smart Fix didn't work as well as you'd hoped), you're already in the right place.

Step Three:
If you apply Smart Fix and you're not happy with the results, don't try to stack more "fixes" on top of that—instead, click the Reset button that appears over the top-right corner of the After preview to reset the photo to how it looked when you first entered Quick Fix mode. If the color in your photo looks a little flat and needs more contrast, try the Levels Auto button, found in the Lighting palette (the second palette down). I generally stay away from Auto Contrast, as Auto Levels seems to do a better job. There's another very powerful tool in this palette—the Lighten Shadows slider. Drag it to the right a little bit, and watch how it opens up the dark shadow areas in your photo (mainly in the hair here). When you're done with the slider, click the Commit checkmark in the palette header.

Continued

Step Four:
You may notice a tiny icon to the left of each slider in Quick Fix. This is new in Elements 8 and lets you adjust each setting in a more visual (and some-times precise) way. Just click on an icon and a group of thumbnails will appear below the slider. As you hover your cursor over each thumbnail, you'll see a preview of your image with that setting, so you don't have to drag the slider back and forth. If you like one, but want just a little more (or less) of the setting, click-and-drag from side to side on a thumbnail to move the slider in increments of 1. Now, on to more Quick Fixing.

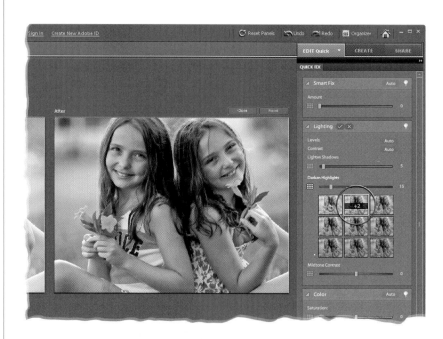

Step Five:
The next palette down, Color, has an Auto button that (surprisingly enough) tries to remove color casts and improve contrast like Smart Fix and Levels do, but it goes a step further by including a midtones correction that can help reduce color casts in the midtone areas. Hit the Reset button to remove any corrections you've made up to this point, and then try the Auto button in the Color palette. See if the grays in the photo don't look grayer and less yellow. In fact, with this photo, everything looks cooler and less yellow. Here's the thing, though: just because it looks cooler doesn't mean that it's right. Elements is just trying to neutralize the photo. In this case, I personally like the warmer feel, but it's a creative choice by you at this point. The Saturation and Hue sliders here are mostly for creating special color effects (try them and you'll see what I mean). You can pretty much ignore these sliders unless you want to get "freaky" with your photos. In the Balance palette, the Temperature and Tint sliders will let you manually remove color casts, but honest-ly, the Auto button in the Color palette is probably going to be your best bet.

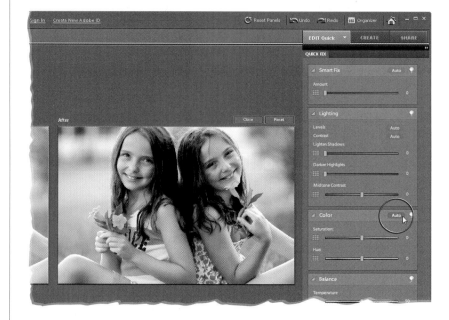

Step Six:

After you've color corrected your photo (using the Auto buttons and the occasional slider), the final step is to sharpen your photo (by the way, to maintain the best quality, this should be the final step—the last thing you do in your correction process). Just click the Auto button in the Detail palette and watch the results. If the photo isn't sharp enough for you, drag the Sharpen slider to the right to increase the amount of sharpening, but be careful—oversharpening can ruin the photo by becoming too obvious, and it can introduce color shifts and "halos" around objects.

Step Seven:

There are a few other things you can do while you're here (think of this as a one-stop shop for quickly fixing images). Along the bottom of the window are icons you can click to rotate your photo (this photo doesn't need to be rotated, but hey, ya never know). In the Toolbox on the left, there's a Red Eye Removal tool, if your photo needs it. Just click-and-drag over the problem area in your After preview for red-eye control. The Toolbox also has tools for whitening teeth, making skies blue, and making your photo black and white, but you'll probably find you like other techniques shown in this book for those tasks better. You know what the Zoom and Hand tools do (they zoom you in, and then move you around), and you can also crop your photo by using the Crop tool within the After preview, so go ahead and crop your photo down a bit. Lastly, you can make a selection with the Quick Selection tool.

Continued

Step Eight:
Okay, you've color corrected, fixed the contrast, sharpened your image, and even cropped it down to size. So how do you leave Quick Fix mode and return to the regular Elements Editor? Choose EDIT Full from the Edit tab's pop-up menu at the top of the Palette Bin (the same menu you used to get into Quick Fix mode). It basically applies all the changes to your photo and returns you to the normal editing mode.

Before

After

A histogram is a graph that shows you the tonal range of your photos (lights, darks, and grays). It's usually seen in the Levels dialog, but here's the thing: as you make Levels adjustments, the histogram there isn't updated live. That's why there's a palette dedicated to showing the histogram. That means you can have it open while you're making adjustments to your photos and get a live reading of how your histogram is looking while you edit.

Getting a Visual Readout (Histogram) of Your Corrections

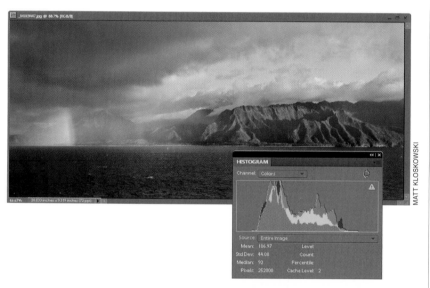

Step One:
Open the photo that needs a tonal adjustment. Now, go under the Window menu and choose Histogram to open the Histogram palette. (By the way, this palette is only available in Elements' Full Edit mode—not in Quick Fix mode.)

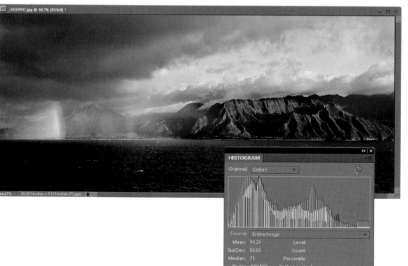

Step Two:
Go under the Enhance menu and choose Auto Color Correction. Take a look in the floating Histogram palette and you'll see how the Auto Color Correction command affected the photo's histogram. *Note:* If you see a small symbol in the upper right-hand corner of the graph that looks like a tiny yellow yield sign with an exclamation point in it (as seen in Step One), that's a warning that the histogram you're seeing is not a new histogram—it's a previous histogram cached from memory. To see a fresh histogram, click directly on that warning symbol and a new reading will be generated based on your current adjustment.

Color Correcting Digital Camera Images

Ever wonder why the term "color correction" gets thrown around so much? That's because every digital camera (and even most scanners used for capturing traditional photos) puts its little signature (i.e., color cast) on your photos. Most times it's a red cast, but it can also be blue or green. Don't get me wrong—they are getting better, but the color cast is still there. Here's how to help combat those color problems in Elements:

Step One:
Open the digital camera photo you want to color correct. (The photo shown here doesn't look too bad, but as we go through the correction process, you'll see that, like most photos, it really needed a correction.)

Step Two:
Go under the Enhance menu, under Adjust Lighting, and choose Levels (or press **Ctrl-L [Mac: Command-L]**). The dialog may look intimidating at first, but the technique you're going to learn here requires no previous knowledge of Levels, and it's so easy, you'll be correcting photos using Levels immediately.

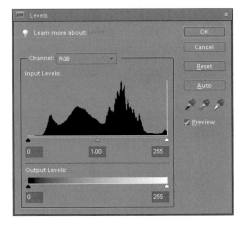

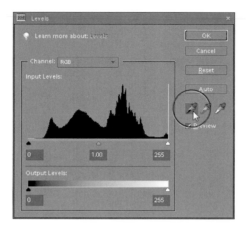

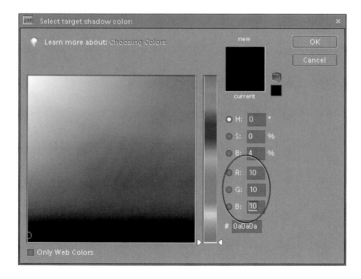

Step Three:
First, we need to set some preferences in the Levels dialog so we'll get the results we're after when we start correcting. We'll start by setting a target color for our shadow areas. To set this preference, in the Levels dialog, double-click on the black Eyedropper tool (it's on the right-hand side of the dialog, the first Eyedropper from the left). A Color Picker will appear asking you to "Select target shadow color." This is where we'll enter values that, when applied, will help remove any color casts your camera introduced in the shadow areas of your photo.

Step Four:
We're going to enter values in the R, G, and B (red, green, and blue) fields of this dialog.

> For R, enter 10
> For G, enter 10
> For B, enter 10

TIP: Tab to Change Fields
To move from field to field, just press the **Tab key**.

Then click OK. Because these figures are evenly balanced (neutral), they help ensure that your shadow areas won't have too much of one color (which is exactly what causes a color cast—too much of one color).

Continued

Step Five:

Now we'll set a preference to make our highlight areas neutral. Double-click on the highlight Eyedropper (the third of the three Eyedroppers in the Levels dialog). The Color Picker will appear asking you to "Select target highlight color." Click in the R field, and then enter these values:

> For R, enter 240
> For G, enter 240
> For B, enter 240

Then click OK to set those values as your highlight target.

Step Six:

Finally, set your midtone preference. You know the drill—double-click on the midtones Eyedropper (the middle of the three Eyedroppers) so you can "Select target midtone color." Enter these values in the R, G, and B fields (if they're not already there by default):

> For R, enter 128
> For G, enter 128
> For B, enter 128

Then click OK to set those values as your midtone target.

Step Seven:
Okay, you've entered your preferences (target colors), so go ahead and click OK in the Levels dialog (without making any changes to your image). You'll get an alert dialog asking you if you want to "Save the new target colors as defaults?" Click Yes, and from that point on, you won't have to enter these values each time you correct a photo, because they'll already be entered for you—they're now the default settings.

Step Eight:
You're going to use these Eyedropper tools that reside in the Levels dialog to do most of your correction work. Your job is to determine where the shadow, midtone, and highlight areas are, and click the right Eyedropper in the right place (you'll learn how to do that in just a moment). So remember your job—find the shadow, midtone, and highlight areas and click the right Eyedropper in the right spot. Sounds easy, right? It is. You start by opening Levels and setting the shadows first, so you'll need to find an area in your photo that's supposed to be black. If you can't find something that's supposed to be the color black, then it gets a bit trickier—in the absence of something black, you have to determine which area in the image is the darkest. If you're not sure where the darkest part of the photo is, you can use the following trick to have Elements tell you exactly where it is.

Step Nine:
Go to the bottom of the Layers palette and click on the half-black/half-white circle icon to bring up the Create New Adjustment Layer pop-up menu. When the pop-up menu appears, choose Threshold, which brings up the Adjustments palette with a histogram and a slider under it.

Continued

Step 10:

In the Adjustments palette, drag the Threshold Level slider under the histogram all the way to the left. Your photo will turn completely white. Slowly drag the slider back to the right, and as you do, you'll start to see some of your photo reappear. The first area that appears is the darkest part of your image. That's it—that's Elements telling you exactly where the darkest part of the image is. Now that you know where your shadow area is, make a mental note of its location. Next, find a white area in your image.

Step 11:

If you can't find an area in your image that you know is supposed to be white, you can use the same technique to find the highlight areas. With the Adjustments palette still open, drag the slider all the way to the right. Your photo will turn black. Slowly drag the slider back toward the left, and as you do, you'll start to see some of your photo reappear. The first area that appears is the lightest part of your image. Make a mental note of this area, as well (yes, you have to remember two things, but you have to admit, it's easier than remembering two PINs). You're now done with Threshold, so in the Layers palette, just click-and-drag the Threshold adjustment layer onto the Trash icon at the bottom of the palette, because you don't actually need it anymore.

Step 12:
Press Ctrl-L (Mac: Command-L) to bring up the Levels dialog again. First, select the shadow Eyedropper (the one half-filled with black) from the right side of the Levels dialog. Move your cursor outside the Levels dialog into your photo and click once in the area that Elements showed you was the darkest part of the photo (in Step 10). When you click there, you'll see the shadow areas correct. (Basically, you just reassigned the shadow areas to your new neutral shadow color—the one you entered earlier as a preference in Step Four.) If you click in that spot and your photo now looks horrible, you either clicked in the wrong spot or what you thought was the shadow point actually wasn't. Undo the setting of your shadow point by clicking the Reset button in the dialog and try again. If that doesn't work, don't sweat it; just keep clicking in areas that look like the darkest part of your photo until it looks right.

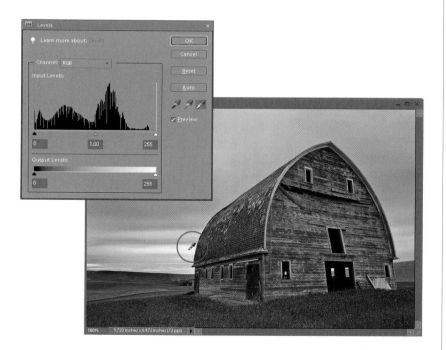

Step 13:
While still in the Levels dialog, click on the highlight Eyedropper (the one half-filled with white). Move your cursor over your photo and click once on the lightest part (the one you committed to memory in Step 11) to assign that as your highlight. You'll see the high-light colors correct.

Continued

Step 14:

Now that the shadows and highlights are set, you'll need to set the midtones in the photo. It may not look as if you need to set them, because the photo may look properly corrected, but chances are there's a cast in the midtone areas. You may not recognize the cast until you've corrected it and it's gone, so it's worth giving it a shot to see the effect (which will often be surprisingly dramatic). Unfortunately, there's no Threshold adjustment layer trick that works well for finding the midtone areas, so you have to use some good old-fashioned guesswork (or try "Dave's Amazing Trick for Finding a Neutral Gray" next in this chapter). Ideally, there's something in the photo that's gray, but not every photo has a "gray" area, so look for a neutral area (one that's obviously not a shadow, but not a highlight either). Click the middle (gray) Eyedropper in that area. If it's not right, click the Reset button and repeat Steps 12 through 14.

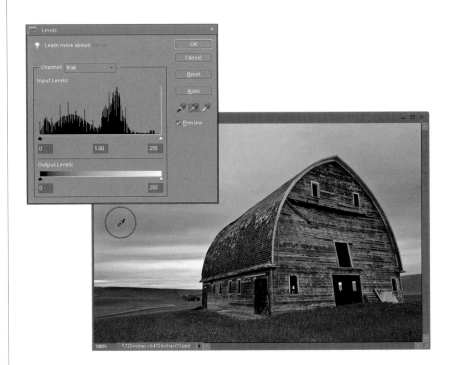

Step 15:

There's one more important adjustment to make before you click OK in the Levels dialog and apply your correction. Under the histogram (that's the black mountain-range-looking thing), click on the center slider (the Midtone Input Levels slider—that's why it's gray) and drag it to the left a bit to brighten the midtones of the image. This is a visual adjustment, so it's up to you to determine how much to adjust, but it should be subtle—just enough to bring out the midtone detail. When it looks right to you, click OK to apply your correction to the highlights, midtones, and shadows, removing any color casts and brightening the overall contrast.

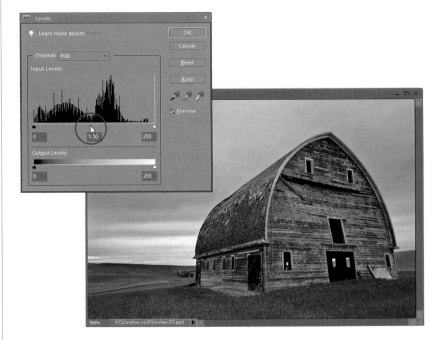

Before

After

Dave's Amazing Trick for Finding a Neutral Gray

If you read the previous tutorial and are saying to yourself, "But what about that middle gray eyedropper? How do I accurately set that point?" you're not alone. It has always been kind of tricky actually, but Dave Cross, Senior Developer of Education and Curriculum for the National Association of Photoshop Professionals (NAPP), showed us this amazing trick. Being the friendly Canadian that he is, he even offered to let us include it in the book so everyone else can see it, as well.

Step One:
Open any color photo and click on the Create a New Layer icon at the bottom of the Layers palette to create a new blank layer. Then, go under the Edit menu and choose Fill Layer. When the Fill Layer dialog appears, in the Contents section, under the Use pop-up menu, choose 50% Gray, and then click OK to fill your new layer with (you guessed it) 50% gray.

Step Two:
Now, go to the Layers palette and change the blend mode pop-up menu to Difference. Changing this layer's blend mode to Difference doesn't do much for the look of your photo (in fact, it rarely does), but just remember—it's only temporary.

Step Three:
Choose Threshold from the Create New Adjustment Layer pop-up menu at the bottom of the Layers palette. When the Adjustments palette appears, drag the slider all the way to the left (your photo will turn completely white). Now, slowly drag the slider back to the right, and the first areas that appear in black are the neutral midtones. Make a mental note of where those gray areas are, and then click-and-drag the Threshold adjustment layer onto the Trash icon at the bottom of the palette, because you no longer need it. (In the example shown here, there are neutral midtones in the edge of the blanket.)

Step Four:
Now that you know where your midtone point is, go back to the Layers palette and drag the 50% gray layer onto the Trash icon (it's also done its job, so you can get rid of it, too). You'll see your full-color photo again. Now, press **Ctrl-L (Mac: Command-L)** to open Levels, get the midtones Eyedropper (it's the middle Eyedropper), and click directly on one of the neutral areas. That's it; you've found the neutral midtones and corrected any color within them. So, will this work every time? Almost. It works most of the time, but you will run across photos that just don't have a neutral midtone, so you'll have to either not correct the midtones or go back to what we used to do—guess.

Studio Photo Correction Made Simple

If you're shooting in a studio—whether it's portraits or products—there's a technique you can use that makes the color correction process so easy that you'll be able to train laboratory test rats to correct photos for you. In the back of this book, we've included a color swatch card (it's perforated so you can easily tear it out). After you get your studio lighting set the way you want it, and you're ready to start shooting, put this swatch card into your shot (just once) and take the shot. What does this do for you? You'll see.

Step One:
When you're ready to start shooting and the lighting is set the way you want it, tear out the swatch card from the back of this book and place it within your shot (if you're shooting a portrait, have the subject hold the card for you), and then take the shot. After you've got one shot with the swatch card, you can remove it and continue with the rest of your shoot.

Step Two:
When you open the first photo taken in your studio session, you'll see the swatch card in the photo. By having a card that's pure white, neutral gray, and pure black in your photo, you no longer have to try to determine which area of your photo is supposed to be black (to set the shadows), which area is supposed to be gray (to set the midtones), or which area is supposed to be white (to set the highlights). They're right there in the card. *Note:* We've even included a Camera Raw White Balance swatch if you're working with RAW files. See "The Essential Adjustments: White Balance" in Chapter 2 for more info.

SCOTT KELBY

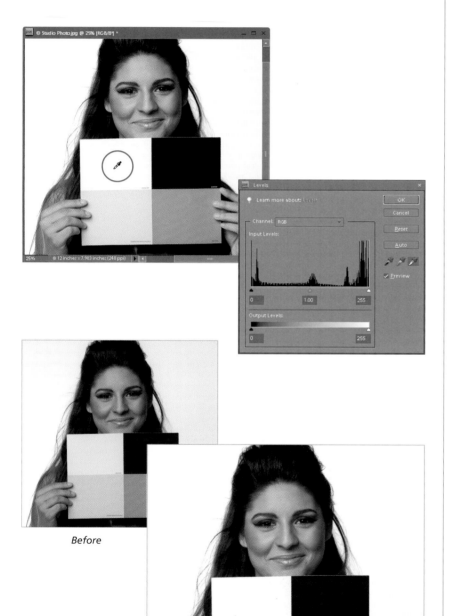

Before

After

Step Three:
Press **Ctrl-L (Mac: Command-L)** to bring up the Levels dialog. Click the black Eyedropper on the black panel of the card (to set shadows), the middle Eyedropper on the gray panel (for midtones), and the white Eyedropper on the white panel (to set the highlights), and the photo will nearly correct itself. No guessing, no using Threshold adjustment layers to determine the darkest areas of the image—now you know exactly which part of that image should be black and which should be white.

Step Four:
If you'd like to still use this photo, then press **C** to get the Crop tool and crop the card out of the image. However, the more likely situation is that you don't want to use this photo (since it does have a big card in it), but you'd now like to apply this color correction to some other photos. Well, now that you have the Levels settings for the first image, you can correct the rest of the photos using the same settings. Just open the next photo and press **Ctrl-Alt-L (Mac: Command-Option-L)** to apply the exact same settings to this photo that you did to the swatch card photo. Or, you can use the "Drag-and-Drop Instant Color Correction" method that appears next in this chapter.

TIP: Try a Color Checker Chart
If you want to take this process a step further, many professionals use a Munsell ColorChecker color-swatch chart (from X-Rite; www.xrite.com), which also contains a host of other target colors. It's used exactly the same way: just put the chart into your photo, take one shot, and then when you correct the photo, each color swatch will be in the photo, just begging to be clicked on.

Drag-and-Drop Instant Color Correction

Here's a trick for quickly correcting lots of photos that have the same lighting problem. It's a huge time saver! You'll see that it's ideal for photos where your lighting conditions were the same (indoor studio shots are perfect candidates for this one), but it works in plenty of other situations, as well.

Step One:
First, here's a tip-within-a-tip: If you're opening a group of photos, you don't have to open them one by one. Just go under the File menu and choose Open. In the Open dialog, click on the first photo you want to open, then press-and-hold the Ctrl (Mac: Command) key and click on any other photos you want to open. Then, when you click the Open button, Elements will open all the selected photos. (If all your photos are contiguous, press-and-hold the Shift key and click on the first and last photos in the list to select them all.) So now that you know that tip, go ahead and open at least three or four images, just to get you started.

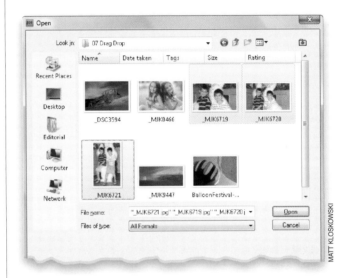

Step Two:
At the bottom of the Layers palette, click on the Create New Adjustment Layer pop-up menu and choose Levels. *Note:* An adjustment layer is a special layer that contains the tonal adjustment of your choice (such as Levels, Brightness/Contrast, etc.). There are a number of advantages to having this correction applied as a layer, as you'll soon see, but the main advantage is that you can edit or delete this tonal adjustment at any time while you're working, plus you can save this adjustment with your file as a layer.

Step Three:
When you choose this adjustment layer, you'll notice that the Adjustments palette appears with your Levels controls. Go ahead and make your corrections using Levels (see "Color Correcting Digital Camera Images" earlier in this chapter). In the Layers palette, you'll see that a new Levels adjustment layer is created.

Step Four:
Because you applied this correction as an adjustment layer, you can treat this adjustment just like a regular layer, right? Right! And Elements lets you drag layers between open documents, right? Right again! (Note: You must have them open as floating, not tabbed, documents to drag a layer between them.) So, go to the Layers palette, click on the Levels adjustment layer, and drag-and-drop it right onto one of your other open photos. That photo will instantly have the same correction applied to it. This technique works because you're correcting photos that share similar lighting conditions. Need to correct 12 open photos? Just drag-and-drop it 12 times (making it the fastest correction in town!).

Continued

Step Five:
Okay, what if one of the "dragged corrections" doesn't look right? That's the beauty of these adjustment layers. Just click directly on the adjustment layer thumbnail for that photo, and go to the Adjustments palette, where the last settings you applied are still in place. You can then adjust this individual photo separately from the rest. Try this dragging-and-dropping-adjustment-layers trick once, and you'll use it again and again to save time when correcting a digital roll that has similar lighting conditions.

So what do you do if you've used Levels to properly set the highlights, midtones, and shadows, but the flesh tones in your photo still look too red? You can try this quick trick for getting your flesh tones in line by removing the excess red. This one small adjustment can make a world of difference.

Adjusting Flesh Tones

©ISTOCKPHOTO/JACOB WACKERHAUSEN

Step One:
Open a photo that needs red removed from the flesh tones. If the whole image appears too red, skip this step and move on to Step Three. However, if just the flesh-tone areas appear too red, get the Quick Selection tool **(A)** and click on all the flesh-tone areas in your photo. (Press-and-hold the Alt [Mac: Option] key to remove any areas that were selected that shouldn't have been, such as the clothes and hair.)

Step Two:
Go under the Select menu and choose Feather. Enter a Feather Radius of about 3 pixels, then click OK. By adding this feather, you're softening the edges of your selection, preventing a hard, visible edge from appearing around your adjustments.

Continued

Step Three:
Click on the Create New Adjustment Layer icon at the bottom of the Layers palette, and choose Hue/Saturation from the pop-up menu. Then, in the Adjustments palette, click on the pop-up menu near the top and choose Reds, so you're only adjusting the reds in your photo (or in your selected areas if you put a selection around the flesh tones).

Step Four:
The rest is easy—you're simply going to reduce the amount of saturation so the flesh tones appear more natural. Drag the Saturation slider to the left to reduce the amount of red (I moved mine to –20, but you may have to go further to the left, or not as far, depending on how red your skin color is). The changes are live, so you'll be able to see the effect of reducing the red as you lower the Saturation slider. Also, if you made a selection of the flesh-tone areas, once you create the adjustment layer, it will hide the selection border from view and create a layer mask with your selection. When the flesh tones look right, you're done.

Before

After

Warming Up (or Cooling Down) a Photo

Before digital photography, you had to adjust your camera for each particular lighting situation (the photo might come out too blue or too warm because of the lighting), and there were filters that you'd screw on to the end of a lens to help combat the effect. Well, Elements has a Photo Filter adjustment, and it works so well at warming and cooling digitally that I don't even carry those filters in my bag anymore. Here's how to use it:

Step One:
Open the photo that needs cooling down (or warming up). In the example shown here, the photo is too warm and has a yellowish tint, so we want to cool it down and make it look more natural. Go to the Layers palette and choose Photo Filter from the Create New Adjustment Layer pop-up menu at the bottom of the palette (its icon looks like a half-black/half-white circle).

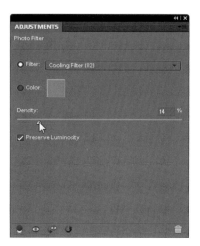

Step Two:
When the Photo Filter controls appear in the Adjustments palette, choose Cooling Filter (82) (or choose a Warming Filter if your image is too cool) from the Filter pop-up menu (this approximates the effect of a traditional screw-on lens filter). If the effect is too cool for you, drag the Density slider to the left to warm the photo up a little. I took mine down a bit to 14% to not cool down the sky too much.

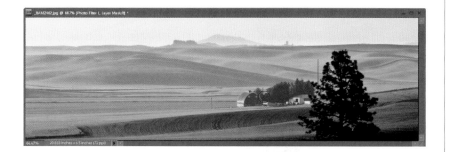

Step Three:
Because this Photo Filter is an adjustment layer, you can edit where the cooling is applied, so press **B** to switch to the Brush tool. In the Options Bar, click on the down-facing arrow next to the Brush thumbnail and choose a soft-edged brush in the Brush Picker. Then, press **X** to make black your Foreground color, and begin painting over any areas that you don't want to be cool (for example, if you wanted the barns and trees next to them to stay warm, you'd paint over that area). The original color of the image will be revealed wherever you paint.

Color Correcting One Problem Area Fast!

This technique really comes in handy when shooting outdoor scenes because it lets you enhance the color in one particular area of the photo, while leaving the rest of the photo untouched. Real estate photographers often use this trick because they want to present a house on a bright, sunny day, but the weather doesn't always cooperate. With this technique, a blown-out sky shot at daybreak can become a beautiful blue sky in just seconds.

Step One:
Open the image that has an area of color you would like to enhance, such as the sky.

Step Two:
Go to the bottom of the Layers palette and choose Hue/Saturation from the Create New Adjustment Layer pop-up menu (it's the half-black/half-white circle icon). A new layer named "Hue/ Saturation 1" will be added to your Layers palette and the Hue/Saturation controls will appear in the Adjustments palette. (*Note:* If you prefer using the Smart Brush tool [covered in Chapter 5], you'll find it has a Blue Skies option that also works pretty well in cases like this.)

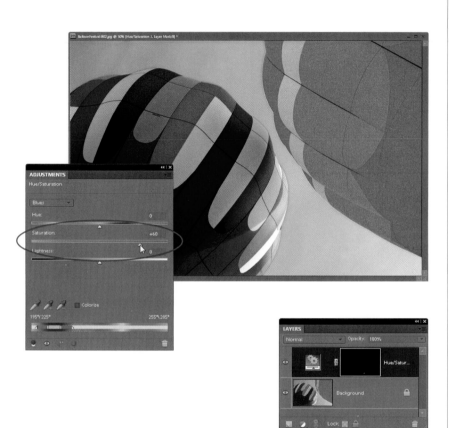

Step Three:

From the pop-up menu at the top of the Adjustments palette, choose the color that you want to enhance (Blues, Reds, etc.), then drag the Saturation slider to the right. You might also choose Cyans, Magentas, etc., from the pop-up menu and do the same thing—drag the Saturation slider to the right, adding even more color, until your image's area looks as enhanced as you'd like it. In the example here, I increased the saturation of the Cyans to 30 and the Blues to 60.

Step Four:

Your area is now colorized, but so is everything else. That's okay; you can fix that easily enough. Press the letter **X** until your Foreground color is set to black, then press **Alt-Backspace (Mac: Option-Delete)** to fill the Hue/Saturation layer mask with black. Doing this removes all the color that you just added, but now you can selectively add (actually paint) the color back in where you want it.

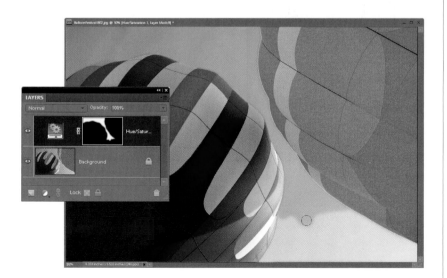

Step Five:

Press the letter **B** to switch to the Brush tool. In the Options Bar, click the down-facing arrow to the right of the Brush thumbnail, and in the Brush Picker, choose a large, soft-edged brush. Press **X** again to toggle your Foreground color to white, and begin painting over the areas where you want the color enhanced. As you paint, the version of your enhanced photo will appear. For well-defined areas, you may have to go to the Brush Picker again in the Options Bar to switch to a smaller, hard-edged brush.

Continued

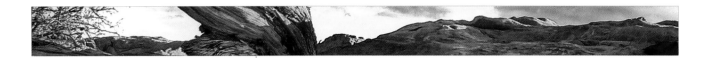

TIP: Fixing Mistakes

If you make a mistake and paint over an area you shouldn't have—no problem—just press **X** again to toggle your Foreground color to black and paint over the mistake—it will disappear. Then, switch back to white and continue painting. When you're done, the colorized areas in your photo will look brighter.

Before

After

I've run into a lot of digital photographers that use the Remove Color function in Elements to convert from color to black and white. Nearly every single one of them is disappointed with the results. That's because Elements simply removes the color from the photo and leaves a very bland looking black-and-white image. Plus, there are no settings, so you can't customize your black-and-white photo in any way. Here's a great technique that creates a better black and white and gives you plenty of control to really customize the way it looks.

Getting a Better Conversion from Color to Black and White

Step One:
Open the color photo you want to convert to black and white. Press **D** to set your Foreground and Background to the default black and white.

Step Two:
To really appreciate this technique, it wouldn't hurt if you went ahead and did a regular conversion to black and white, just so you can see how lame it is. Go under the Image menu, under Mode, and choose Grayscale. When the "Discard color information?" dialog appears, click OK, and behold the somewhat lame conversion. Now that we agree it looks pretty bland, press **Ctrl-Z (Mac: Command-Z)** to undo the conversion, so you can try something better.

Continued

Step Three:

Go to the bottom of the Layers palette and choose Levels from the Create New Adjustment Layer pop-up menu (it's the half-black/half-white circle icon). The Levels controls will appear in the Adjustments palette. and a new layer will be added to your Layers palette named "Levels 1."

Step Four:

Press **X** until your Foreground color is set to black, then go to the bottom of the Layers palette and choose Gradient Map from the Create New Adjustment Layer pop-up menu. This brings up the Gradient Map options in the Adjustments palette.

Step Five:

Just choosing Gradient Map gives you a black-and-white image (and doing just this, this one little step alone, usually gives you a better black-and-white conversion than just choosing Grayscale from the Mode submenu. Freaky, I know). If you don't get a black-to-white gradient, it is because your Foreground and Background colors were not set at their defaults. Click-and-drag the Gradient Map adjustment layer onto the Trash icon at the bottom of the palette, press **D**, then add your Gradient Map adjustment layer again. This adds another layer to the Layers palette (above your Levels 1 layer) named "Gradient Map 1."

Step Six:
In the Layers palette, click directly on the Levels thumbnail in the Levels 1 layer to bring up the Levels controls in the Adjustments palette again. In the pop-up menu at the top of the palette, you can choose to edit individual color channels (kind of like you would with Photoshop's Channel Mixer). Choose the Red color channel.

Step Seven:
You can now adjust the Red channel, and you'll see the adjustments live onscreen as you tweak your black-and-white photo. (It appears as a black-and-white photo because of the Gradient Map adjustment layer above the Levels 1 layer. Pretty sneaky, eh?) You can drag the shadow Input Levels slider to the right a bit to increase the shadows in the Red channel, as shown here.

Continued

Step Eight:

Now, switch to the Green channel in the pop-up menu at the top of the Adjustments palette. You can make adjustments here, as well. Try increasing the highlights in the Green channel by dragging the highlight Input Levels slider to the left, as shown here.

Step Nine:

Now, choose the Blue channel from the pop-up menu, and try increasing the highlights quite a bit and the shadows just a little by dragging the Input Levels sliders (the ones below the histogram that we've been using). These adjustments are not standards or suggested settings for every photo; I just experimented by dragging the sliders, and when the photo looked better, I stopped dragging. When the black-and-white photo looks good to you (good contrast and good shadow and highlight details), just stop dragging.

Step 10:

To complete your conversion, go to the Layers palette, click on the flyout menu at the top right, then choose Flatten Image to flatten the adjustment layers into the Background layer. Although your photo looks like a black-and-white photo, technically, it's still in RGB mode, so if you want a grayscale file, go under the Image menu, under Mode, and choose Grayscale.

Before (lame grayscale conversion)

After (awesome adjustment layers conversion)

Correcting Color and Contrast Using Color Curves

Users of the full professional version of Adobe Photoshop have had the benefit of using Curves since version 1, and it's the pros' choice for color correction without a doubt. There's only one problem—it's a bit hard for most folks to master. That's why you'll fall in love with the Color Curves adjustment—it makes using Curves so easy, it will actually make pro users of Photoshop jealous. Adobe has done a really brilliant job of giving us the power of Curves without the hassles and steep learning curve. Life is good.

Step One:
Open the photo you want to adjust with Color Curves (a typical situation might be a photo that lacks contrast or has an obvious color cast, but in reality most photos can benefit from a short trip to Color Curves, so don't just save it for really messed up photos). Then go under the Enhance menu, under Adjust Color, and choose Adjust Color Curves (as shown here).

Step Two:
When the Adjust Color Curves dialog first appears, you've got two options for using it. First there's the simple fix (I know, it's not the official name, but it's what we call it). This simple fix lets you simply select what you'd like to do with your photo from a list of choices on the bottom-left side of the dialog (you can compare the before and after views to see if you're happy with the changes). Just click on a choice in the Select a Style list and it applies a color curve for you. Easy enough, right? (By the way, don't click on Solarize unless you've had a few glasses of Merlot first.) *Note:* You can only apply one curve at a time. If you want to apply more than one style adjustment, click OK, then reopen the Adjust Color Curves dialog and select another adjustment to add it.

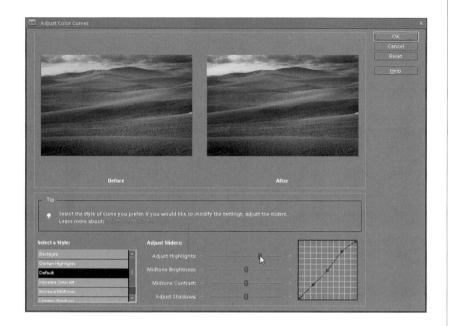

Step Three:

So, you might get lucky and find a choice that works great for you right off the bat. Your photo will look better, and life will be good. However, to reveal the real power of these curves, you'll need to go to Adjust Sliders at the bottom right of the dialog. That's where you'll see four sliders and the curve itself. Now, as you drag the sliders, you'll see how the curve is affected. For example, drag the Adjust Highlights slider to the right, and you'll see the top-right curve point move upward. That's because the highlights are controlled by that upper-right point.

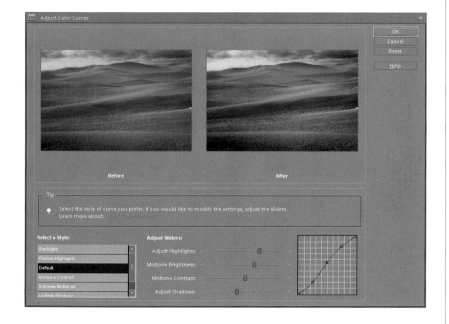

Step Four:

The center point represents the midtones in your photo. Try dragging the Midtone Brightness slider to the right, and look over at the curve. See how the center point moves upward? Now, drag the Midtone Contrast slider to the left, and watch how the contrast increases. Anytime you make the curve steeper, it adds contrast to your photo, but you don't want it to get too steep, or your photo will lose quality. Lastly, drag the Adjust Shadows slider to the left. Notice how the shadow point on the curve (the far-left point) moves downward, darkening the shadow area. These sliders make it easy to adjust the tone and contrast in your photo without having to manually move points on the curve (like you do in the pro version of Photoshop).

Continued

Step Five:

Now, let's click the Reset button and start over from scratch. Let's fix the problem photo we have here, using nothing but Adjust Color Curves. First, let's start with the preset styles and see if any of them look better than our current photo. To me, the Increase Contrast style looks better than the original photo, so go ahead and click on that. It makes a great starting point for our correction.

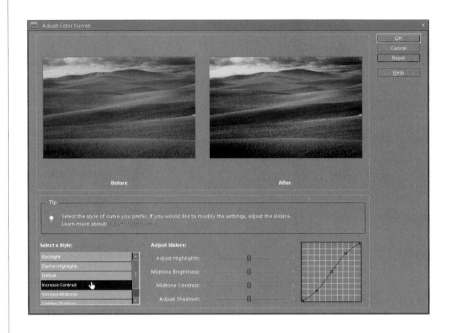

Step Six:

Okay, here's the problem (at least as I see it). Although we increased the contrast, and I think the photo certainly looks better than it did, it seems a little dark, and it looks like it's lacking highlights. So, drag the Adjust Highlights slider over to the right a little bit and see how that looks. Now, to me, that looks better (but hey, that's just me. There is no official government agency that determines whether your photo has enough highlights or not, so the choice is really up to you—the photographer). In fact, since it's up to you (or me, in this case), I think I might even drag it a little farther to the right, to really open up those highlights in the sky. In fact, I'll keep dragging until the white areas of my photo start to look blown out (lacking detail).

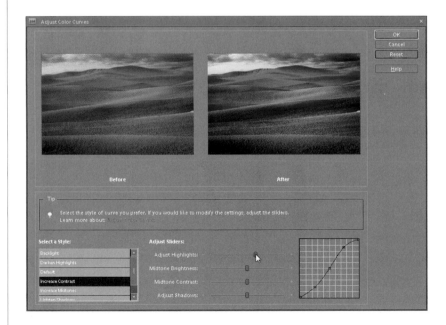

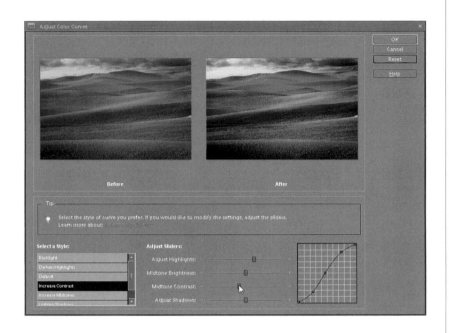

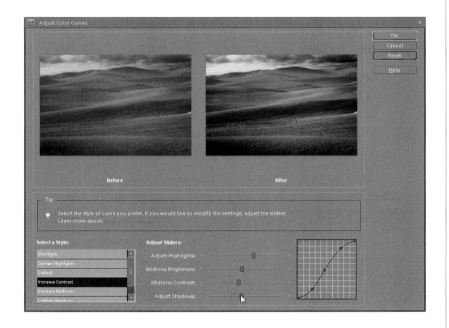

Step Seven:

Now, if it were me (and it is, by the way), I'd then drag the Midtone Contrast slider to the left a bit to add more contrast in the midtones. This tends to brighten the midtones. I won't do this for every photo, but for this photo, it seems to look better. That's the great thing about these sliders—you can drag one to the left, and if your photo looks better, then great. If it doesn't, drag it to the right and see how that looks. If it looks better when you drag it to the right, then great. If not, drag it back to the center and leave it alone. In this case, I dragged both ways, and I like the way the midtone contrast looked when I had the slider dragged to the left a bit, so that's where I'm leaving it.

Step Eight:

My final two tweaks are to drag the Midtone Brightness slider to the left, then the right, to see which one looks better. I like the way it looks when I drag it to the right, so to the right it stays. I know this sounds like a really simplistic way to adjust your photos, but it's deeper than you think. If you drag a slider in either direction, and your photo looks better, then how could that be wrong? Lastly, let's drag the Adjust Shadows slider. Dragging just a little bit to the left seemed to make the shadow areas darker, while dragging it to the right made them look washed out. So, needless to say, I left it a little to the left. If you look at the curve itself, you'll see the classic "S" shape (known as the "S" curve), which is pretty common in curve correction, as that shape adds contrast and helps to make colors rich and saturated. So, in short, don't be afraid to slide those sliders.

Continued

Before *After*

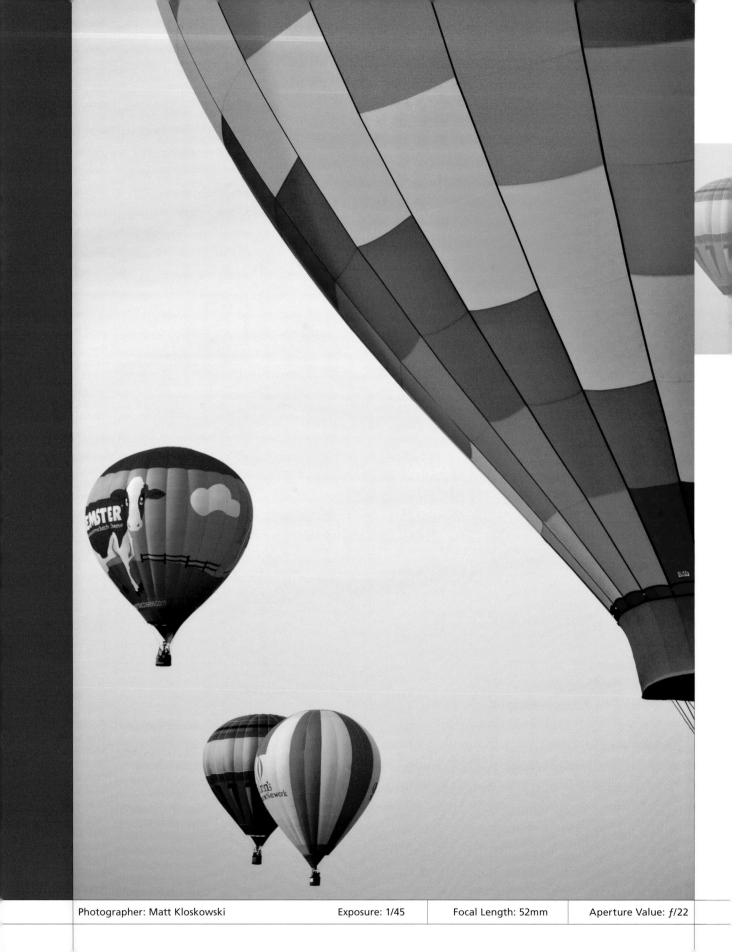

Photographer: Matt Kloskowski Exposure: 1/45 Focal Length: 52mm Aperture Value: ƒ/22

99 Problems
digital camera image problems

Yo, we got some Jay-Z up in the house (that's my sad attempt at trying to sound "street." Seriously, is there nothing sadder than some 40-something guy trying to sound like he's 17 because he's trying to appeal to a demographic with huge amounts of disposable income? That's exactly why I would never stoop to those tactics. Yo dog, I just ain't all that)! Anyway, his song "99 Problems" is actually a pretty decent song, even though when I watched the video in Apple's iTunes, a lot of the words had been blanked out (there were gaps in the vocals—his mouth was moving, but you couldn't hear what he was saying). For example, at one point he says, "In my rear view mirror is…" and then the next few phrases are blanked out. So, I guess we're to form our own conclusions about what Jay-Z was seeing in his rear view mirror. You know what I think he was seeing? I think it was probably a billboard advertising a local dry cleaner, and they had one of those "Spring Cleaning" specials where you get like 20% off when they clean your comforters, blankets, or quilts, and you know they really have to give a pretty decent discount like that because it's already spring, and you won't be using that stuff again until next fall, but then it will be full price, so it's probably good if you take advantage of that discount now. Anyway, I'll bet Jay-Z saw something like that, and since they weren't paying Jay-Z a promotional fee, he wasn't going to give the name of the dry cleaner out—or their special offer—without "gettin' some bank" (dig my street lingo), right? So, in the studio, they probably blanked out that part. Yeah, that's probably what it was. Yo!

Using the Smart Brush Tool to Select and Fix at the Same Time

Photoshop Elements includes a brush tool that lets you fix problem areas (as well as create some pretty cool effects) with just a brush stroke. It's called the Smart Brush tool, and it helps keep you from making complicated selections and then having to fix them in a separate step. Instead, you choose which effect you want to apply and just brush away. Let's check it out.

Step One:
Open a photo that has an area you want to enhance or fix. There's actually a huge list of things you can do with this brush, but let's concentrate on one area for now—the sky. A big digital image problem is that the sky never seems to look as vibrant and dramatic as it does when we're there photographing it. Well, the Smart Brush tool has an option to help fix this, so go ahead and select it from the Toolbox (it's the brush icon with a little gear to the left of it, right below the Brush tool and directly above the Paint Bucket tool) or just press the **F key**.

Step Two:
Once you select the tool, you'll see a Preset Picker pop down from the top Options Bar. As you change the preset pop-up menu and scroll through the Preset Picker, you'll see what I meant in Step One—there are indeed a bunch of things you can do here. Let's go ahead and choose Nature from the preset pop-up menu at the top, though, to narrow it down. Then click on the Cloud Contrast preset.

Step Three:
Now the main thing to remember about this tool is that it is still a brush, which means it has settings just like all other brushes (diameter, hardness, spacing, etc.). So, click on the down-facing arrow to the right of Brush in the Options Bar, and set your diameter to a size that'll help you paint over the area fairly quickly. In this example, I'm using a 200-pixel brush for the sky.

Step Four:
The rest is pretty simple—just click-and-drag on the sky to paint the effect on the photo. By the way, notice how Elements automatically started adding the Cloud Contrast effect to parts of the sky that you haven't even painted over yet? That's where the "smart" part of this brush comes into play. It automatically examines your photo for areas similar to what you clicked on and adds them to the selection.

Step Five:
Now keep brushing on the sky to get the rest of it. Each time you click, you're adding to the selection, so there's no need to press-and-hold any keys or change tools to widen the effect to other parts of the photo.

Continued

Step Six:

Okay, this brush is pretty cool right? But it's not perfect. There will inevitably come a time (probably sooner than later) where the "smartness" of the brush isn't as smart as it thinks it is, and it bleeds into a part of the photo you didn't want it to (like the lighthouse here). When that happens, press-and-hold the **Alt (Mac: Option) key** to put the brush into subtract mode. Then paint over the areas you didn't want to apply the effect to. Again, Elements will do a lot of the work for you and wipe away the areas, even if you don't paint directly on them. *Note:* Decrease the size of your brush and zoom in on the area, if needed, to help remove it from the selection.

Step Seven:

Here's another really cool part about the Smart Brush tool: it's non-destructive to your photo. This means you can always go back and change (or even delete) the effects. You'll see this in two ways: First, you'll notice that the Smart Brush tool automatically adds a new adjustment layer to the Layers palette. If you ever find the effect is too harsh, you can always reduce the opacity of the layer to reduce the effect.

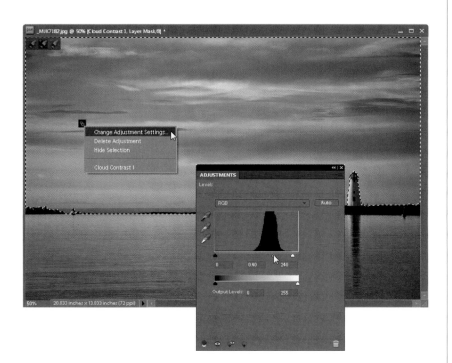

Step Eight:

Also, you may have noticed a tiny red box on your photo where you started to paint with the Smart Brush tool. This is the adjustment marker letting you know you've applied a Smart Brush adjustment to the photo. If you Right-click on it, you'll see you can delete it if you want or you can change the adjustment settings. Clicking Delete Adjustment does just what you think it does—the adjustment will be removed totally. But try clicking Change Adjustment Settings instead. It brings up the Adjustments palette with the controls for whatever adjustment Elements used to achieve your effect. If you're familiar with the Adjustments palette, you can always try tweaking the settings. In this case, Levels was used, so the Levels controls appeared in the palette. If I wanted to try to make the sky even darker, I could drag that middle gray slider below the histogram toward the right a little.

Step Nine:

One more thing: the Smart Brush tool is so smart that you can not only change the adjustment settings, but you can also totally change the Smart Brush adjustment you've applied. For example, let's say I want to see what the Blue Skies adjustment looks like. Just click on the Blue Skies preset in the Options Bar and Elements will swap out the Cloud Contrast adjustment with the Blue Skies one. If you like it, then keep it; if not, then just click back on the first preset you chose or try a new one altogether. Once you're finished, just choose Flatten Image from the Layers palette's flyout menu.

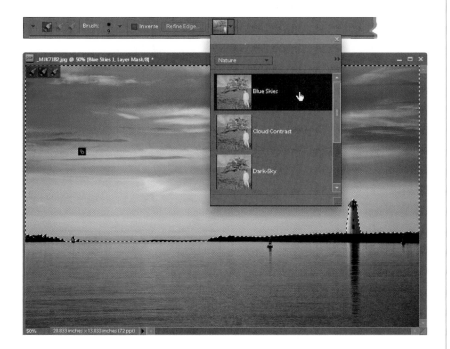

Continued

Before *After (with the Blue Skies preset)*

Digital noise is that stuff (or junk) that you see throughout your photo if you shoot with a high ISO (it also happens when you use a low-quality camera). It typically pops up in low-light photos, but can really rear its ugly head at other times, too. While you can't remove all of this noise in Photoshop Elements, you can reduce its appearance with a filter. Here's how:

Removing Digital Noise

Step One:
Open the photo that was taken in low lighting (or using a high ISO setting) and has visible digital noise. This noise will be most obvious when viewed at a magnification of 100% or higher (noise appears in the part of the balloon at the bottom of this photo, although it's hard to see at the small size of the image here). *Note:* If you view your photos at smaller sizes, you may not notice the noise until you make your prints.

Step Two:
Go under the Filter menu, under Noise, and choose Reduce Noise. The default settings really aren't too bad, but if you're having a lot of color aliasing (dots or splotchy areas of red, green, and blue), drag the Reduce Color Noise slider to the right (try 65% and see how that works).

Continued

Step Three:

One thing to watch out for when using this filter is that, although it can reduce noise, it can also make your photo a bit blurry, and the higher the Strength setting and the higher the amount of Reduce Color Noise, the blurrier your photo will become. If the noise is really bad, you may prefer a bit of blur to an incredibly noisy photo, so you'll have to make the call as to how much blur-ring is acceptable, but to reduce the amount of blur a bit, drag the Preserve Details slider to the right.

TIP: See a Before/After

To see an instant before/after of the Reduce Noise filter's effect on your photo without clicking the OK button, click your cursor within the Reduce Noise dialog's preview window. When you click-and-hold within that window, you'll see the before version without the filter (zoom in if you need to). When you release the mouse button, you'll see how the photo will look if you click the OK button.

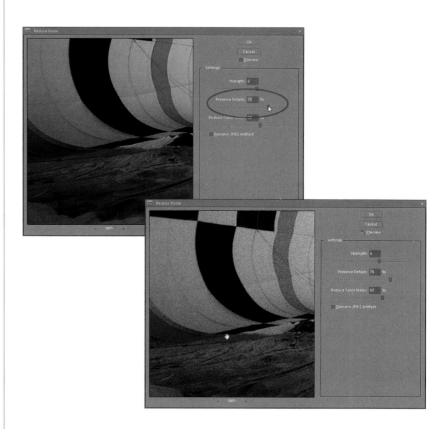

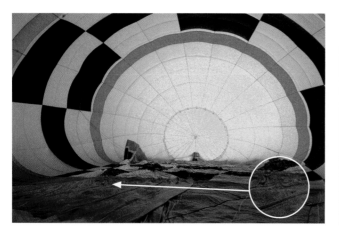

Before (although it's difficult to see, look for the digital noise in the part of the balloon on the ground)

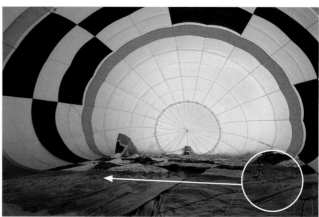

After (noise removed using a slight blur from the Reduce Noise filter)

I've got some bad news and some good news (don't you hate it when people start a conversation like that?). The bad news first (yeah, I like it that way, too): Elements' Dodge and Burn tools are kind of lame. The pros don't use them and, after you read this tutorial, I hope you won't either. The good news...there is a great method the pros do use to dodge and burn and it's totally non-destructive. It's flexible and really quite easy to use. See, isn't it better to end on a good note (with the good news, that is)?

Focusing Light with Digital Dodging and Burning

Step One:
In this tutorial, we're going to dodge areas to add some highlights, then we're going to burn in the background a bit to darken some of those areas. Start by opening the photo you want to dodge and burn.

Step Two:
Go to the Layers palette, click on the down-facing arrow at the top right, and from the flyout menu, choose New Layer (or just **Alt-click [Mac: Option-click]** on the Create a New Layer icon at the bottom of the palette). This accesses the New Layer dialog, which is needed for this technique to work.

Continued

Step Three:

In the New Layer dialog, change the Mode to Overlay, then right below that, turn on the checkbox for Fill with Overlay-Neutral Color (50% Gray). This is normally grayed out, but when you switch to Overlay mode, this choice becomes available. Click the checkbox to turn it on, then click OK.

Step Four:

This creates a new layer, filled with 50% gray, above your Background layer. (When you fill a layer with 50% gray and change the Mode to Overlay, Elements ignores the color. You'll see a gray thumbnail in the Layers palette, but the layer will appear transparent in your image window.)

Step Five:

Press **B** to switch to the Brush tool, and choose a medium, soft-edged brush from the Brush Picker (which opens when you click on the Brush thumbnail in the Options Bar). While in the Options Bar, lower the Opacity to approximately 30%.

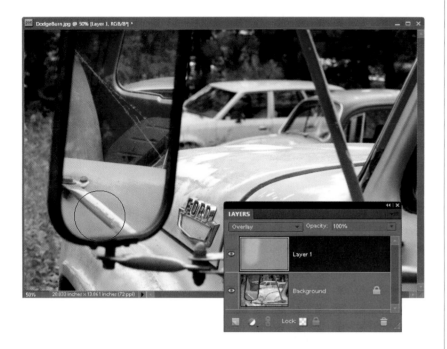

Step Six:
Press **D**, then **X** to set your Foreground color to white. Begin painting over the areas that you want to highlight (dodge). As you paint, you'll see light gray strokes appear in the thumbnail of your gray transparent layer, and in the image window, you'll see soft highlights.

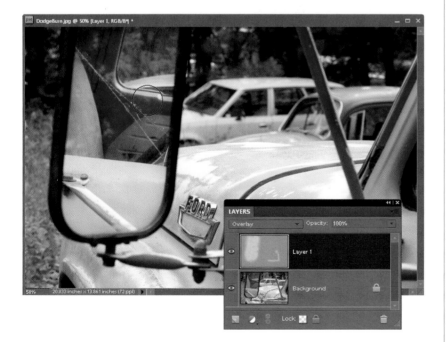

Step Seven:
If your first stab at dodging isn't as intense as you'd like, just release the mouse button, click again, and paint over the same area. Since you're dodging at a low opacity, the highlights will "build up" as you paint over previous strokes. If the highlights appear too intense, just go to the Layers palette and lower the Opacity setting of your gray layer until they blend in.

Continued

Step Eight:

If there are areas you want to darken (burn) so they're less prominent (such as the background or the truck's hood), just press **D** to switch your Foreground color to black and begin painting in those areas. Okay, ready for another dodging-and-burning method? Good, 'cause I've got a great one.

Alternate Technique:

Open the photo that you want to dodge and burn, then just click on the Create a New Layer icon in the Layers palette and change the blend mode to Soft Light. Now, set white as your Foreground color and you can dodge right on this layer using the Brush tool set to 30% Opacity. To burn, just as before, switch to black. The dodging and burning using this Soft Light layer appears a bit softer and milder than the previous technique, so you should definitely try both to see which one you prefer.

Before

After

Opening Up Shadow Areas That Are Too Dark

One of the most common problems you'll run into with your digital photos is that the shadow areas are too dark. Fortunately for you, since it is the most common problem, digital photo software like Elements has gotten really good at fixing this problem. Here's how it's done:

Step One:
Open the photo that needs to have its shadow areas opened up to reveal detail that was "lost in the shadows."

Step Two:
Go under the Enhance menu, look under Adjust Lighting, and choose Shadows/Highlights.

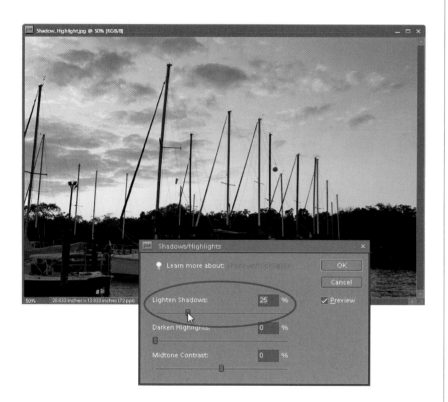

Step Three:
When the dialog appears, it already assumes you have a shadow problem (sadly, most people do but never admit it), so it automatically opens up the shadow areas in your document by 25% (you'll see that the Lighten Shadows slider is at 25% by default [0% is no lightening of the shadows]). If you want to open up the shadow areas even more, drag the Lighten Shadows slider to the right. If the shadows appear to be opened too much with the default 25% increase, drag the slider to the left to a setting below 25%. When the shadows look right, click OK. Your repair is complete.

Before

After

Fixing Areas That Are Too Bright

Although most of the lighting problems you'll encounter are in the shadow areas of your photos, you'll be surprised how many times there's an area that is too bright (perhaps an area that's lit with harsh, direct sunlight, or you exposed for the foreground but the background is now overexposed). Luckily, this is now an easy fix, too!

Step One:
Open the photo that has highlights that you want to tone down a bit. *Note:* If it's an individual area (like the sun shining directly on your subject's hair), you'll want to press the **L key** to switch to the Lasso tool and put a loose selection around that area. Then go under the Select menu and choose Feather. For low-res, 72-ppi images, enter 2 pixels and click OK. For high-res, 300-ppi images, try 8 pixels.

©ISTOCKPHOTO/MICHAEL SVOBODA

Step Two:
Now go under the Enhance menu, under Adjust Lighting, and choose Shadows/Highlights.

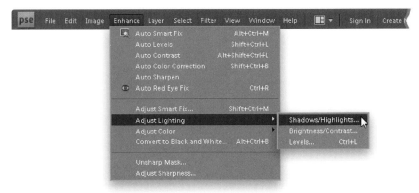

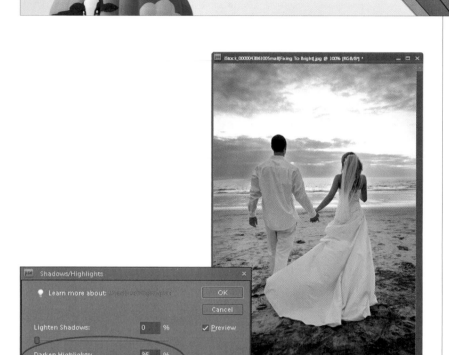

Step Three:
When the dialog appears, drag the Lighten Shadows slider to 0% and drag the Darken Highlights slider to the right, and as you do, the highlights will decrease, bringing back detail and balancing the overall tone of your (selected) highlights with the rest of your photo. (You'll mainly see it in the sky, shirt, dress, and veil here. They were just white before and now they've got more detail.) Sometimes when you make adjustments to the highlights (or shadows), you can lose some of the contrast in the midtone areas (they can become muddy or flat looking, or they can become oversaturated). If that happens, drag the Midtone Contrast slider (at the bottom of the dialog) to the right to increase the amount of midtone contrast, or drag to the left to reduce it. Then click OK. *Note:* If you made a selection, you'll need to press **Ctrl-D (Mac: Command-D)** to Deselect when you're finished.

Before

After

When Your Subject Is Too Dark

Sometimes your subject is too dark and blends into the background: maybe there just wasn't enough light, or you forgot to use fill flash, or a host of other reasons that could have caused this. You could go and retake the photo if you realize it right away. However, you don't always realize it immediately, so you'll need to get Elements to help out. For those times, there's a really clever way in Elements to essentially paint your light onto the subject after the fact.

Step One:
Open a photo where the subject(s) of the image appears too dark.

Step Two:
Click on the Create New Adjustment Layer icon at the bottom of the Layers palette (shown circled here), and choose Levels. This will add a Levels adjustment layer above your Background layer, and open the Adjustments palette with the Levels controls available.

Step Three:

Drag the middle gray Input Levels slider (under the histogram) to the left until your subject(s) looks properly exposed. (*Note:* Don't worry about how the background looks—it will probably become completely blown out, but you'll fix that later—for now, just focus on making your subject look right.) If the midtones slider doesn't bring out the subject enough, you may have to increase the highlights as well, so drag the far-right (white) Input Levels slider to the left to increase the highlights.

Step Four:

When your subject looks properly exposed, press **D** to set your Foreground color to white and your Background color to black. Then press **Ctrl-Backspace (Mac: Command-Delete)** to fill the layer mask with black and remove the brightening of the photo. Press **B** to switch to the Brush tool and click on the Brush thumbnail in the Options Bar to open the Brush Picker, where you'll choose a soft-edged brush. Now, you'll paint (on the layer mask) over the areas of the image that need a fill flash with your newly created "Fill Flash" brush. The areas you paint over will appear lighter, because you're "painting in" the lightening of your image on this layer.

Continued

Step Five:
Continue painting until it looks as if you had used a fill flash. If the effect appears too intense, just lower the opacity of the adjustment layer by dragging the Opacity slider to the left in the Layers palette (as shown here).

TIP: Try the Smart Brush Tool Instead
The Smart Brush tool (covered at the beginning of this chapter) has a Portrait preset called Lighten Skin Tones that also works pretty well in cases like this.

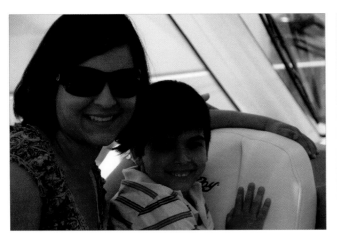

Before

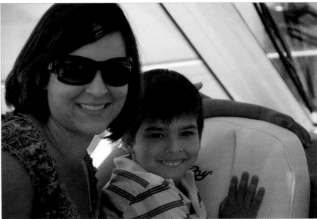

After

It just doesn't get any easier than this. If you dislike (maybe even dread) opening up the Levels dialog to make a tonal correction, then give this a try first. It's not always perfect, but you'll know in about 10 seconds whether or not it works. If it doesn't work, well then, you'll have to suck it up and go the Levels route (sorry, it's a cruel world out there sometimes).

Fixing Under- or Overexposed Photos

Step One:
Open an underexposed photo that could've used either a fill flash or a better exposure setting. Make a copy of the Background layer by pressing **Ctrl-J (Mac: Command-J)**. This will create a layer titled "Layer 1."

Step Two:
In the Layers palette, change the blend mode of this new layer from Normal to Screen to lighten the entire photo. If the photo still isn't properly exposed, press Ctrl-J again to duplicate this Screen layer, and keep duplicating it until the exposure looks about right (this may take a few layers, but don't be shy about it—keep going until it looks good).

Continued

Step Three:
There's a good chance that at some point you'll duplicate the Screen layer again and the image will look overexposed. What you need is "half a layer"—half as much lightening. Here's what to do: Lower the Opacity of your top layer to "dial in" the perfect amount of light, giving you something between the full intensity of the layer (at 100%) and no layer at all (at 0%). For half the intensity, try 50%. (Did I really even have to say that last line? Didn't think so.) Once the photo looks properly exposed, click on the down-facing arrow at the top right of the Layers palette and choose Flatten Image from the flyout menu.

P.S. Yep, I know this isn't an email or a letter so P.S. probably isn't appropriate here, but it caught your attention, didn't it? What if you have an overexposed photo? Here we just covered a trick for underexposed photos, but the same technique works if the photo is overexposed. Check it out below.

Step Four:
For an overexposed photo, you pretty much do the same thing: you start by duplicating the Background layer (as shown here), so it's exactly the same thus far.

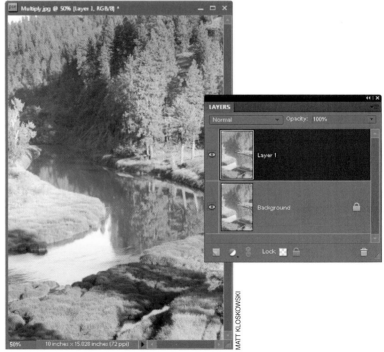

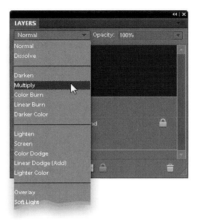

Step Five:
The only difference in this technique is that instead of choosing Screen mode (which makes things lighter), you'll choose Multiply (as shown here), which makes the image darker. Even just adding one Multiply layer looks dramatically better. In the After example shown below, I duplicated the Multiply layer (for a total of three layers) to get the trees, water, and grass darker, then reduced the opacity of the top layer to 70%. So, the next time you run across a photo that's too light or too dark, give one of these two 15-second fixes a try.

P.S. (There's that misused P.S. again.) These techniques are particularly handy when you're working on restoring old scanned family photos, so give 'em a try.

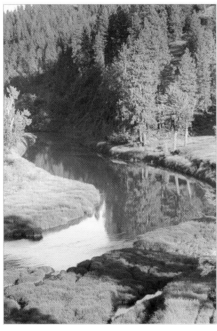

Before

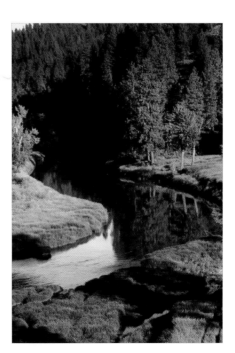

After

Automatic Red-Eye Removal

If you just finished shooting an indoor event with lots of flash and low light, chances are you're going to have a ton of photos with red eyes. If you know this ahead of time, then the feature you're about to see comes in very handy. You can set up Elements to automatically remove red eye as your photos are being imported into the Organizer. No interaction by you is needed. Just let Elements do its work and by the time you see your photos onscreen, you'll never even know red eye existed.

Step One:
First, we'll start with the fully automatic version, which you can use when you're importing photos into the Organizer. (*Note:* This option is not available in Bridge for Mac users.) Here's how it works: When importing photos, the Elements Organizer–Photo Downloader dialog appears. On the right side of the dialog, in the Advanced Options section, there's a checkbox for Automatically Fix Red Eyes (if your dialog doesn't look like this, click on the Advanced Dialog button at the bottom). If you think some of the photos you're about to import will have red eye, just turn on this checkbox (shown circled here), and then click the Get Photos button to start the importing and the red-eye correction.

Step Two:
Once you click the Get Photos button, the Getting Media dialog will appear. In this dialog, there's a status bar indicating how many photos are being "fixed." It also shows you a preview of each photo it's importing.

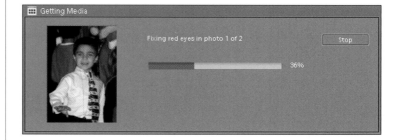

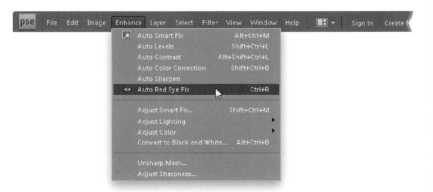

Step Three:
Once the process is complete, it automatically groups the original with the fixed version in a Version Set (you'll see an icon at the top right of the image thumbnail), so if you don't like the fix (for whatever reason), you still have the original. You can see both versions of the file by Right-clicking on the photo (in the Organizer) and in the contextual menu, under Version Set, choosing Expand Items in Version Set (or by just clicking on the right-facing arrow to the right of the image thumbnail).

Step Four:
Here is one of the photos with red eye and with it automatically removed.

Step Five:
This really isn't a step; it's another way to get an auto red eye fix, and that's by opening an image in the Editor, or even in Quick Fix, and then going under the Enhance menu and choosing Auto Red Eye Fix. You can also use the keyboard shortcut **Ctrl-R (Mac: Command-R)**. Either way, it senses where the red eye(s) is, removes it automatically, and life is good.

Instant Red-Eye Removal

When you use the flash on your digital point-and-shoot camera (or even the on-camera flash on a digital SLR), do you know what you're holding? It's called an A.R.E.M. (short for automated red-eye machine). Yep, that produces red eye like it's going out of style. Studios typically don't have this problem because of the equipment and positioning of the flashes, but sometimes you don't have a choice—it's either an on-camera flash or a really dark and blurry photo. In those cases, just accept the red eye. Become one with it and know that you can painlessly remove it with a couple of clicks in Elements.

Step One:
Open a photo where the subject has red eye.

MARGIE ROSENSTEIN

Step Two:
Press **Z** to switch to the Zoom tool (it looks like a magnifying glass in the Toolbox) and drag out a selection around the eyes (this zooms you in on the eyes). Now, press the letter **Y** to switch to the Red Eye Removal tool (its Toolbox icon looks like an eye with a tiny crosshair cursor in the left corner). There are two different ways to use this tool: click or click-and-drag. We'll start with the most precise, which is click. Take the Red Eye Removal tool and click it once directly on the red area of the pupil. It will isolate the red in the pupil and replace it with a neutral color. Instead, now you have "gray" eye, which doesn't look spectacular, but it's a heck of a lot better than red eye.

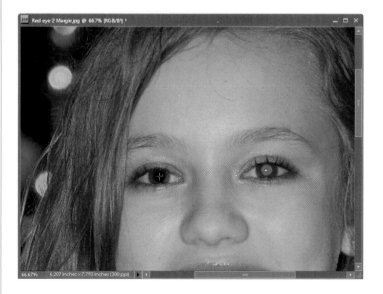

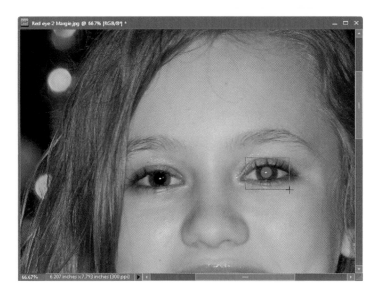

Step Three:
If the gray color that replaces the red seems too "gray," you can adjust the darkness of the replacement color by going to the Options Bar and adjusting the Darken Amount. To get better results, you may have to adjust the Pupil Size setting so that the area affected by the tool matches the size of the pupil. This is also done in the Options Bar when you have the Red Eye Removal tool selected. Now, on to the other way to use this tool (for really quick red-eye fixes).

Step Four:
If you have a lot of photos to fix, you may opt for this quicker red-eye fix—just click-and-drag the Red Eye Removal tool over the eye area (putting a square selection around the entire eye). The tool will determine where the red eye is within your selected area (your cursor will change to a timer), and it removes the red. Use this "drag" method on one eye at a time for the best results.

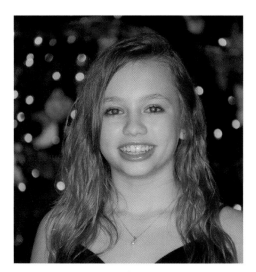

Before

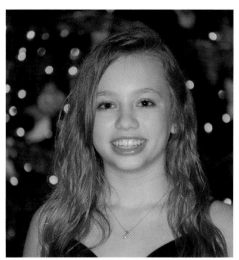

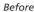

After

Fixing Problems Caused by Your Camera's Lens

Back in Elements 5, Adobe introduced a filter called the Correct Camera Distortion filter. It is pretty much a one-stop shop for repairing the most common problems caused by the camera's lens, including pincushion and barrel distortion, horizontal and vertical perspective problems, and edge vignetting.

Problem One:
Perspective Distortion

Step One:
The first problem we're going to tackle is perspective distortion. In the example shown here, the buildings all look like they are leaning towards the center of the photo.

©ISTOCKPHOTO/OLIVER MALMS

Step Two:
To fix this problem (caused by the lens), go under the Filter menu and choose Correct Camera Distortion. When the dialog appears, turn off the Show Grid checkbox at the bottom right of the preview window (it's on by default), then go to the Perspective Control section (on the center-right side of the dialog) and drag the Vertical Perspective slider to the left until the buildings start to look straight. When you make this correction, the filter pinches the bottom third of your photo inward, which leaves transparent gaps along the bottom and lower-side edges of your photo (you can see the checkerboard in these areas).

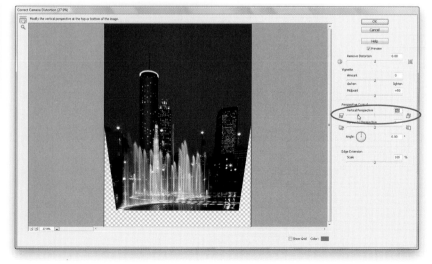

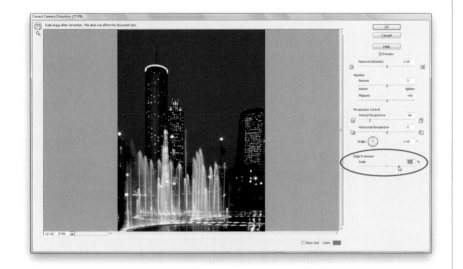

Step Three:
The Scale slider at the bottom of the dialog in the Edge Extension section lets you deal with these edge gaps caused by the perspective repair. Move the slider to the right to increase your image size in the frame, covering those gaps, so you don't have to crop your photo later.

Before (the buildings are leaning inward)

After (the perspective distortion is corrected)

Continued

Problem Two:
Barrel Distortion

Step One:
Another common lens correction problem is called barrel distortion, which makes your photo look bloated or rounded. So, open the Correct Camera Distortion filter again, but this time you're going to drag the Remove Distortion slider (in the top right of the dialog) slowly to the right to "pucker" the photo inward from the center, removing the rounded, bloated look. To remove pincushion distortion, in which the sides of your photo appear to curve inward, drag the slider to the left.

Step Two:
When you click OK, the correction will leave gaps around the edges, so get the Crop tool **(C)** and crop the image to hide the missing edges. It's hard to see the difference in the small images below, but try this technique, and you'll see the difference.

Before

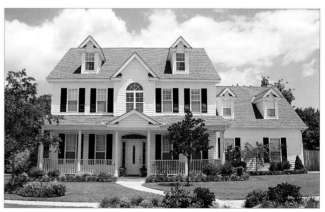

After (removing the bloating caused by barrel distortion)

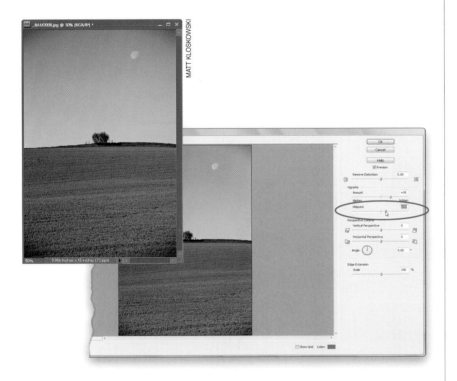

MATT KLOSKOWSKI

Problem Three:
Lens Vignetting

Step One:
Vignetting is a lens problem where the corners of your photo appear darkened. To remove this problem, go back to the Correct Camera Distortion filter.

Step Two:
In the Vignette section at the center-right side of the dialog, drag the Amount slider to the right, and as you do, you'll see the edges brighten. Keep dragging the slider until the edges match the brightness of the rest of the photo. The Midpoint slider (just below the Amount slider), determines how far into the photo your corner brightening will extend. In this case, you have to retract it just a little bit by dragging the slider to the right (as shown here), then click OK.

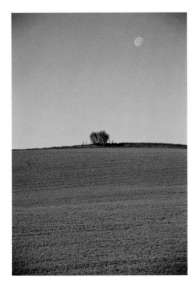

*Before (you can see the dark vignett-
ed areas in the corners)*

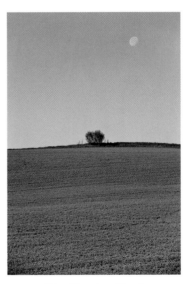

*After (the vignetting is
completely removed)*

The Elements Secret to Fixing Group Shots

Group shots can be a challenge. Everyone has to be looking and smiling at the right time. If one person isn't, then you have to shoot it again. The real problem comes from the fact that you really can't tell if everyone has their eyes open or is looking the right way from the small LCD on the back of your camera. So you get back and upload your photos only to find out that not one of them has everyone looking and smiling the way that they need to be. No sweat, with Elements' Group Shot feature. As long as you have a few photos to choose from, you can create the perfect group photo afterward.

Step One:
Here's a photo of some kids that I took. As you can see, the little boy on the right isn't looking at the camera.

Step Two:
If you've ever taken group shots before, you're guilty of photographing until your group threatens to riot or otherwise destroy your gear. Chances are, you took more photos of the same group before such threats ensued. So here's another shot that has the same group in it, but this time the boy is looking at the camera. Sweet! However, this time the boy in the middle doesn't have his eyes open like he did in the first photo. No problem. We're going to use the Group Shot feature to give us the best of both worlds and combine these photos.

Step Three:
At this point, you should have both photos open in the Editor. So, click on the down-facing arrow on the right of the Edit tab (on the top-right side of the Palette Bin) and choose EDIT Guided from the pop-up menu.

Note: A quick rule of thumb when using the Group Shot feature is to pick the best photo of the group as the first photo selected. See, Elements uses the first photo as the bottommost layer in the Layers palette. You'll see in a few steps, that makes it easier for us to go back later and restore the best parts of the photo with the Eraser tool.

TIP: Using More Photos
Even though I'm only using two photos here, you can use the Group Shot feature with up to 10 photos of the same group. So, if everyone is looking the wrong way, not smiling, or has their eyes closed at some point, you'll have a better chance of fixing the photo with more than two shots.

Step Four:
Next, in the Guided Edit panel, go down to the Photomerge section and click on Group Shot. A dialog will open (shown above) asking you to go back and select from two to 10 photos from the Project Bin or to select Open All. Since these are the only two photos I have open in the Editor, I just clicked Open All.

Continued

Step Five:

Now you're in the Photomerge Group Shot window. The first thing you need to do here is set up the photos as a source and a final. In the example here, I wanted the good photo of the little boy in the middle (with his eyes open) on the Source side (if it wasn't, I would've just clicked on its thumbnail down in the Project Bin). Then, I went to the Project Bin and clicked-and-dragged the thumbnail of the photo where the boy has his eyes closed (but where the boy on the right is looking at the camera and not off to the side) to the Final side. So basically, what I want to do is take the boy in the middle from the Source side (the one where his eyes are open) and use him to replace the boy in the middle on the Final side (where his eyes are closed).

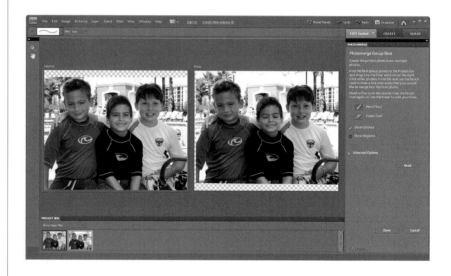

Step Six:

The rest is pretty easy: Make sure the Pencil tool is selected in the panel on the right-hand side. Then, paint on the area in the Source image that you want to appear in the Final image. In this example, I want the boy's eyes to be wide open, so I painted over the Source image where his face is (I even painted over his shirt a little, since it's close to his face). Elements will think for a moment, and magically replace the boy's face in the Final photo with the one from the Source photo.

TIP: Change Your Brush Size

Sometimes the default brush size is way too small and it takes you a while to paint in your source image. If that happens, then increase the Size setting in the Options Bar at the top of the screen to something larger.

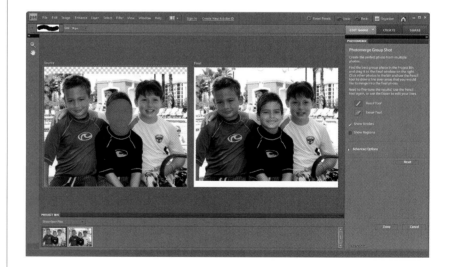

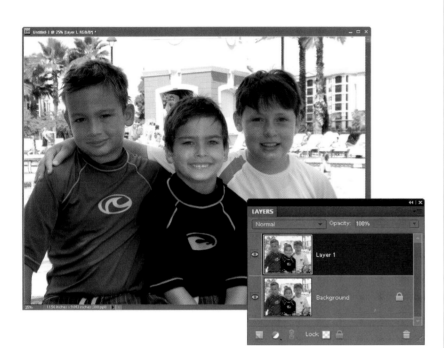

Step Seven:
At this point, if things look good (and trust me, things don't always look good here, although it may work on the first try), then click the Done button at the bottom right of the window, and choose EDIT Full from the EDIT tab's pop-up menu to return to the Editor. Your merged photo is in a new document with two layers (the original on the bottom and new merged photo on the top) in the Layers palette (use the Crop tool **[C]** to crop away any excess canvas).

TIP: Use the Eraser Tool to Fix It
If the Group Shot merge doesn't work perfectly, you can finesse it by painting with the Eraser tool **(E)** on the top layer to reveal the layer below. You'll want to zoom in really close, but it's a good trick to fix any flaws that remain.

Before #1 (the boy in the middle has his eyes open, but the boy on the right is looking off to the side)

Before #2 (the boy on the right is looking straight ahead, but now the boy in the middle has his eyes shut)

After (we've got the best of both worlds— the boy on the right is looking at the camera and the boy in the middle has his eyes wide open, all in the same shot)

Blending Multiple Exposures (a.k.a. Pseudo-HDR Technique)

As an outdoor photographer, one of the biggest battles you face is balancing the details in the highlights and shadows. Usually, you have to make a choice and set the camera's exposure to capture detail in the shadows (which produces bright, blown-out skies), or set the exposure for the brighter areas (which makes the darker areas almost black). With the new Photomerge Exposure feature, we can do both. If you've heard of HDR (High Dynamic Range) photography and software, it's similar—we take multiple photos with differing exposures and combine them together in Elements automatically (without a bunch of selections and layers).

Step One:
Open the photos you're going to merge together. Here are a couple of photos of the same subject. To make these photos, I set my camera on a tripod and just changed exposure settings to capture one photo with lots of details in the shadows (even though it looks really bright) and one photo with lots of detail in the highlight areas, such as the sky (even though the other areas look too dark).

TIP: Try This with Portraits, Too
This doesn't just work on landscape photos. You can try this with people, too. The key here is to have them be as still as possible. Oh, and you don't always have to be on a tripod, but it sure helps you get a better result in the end.

Step Two:
Go to the File menu, choose New, and then choose Photomerge Exposure. In the resulting dialog, click Open All.

Step Three:

This takes you into the Photomerge Exposure window. On the right side, you'll see two tabs: Automatic and Manual. Automatic has two modes in it: Simple Blending and Smart Blending. Manual mode has some settings, as well, but we'll check out Automatic first.

Step Four: Automatic Mode— Simple Blending

When you're in Automatic mode, Elements starts you out using the Smart Blending option. In this example (in the top capture), it doesn't look that great, so switch to the Simple Blending option (as shown below). Not bad, huh? I mean, check out the sky. It was pretty blown out in one of the original photos, but it looks good here and the shadowy areas under the overhangs actually have detail (remember they were almost black in the other original). Elements has essentially taken the best parts of each photo and automatically blended them together. If you're happy with it, then just click Done near the bottom right of the window to return to the Editor (you may have to crop off some excess areas). The problem with this option, though, is that it has no settings at all (the sliders in the panel are not active). You get what you get and if you're not happy with it, well, you'll have to resort to another method. So, we'll look at the Smart Blending option next.

TIP: Using More Photos

Even though I'm only using two photos here, you can use Photomerge Exposure with up to 10 photos of the same scene. Honestly, 10 is kinda overkill, but if you had a really contrasty scene with lots of bright highlights and dark shadows (say, inside of a house with lots of windows on a bright, sunny day), you may want to take three or four of the same scene with different exposures.

Continued

Step Five: **Automatic Mode—Smart Blending**

Try opening two more photos, go to the File menu, choose New, and then choose Photomerge Exposure, again. Click on the Simple Blending radio button just to compare. It's not bad, but I think the rocks in the foreground are too dark. That's why we'll use Smart Blending, so click back on the Smart Blending radio button. Elements still tries its best to blend the photos, but the difference here is that you'll see the three sliders are now active and can help you get better results. The first one is Highlight Details. Move this slider if the highlights (or really bright parts of the photo) look too bright. In this example, I thought the sky and the clouds were looking a little too bright, so I moved the Highlights slider to the right to darken them a little.

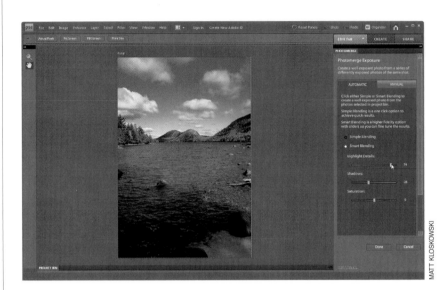

Step Six:

Now take a look at the shadow areas, of the blended photo. If they look too bright or too dark, then you can move the Shadows slider to help out. Let's move it to the right to brighten them here. In fact, I can get away with a lot of brightening because the foreground is really dark in this example. Be careful, though. You don't want to make the shadows too bright. You won't immediately know what's wrong with the photo, but your mind just kinda knows something isn't right here, since it's not used to seeing nice bright skies and really bright foreground areas, as well.

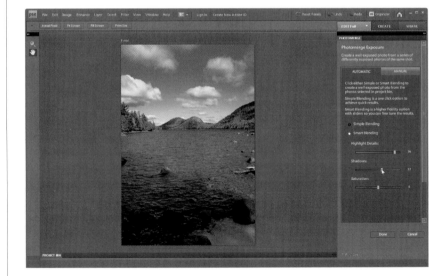

TIP: Which Way to Drag

One way to know what dragging the Highlight Details or Shadows slider will do is to look at the slider itself— it goes from white to black. So, if you want to make something darker, drag the slider toward the dark part of the gradient, or toward the light part to make it lighter.

MATT KLOSKOWSKI

Step Seven:

When you're merging different exposures together, you'll often lose some saturation in the photo, so Adobe included a Saturation slider, as well, in case you need to bump it up a little. Be careful here, though. I've never run into a photo that needed a Saturation setting of more than 30–35. If you start moving it too far, your photo will end up looking radioactive. If you're not happy with the results, you can always hit the Reset button to get back to the default settings.

TIP: Read Chapter 4

The Saturation slider here is fine, but if you've read Chapter 4, you can skip this and use the techniques you learned there to really get some control over color and saturation in specific parts of your photo.

Step Eight: **Manual Mode**

Here are two photos that didn't really work in Automatic mode. To me, Elements did too much blending of the foreground and background, and what I really want is to take the rocks from the foreground image (with a really bright sky) and combine them with the sky from the background image (with really dark rocks), but I don't want to make any complex selections or bother with layers. That's where the Manual mode comes in handy—when you literally want to grab something (rocks, or even a person) from one photo and move it into the other one. So click on the Manual tab at the top of the panel area. First, click on the photo that has your foreground in it (the brighter rocks) in the Project Bin to put it in the Foreground window on the left and then drag the photo of the background (the good sky) to the Background window on the right.

Continued

Step Nine:

Now, click on the Selection tool in the middle of the Manual tab, choose a brush size from the top of the window, and draw over parts of the Foreground photo (the one on the left) that you want to appear in the final image (the one on the right). Just a few quick scribbles over that rocky arch area should do it here. If you happen to scribble too much, or Elements pulls too much over from the Foreground photo, then click on the Eraser tool and use it to erase some of the scribbles.

Step 10:

One of the telltale signs that you've retouched this photo in some way is the fact that the foreground looks too bright. One way to combat this is to drag the Transparency slider (at the bottom of the Photomerge palette) to the right to reduce the brightness of the source (Foreground) image in the final (Background) image on the right. Give it a try here. I dragged mine to about 15 to darken the arch a little.

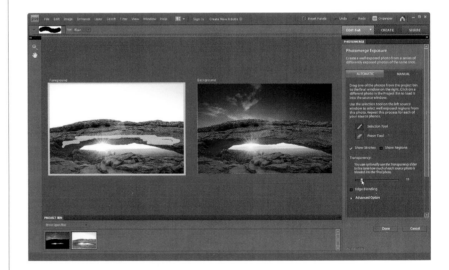

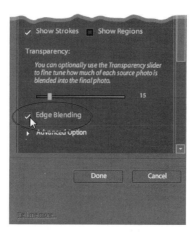

Step 11:
If you see a fringe along the edge of your selected area (I could see one between the arch and the sky in the last step), then try turning the Edge Blending checkbox on (below the Transparency slider) to help blend those edges together.

Here are the two before photos for the last image. Neither one of them look that great, and both would have needed some pretty heavy editing to turn them into what I actually "saw" when I took the shot.

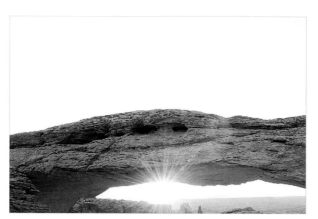

Before 1

Before 2

Continued

Here are the end results for the last image we worked on (I've compared both Automatic modes and the Manual mode).

ONE LAST TIP: If You Don't Shoot on a Tripod

If you didn't shoot on a tripod, the Photomerge feature can cause some pretty funky results in the final image, because Elements doesn't know which parts of the photos should overlap. In other words, if you laid them on top of each other, where the subject is in the top photo may not exactly match where it is in the bottom one. But you can help out by using the Alignment tool (the little blue target-looking thing at the bottom of the panel in Manual mode, under Advanced Option). Click on it to select the tool, then place three targets in key areas (corners, logos on a shirt, eyes, etc.) on the Foreground photo. Move over to the Background photo and do the same thing. Click the Align Photos button beneath the tool and Elements will do its best to align the photos with each other, so your end results look better.

*Automatic mode: Simple Blending
(no sliders available)*

*Automatic mode: Smart Blending
(using the few available sliders)*

*Manual mode (a quick brush selection, but that's it.
No major selections or layering needed)*

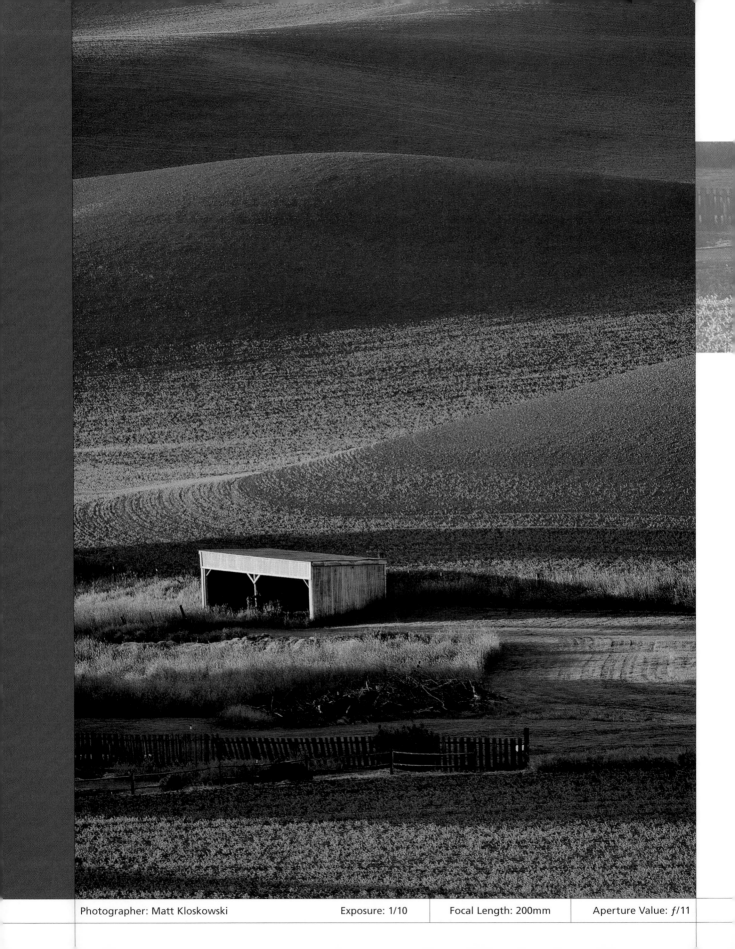

Photographer: Matt Kloskowski | Exposure: 1/10 | Focal Length: 200mm | Aperture Value: ƒ/11

The Mask
selection techniques

One of the problems with people is you can't always get them to stand in front of a white background so you can easily select them and place them on a different background in Elements 8. It's just not fair. If I were elected president, one of my first priorities would be to sign an executive order requiring all registered voters to carry with them a white, seamless roll at all times. Can you imagine how much easier life would be? For example, let's say you're a sports photographer and you're shooting an NFL *Monday Night Football* game with one of those Canon telephoto lenses that are longer than the underground tube for a particle accelerator; and just as the quarterback steps into the pocket to complete a pass, a fullback comes up from behind, quickly unfurls a white, seamless backdrop, and lets you take the shot. Do you know how fast you'd get a job at *Sports Illustrated*? Do you know how long I've waited to use "unfurl" in a sentence and actually use it in the proper context? Well, let's just say at least since I was 12 (three long years ago). In this chapter, you'll learn how to treat everyone, every object, every thing, as though it were shot on a white, seamless background.

Selecting Square, Rectangular, or Round Areas

Selections are an incredibly important topic in Elements. They're how you tell Elements to affect only specific areas of your photos. Whether it's moving part of one photo into another or simply trying to draw more attention to or enhance part of a photo, you'll have so much more control if you know how to select things better. For starters, Elements includes quick and easy ways to make basic selections (square, round, rectangle). These are probably the ones you'll use most, so let's start here.

Step One:
To make a rectangular selection, choose (big surprise) the Rectangular Marquee tool by pressing the **M key**. Adobe's word for selection is "marquee." (Why? Because calling it a marquee makes it more complicated than calling it what it really is—a selection tool—and giving tools complicated names is what Adobe does for fun.)

Step Two:
We're going to start by selecting a rectangle shape, so click your cursor in the upper left-hand corner of the barn wall and drag down and to the right until your selection covers the entire shape, then release the mouse button. That's it! You've got a selection, and anything you do now will affect only the area within that selected rectangle (in other words, it will only affect the red wall and windows of the barn).

Step Three:
To add another area to your current selection, just press-and-hold the Shift key, and then draw another rectangular selection. In our example here, you'll want to select the red cupola at the top, so press-and-hold the Shift key, drag out a rectangle around it, and release the mouse button. Now all the red is selected.

Step Four:
Now let's make an adjustment and you'll see that your adjustment will only affect your selected areas. Click on the Create New Adjustment Layer icon at the bottom of the Layers palette, and choose Levels from the pop-up menu. In the Adjustments palette, drag the middle gray slider under the histogram to the right (or left), and you'll see the red changes as you drag. More importantly, you'll see that nothing else changes—just those areas. This is why selections are so important—they are how you tell Elements you only want to adjust a specific area. You can also drag the white and black sliders to get the lighting you want. To Deselect (making your selection go away), just press **Ctrl-D (Mac: Command-D)**.

Continued

Step Five:

Okay, you've got rectangles, but what if you want to make a perfectly square selection? It's easy—the tool works the same way, but before you drag out your selection, you'll want to hold the Shift key down. Let's try it: open another image, get the Rectangular Marquee tool, press-and-hold the Shift key, and then draw a perfectly square selection (around the black area inside of this fake Polaroid frame, in this case).

©ISTOCKPHOTO/NICK BELTON

Step Six:

While your selection is still in place, open a photo that you'd like to appear inside your selected area and press **Ctrl-A (Mac: Command-A)**; this is the short-cut for Select All, which puts a selection around your entire photo at once. Then press **Ctrl-C (Mac: Command-C)** to copy that photo into Elements' memory.

©ISTOCKPHOTO/SEAN LOCKE

Step Seven:

Switch back to the Polaroid image, and you'll notice that your selection is still in place. Go under the Edit menu and choose Paste Into Selection. The image held in memory will appear pasted inside your square selection. If the photo is larger than the square you pasted it into, you can reposition the photo by just clicking-and-dragging it around inside your selected opening.

Step Eight:
You can also use Free Transform (press **Ctrl-T [Mac: Command-T]**) to scale the pasted photo in size. Just grab a corner point (press **Ctrl-0 [Mac: Command-0]** if you don't see them), press-and-hold the Shift key (or turn on the Constrain Proportions checkbox in the Options Bar), and drag inward or outward. When the size looks right, press the **Enter (Mac: Return) key** and you're done. (Well, sort of—you'll need to deselect, but only do this once you're satisfied with your image, because once you deselect, Elements flattens your new image into your Background layer, meaning there's no easy way to adjust this image.) Now, on to oval and circular selections…

Step Nine:
Open an image with a circle shape you want to select (the basketball here), and then press **M** to switch to the Elliptical Marquee tool (pressing M toggles you between the Rectangular and Elliptical Marquee tools by default). Now, just click-and-drag a selection around your circle. Press-and-hold the Shift key as you drag to make your selection perfectly round. If your round selection doesn't fit exactly, you can reposition it by moving your cursor inside the borders of your round selection and clicking-and-dragging to move it into position. You can also press-and-hold the Spacebar to move the selection as you're creating it. If you want to start over, just deselect, and then drag out a new selection. *Hint:* With circles, it helps if you start dragging before you reach the circle, so try starting about ¼" to the top left of the circle.

Continued

Step 10:

We'll change the ball's lighting to really make it pop, so go under the Enhance menu, under Adjust Lighting, and choose Shadows/Highlights. Crank the Lighten Shadows slider way up to 84%. Move the Darken Highlights slider up to around 10%. Finally, take the Midtone Contrast slider up to 66%. That should make the rather blah-looking basketball nice and crisp. Now deselect.

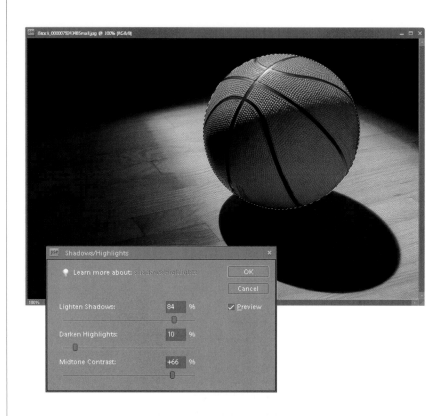

Step 11:

This isn't really a step, it's more of a recap: To make rectangles or ovals, you just grab the tool and start dragging. However, if you need to make a perfect square or a circle (rather than an oval), you press-and-hold the Shift key before you start dragging. You're starting to wish you'd paid attention in geometry class now, aren't you? No? Okay, me either.

If you've spent 15 or 20 minutes (or even longer) putting together an intricate selection, once you deselect it, it's gone. (Well, you might be able to get it back by choosing Reselect from the Select menu, as long as you haven't made any other selections in the meantime, but don't count on it. Ever.) Here's how to save your finely-honed selections and bring them back into place anytime you need them.

Saving Your Selections

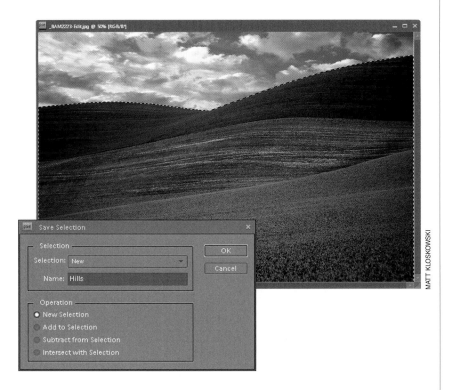

MATT KLOSKOWSKI

Step One:

Open an image and then put a selection around an object in your photo using the tool of your choice. Here I used the Quick Selection tool **(A)** to select the sky, then went under the Select menu and chose Inverse to select the ground. To save your selection once it's in place (so you can use it again later), go under the Select menu and choose Save Selection. This brings up the Save Selection dialog. Enter a name in the Name field and click OK to save your selection.

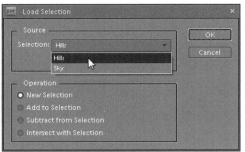

Step Two:

Now you can get that selection back (known as "reloading" by Elements wizards) at any time by going to the Select menu and choosing Load Selection. If you've saved more than one selection, they'll be listed in the Selection pop-up menu—just choose which one you want to "load" and click OK. The saved selection will appear in your image.

How to Select Things That Aren't Round, Square, or Rectangular

By now you know that selecting squares, rectangles, circles, or ovals is a total no-brainer. But things get a little stickier when the area you want to select isn't square or rectangular or, well…you get the idea. Luckily, although it's not quite the no-brainer of the Marquee tools, making those selections isn't hard—if you don't mind being just a little patient. And making these "non-conformist" selections can actually be fun. Here's a quick project to get your feet wet:

Step One:
Open a photo with an odd-shaped object that's not rectangular, square, etc. This is what the Lasso tool was born for, so press the **L key** to access it from the Toolbox.

Step Two:
Click-and-hold the Lasso tool on the object you want to select (in this case, you'll be selecting the drink glass on the left) and slowly (the key word here is slowly) drag the Lasso tool around the object, tracing its edges. If, after you're done, you've missed a spot, just press-and-hold the Shift key and click-and-drag around that missing area—it will be added to your selection. If you selected too much, press-and-hold the Alt (Mac: Option) key, click-and-drag around the area you shouldn't have selected, and it will be removed.

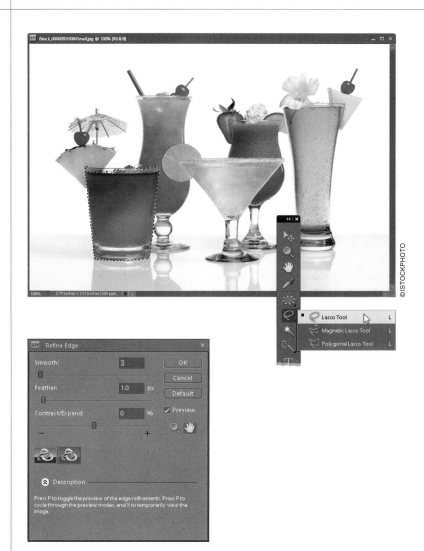

Step Three:
When the object is fully selected, click on the Refine Edge button in the Options Bar. This dialog lets you make your edges smoother (and just plain better), so no one can tell you've modified the image. We've always been able to do these things in Elements, but this dialog lets you see the changes so you don't have to guess what they'll look like.

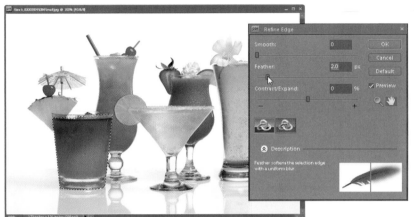

Step Four:
Set Smooth and Contract/Expand to 0 (zero). Then set the Feather amount to 2 px. This will soften the edges of the selection (turn the Preview checkbox on and off to see the difference). Click OK. Now we can make adjustments to the object without "getting caught."

Step Five:
In the example here, we're going to make the orange drink blue. Click on the Create New Adjustment Layer icon at the bottom of the Layers palette, and choose Hue/Saturation. In the Adjustments palette, drag the Hue slider to the left until the drink turns blue. When you do this, you'll quickly see if you made an accurate selection or not. If you see little slivers of orange, you missed those spots when you were doing your tracing with the Lasso tool. If you want to try again, just press **Ctrl-D (Mac: Command-D)** to Deselect, and then press **Ctrl-Z** (Undo; **Mac: Command-Z)** a few times until the original color comes back. Now you can try again, making sure you've got the entire drink accurately selected. Remember, this adjustment affects only the orange drink on the left, not the whole photo, because you selected it with the Lasso tool before you altered the color.

Softening Those Harsh Edges

When you make an adjustment to a selected area in a photo, your adjustment stays completely inside the selected area. That's great in many cases, but when you deselect, you'll see a hard edge around the area you adjusted, making the change look fairly obvious. However, softening those hard edges (thereby "hiding your tracks") is easy—here's how:

Step One:

Let's say you want to darken the area around the couple, so it looks almost like you shined a soft spotlight on them. Start by drawing an oval selection around the couple using the Elliptical Marquee tool (press **M** until you have it). Make the selection big enough so the couple and the surrounding area appear inside your selection. Now we're going to darken the area around them, so go under the Select menu and choose Inverse. This inverses the selection so you'll have everything but the couple selected (you'll use this trick often).

Step Two:

Click on the Create New Adjustment Layer icon at the bottom of the Layers palette, and choose Levels. In the Adjustments palette, drag the bottom right-hand Output Levels slider to the left to about 160 and then press **Ctrl-D (Mac: Command-D)** to Deselect. You can see the harsh edges around the oval, and it looks nothing like a soft spotlight—it looks like a bright oval. That's why we need to soften the edges so there's a smooth blend between the bright oval and the dark surroundings.

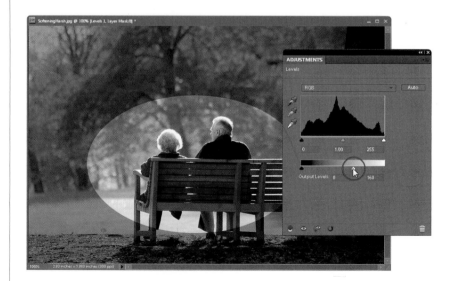

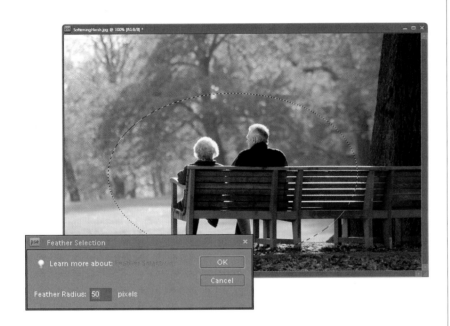

Step Three:
Press **Ctrl-Z (Mac: Command-Z)** three times so your photo looks like it did when you drew your selection in Step One (your selection should be in place—if not, drag out another oval). With your selection in place, go under the Select menu and choose Feather. When the Feather Selection dialog appears, enter 50 pixels (the higher the number, the more softening effect on the edges) and click OK. That's it—you've softened the edges. Now, let's see what a difference that makes.

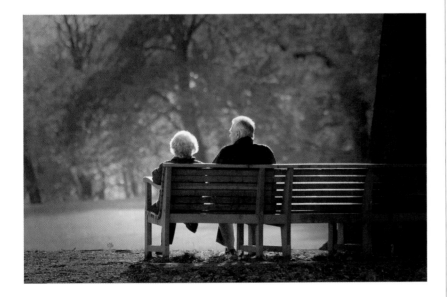

Step Four:
Go under the Select menu and choose Inverse again. Add a Levels adjustment layer again, drag the bottom-right Output Levels slider to between 150 and 160, deselect, and you can see that the edges of the area you adjusted are soft and blending together smoothly, so it looks more like a spotlight. Now, this comes in really handy when you're doing things like adjusting somebody with a face that's too red. Without feathering the edges, you'd see a hard line around your person's face where you made your adjustments, and it would be a dead giveaway that the photo had been adjusted. But add a little bit of feather (with a face, it might only take a Feather amount of 2 or 3 pixels), and it will blend right in, hiding the fact that you made an adjustment at all.

Selecting Areas by Their Color

So, would you select an entire solid-blue sky using the Rectangular Marquee tool? You probably wouldn't. Oh, you might use a combination of the Lasso and Rectangular Marquee tools, but even then it could be somewhat of a nightmare (depending on the photo). That's where the Magic Wand tool comes in. It selects by ranges of color, so instead of clicking-and-dragging to make a selection, you click once and the Magic Wand selects things in your photo that are fairly similar in color to the area you clicked on. The Magic Wand tool is pretty amazing by itself, but you can make it work even better.

Step One:
Open a photo that has a solid-color area that you want to select (in this case, it's the girl's bucket). Start by choosing the Magic Wand tool from the Toolbox (or press the **W key**). Then, click it once in the solid-color area you want to select. You can see that part of the bucket is selected, but not all of it (because, although the bucket is pink, there are all different shades of pink in it, caused by shadows and highlights. That's why this is such a good example—sometimes one click is all it takes and the whole object will be selected, but more often than not, you'll need to do a little more Magic Wanding to get all of the color).

MATT KLOSKOWSKI

Step Two:
As you can see above, the first click didn't select the entire area, so to add other areas to what you already have selected, just press-and-hold the Shift key, and then click on those parts of the bucket that aren't selected. Keep holding down the Shift key and click-ing on all the areas that you want to select until the entire bucket is selected, as shown here. It took about 10 Shift-clicks with the Magic Wand for me to get this bucket selected.

Step Three:
Now you can use a Hue/Saturation adjustment layer to change the color of the bucket, just like you did in an earlier technique. Click on the Create New Adjustment Layer icon at the bottom of the Layers palette, and choose Hue/Saturation. In the Adjustments palette, drag the Hue slider until the bucket looks the way you want it.

TIP: Increase the Tolerance
If you click in an area with the Magic Wand and not all of that area gets selected, then deselect **(Ctrl-D [Mac: Command-D])**, go to the Options Bar, increase the Tolerance setting, and try again. The higher the setting, the wider the range of colors it will select; so as a rule of thumb: if the Magic Wand doesn't select enough, increase the Tolerance amount. If it selects too much, decrease it.

Making Selections Using a Brush

A lot of people are more comfortable using brushes than using Marquee tools. If you're one of those people (you know who you are), then you're in luck—you can make your selections by painting over the areas you want selected. Even if this sounds weird, it's worth a try—you might really like it (it's the same way with sushi). A major advantage of painting your selections is that you can choose a soft-edged brush (if you like) to automatically give you feathered edges. Here's how it works:

Step One:
Choose the Selection Brush tool from the Toolbox (press the **A key** until you have it). Before you start, you'll want to choose your brush size by clicking on the Brush thumbnail in the Options Bar to open the Brush Picker. If you want a soft-edged selection (roughly equivalent to a feathered selection), choose a soft-edged brush in the Picker or change your brush's Hardness setting in the Options Bar: 0% gives a very soft edge, while 100% creates a very hard edge.

Step Two:
Now you can click-and-drag to "paint" the area you want selected. When you release the mouse button, the selection becomes active. *Note:* You don't have to hold down the Shift key to add to your selection when using this brush—just start painting somewhere else and it's added. However, you can press-and-hold the Alt (Mac: Option) key while painting to deselect areas.

MATT KLOSKOWSKI

Once you have one or more objects on a layer, putting a selection around everything on that layer is a one-click affair. What's especially great about this ability is that not only does it select the hard-edged areas in a layer, but it also selects the soft-edged areas, such as drop shadows. It'll make sense in a moment.

Selecting Everything on a Layer at Once

Step One:
Open a layered image in which one layer contains elements you want to select and alter. To instantly put a selection around everything on that layer, just **Ctrl-click (Mac: Command-click)** on that layer's thumbnail in the Layers palette (not its name; its thumbnail).

Step Two:
For one example of why you might want to do this, while your selection is still in place, open another photo, such as the girls seen here. Then press **Ctrl-A (Mac: Command-A)** to select the entire photo and **Ctrl-C (Mac: Command-C)** to copy it. Go back to the photo with the iMac in it and click on the Create a New Layer icon at the bottom of the Layers palette to make a new blank layer. Now go to the Edit menu and choose Paste Into Selection. If the photo is too big, just press **Ctrl-T (Mac: Command-T)** to bring up Free Transform and click-and-drag the corner handles to resize the photo so it fits better. Press **Enter (Mac: Return)** to lock in your transformation, then press **Ctrl-D (Mac: Command-D)** to Deselect.

Getting Elements to Help You Make Tricky Selections

If you've tried the Lasso tool for making selections, then you know two things: (1) it's pretty useful, and (2) tracing right along the edge of the object you're trying to select can be pretty tricky. But you can get help in the form of a tool called (are you ready for this?) the Magnetic Lasso tool! If the edges of the object you're trying to select are fairly well defined, this tool will automatically snap to the edges (as if they're magnetic), saving you time and frustration (well, it can save frustration if you know this technique).

Step One:
Click-and-hold for a moment on the Lasso tool in the Toolbox and a menu will pop up where you can choose the Magnetic Lasso tool (or just press the **L key** until you have it). Then, open an image in which you want to make a selection. Click once near the edge of the object you want to select. Without holding the mouse button, move the Magnetic Lasso tool along the edge of the object, and the selection will "snap" into place. Don't move too far away from the object; stay close to it for the best results.

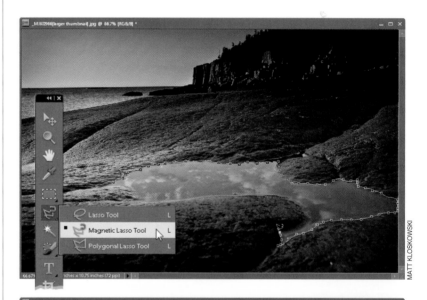

Step Two:
As you drag, the tool lays down little points along the edge. If you're dragging the mouse and it misses an edge, just press Backspace (Mac: Delete) to remove the last point and try again. If it still misses, press-and-hold the Alt (Mac: Option) key and then hold down the mouse button, which temporarily switches you to the regular Lasso tool. Drag a Lasso selection around the trouble area, then release the Alt key and the mouse button, and BAM— you're back to the Magnetic Lasso tool to finish up the job. *Note:* You can also click the Magnetic Lasso tool to add selection points if needed.

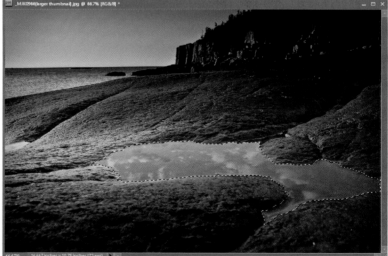

This is another one of those tools in Photoshop Elements that makes you think, "What kind of math must be going on behind the scenes?" because this is some pretty potent mojo for selecting an object (or objects) within your photo. What makes this even more amazing is that I was able to inject the word "mojo" into this introduction, and you didn't blink an eye. You're one of "us" now....

Easier Selections with the Quick Selection Tool

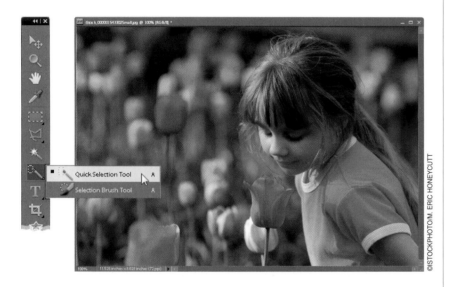

Step One:

Open the photo that has an object you want to select (in this example, we want to select the pink tulip the little girl is smelling). Go to the Toolbox and choose the Quick Selection tool (or just press the **A**, for Awesome, **key**).

Step Two:

The Quick Selection tool has an Auto-Enhance checkbox up in the Options Bar. By default, it's turned off. My line of thinking is this: when would I ever not want an enhanced (which in my book means better) selection from the Quick Selection tool? Seriously, would you ever make a selection and say, "Gosh, I wish this selection looked worse?" Probably not. So go ahead and turn on the Auto-Enhance check-box, and leave it that way from now until the cows come home. And if they ever do really come home, then you've probably got bigger problems.

Continued

Step Three:
Take the Quick Selection tool and simply paint squiggly brush strokes inside of what you want to select. You don't have to be precise, and that is what's so great about this tool—it digs squiggles. It longs for the squiggles. It needs the squiggles. So squiggle.

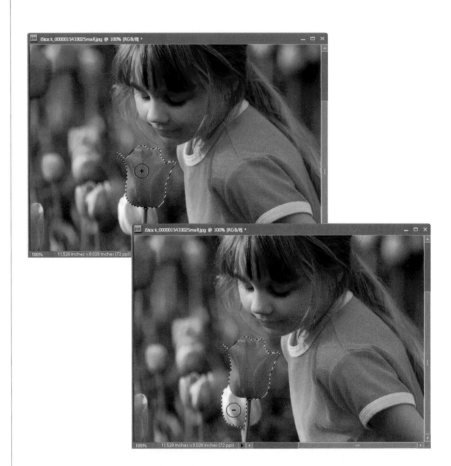

Step Four:
Once you release the mouse button, the Quick Selection tool makes your selection for you, based on the area that you painted over. If the selection includes areas you don't want, such as the lighter pink tulip below the darker one, simply press-and-hold the Alt (Mac: Option) key and paint over the unwanted part. This removes it from your selection.

Step Five:
Now that we've got it selected, we might as well do something to it, eh? How about this: let's leave the tulip pink, and make the background and little girl black and white. You start by going under the Select menu and choosing Inverse (which inverses your selection so you've got everything selected but the tulip). Go under the Enhance menu, under Adjust Color, and choose Remove Color. That's it. Now you can deselect by pressing **Ctrl-D (Mac: Command-D)**.

One of the most requested selection tasks is how to remove someone (or something) from a background. Luckily, this task has been made dramatically easier thanks to a fairly amazing tool called the Quick Selection tool (and you know if they use the word "quick" it must be true, thanks to rigid enforcement of the truth in advertising laws).

Removing People (or Objects) from Backgrounds

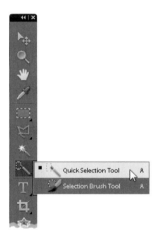

Step One:
You'll find the Quick Selection tool in the Toolbox (as you might expect) nested with the Selection Brush tool (or you can press **A** to get it).

Step Two:
Here's how it works: Just take the brush and drag it over the person or object you want to select (in this case, I wanted to select the whole family from the background, so I dragged across them). The first time I tried it, it almost selected all of them. The key word here is "almost." Sometimes, it does a perfect job and other times, well…not so perfect. But more often than not, it really works wonders. Now, if you drag over an area, and it doesn't get the entire person, just drag again over (or just click on) any areas it missed the first time. So, be prepared to drag one or more times to get them all. If you get part of the background in your selection, press-and-hold the Alt (Mac: Option) key and paint over the area you want removed.

Continued

Step Three:

Here the family is selected after just a couple of paint strokes. Then I used the Zoom tool **(Z)** to zoom in, and removed a few areas of sky and trees that were selected accidentally.

Step Four:

Well, now that we've got a selection, we might as well have some fun with it. Open a different image (in this case, a hilly landscape), then go back to your selected family image (make sure all your windows are floating by going under Window, under Images). Press **V** to get the Move tool, and drag your selected family right over onto the hilly landscape photo. If the people are too big, press **Ctrl-T (Mac: Command-T)** to bring up the Free Transform bounding box, then press-and-hold the Shift key (or turn on the Constrain Proportions checkbox in the Options Bar), grab a corner handle, and drag inward to scale it down to size. Press **Enter (Mac: Return)** to lock in your resizing. *Note:* If you can't see the corner handles, press **Ctrl-0** (zero; **Mac: Command-0**).

©ISTOCKPHOTO/BRANDON SMITH

Step Five:
Since you're a photographer, you've probably already noticed a problem or two. First, the depth of field doesn't look realistic here. Generally, the people should be in focus in the photo and the background should be blurry. The people also look too "cool" for the surroundings, so we'll have to remove some of the blue tint to make it look like the family is really in the scene. Let's take care of the depth of field first. Click on the landscape layer (the Background layer). Go under the Filter menu and, under Blur, choose Gaussian Blur. Enter a setting of around 1 to 2 pixels and click OK. This should make the people look more like they were really there.

Step Six:
Now, click on the family image layer (Layer 1) in the Layers palette. Go under the Filter menu, under Adjustments, and choose Photo Filter. From the Filter pop-up menu, choose Warming Filter (85). If the effect is too intense, reduce the Density a little, and the family will better match the warmer tones of the landscape photo. Click OK and you're done.

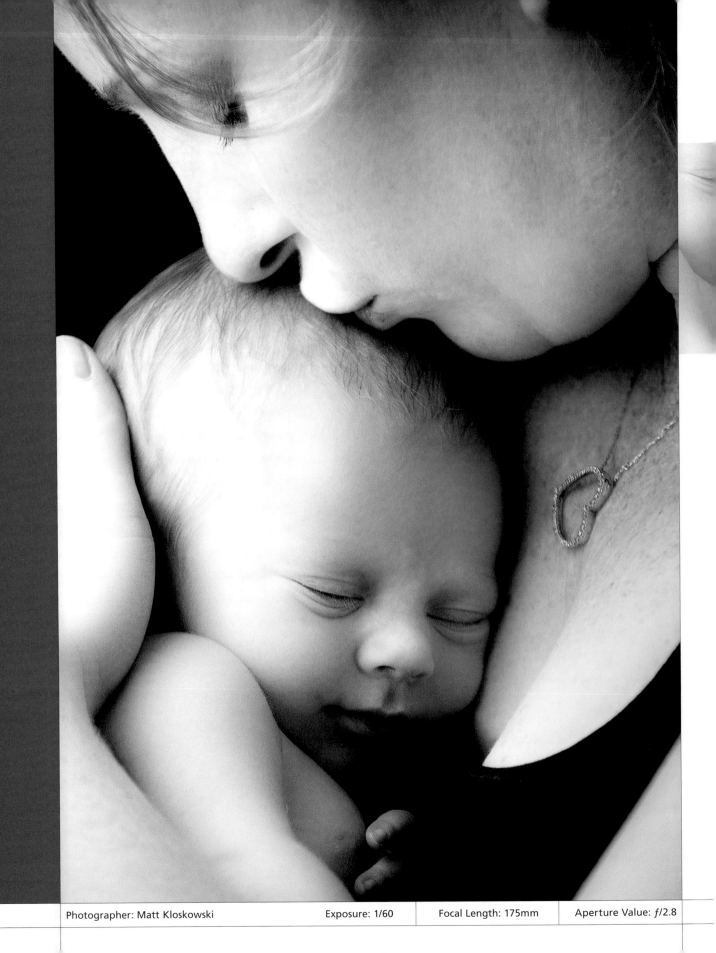

Photographer: Matt Kloskowski Exposure: 1/60 Focal Length: 175mm Aperture Value: ƒ/2.8

Faces
retouching portraits

Okay, this one isn't a song title (well, there are a bunch of songs with the word "faces" in the title), this one is actually a band name. Well, at least part of a band name—it's my tribute to Rod Stewart and Faces (of course, when he got really big, he quickly dumped Faces and just became Rod Stewart, but that wasn't until he got ahold of some really strong mousse). That type of thing always happens, doesn't it? It even happened to me a long time ago. When I first started retouching portraits, I started a firm called Scott Kelby and the Ugly Pug Fixers, and I would go to local bars and nightclubs and retouch photos of the doorman, or bouncer, or bartender, etc., but then one night I got my big break when I was able to retouch the club owner himself (I still remember him to this day—his name was Nigel Buttocks). Anyway, he had this crack in his smile, and I was able to use a combination of Elements tools to seamlessly remove his crack, and he was so gassed about the results that he cut one—of his in-house staff of retouchers and made me his new headliner. I'll never forget walking back into my old studio for the last time. All the Ugly Pug Fixers were there, and they could tell by the look in my eyes it was over. But thankfully, we're still friends to this very day, and every once in a while I'll run across a really hideous portrait of someone, and I'll jump in my Porsche 911 Turbo and drive over to their small, dimly lit retouching studio, and we'll pull the image up on the screen, look at the person with all those facial imperfections, and we'll just laugh and laugh. Gosh I miss those days.

Quick Skin Tone Fix

In photos of people, the most important thing is that the skin tone looks good. That's because it's really hard for someone looking at your photo to determine if the grass is exactly the right shade of green or if the sky is the right shade of blue; but if the skin tone is off, it sticks out like a sore thumb (which would be red if it were really sore). Here's a quick fix to get your skin tones patched up in a hurry:

Step One:
Open an image in which the flesh tone looks like it needs adjusting. In the example here, I photographed him early in the morning. As you can see, the skin is just too warm, so it definitely needs a fix to look right.

MATT KLOSKOWSKI

Step Two:
Go under the Enhance menu, under Adjust Color, and choose Adjust Color for Skin Tone.

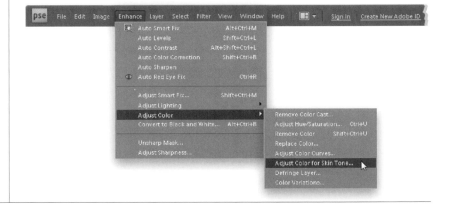

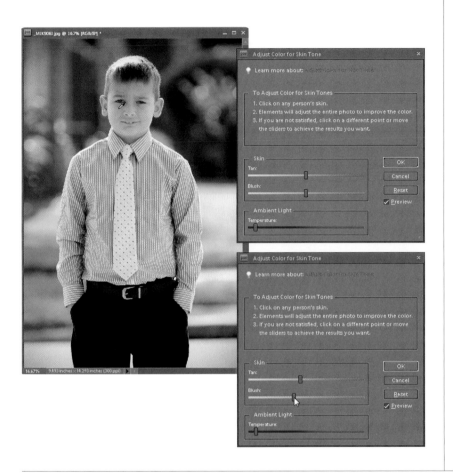

Step Three:
When the Adjust Color for Skin Tone dialog appears, move your cursor over an area of skin tone and click once to set the skin tone for the image. If you don't like your first results, click in a different area of skin tone until you find a skin-tone adjustment you're happy with.

Step Four:
You can also manually tweak the skin tone by using the Tan and Blush sliders, and you can control the overall tint of the light by dragging the Temperature slider to the left to make the skin tones cooler or to the right to make them warmer. *Note:* This skin-tone adjustment affects more than just skin—it usually warms the entire photo. If that creates a problem, use one of the selection tools (even the Lasso tool) to put a selection around the skin-tone areas first, add a 2-pixel Feather (under the Select menu), and then use the Adjust Color for Skin Tone command.

Before

After

Removing Blemishes and Hot Spots

Over the years, we've learned lots of different ways to remove hot spots, blemishes, and other imperfections on the skin. I believe the technique you're about to see here is the easiest and best way, though. It not only removes the blemishes, but it's flexible enough so you can maintain the original skin texture, as well. That way the skin looks real and not like the fakey, smooth skin that's always a dead giveaway the photo has been retouched in Elements.

Step One:
Open a photo containing some skin imperfections you want to remove (in this example, we're going to remove a series of blemishes). Get the Zoom tool **(Z)** and zoom in, if needed, on the area you want to retouch, then get the Healing Brush tool **(J)** from the Toolbox (as shown here). You might be tempted to use the Spot Healing Brush tool because it's so easy to use (and it's the default healing tool in the Toolbox), but don't fall for it. Although it does a pretty good job on its own, you can do better and work faster with the Healing Brush because you won't have to redo anything (and you generally will have several redos using the Spot Healing Brush). Besides, you only save one click using the Spot Healing Brush over the regular Healing Brush.

Step Two:
The key to using the Healing Brush correctly is to find an area of skin to sample that has a similar texture to the area you want to repair (this is different than the Clone Stamp tool, where you're looking for matching color and shading, as well). Move your cursor over this "clean" area of skin, press-and-hold the Alt (Mac: Option) key, and click once to sample that area. Your cursor will momentarily change to a target as you sample (as shown here).

Step Three:
Now, just move the Healing Brush directly over the blemish or hot spot you want to remove and simply click. Don't paint—click. Once. That's it. That's the whole technique—BAM—the blemish is gone!

TIP: Resizing Your Brush
For the best results, use a brush size that is just a little bit larger than the blemish or hot spot you want to remove (use the **Left/Right Bracket keys** on your keyboard [they're to the right of the letter P] to change brush sizes). Also, you don't have to worry about sampling an area right near where the blemish or hot spot is—you can sample from another side of the face, even in the shadows—just choose a similar texture, that's the key.

Before

After

Lessening Freckles or Facial Acne

This technique is popular with senior class portrait photographers who need to lessen or remove large areas of acne, pockmarks, or freckles from their subjects. This is especially useful when you have a lot of photos to retouch and don't have the time to use the method shown previously, where you deal with each blemish individually.

Step One:
Open the photo that you need to retouch. Make a duplicate of the Background layer by going to the Layer menu, under New, and choosing Layer via Copy (or just pressing **Ctrl-J [Mac: Command-J]**). We'll perform our retouch on this duplicate of the Background layer, named "Layer 1."

Step Two:
Go under the Filter menu, under Blur, and choose Gaussian Blur. When the Gaussian Blur dialog appears, drag the slider all the way to the left, then drag it slowly to the right until you see the freckles blurred away. The photo should look very blurry, but we'll fix that in just a minute, so don't let that throw you off—make sure it's blurry enough that the freckles are no longer visible. Click OK.

Step Three:
Press-and-hold the Ctrl (Mac: Command) key and click once on the Create a New Layer icon at the bottom of the Layers palette. This creates a new blank layer (Layer 2) directly beneath your current layer (the blurry Layer 1).

Step Four:
Now, in the Layers palette, click back on the top layer (the blurry Layer 1), then press **Ctrl-G (Mac: Command-G)** to group the blurry layer with the blank layer beneath it (Layer 2) and create a clipping mask. Doing this removes all the blurriness from view (and that's exactly what we want to do at this point).

Step Five:
In the Layers palette, click on the middle layer (the blank Layer 2), as you're going to paint on this layer. Press the letter **D** to set your Foreground color to black. Press the letter **B** to switch to the Brush tool, then click on the Brush thumbnail in the Options Bar, and from the Brush Picker choose a soft-edged brush.

Continued

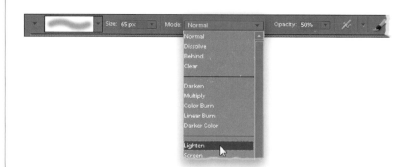

Step Six:

Lower the Opacity setting of your brush in the Options Bar to 50%, and change the Mode pop-up menu from Normal to Lighten. Now when you paint, it will affect only the pixels that are darker than the blurred state. Ahhh, do you see where this is going?

Step Seven:

Now you can paint over the freckle areas, and as you paint, you'll see them diminish quite a bit. If they diminish too much, and the person looks "too clean," undo (**Ctrl-Z [Mac: Command-Z]**), then lower the Opacity of the brush to 25% and try again.

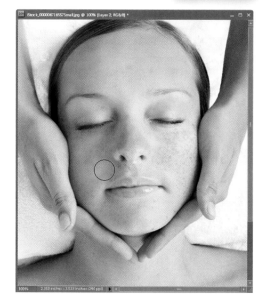

Before

After

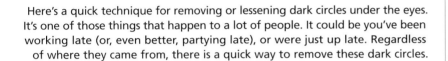

Here's a quick technique for removing or lessening dark circles under the eyes. It's one of those things that happen to a lot of people. It could be you've been working late (or, even better, partying late), or were just up late. Regardless of where they came from, there is a quick way to remove these dark circles.

Removing Dark Circles Under Eyes

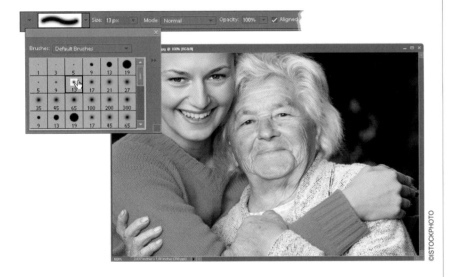

Step One:
Open the photo that has the dark circles you want to remove or lessen. Select the Clone Stamp tool in the Toolbox (or press the **S key**). Then, click on the Brush thumbnail in the Options Bar to open the Brush Picker and choose a soft-edged brush that's half as wide as the area you want to repair. *Note:* Press the letter **Z** to switch to the Zoom tool and zoom in if needed.

Step Two:
Go to the Options Bar and lower the Opacity of the Clone Stamp tool to 50%. Then, change the Mode pop-up menu to Lighten (so you'll only affect areas that are darker than where you'll sample from).

Continued

Step Three:
Press-and-hold the Alt (Mac: Option) key and click once in an area near the eye that isn't affected by the dark circles. If the cheeks aren't too rosy, you can click there, but more likely you'll click on (sample) an area just below the dark circles under the eyes.

Step Four:
Now, take the Clone Stamp tool and paint over the dark circles to lessen or remove them. It may take two or more strokes for the dark circles to pretty much disappear, so don't be afraid to go back over the same spot if the first stroke didn't work. *Note:* If you want the dark circles to completely disappear, try using the Healing Brush tool **(J)** from the Toolbox. Simply Alt-click (Mac: Option-click) the Healing Brush in a light area under the dark circles, and then paint the circles away.

Before

After

This is a great trick for removing wrinkles, with a little twist at the end (courtesy of my buddy Kevin Ames) that helps make the technique look more realistic. This little tweak makes a big difference because (depending on the age of the subject) removing every wrinkle would probably make the photo look obviously retouched (in other words, if you're retouching someone in their 70s and you make them look as if they're 20 years old, it's just going to look weird). Here's how to get a more realistic wrinkle removal:

Removing or Lessening Wrinkles

Step One:
Open the photo that needs some wrinkles or crow's-feet lessened or removed. Start by duplicating the Background layer by going to the Layer menu, under New, and choosing Layer via Copy (or pressing **Ctrl-J [Mac: Command-J]**). You'll perform your "wrinkle removal" on this duplicate layer, named "Layer 1" in the Layers palette.

Step Two:
Get the Healing Brush tool from the Toolbox (or press the **J key**). Then, use the **Left ([) and Right Bracket (])** **keys** to make your brush close to the size of the wrinkles you want to remove. Find a clean area that's somewhere near the wrinkles (perhaps the upper cheek if you're removing crow's-feet, or if you're removing forehead wrinkles, perhaps just above or below the wrinkle). Press-and-hold the Alt (Mac: Option) key and click once to sample the skin texture from that area. Now, take the Healing Brush tool and paint over the wrinkles. As you paint, the wrinkles will disappear, yet the texture and detail of the skin remains intact, which is why this tool is so amazing.

Continued

©ISTOCKPHOTO/PALI RAO

Step Three:
Now that the wrinkles are gone, it's time to bring just enough of them back to make it look realistic. Simply go to the Layers palette and reduce the Opacity of this layer to bring back some of the original wrinkles. This lets a small amount of the original photo (the Background layer, with all its wrinkles still intact) show through. Keep lowering the Opacity until you see the wrinkles, but not nearly as prominent as before.

Before

After

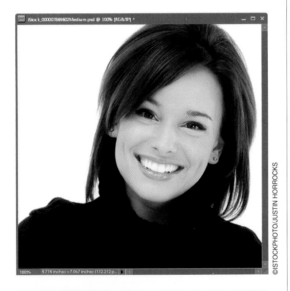

This is a great little technique for quickly whitening the whites of the eyes, and it has the added benefit of removing any redness in the eye along the way. *Note:* By redness, I mean the "bloodshot-I-stayed-up-too-late" type of redness, not the "red-eye-from-a-flash-mounted-above-the-lens" type of redness, which is addressed in Chapter 5.

Whitening the Eyes

Step One:
Open the photo where the subject's eyes need whitening. Press the letter **Z** to switch to the Zoom tool and zoom in if needed.

Step Two:
Choose the Lasso tool from the Toolbox (or press the **L key**) and draw a selection around one side of the whites in one of the eyes. Press-and-hold the Shift key and draw selections around the other area of whites in the same eye and the whites of the other eye, until all the whites are selected in both eyes. (*Note:* You can also try the Quick Selection tool **[A]** for this.) Go under the Select menu and choose Feather. You'll need to use Feather to soften the edges of your selection so your retouch isn't obvious. In the Feather Selection dialog, enter 2 pixels and click OK.

Continued

Step Three:
Click on the Create New Adjustment Layer icon at the bottom of the Layers palette, and choose Hue/Saturation. When the Hue/Saturation controls appear in the Adjustments palette, choose Reds from the pop-up menu at the top (to edit just the reds in the selection). Now, drag the Saturation slider to the left to lower the amount of red (which removes any bloodshot appearance in the whites of the eyes).

Step Four:
Then, switch the pop-up menu back to Master, and drag the Lightness slider to the right to increase the lightness of the whites of the eyes. Now your enhancement is complete. *Note:* Check out the Smart Brush tool (mentioned in Chapter 5). It has an effect (under Portrait in the preset pop-up menu) called Bright Eyes that does a pretty good job of this, as well.

Before

After

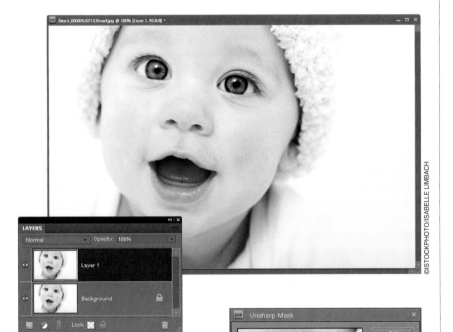

Making Eyes That Sparkle

This is another one of those 30-second miracles for enhancing the eyes. This technique makes the eyes seem to sparkle by accentuating the catch lights, and generally draws attention to the eyes by making them look sharp and crisp (crisp in the "sharp and clean" sense, not crisp in the "I-burned-my-retina-while-looking-at-the-sun" sense).

©ISTOCKPHOTO/ISABELLE LIMBACH

Step One:
Open the photo that you want to retouch. Make a duplicate of the Background layer by going under the Layer menu, under New, and choosing Layer via Copy (or pressing **Ctrl-J [Mac: Command-J]**), which creates a new layer named "Layer 1." *Note:* Press the **Z key** to switch to the Zoom tool and zoom in if needed.

Step Two:
Go under the Enhance menu and choose Unsharp Mask. (It sounds like this filter would make things blurry, but it's actually for sharpening photos.) When the Unsharp Mask dialog appears, enter your settings. (If you need some settings, go to the first technique, named "Basic Sharpening," in Chapter 10.) Here, we seem to be able to get away with a lot of sharpening (and I mean a lot), so I'm going to use Amount: 175, Radius: 1.5, and Threshold: 3. Then click OK to sharpen the entire photo.

Continued

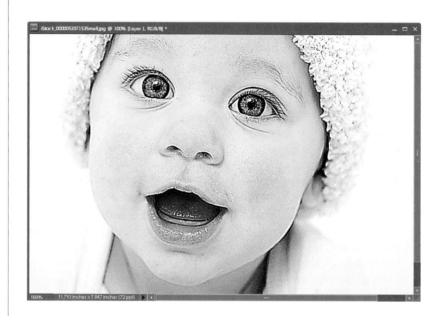

Step Three:

After you've applied the Unsharp Mask filter, apply it again using the same settings by pressing **Ctrl-F (Mac: Command-F)**, and then apply it one more time using the same keyboard shortcut (you'll apply it three times in all, although if you still think it's not enough, try it a fourth time). The eyes will probably look nice and crisp at this point, but the rest of the person will be severely oversharpened, and you'll probably see lots of noise and other unpleasant artifacts.

Step Four:

Press-and-hold the Ctrl (Mac: Command) key and click once on the Create a New Layer icon at the bottom of the Layers palette. This creates a new blank layer directly beneath your sharpened layer. Now, in the Layers palette, click back on the top layer (the sharpened layer), then press **Ctrl-G (Mac: Command-G)** to group the sharpened layer with the blank layer beneath it and create a clipping mask. This removes all the visible sharpness (at least for now). Then, click on the middle layer (the blank layer), as you're going to paint on this layer.

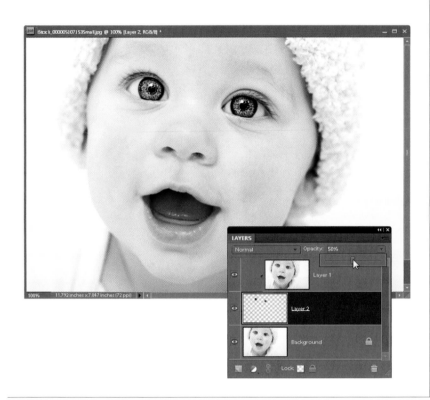

Step Five:

Press the letter **D** to set your Foreground color to black. Then, press **B** to switch to the Brush tool. Click on the Brush thumbnail in the Options Bar to open the Brush Picker, and choose a soft-edged brush that's a little smaller than your subject's eyes. Now paint over just the irises and pupils of the eyes to reveal the sharpening, making the eyes really sparkle and completing the effect. If the effect seems too strong (it did here), just lower the Opacity of the painted layer (Layer 2).

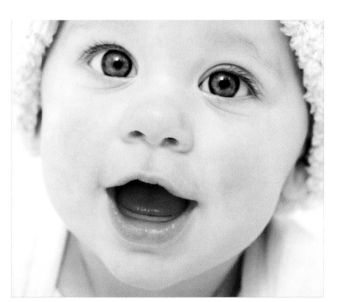

Before

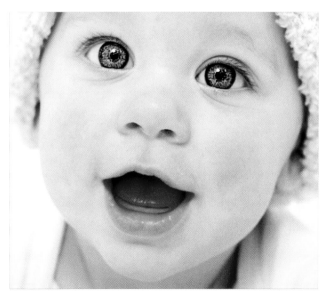

After

Whitening and Brightening Teeth

This really should be called "Removing Yellowing, Then Whitening Teeth" because almost everyone has some yellowing, so we remove that first before we move on to the whitening process. This is a simple technique, but the results have a big impact on the overall look of the portrait, and that's why I do this to every single portrait where the subject is smiling.

Step One:

Open the photo you need to retouch. Press **Z** to switch to the Zoom tool and zoom in if needed.

Step Two:

Press **L** to switch to the Lasso tool, and carefully draw a selection around the teeth, being careful not to select any of the gums or lips. If you've missed a spot, press-and-hold the Shift key while using the Lasso tool to add to your selection, or press-and-hold the Alt (Mac: Option) key and drag the Lasso to remove parts of the selection. If you've grown fond of the Quick Selection tool, then give that one a try here, as it works great too.

©ISTOCKPHOTO/MARK PAPAS

Step Three:
Go under the Select menu and choose Feather. When the Feather Selection dialog appears, enter 1 pixel and click OK to smooth the edges of your selection. That way, you won't see a hard edge along the area you selected once you've whitened the teeth.

Step Four:
Click on the Create New Adjustment Layer icon at the bottom of the Layers palette (it's the half-black/half-white circle icon) and choose Hue/Saturation. When the Hue/Saturation controls appear in the Adjustments palette, choose Yellows from the pop-up menu at the top. Then, drag the Saturation slider to the left to remove the yellowing from the teeth.

Continued

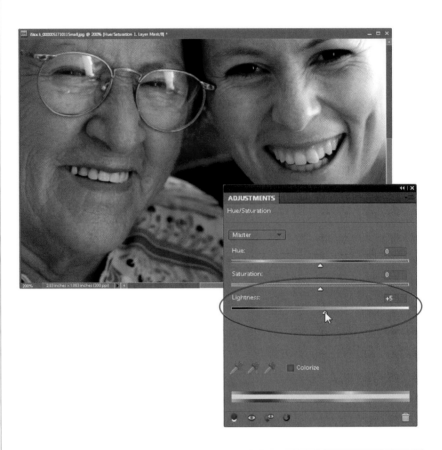

Step Five:

Now that the yellowing is removed, switch the pop-up menu back to Master, and drag the Lightness slider to the right to whiten and brighten the teeth. Be careful not to drag it too far, or the retouch will be obvious. Go ahead and whiten the other woman's teeth the same way. *Note:* The Smart Brush tool **(F)** has an effect (under the Portrait preset in the pop-up menu) called Pearly Whites, which does pretty much the same thing but in a little different way. And if that one doesn't do the trick for you, then there's another effect called Very Pearly Whites (you think I'm kidding, don't you?) that does, well, the same thing but more intense.

Before

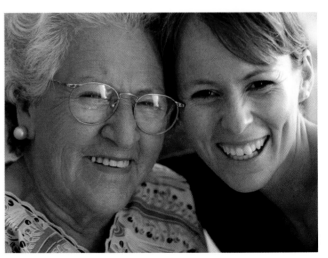

After

The tutorial you're about to read is perfect for (as Scott calls it) desnozilization, dehonkerizing, and unsnoutilation. The coolest part about it is that it uses a tool that you'd never think about using in your normal everyday Elements use. In fact, when you hear the name in Step Two you'll probably even laugh to yourself thinking we're going to play a joke on someone. Trust me, though—we're not. This tool has a ton of uses, and getting pro-quality retouching results is one of them.

Digital Nose Jobs Made Easy

Step One:
Open the photo that you want to retouch. By the way, did you notice how gentle I was in that opening phrase, and how I made no mention whatsoever of a somewhat minor facial retouch that might be considered in this instance? (Wait for it…wait for it…no! I'm not going to do it! Not this time. Not here. Not now.) Let's continue, shall we?

©ISTOCKPHOTO/JOSHUA BLAKE

Step Two:
Go to the Filter menu and, under Distort, choose Liquify. When the Liquify dialog appears (as seen here), choose the fifth tool down from the top of the Liquify Toolbox (the Big Honker tool), shown circled here in red. Okay, I tried to slip one past you. Actually, the real name of this tool is the Bulbous Nasal Retractor, or BNR for short. (Aw, come on, that last one was pretty funny. Even I heard you giggling.) Okay, if you must know, the official "Adobe name" for the tool is the Pucker tool, and basically it "puckers in" the area where you click it. The more you click it, the more it puckers.

Continued

Step Three:
Take the tool and move it right over your subject's nose (as shown here), and make the brush size a little bigger than the entire nose itself. The quickest way to do that is to press-and-hold the **Shift key** and press the **Right Bracket (])** **key** on your keyboard. Each time you press that, it will jump up 10 points in size. Once you have the size right, just click it three or four times (don't paint—just click). Here, I clicked three times, for obvious reasons. (Sorry, I couldn't help myself.)

Step Four:
Move the center of the brush over his left nostril and click two or three times, then do the same to the right nostril. Move to the bridge of the nose and click two or three times there, and you're done. Here, the entire retouch took about five clicks (12 seconds—I timed it). Also, if you make any mistakes, you have multiple Undos by pressing **Ctrl-Z (Mac: Command-Z)**. When it looks good, click OK.

Before

After

This is a pretty slick technique for taking a photo where the subject is frowning and tweaking it just a bit to add a pleasant smile—which can often save a photo that otherwise would've been ignored.

Transforming a Frown into a Smile

Step One:
Open the photo that you want to retouch.

Step Two:
Go under the Filter menu, under Distort, and choose Liquify. When the Liquify dialog appears, choose the Zoom tool (it looks like a magnifying glass) from the Liquify Toolbox (found along the left edge of the dialog). Click it once or twice within the preview window to zoom in closer on your subject's face. Then, choose the Warp tool (it's the top tool in the Liquify Toolbox).

Continued

Step Three:
In the Tool Options on the right side of the dialog, choose a brush size that's roughly the size of the person's cheek. Place the brush at the base of a cheek and click-and-"tug" slightly up. This tugging of the cheek makes the corner of the mouth turn up, creating a smile.

Step Four:
Repeat the "tug" on the opposite side of the mouth, using the already tugged side as a visual guide as to how far to tug. Be careful not to tug too far, or you'll turn your subject into the Joker from *Batman Returns*. Click OK in Liquify to apply the change, and the retouch is applied to your photo.

Before

After

This is an incredibly popular technique because it consistently works so well, and because just about everyone would like to look about 10 to 15 pounds thinner. I've never applied this technique to a photo and (a) been caught, or (b) not had clients absolutely love the way they look. The most important part of this technique may be not telling the client you used it.

Slimming and Trimming

Step One:
Open the photo of the person that you want to put on a quick diet.

©ISTOCKPHOTO/JACOM STEPHENS

Step Two:
Click on the bottom right corner of your image window and drag it out so you see some gray background behind your image. Now, press **Ctrl-A (Mac: Command-A)** to put a selection around the entire photo. Then, press **Ctrl-T (Command-T)** to bring up the Free Transform command. The Free Transform handles will appear at the corners and sides of your photo.

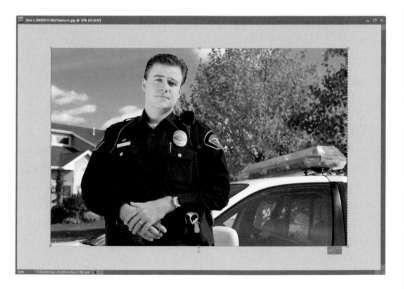

Continued

Step Three:
Grab the right-center handle and drag it horizontally toward the left to slim the subject. The farther you drag, the slimmer the subject becomes.

Step Four:
How far is too far (in other words, how far can you drag before people start looking like they've been retouched)? Use the Width field in the Options Bar as a guide. You're pretty safe to drag inward to around 95%, although I've been known to go to 94% or even 93% once in a while (it depends on the photo). I think we'll settle on 95.1% for this photo, though.

Step Five:
Press **Enter (Mac: Return)** to lock in your transformation. Then, before you deselect, go to the Image menu and choose Crop. That'll crop to the selection you had and remove the background area that is now visible on the right side of your photo (you could always use the Crop tool, too). Then hit **Ctrl-D (Mac: Command-D)** to Deselect. You can see how effective this simple little trick is at slimming and trimming your subject. Also, notice that because we didn't drag too far, the subject still looks very natural.

Before

After

Advanced Skin Softening

Although this technique has a number of steps, it's actually very simple to do and is worth every extra step. It breaks away from the overly soft, porcelain-skin look that is just "so 2006" to give you that pro skin-softening look, along with keeping some of the original skin texture, which makes it much more realistic. This "keeping some of the original skin texture" look is totally "in" right now, so it's worth spending an extra two minutes on. I also want to give credit to Ray 12, whose article on RetouchPro.com turned me on to the texture mask, which I now use daily.

Step One:
Start by pressing **Ctrl-J (Mac: Command-J)** to duplicate the Background layer, as shown here. (See? I told you these steps were going to be simple.)

Step Two:
Go under the Filter menu, under Blur, and choose Gaussian Blur. For a low-resolution photo, like this one, try a 6-pixel blur, then click OK. For high-resolution photos (from a 6- to 10-megapixel camera), apply a 20-pixel blur, or for 12 megapixels or higher, try 25 pixels. This blurs the living daylights out of the photo (as seen here). Sure, it's blurry, but boy is her skin soft! (Okay, that was lame. Continue.)

Step Three:
Press-and-hold the Ctrl (Mac: Command) key and click once on the Create a New Layer icon at the bottom of the Layers palette. This creates a new blank layer (Layer 2) directly beneath your current layer (the blurry Layer 1). Now, in the Layers palette, click back on the top layer (the blurry Layer 1), then press **Ctrl-G (Mac: Command-G)** to group the blurry layer with the blank layer beneath it (Layer 2) and create a clipping mask. Doing this removes all the blurriness from view (and that's exactly what we want to do at this point). The idea is to reveal the blurry layer just where you want it (on her skin), while avoiding all the detail areas (like her eyes, hair, clothing, eyebrows, nostrils, lips, jewelry, etc.). That's what we'll do next.

Continued

Step Four:
In the Layers palette, click on the middle layer (the blank Layer 2), as you're going to paint on this layer. Press the letter **D** to set your Foreground color to black. Get the Zoom tool **(Z)** and zoom in on her face. Then get the Brush tool **(B)**, choose a medium-sized, soft-edged brush from the Brush Picker up in the Options Bar, and begin painting over her skin (as shown here). You're not actually painting over the photo— you're painting in black on the blank layer, and as you paint, it reveals that part of the blurry layer that is on top of it. Remember the rule: don't paint over detail areas—avoid the eyes, hair, etc., as I mentioned earlier. In the example shown here, I have only painted over (softened) the left side of her face, so you can see the effect of the skin softening.

Step Five:
Continue painting on both sides of her face until you've carefully covered all the non-detail areas of her face. You'll have to vary the size of the brush to get under her nose, and carefully between the eyes and the eyebrows.

TIP: Resizing Your Brush
You can use the Bracket keys on your keyboard to change brush sizes—the **Left Bracket key ([)** makes the brush size smaller; the **Right Bracket key (])** makes it larger. By the way, the Bracket keys are to the right of the letter P. Well, if you're using a U.S. English keyboard anyway.

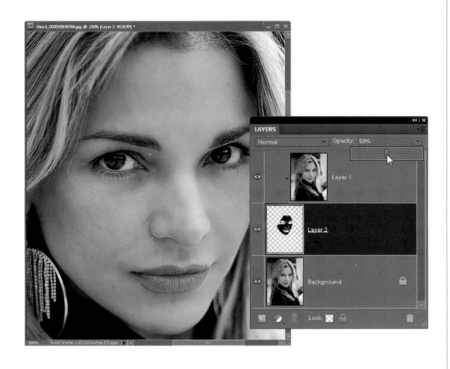

Step Six:

Continue to paint over all the other areas that need softening, and I know I sound like a broken record but avoid those detail areas, like her hair, and her eyebrows, and her lips, etc. Now, you can see that at this point we do have the porcelain-skin look. If you like this look, but you think it's just a little too soft, then simply go to the Layers palette and lower the Opacity of Layer 2 (the one you just painted on) to 50% and see how that looks. That will lighten the softening pretty significantly, and it might be just the amount you're looking for. If 50% is still too much, try 40%, or even 30%. So, you could be done right here. But, if you want something even better, continue on.

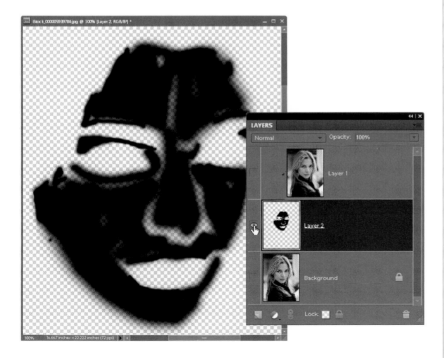

Step Seven:

Let's first make sure you haven't missed any areas, so press-and-hold the **Alt (Mac: Option) key**, and in the Layers palette, click directly on the little Eye icon next to the layer thumbnail of Layer 2 (as shown here). This displays just the black brush stroke layer itself, and you'll see instantly whether you missed any areas or not. If you can't see it very well (remember we just dropped the opacity of this layer), then you may need to increase the opacity for a minute. In this case, you can see I missed areas on both her cheeks, as well as some on her upper lip and forehead.

Continued

Step Eight:
These missed areas are really easy to fix—just take your Brush tool and paint right over them. Now, to get back to your regular view, **Alt-click (Mac: Option-click)** on the Eye icon again and things will be back to normal, so you'll see all of the layers again. Don't forget to reduce the opacity of the layer with the black brush strokes on it to whatever you had it set at in Step Six.

Step Nine:
Now that you can see your full-color image again, you're going to load your black brush strokes as a selection (it's easier than it sounds). Just press-and-hold the Ctrl (Mac: Command) key and click once directly on the layer thumbnail. This loads it as a selection, as seen here.

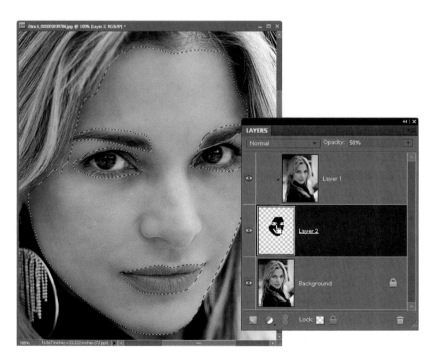

Step 10:
Now, click on the Background layer (your selection will still be in place), then press **Ctrl-J (Mac: Command-J)** to take those selected areas of your Background layer and put them up on their own separate layer (as shown here in the Layers palette). Go ahead and hide the top two grouped layers (the blurry layer and black brushed layer below it) and the Background layer from view (click on the little Eye icons to the left of each of those layers, or Alt-click [Mac: Option-click] on the Eye icon for your new layer, like you did to see the black mask), and you'll see the awful-looking thing you see here.

Step 11:
You'll need to remove the color from this layer, so go under the Enhance menu, under Adjust Color, and choose Remove Color. This removes the color from just your current layer (as shown here). I know, it looks pretty creepy. Retouching isn't pretty. Well, at least not until you're done.

Continued

Step 12:

Now, to bring the texture, highlights, and shadows back into the skin, go under the Filter menu, under Other, and choose High Pass to bring up the High Pass filter dialog (seen here). Drag the Radius slider all the way to the left (as shown) to make the image pretty flat-looking. Don't click OK quite yet.

Step 13:

Now drag the Radius slider to the right until some of the texture, highlights, and shadows start to return to the image (as shown here). I can't give you an exact number to dial in every time, so just drag it until your image looks somewhat like the one you see here, then click OK.

Step 14:

Next, make the other layers visible again (by Alt-clicking [Mac: Option-clicking] on the Eye icon for the layer you were just working on), then drag your gray texture layer to the top of the layer stack (as shown here). Okay, it's still not looking that great yet. Be patient, we're almost there.

Step 15:

Now to bring her original skin texture and highlights back into our photo, you're going to change the layer blend mode of this top layer (the gray texture layer) from Normal to Soft Light, in the pop-up menu at the top left of the Layers palette (as shown here). When you first do this, it brings back the skin texture with a vengeance, which is not our goal. Okay, it's not as much as the original texture, because there is some softening on the layers below it, but it's too intense at this point.

Continued

Step 16:

So (and here's where the cool part is), you're going to dial in the exact amount of original skin texture you'd like visible by lowering the Opacity setting of this texture layer. The lower you make the opacity, the less skin texture is visible. For this particular photo, lowering the Opacity to 20% looks like it gives about the right balance between softening and texture. Compare the before and after photos below.

Before

After

I used to cringe when someone asked how to remove reflections from glasses. It took the better part of an hour sitting there cloning and erasing, and cloning and erasing some more. Put simply, it was a total pain in the butt. Now, with Elements, it's a snap to fix. So if you've ever spent an hour cloning away reflections, you'll love this. If you haven't removed reflections before, then just be thankful that it's really easy now and you'll never know the pain that we once felt.

Fixing Reflections in Glasses

Step One:
First, open the photo that has a reflection on the glasses. This is a photo of our buddy Larry Becker (the Director of the National Association of Photoshop Professionals).

Step Two:
When my friend Brad shot this photo, he could see that he was going to have a reflection in Larry's glasses, so he told him after the shot not to move his head, but just to reach up and remove his glasses, and then he got another photo without the glasses on. So, open the photo without the glasses. Then, click on the Edit tab at the top of the Palette Bin, and choose EDIT Guided from the pop-up menu. In the Project Bin, Ctrl-click (Mac: Command-click) on the photo with the glasses, then on the one without the glasses. In the Guided Edit palette on the right, under Photomerge, choose Group Shot (I know it's not really a group shot, but it works great anyway).

Continued

Step Three:

You'll probably see a progress bar telling you that Elements is aligning the photos. When it's done, you'll be in the Photomerge Group Shot feature. First, click-and-drag the photo with the glasses from the Project Bin over to the Final side of the preview window, then click on the photo without the glasses down in the Project Bin. Now you should have the photo without the glasses on the left side and the photo with the glasses on the right side.

Step Four:

Next, use the Pencil tool to paint over one of the eyes on the Source photo (you can set the size up in the Options Bar). Be careful not to go too far outside of the eyes, though. Elements will use that source area to replace the coinciding destination area on the Final image. This will replace the eye and probably most of the eyeglass rim around it. If it doesn't, then paint again until you see most of the eyeglass rim disappear. Then do the same thing for the other eye.

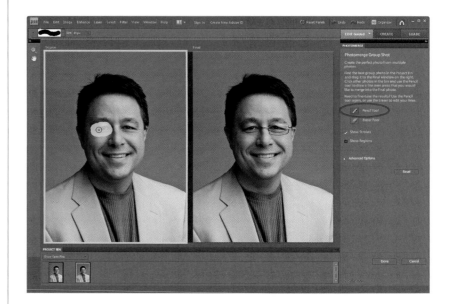

Step Five:

When you see the eyes and just the sides of the eyeglasses, click the Done button at the bottom right. Then click back on the Edit tab at the top right of the window and choose EDIT Full to take you into Full Edit mode again. You should see your image just as it looked in Group Shot, but you'll also see two layers in the Layers palette. Use the Crop tool **(C)** to crop away any extra white canvas.

Step Six:

So that takes care of getting rid of the reflection. Unfortunately, it got rid of most of the eyeglasses too, right? No sweat. We've got a really neat trick to help fix that problem. First, check out the Layers palette. The top layer is the Final image you saw back in the Photomerge Group Shot window and the bottom layer is the original glarey (is that even a word?) eyeglass photo. So what we need to do here is combine the best of both of them.

Continued

Step Seven:
Click once on the top layer to make it active, and change the layer blend mode to Difference. Curiously enough, the Difference blend mode actually shows you just that—the difference between the top layer and the bottom one. Areas that appear black are pretty much exactly the same between the two layers. Any other areas (such as the eyes here) show you things that aren't the same.

Step Eight:
Now use the Zoom tool **(Z)** to zoom in on the eyes. To complete the effect, just select the Eraser tool **(E)**, with a small, hard-edged brush that isn't much thicker than the eyeglass rim itself, and erase over the outline you see in Difference mode on the top layer (as shown here). The rimless eyes from the top layer will be erased and reveal the rim from the original glasses layer, and your reflection problems are gone. Be careful not to erase too much into the lenses themselves, though, because you don't want to reveal any of the glare from the layer below.

Step Nine:
Try switching the top layer's blend mode back to Normal to see your progress and make sure you chose a small enough brush.

Step 10:
Go ahead and finish up the erasing on the top layer. Then change the blend mode back to Normal and you'll see how the reflections are totally gone. Better yet—if the person has large eyeglass frames, it also will fix the fall-off that makes a person's eyes look smaller (where you can see the side of the face in the outside edge of the lens).

Before (notice the reflection—most visible in the right eye)

After (the reflection is gone)

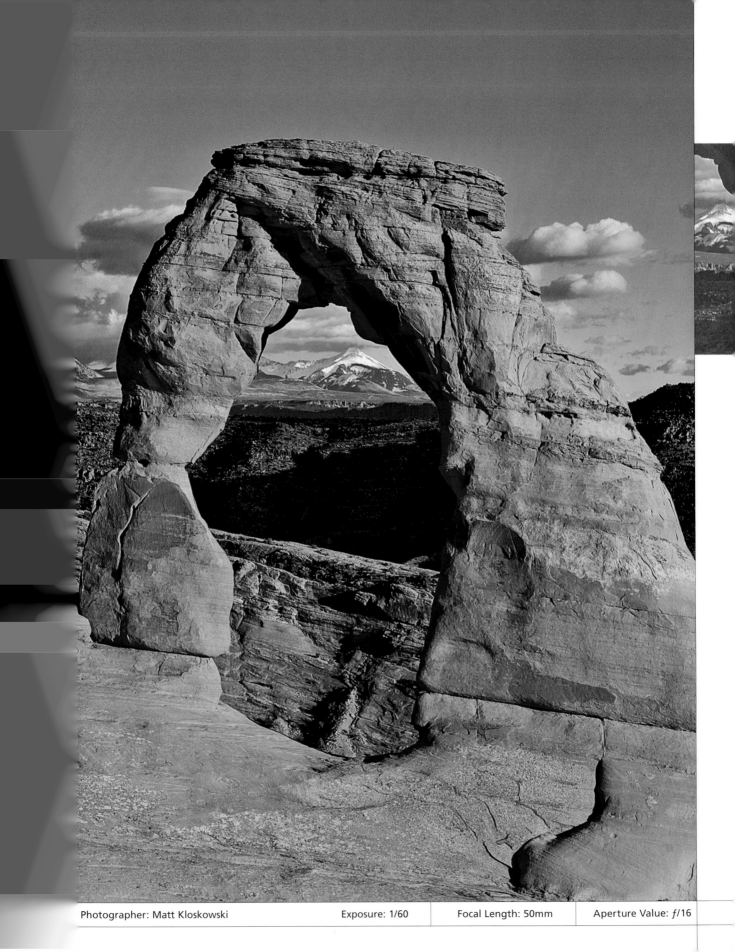

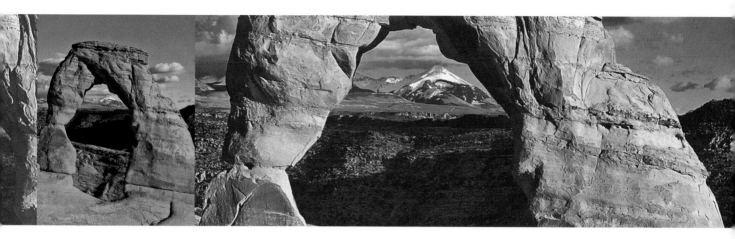

Take Me Away
removing unwanted objects

Is "Take Me Away" a perfect title for a chapter about removing unwanted objects from your photos or what? I've heard the song (by Avril Lavigne) a couple of thousand times now, because my son likes to listen to it (over and over again) on the way to school each morning. Not only have I unconsciously memorized the words, I've actually begun to like the song. It happened around the 13-hundredth time I heard it. By my 14-hundredth listen, I started developing my own background harmonies, and by the 15-hundredth time, I went out and bought the sheet music. This is highly embarrassing stuff, so don't tell anyone. Anyway, this chapter shows you how to remove things that ruin otherwise beautiful photos. For example, let's say you got married, and you've got some great photos from your wedding, but then a year or so later, you get divorced. You looked really great in your wedding dress, so you want to keep the photos, but you hate seeing your ex in there. Well, this chapter will show you how to remove him. Well, it doesn't show you exactly that—how to remove your ex from your wedding photos—but it does show you how to remove any annoying thing, so really you could apply these techniques to your wedding photos. But I gotta tell ya, if you spend your time removing your ex from your wedding photos, perhaps learning new Elements techniques shouldn't be your biggest concern.

Cloning Away Unwanted Objects

The Clone Stamp tool has been the tool of choice for removing distracting or other unwanted objects in photos for years now. Although the Healing Brush in many ways offers a better and more realistic alternative, there are certain situations where the Clone Stamp tool is still the best tool for the job. Here's an example of how this workhorse removes unwanted objects:

Step One:
Nothing ruins a nice shot like distracting objects on your subjects. Here we have a nice shot of a canoe on a beach, but the writing on the far left side of it is kinda distracting, so let's get rid of it.

Step Two:
Use the Zoom tool (**Z**) to zoom in if you need to. Then, press **S** to get the Clone Stamp tool. In the Options Bar, click on the Brush thumbnail to the left of the Size pop-up menu and choose a small, soft-edged brush in the Brush Picker. Now, press-and-hold the Alt (Mac: Option) key and click once in an area to the left of the writing on the canoe. This is called "sampling." You just sampled an area, and in the next step, you're going to clone that blue area over the writing to completely cover it. (By the way, when you sample, a little "target" cursor appears letting you know you're sampling, as you see here.)

MATT KLOSKOWSKI

Step Three:

Move directly over and begin painting with the Clone Stamp tool. As you paint over the writing, the blue area you sampled is cloned right over it, so it looks like the writing has disappeared. Paint a little in this area to get a feel for how the Clone Stamp works (at least, if it's your first time cloning; if it's not, then you know what to do—start cloning over that writing). As you can see here, the writing disappears as you clone. But what if you're not able to clone the whole thing in one brush stroke? Read on to the next page, and I'll show you a little trick.

TIP: Sample a Similar Area

The key technique to remember is to sample in an area where the basic light and texture are the same (next to the writing), then move straight over to the writing. *Note:* The little plus-sign cursor (the area where you sampled) is immediately to the left of the circular brush cursor (where you're painting now). By keeping them next to each other, you're making sure you don't pick up patterns or colors from other parts of the photo that would make your cloning look obvious (you'll want to Alt-click [Mac: Option-click] in different but nearby areas to sample the multiple colors on the canoe and around the writing).

Continued

Step Four:
Now, what happens if you can't clone all the way over the writing in one brush stroke? This actually happens a lot. In my example here, if I continue to paint with one brush stroke, my sample point starts going over the original writing on the canoe and I wind up cloning over the writing with more writing (as shown here, where I sampled just to the left of the word "Four," started painting over "Four," and moved to the right, where it cloned the word).

Step Five:
Here's the trick: You'll need to release your mouse button and click to paint again. Each time you release your mouse button, Elements resamples the area you're cloning from and basically resets it. This lets you paint a little more of the blue area over the writing each time. Just keep an eye on that little crosshair as you're cloning. If it starts going over a part of the canoe where the writing once existed, then weird things are going to happen. So release the mouse button often, let the source reset itself on the empty blue area, and paint smaller areas at a time, instead of one large area.

Step Six:

One more thing. Try sampling from an area to the right of the writing on the canoe. Look at the plus-sign cursor (where we just sampled from). Now you can start painting over the writing to clone over it (as shown here), but it's important to understand why you have to sample from an area that has similar color and texture. For example, try this: Alt-click (Mac: Option-click) by the bottom of the canoe near the shadier area, then go back and start cloning over the writing. Look how much darker (and more obvious) the cloning looks (as shown in the bottom image). That's why you usually have to sample very close to where you clone. If not, it's a dead giveaway.

TIP: Sample Different Areas

One of the tricks to removing objects realistically is to sample often (by Alt-clicking [Mac: Option-clicking]) in different but nearby areas so that your cloning appears random, therefore avoiding repeating patterns.

Continued

Before

After

This is an incredibly handy little trick I learned from a friend, and I've found no better way to clone away objects on things that are straight (like horizons, walls, etc.).

Removing Things in a Straight Line

Step One:
Open your image, and then press **S** to get the Clone Stamp tool (here, we are going to remove the two spots under the eaves at the very top). Now press-and-hold the Alt (Mac: Option) key, and take a look at your cursor (shown here enlarged in the white box). See the horizontal and vertical lines inside the circle? That's the key. You must position the cursor's center "target" line (either horizontal or vertical) on the straight edge that you want to clone in your image (in this case, the eaves). With the Alt key held down, click once when the target (called the "sample cursor") is aligned on the straight edge in your image.

Step Two:
Drag directly to the left while pressing-and-holding the Alt key, but don't click yet. With this key held down, drag to align the sample cursor's horizontal center line along the edge in your image. (Use the Zoom tool **[Z]** to zoom in, if you need to.)

Continued

Step Three:
With the horizontal line positioned along the edge in your photo, release the Alt key and now click-and-drag to start cloning. As you clone, paint along the same straight line. It's all about making sure that the cursor's horizontal line is aligned with the edge in your image *before* you start painting.

Step Four:
After using a smaller brush to clone away part of your object along a straight line, you may need to switch to a larger brush to start cloning away other areas of the object. Then, get your smaller brush again to finish cloning along the line. Here is the finished image.

In Elements 3, Adobe added the Spot Healing Brush tool, which is just about the perfect tool for getting rid of spots and other artifacts. (By the way, the term "artifacts" is a fancy "ten-dollar" word for spots and other junk that wind up in your photos.) Believe it or not, it's even faster and easier to use than the regular Healing Brush, because it's pretty much a one-trick pony—it fixes spots.

Removing Spots and Other Artifacts

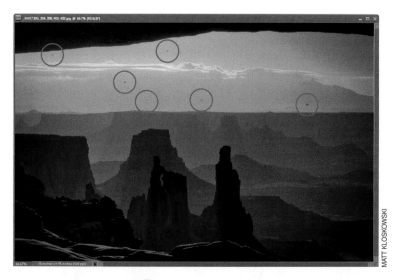

Step One:
Open a photo that has spots (whether they're in the scene itself or are courtesy of specks or dust on either your lens or your camera's sensors). In the photo shown here, there are all sorts of distracting little spots in the sky.

Step Two:
Press **Z** to get the Zoom tool and zoom in on an area with lots of spots (in this case, I zoomed in on an area of sky). Now get the Spot Healing Brush tool from the Toolbox (or just press the letter **J**).

Continued

Step Three:

Position the Spot Healing Brush directly over the spot you want to remove and click once. That's it. You don't have to sample an area or Alt-click anywhere first—you just move it over the spot and click, and the spot is gone.

Step Four:

You remove other spots the same way—just position the Spot Healing Brush over them and click. I know it sounds too easy, but that's the way it works. So, just move around and start clicking away on the spots. Now you can "de-spot" any photo, getting a "spotless" version in about 30 seconds, thanks to the Spot Healing Brush.

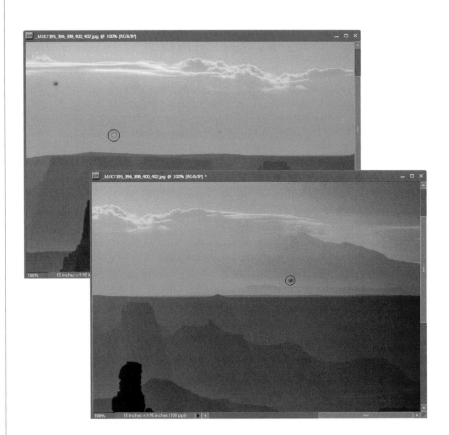

Before

After

The Healing Brush is ideal for removing spots, little rips, stains, and stuff like that because it keeps more of the original texture and the fixes look more realistic, but it isn't as good as the Clone Stamp tool at removing larger, unwanted objects. For example, if the thing you want to remove is all by itself (it's not overlapping or touching anything else in your photo), then it works great. If not, it "frays" the ends and looks messy. So here you'll see how it works, why it doesn't always work, and a great trick for making it work most of the time (with some help from the Clone Stamp tool).

Removing Distracting Objects (Healing Brush)

Step One:
In this photo, let's say a creative director wants the flagpole removed before some text is added, because he feels it's distracting. So, we're going to use a combination of the Healing Brush and a little bit of the Clone Stamp tool to remove it, while maintaining as much of the original texture and grain as possible.

Step Two:
First we'll look at how the Healing Brush works, and then you'll see what the limitation of the Healing Brush is. Start by pressing **Z** to get the Zoom tool and zoom into an area you want to fix (in this case, we're going to fix the hole and flagpole on the green). Press **J** until you get the Healing Brush, and then Alt-click (Mac: Option-click) in an area near that flagpole on the green. At this stage, the Healing Brush works kind of like the Clone Stamp tool, so just click-and-drag on the hole and pole. See, it's gone. Piece of cake so far.

Continued

Step Three:

Now you're going to see the main limitation of the Healing Brush—when objects touch. Look at the area where the flagpole goes over the back of the green in the background. That's trouble. Go ahead and Alt-click anywhere near that part of the photo and try to use the Healing Brush to remove that area of the pole. Ahh, now you see the problem: Where the pole meets the background, it's all smudged. The Healing Brush only gives you a clean removal if you can paint around the entire object without hitting an edge.

Step Four:

Undo your healing by pressing **Ctrl-Z (Mac: Command-Z)**. Now we'll try getting around that limitation: The first thing we want to do is make sure we don't accidentally remove any part of the sky, so choose your favorite selection tool from the Toolbox (here, I used the Lasso tool **[L]**). You're going to use it to select the area you want to clone, which will protect the sky, because you can only clone inside your selected area. Carefully select the pole between the green and the sky, pressing Shift to add to the selection (for the Lasso tools or the Magic Wand tool) or Alt (Mac: Option) to subtract from it.

Step Five:

Press **S** to get the Clone Stamp tool from the Toolbox, and then Alt-click (Mac: Option-click) once just to the right of the pole. Now paint a stroke right over the pole to remove it. In the example here, the plus-sign cursor shows where I sampled, and the circular brush cursor shows where I've painted over the pole. Again, having that selection in place prevents you from accidentally cloning over any of the sky, because you can only clone inside the selected area. Alt-click again and sample near the grassy hill to the right when cloning over the pole near those areas.

Step Six:

Once you've cloned over enough area so the pole is no longer visible over the green or the hill behind the green, you can press **Ctrl-D (Mac: Command-D)** to Deselect. You'll see part of the pole has been removed, but without all the smudging, thanks to using the Clone Stamp tool. Go ahead and use the Clone Stamp tool again to remove the rest of the pole up to the top, near the flag. Try sampling to the right of the pole in the cloudy sky area to get a good replacement source.

Continued

Step Seven:
Now switch back to the Healing Brush (as shown in the Toolbox), and Alt-click somewhere over to the left of the top of the flagpole, in the empty sky (unlike the Clone Stamp tool, you don't have to Alt-click right next to the area where you'll be healing—just pick a spot, any spot, that has a similar texture or color).

Step Eight:
Begin painting over the flag to remove it. Don't let it throw you off that the tone looks a bit funny as you're painting. The final healing doesn't take place until you release the mouse button, so there's a second or two where your healing looks bad, but just be patient for a moment.

Step Nine:
If you can't get the entire flag in just one stroke—don't sweat it. Just Alt-click in a different area (again, I'd try somewhere to the left of the flag), and paint another stroke until the entire flag has been removed. So, in short, if you don't mind using the Clone Stamp just a little bit, you can turn the Healing Brush into a real tool for removing larger, unwanted objects. Below is a before/after of our fix.

Before

After

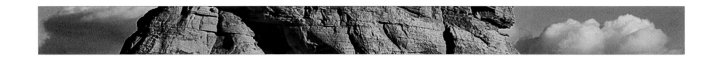

Automatically Cleaning Up Your Scenes (a.k.a. The Tourist Remover)

If you've ever tried to photograph a popular landmark or national monument, you'll know that it's pretty unlikely you'll be there alone. Unless you're willing to get up really early in the morning (when most people are still sleeping), you're bound to get a tourist or two (or 20) in your photos. In this tutorial, you'll learn a few tricks to help clean up those scenes and remove the tourists with just a few brush strokes.

Step One:
The first step starts in the camera. You'll need to photograph at least two shots of the same scene (but you can use up to 10 if you'd like). Here's a photo of Delicate Arch in Arches National Park, Utah.

Step Two:
I realized it was going to be really difficult for me to get a photo when someone wasn't walking near or under the arch. I knew that I had a feature that could fix this available to me in Elements, so I decided to take another photo. As you can see, I wasn't able to capture a photo with no tourists, but at least I had another one where they had moved.

TIP: Shoot with a Tripod
I was on a tripod when I shot this, and doing this makes your life dramatically easier when you use Elements to clean up the scene. However, I know it's not always possible, so if you're hand-holding the camera, try to make sure you don't move locations or shoot from another angle. Basically, stand really still and wait for tourists to move or, more likely, relocate and start over. Also, check out the tip after Step Three.

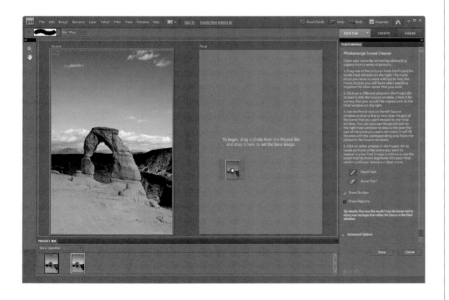

Step Three:
Go ahead and open the photos you've taken (remember, you'll need at least two but can use up to 10. In this example, I'm only using two) in the Elements Editor. Then select them down in the Project Bin by clicking on the first one and Shift-clicking on the last one. Now, go under the File menu, under New, and choose Photomerge® Scene Cleaner. This will take you into Photomerge.

ADVANCED TIP: Try the Advanced Options
Here's a follow-up to the previous tip. In fact, just file this tip away, because you may or may not need it. If you didn't shoot on a tripod, and you're not getting good results from Photomerge, then click on the Advanced Options section at the bottom of the Photomerge palette. Use the Alignment tool to place three markers in the Source window and three in the Final window, on similar places in the photos. Then click Align Photos, and Elements will do its best to align the photos based on those markers. This helps the Scene Cleaner give more predictable results. Again, give Step Three through Step 10 a try first and see how things work out. If everything looks good, then you don't need the Advanced Options.

Step Four:
The Source window on the left will automatically be populated with the first photo you chose. You'll need to create a Final photo though, so drag the other photo from the Project Bin into the Final window on the right.

Continued

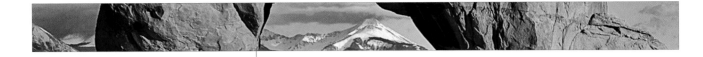

Step Five:

Now look over at the Source window and find the clean areas from this photo that you'd like copied over to the Final photo. Here, I'd like to copy the clean area under the center of the arch, as well as the tourist-free area near the far-left edge of the photo.

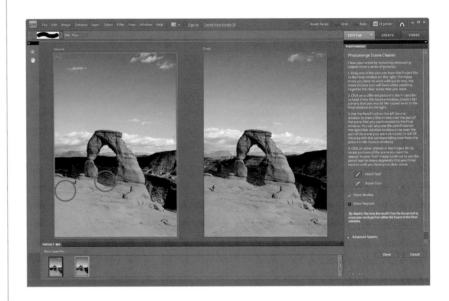

Step Six:

If you're thinking, "But what about those two tourists in the Source window to the immediate left of the arch?" Don't sweat it. Remember, that left window is the source image and not the final. As long as we stay away from those two tourists, they won't get copied over to our final image.

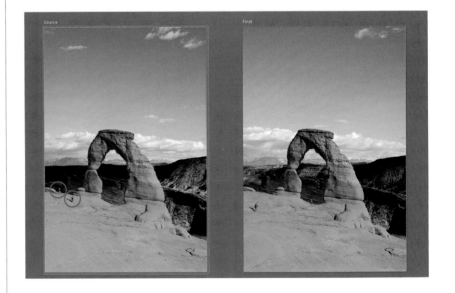

Step Seven:
All right, let's get rid of some tourists. First, use the Pencil tool and paint on the Source image (on the left) under the middle of the arch to get rid of that tourist. It doesn't have to be perfect, so just paint a small area right in the center. When you release your mouse button, you'll see the Scene Cleaner automatically remove the tourist from the center of the arch in the Final image on the right. You can use the Zoom tool (the one that looks like a magnifying glass in the Toolbox on the left) to zoom in to the area if you need to.

TIP: Getting Rid of the Pencil Marks
If you move your mouse over the Final image, you'll see the blue pencil marks on it, too. If you want to see your Final image without the blue pencil marks over it, just move your mouse away from it and they'll disappear. If you want to see the Source image without the blue marks, then turn off the Show Strokes checkbox in the Photomerge palette on the right.

Step Eight:
We still have one more tourist to remove. You could use the Pencil tool and scribble over the clean area of rock on the Source image (on the far-left side, near the edge) to try to match it up with the other tourist in the Final image, but that takes a bit of guesswork. Elements lets you paint in the Final image, too. So, using the Pencil Tool, paint over the remaining tourist on the far-left side of the Final image (as shown here).

Continued

Step Nine:

A couple of things happened in my example here: The tourist on the far left was indeed removed, but in doing so, Elements grabbed a little too much from the Source image, and pulled one of the tourists from there into the Final image. No sweat. Elements does two things to help: (1) it leaves your Pencil tool marks on the photo (you can see them in the next step), in case you don't get the results you were looking for, and 2) it has an Eraser tool, so you can finesse your changes.

Step 10:

So grab the Eraser tool (it's right under the Pencil tool on the right) and click to erase away some of the blue pencil marks in the Final image on the right. Not much, just the top area to force the Scene Cleaner to look more closely at the parts of the Source image it's pulling from. When you release the mouse button, you should see the unwanted tourist disappear from the Final image. If you've taken more than two photos, you can click on another one in the Project Bin to set it as the Source image on the left. Then continue to paint with the Pencil tool just like we did in Step Seven and Step Eight. When you're done cleaning up the image, click the Done button to return to the Editor.

Before *After*

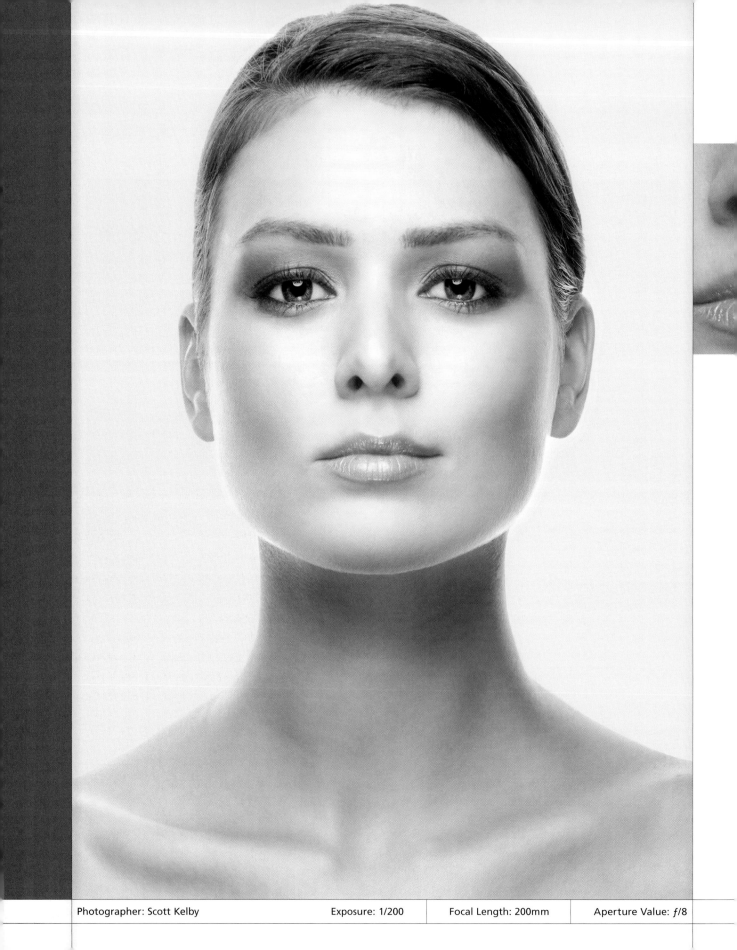

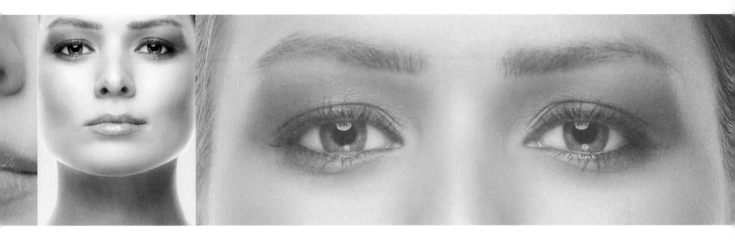

Special Delivery
special effects for photographers

The chapter title above is actually the name of a band. I ran across their song "Love Broke" as I was searching in Apple's iTunes Store under the word "Special." Of course, iTunes came up with songs from bands like .38 Special, as well as a band called The Specials, but somehow in the midst of all this, another title caught my eye. The song was named "Specinal" (which is either a typo or a very clever misspelling of Special designed to throw off authors using iTunes as a research tool for naming chapters), but it wasn't the name of the song that drew me to it, it was the name of the band—Dufus. That's right, they named their band Dufus. Now, I'm not entirely sure, but the name Dufus might not be the best name for attracting members of the opposite sex (if you can, indeed, determine what that would be). I mean, imagine the following conversation be-

tween the bass player for Dufus and a potential date chosen at random from the crowd before they take the stage. Bass player: "So, we haven't met. I'm Mike, the bass player for Dufus." Audience member: "Buh-bye, Dufus." See what I mean? It's hard to put a good spin on that name. I think I might call a band meeting and politely request a snappier name, citing the bass player's bad experience transcribed above. Some alternate names might be The Studs. Or The Heartbreak Kids, or even Eddie from Ohio. So, let's try that scenario again, but using one of these new and improved names. Bass player: "So, we haven't met. I'm Mike, the bass player for Eddie from Ohio." Audience member: "Can you introduce me to Eddie?" Bass player: "Uh, I dunno, he's pretty busy." Audience member: "Leave me alone, you Dufus."

Trendy High-Contrast Portrait Effect

This is just about the hottest Photoshop portrait technique out there right now, and you see it popping up everywhere, from covers of magazines to CD covers, from print ads to Hollywood movie posters, and from editorial images to billboards. It seems right now everybody wants this effect (and you're about to be able to deliver it in roughly 60 seconds flat using the simplified method shown here!).

Step One:
Open the photo you want to apply this trendy high-contrast portrait effect to. Duplicate the Background layer by pressing **Ctrl-J (Mac: Command-J).** Then duplicate this layer using the same shortcut (so you have three layers in all, which all look the same, as shown here).

Step Two:
In the Layers palette, click on the middle layer (Layer 1) to make it the active layer, then press **Ctrl-Shift-U (Mac: Command-Shift-U)** to desaturate and remove all the color from that layer. Of course, there's still a color photo on the top of the layer stack, so you won't see anything change onscreen (you'll still see your color photo), but if you look in the Layers palette, you'll see the thumbnail for the center layer is in black and white (as seen here).

Step Three:
Now lower the Opacity setting of this black-and-white layer to 80% (as shown here), which lets a little bit of the color from the Background layer show through. Now, of course, you still can't see this, because the top layer is still visible, so if you want to see what lowering the opacity to 80% looks like (just for kicks), simply hide the top layer from view (click on the Eye icon to the left of the layer thumbnail), but don't forget to make it visible again before you go on to the next step.

Step Four:
In the Layers palette, click on the top layer in the stack (Layer 1 copy), then switch its layer blend mode from Normal to Soft Light (as shown here), which brings the effect into play. Now, Soft Light brings a very nice, subtle version of the effect, but if you want something a bit edgier with even more contrast, try using Overlay mode instead. If the Overlay version is a bit too intense, try lowering the Opacity of the layer a bit until it looks good to you.

Continued

Step Five:

Flatten the image by clicking on the down-facing arrow in the top-right of the Layers palette and choosing Flatten Image from the palette's flyout menu. The final step is to add some more noise, so go under the Filter menu, under Noise, and choose Add Noise. When the Add Noise filter dialog appears (seen here), set the Distribution to Gaussian, and turn on the Monochromatic checkbox (or your noise will appear as little red, green, and blue specks, which looks really lame). Lastly, dial in an amount of noise that, while visible, isn't overly noisy. This is a very low-resolution photo, so I only used 4%. On a high-res digital camera photo, you'll probably have to use between 10% and 12% to see much of anything. You can see the before/after below. Beyond that, I gave you an example of how this effect looks on another portrait.

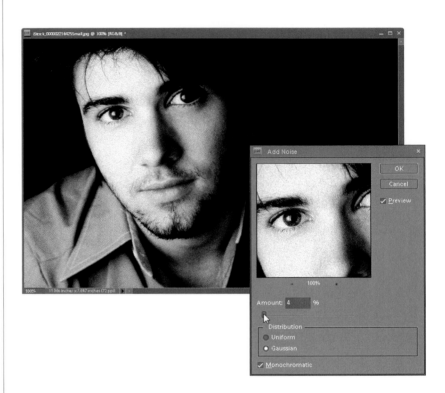

Before

After

Before

After

©ISTOCKPHOTO/TOM YOUNG

Step Six:

Here's another example using the exact same technique and you can see how different the effect looks on a completely different image. I particularly love the almost bronze skin tone it creates in this image. Very cool stuff.

TIP: Don't Add Too Much Noise

Be careful not to add too much noise, because when you add an Unsharp Mask to the image (which you would do at the very end, right before you save the file), it enhances and brings out any noise in the photo.

ANOTHER TIP: Try It on a Background

I recently saw this effect used in a motorcycle print ad. They applied the effect to the background, and then masked (knocked out) the bike so it was in full color. It really looked very slick (almost eerie, in a cool eerie way).

Converting to Black and White

One of my favorite features in Elements is its black-and-white conversion tool. Well, it's not really a tool, it's more like a dialog where you decide how you want your color photo converted into black and white. It's a very visual way to make the jump from color to black and white, and if you can point-and-click, you can do it. Here's how it's done:

Step One:
Open the color photo you want to convert to black and white (yes, you need to start with a color photo), and then go under the Enhance menu and choose Convert to Black and White (as shown here).

Step Two:
When you choose Convert to Black and White, a dialog appears and your photo (behind the dialog) is converted to black and white on the spot (in other words, you get a live preview of your changes). At the top of the dialog is a before and after, showing your color photo on the left, and your black-and-white conversion on the right, which honestly is of little help, especially since you can see your full-sized photo behind the dialog. Anyway, your first step is to choose which style of photo you're converting from the list of styles on the lower-left side of the dialog. These styles are really just preset starting points that are fairly well-suited to each type of photo. The default setting is Scenic Landscape, which is a fairly non-exciting setting. Since I'm generally looking to create high-contrast, black-and-white photos with lots of depth, I recommend the Vivid Landscapes style, which is much punchier. Go ahead and choose that now, just so you can see the difference.

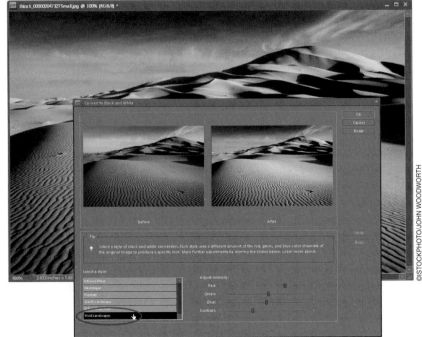

©ISTOCKPHOTO/JOHN WOODWORTH

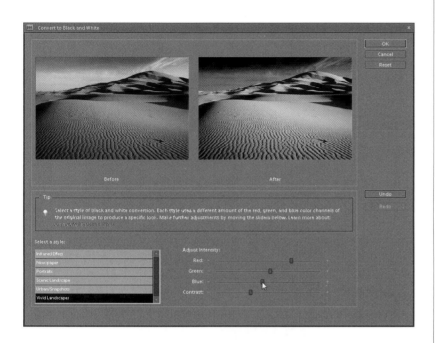

Step Three:
Whether you stay with the default Scenic Landscape, or try my suggested Vivid Landscapes (or any of the other styles to match the subject of your photo), these are just starting places—you'll need to tweak the settings to really match your photo, and that's done by dragging one of the four Adjust Intensity sliders that appear on the bottom-right side of the dialog. The top three (Red, Green, and Blue) let you tweak ranges of color in your photo. So, for example, if you'd like the sky darker, which is blue, you'd drag the Blue slider to the left, as shown here. If you want the sand itself brighter, which is mostly reddish, you'd drag the Red slider to the right. There's not much green in this photo, so moving the Green slider won't have quite as much impact as it would in a scenic landscape shot.

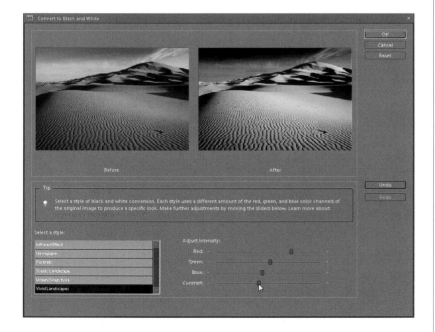

Step Four:
So, basically, you use those three sliders to come up with a mix that looks good to you. You don't have to use these sliders, but if you can't find one of the presets that looks good to you, find one that gets you close, and then use the Red, Green, and Blue sliders to tweak the settings. The fourth slider, Contrast, does just what you'd expect it would—if you drag to the right, it adds contrast (and to the left removes it). I'm very big on high-contrast black-and-white prints, so I wouldn't hesitate to drag this a little to the right just to create even more contrast (so, personally, I'm more likely to start with a preset, like Vivid Landscapes, and then use the Contrast slider, as shown here, than I am to spend much time fooling with the Red, Green, and Blue sliders. But hey, that's just me).

Panoramas Made Crazy Easy

Elements has had a feature to help you stitch multiple photos into a single panoramic photo for years now. As long as you did everything right in the camera (shooting on a tripod with just about every auto feature turned off), Photomerge worked pretty well. However, Photomerge is now so vastly improved that you can pretty much hand-hold your camera without regard to the auto settings, and Photomerge will not only perfectly align the photos, but now it will also seamlessly blend the pieces together, even if the exposure or white balance isn't "on the money." This is very cool stuff.

Step One:
Select the individual pieces of your pano in the Organizer (Mac: Bridge). Here, I choose eight separate photos we're going to stitch together into a panorama. Go under the File menu, under New, and choose Photomerge® Panorama (on a Mac, go under the Tools menu, under Photoshop Elements, and choose Photomerge® Panorama), or simply open all eight photos in the Editor, then go under the File menu, under New, and choose Photomerge® Panorama.

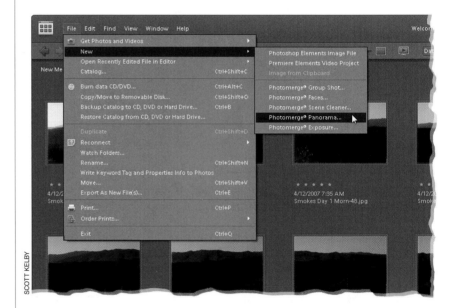

Step Two:
In the Photomerge dialog, click on the button for Add Open Files, and your photos for the pano will appear in the center column. You have five different choices in the Layout section for how your pano will be constructed, and I recommend using Auto (which does a brilliant job). The choices below Auto (Perspective, Cylindrical, and Reposition Only) give you funky looking panos—not the nice long pano we're shooting for. The Interactive Layout brings back the "old" way of stitching panos (the semi-manual way), and that's why I prefer the Auto method. Click OK, and within a minute or two (depending on how large your photos are), your pano is seamlessly stitched together (you'll see status bars that let you know that Elements is auto-aligning and auto-blending your layers to make this mini-miracle happen).

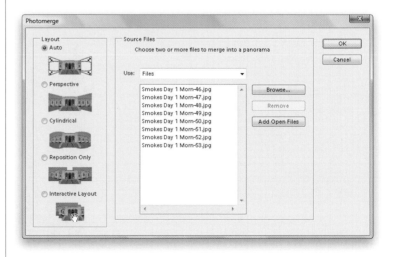

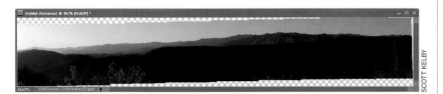

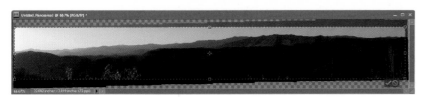

SCOTT KELBY

Step Three:
Usually, to make your pano fit perfectly together, Photomerge has to move and rearrange things in a way that will cause you to have to crop the photo down to get the final result you want (we get the easy job; cropping only takes about 10 seconds). So, get the Crop tool **(C)** and drag out your cropping border (like you see in the bottom image here), encompassing as much of the pano as possible without leaving any transparent areas.

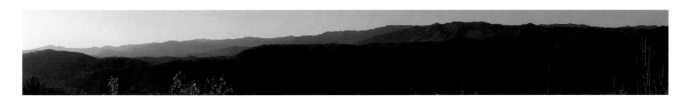

Step Four:
When you press **Enter (Mac: Return)**, your pano is cropped down to size (as shown here). I encourage you to try shooting panos "as is"—without changing all your camera settings, or turning off the auto exposure, or auto focus, or any of those things. Just hand-hold, point, and shoot as many frames as you'd like. There's now just one rule to remember: try to overlap each photo by around 20% to make things easier for Photomerge.

Creating Drama with a Soft Spotlight

This is a great technique that lets you focus attention by using dramatic, soft lighting. The technique I'm showing you here, I learned from famous nature photographer Vincent Versace. I had been getting a similar look by filling a layer with black, making an oval selection, feathering the edges significantly, and then knocking a hole out of the layer (as you'll see in the next technique), but Vincent's technique, using the Lighting Effects filter, is so much easier that it's just about all I use now.

Step One:
Open the RGB photo to which you want to apply a soft spotlight effect. In this example, I want to focus attention on the bride by darkening the area around her. Next, press **Ctrl-J (Mac: Command-J)** to duplicate the Background layer.

Step Two:
Go under the Filter menu, under Render, and choose Lighting Effects. I have to tell you, if you haven't used this filter before, it's probably because its interface (with all its sliders) looks so complex, but luckily there are built-in presets (Adobe calls them "Styles") that you can choose from, so you can pretty much ignore all those sliders. Once you ignore the sliders, the filter is much less intimidating, and you can really have some fun here. The small preview window on the left side of the dialog shows you the default setting, which is a large oval light coming from the bottom right-hand corner.

Step Three:
For this effect, we're going to use a very soft, narrow beam, so go under the Style pop-up menu at the top of the dialog (this is where the presets are) and choose Flashlight.

Step Four:
Once you choose Flashlight, look at the preview window and you'll see a small spotlight in the center of your image. Click on the center point (inside the circle) and drag the light into the position where you want it. If you want the circle of light a little bit larger, just click on one of the side points and drag outward. When you click OK, the filter applies the effect, darkening the surrounding area and creating the soft spotlight effect you see here.

Continued

Step Five:

If the Lighting Effects filter seems too intense, you can remedy it immediately after the fact by lowering the Opacity setting in the Layers palette to reduce the effect of the filter. The lower the setting, the less the intensity of the effect. Then, while in the Layers palette, change the blend mode of this layer to Darken, so the Flashlight effect doesn't make the colors seem too saturated.

Before

After

If you want to focus attention on something within your image, applying a wide vignette that acts like a soft light is a great way to do this (which is really just an alternative to the previous tutorial). What you're doing is creating a dark border that will burn in the edges of your image. Here's how to do just that:

Burned-In Edge Effect (Vignetting)

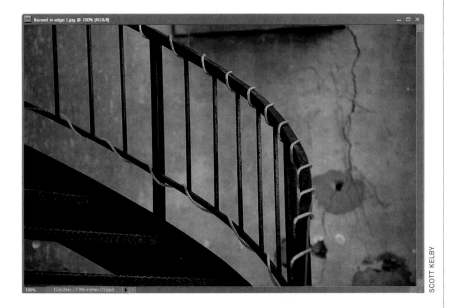

SCOTT KELBY

Step One:
Open the photo to which you want to apply a burned-in edge effect. Just so you know, what we're doing here is focusing attention through the use of light—we're burning in all the edges of the photo (not just the corners, like lens vignetting, which I usually try to avoid), leaving the visual focus in the center of the image.

Step Two:
Go to the Layers palette and add a new layer by clicking on the Create a New Layer icon at the bottom of the palette. Press the letter **D** to set your Foreground color to black, and then fill your new layer with black by pressing **Alt-Backspace (Mac: Option-Delete)**.

Continued

Step Three:

Press **M** to get the Rectangular Marquee tool and drag a selection about 1" or so inside the edges of your photo. Then, to greatly soften the edges of your selection, go under the Select menu and choose Feather. When the dialog appears, enter 50 pixels for a low-res photo (or 170 pixels for a high-res, 300-ppi photo), and click OK.

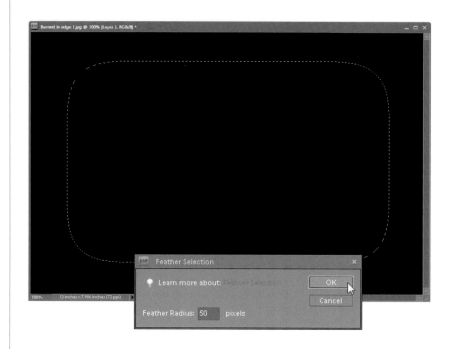

Step Four:

Now that your edges have been softened, all you have to do is press Backspace (Mac: Delete), and you'll knock a soft hole out of your black layer, revealing the photo on the Background layer beneath it. Now press **Ctrl-D (Mac: Command-D)** to Deselect. *Note:* If the edges seem too dark, you can go to the Layers palette and lower the Opacity of your black layer (in the example shown here, I lowered the Opacity to 70%).

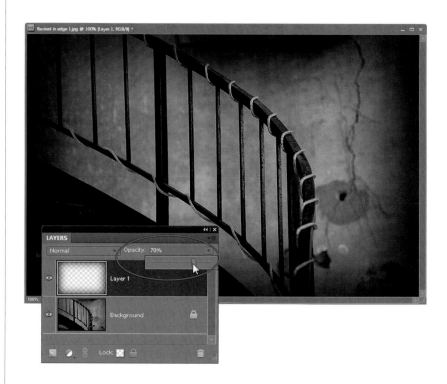

Before

After

Using Color for Emphasis

This is a popular technique for focusing attention by the use of color (or really, it's more like the use of less color—if everything's in black and white, anything that's in color will immediately draw the viewer's eye). As popular as this technique is, it's absolutely a breeze to create. Here's how:

Step One:
Open a photo containing an object(s) you want to emphasize through the use of color. Go under the Layer menu, under New, and choose Layer via Copy (or just press **Ctrl-J [Mac: Command-J]**). This will duplicate the Background layer onto its own layer (Layer 1).

Step Two:
Press **B** to get the Brush tool from the Toolbox and choose a medium, soft-edged brush from the Brush Picker in the Options Bar (just click on the down-facing arrow next to the Brush thumbnail to open the Picker). Also in the Options Bar, change the Mode pop-up menu to Color for the Brush tool.

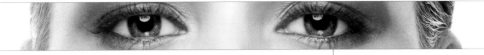

Step Three:

Set your Foreground color to black by pressing the letter **D** and begin painting on the photo. As you paint, the color in the photo will be removed. The goal is to paint away the color from all the areas *except* the areas you want emphasized with color.

TIP: Fixing Mistakes

If you make a mistake while painting away the color or later decide that there was something else that you really wanted to keep in color, just switch to the Eraser tool by pressing the **E key**, paint over the "mistake" area, and the original color will return as you paint. (What you're really doing here is erasing part of the top layer, which is now mostly black and white, and as you erase, it reveals the original layer, which is still in full color.)

Before

After

Soft Focus Effect

This is a quick way to emulate the effect of a soft focus filter on your lens. Besides being quick and easy, what I like about this effect is the soft glow it gives your images. Try this technique on a sharp photo of some trees and you'll love what it does for the image.

Step One:
Open the photo to which you want to apply a soft focus effect. Duplicate the Background layer by pressing **Ctrl-J (Mac: Command-J)**. By default, this duplicate layer is named Layer 1.

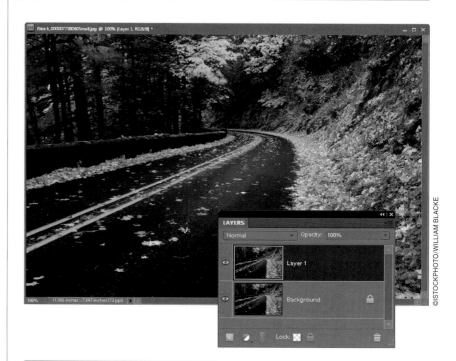

Step Two:
Go under the Filter menu, under Blur, and choose Gaussian Blur. For low-res images, enter about 6–10 pixels (for high-res images, try 20 pixels instead) and click OK.

Step Three:
That amount of Gaussian Blur will blur the entire image so much that it'll be hard to see any detail. So, to bring back the detail, go to the Layers palette and lower the Opacity setting of this blurred layer to between 25% and 50%. Lowering the Opacity setting allows the detail to come back, but along with it comes a soft glow that gives the image a dreamy, almost painted look, which completes the effect.

Before

After

Replacing the Sky

When shooting outdoors, there's one thing you just can't count on—the sun. Yet, you surely don't want to take a photo of your house on a dreary day, or shoot a photo of your car on a gray overcast day. That's why it's so important to have the ability to replace a gloomy gray sky with a bright sunny sky. Is it cheating? Yes. Is it easy? You betcha. Do people do it every day? Of course.

Step One:
Open the photo that needs a new, brighter, bluer sky.

Step Two:
You have to make a selection around the sky. Usually, you can click in the sky area with the Magic Wand tool **(W)** or the Quick Selection tool **(A)** to select most of it, and then choose Similar from the Select menu to select the rest of the sky—but as usual, it likely selected other parts of the image besides just the sky. So use the Lasso tool **(L)** while pressing-and-holding the Alt (Mac: Option) key to deselect any excess selected areas on your image. If needed, press-and-hold the Shift key while using the Lasso tool to add any unselected areas of the sky. You can use any combination of selection tools you'd like—the key is to select the entire sky area.

SCOTT KELBY

Step Three:
Shoot some nice blue skies and keep them handy for projects like this, or steal a sky from another photo. Simply open one of those "blue sky" shots, and then go under the Select menu and choose All to select the entire photo, or use the Magic Wand, Quick Selection, or Lasso tool as you did in the previous step to select just the sky you want. Then, press **Ctrl-C (Mac: Command-C)** to copy this sky photo into memory.

Step Four:
Switch back to your original photo (the selection should still be in place). Create a new layer by clicking on the Create a New Layer icon at the bottom of the Layers palette, then go under the Edit menu and choose Paste Into Selection. The new sky will be pasted into the selected area in your new layer, appearing over the old sky. Press **Ctrl-D (Mac: Command-D)** to Deselect.

Continued

Step Five:
If the sky seems too bright for the photo, simply lower the Opacity of the layer in the Layers palette to help it blend in better with the rest of the photo. That's it—newer, bluer sky.

Before

After

One of the most popular lens filters for outdoor photographers is the neutral density gradient filter, because often (especially when shooting scenery, like sunsets) you wind up with a bright sky and a dark foreground. A neutral density gradient lens filter reduces the exposure in the sky by a stop or two, while leaving the ground unchanged (the top of the filter is gray, and it graduates down to transparent at the bottom). Well, if you forgot to use your ND gradient filter when you took the shot, you can create your own ND gradient effect in Photoshop Elements.

Neutral Density Gradient Filter

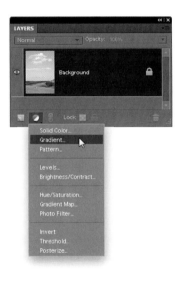

©ISTOCKPHOTO/GLEB VINNIKOV

Step One:
Open the photo (preferably a landscape) where you exposed for the ground, which left the sky too light. Press the letter **D** to set your Foreground color to black. Then, go to the Layers palette and choose Gradient from the Create New Adjustment Layer pop-up menu (it's the half-white/half-black circle icon) at the bottom of the palette.

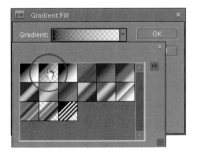

Step Two:
When the Gradient Fill dialog appears, click on the little, black downward-facing arrow (it's immediately to the right of the Gradient thumbnail) to bring up the Gradient Picker. Double-click on the second gradient in the list, which is the gradient that goes from Foreground to Transparent. Don't click OK yet.

Continued

Step Three:
By default, this puts a dark area on the ground (rather than the sky), so turn on the Reverse checkbox to reverse the gradient, putting the dark area of your gradient over the sky and the transparent part over the land. Your image will look pretty awful at this point, but you'll fix that in the next step, so just click OK.

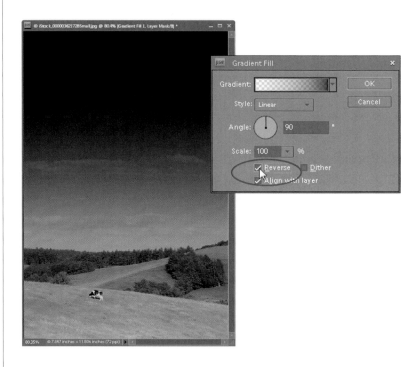

Step Four:
To make this gradient blend in with your photo, go to the Layers palette and change the blend mode of this adjustment layer from Normal to Overlay. This darkens the sky, but it gradually lightens until it reaches land, and then it slowly disappears. So, how does it know where the ground is? It doesn't. It puts a gradient across your entire photo, so in the next step, you'll basically show it where the ground is.

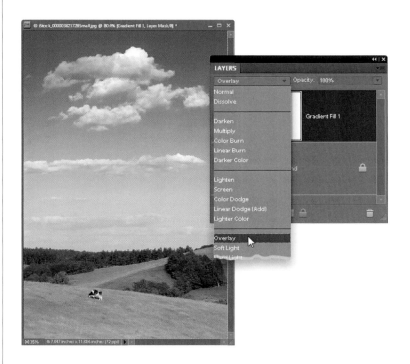

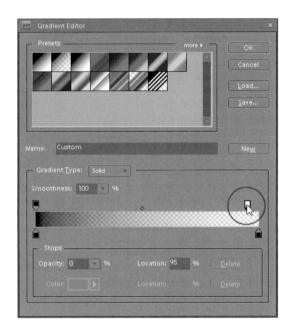

Step Five:
In the Layers palette, double-click on the thumbnail for the Gradient adjustment layer to bring up the Gradient Fill dialog again. To control how far down the darkening will extend from the top of your photo, just click once on the Gradient thumbnail at the top of the dialog. This brings up the Gradient Editor. Grab the top-right white Opacity stop above the gradient ramp near the center of the dialog and drag it to the left; the darkening will "roll up" from the bottom of your photo, so keep dragging to the left until only the sky is affected, and then click OK in the Gradient Editor.

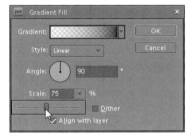

Step Six:
By default, the gradient you choose fills the entire image area, smoothly transitioning from a dark gray at the top center to transparent at the very bottom. It's a smooth, "soft-step" gradient. However, if you want a quicker change from black to transparent (a hard step between the two), you can lower the Scale amount in the Gradient Fill dialog.

Continued

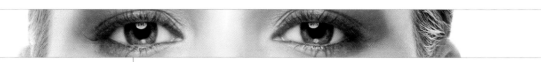

Step Seven:
Also, if the photo you're working on doesn't have a perfectly straight horizon line, you might have to use the Angle control by clicking on the line in the center of the Angle circle and dragging slowly in the direction that your horizon is tilted. This literally rotates your gradient, which enables you to have it easily match the angle of your horizon. When it looks good to you, click OK to complete the effect.

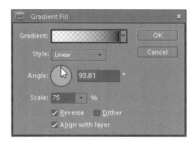

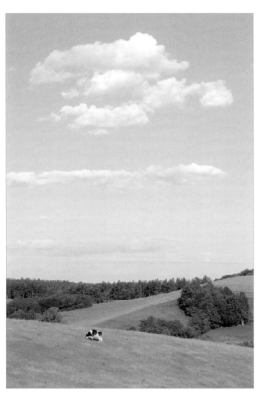

Before (exposing for the ground makes the sky too light)

After (the ground is the same, but the sky is now bluer and more intense)

Sometimes the light falls where you don't want it, and sometimes you just mess up (like in the case here, where not enough attention was paid to the spread of the light, and both the model's face and shirt share pretty much the same intensity of light. The subject really is the model's face, and his shirt just plays a supporting role, but it was lit like they're sharing the starring role). Luckily, it's pretty easy to tame and refocus the light in Elements.

Taming Your Light

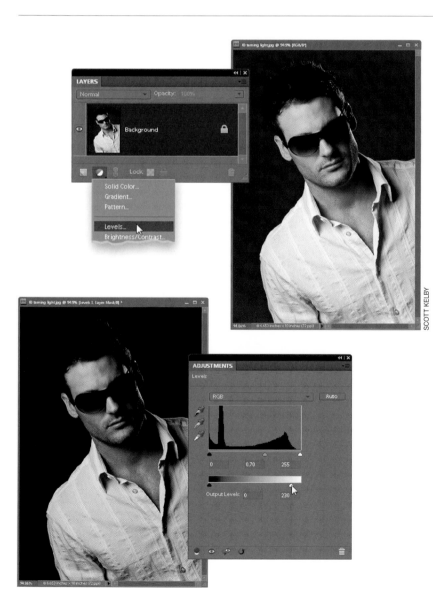

SCOTT KELBY

Step One:
As I mentioned above, here's the shot where the model's face and shirt are both equally as bright, which is not a good thing (in fact, his shirt may even be a little brighter, and is drawing your attention away from his face, which is absolutely not what you want). So, we're going to tame our light using a very simple Levels move. Choose Levels from the Create New Adjustment Layer pop-up menu at the bottom of the Layers palette (as shown here).

Step Two:
The changes I make in the Levels controls of the Adjustments palette will affect the entire photo, but since adjustment layers come with their own built-in layer masks, we'll be able to tweak things very easily after the fact. At this point, you want to darken the shirt, so drag the middle gray slider (right below the histogram) to the right a bit to darken the midtones (and the shirt), and then drag the bottom-right Output Levels slider to the left a little bit to darken the overall photo. One downside is that this oversaturates the colors quite a bit, which can also draw attention away from the face, but that's easy to fix.

Continued

Step Three:

First, to reduce the oversaturation caused by our Levels move, go to the Layers palette and change the blend mode of the Levels adjustment layer from Normal to Luminosity. This keeps the darkening without oversaturating the color. Next, press **Ctrl-I (Mac: Command-I)** to Invert the layer mask, which hides the darkening added by our Levels move behind a black mask. Now, get the Brush tool **(B)**, press **X** to set your Foreground color to white, then with the layer mask active, paint over everything in the photo except for his face, chest, and hair. As you paint, it darkens those areas (as shown here, where I'm darkening the background, so now the model's face is the focus).

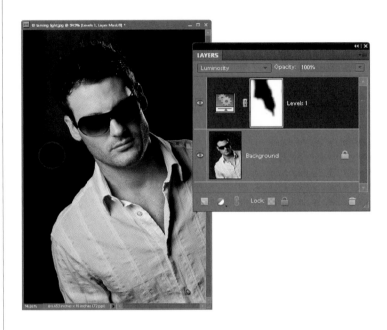

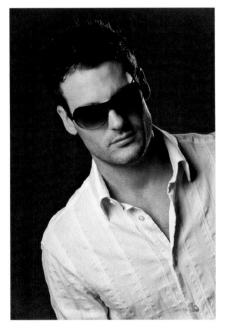

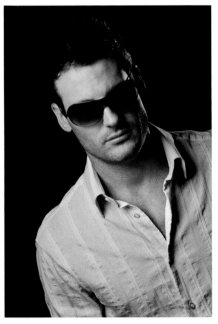

Before (the shirt has at least as much or more light than the model's face)

After (everything else is darkened, leaving the model's face nicely lit and making it the visual focus of the portrait)

Here's a great way to blend multiple photos together to create a photo montage (often referred to as a collage).

Creating Photo Montages

Step One:
Open the photo that you want to use as your base photo—this will serve as the background of your collage. (*Note:* Make sure you have the Allow Floating Documents in Full Edit Mode checkbox turned on in your General Preferences, found under the Edit menu on a PC or the Photoshop Elements menu on a Mac.) Now, open the first photo that you want to collage with your background photo.

©ISTOCKPHOTO/KLAAS JAN SCHRAA

©ISTOCKPHOTO/MARCUS LINDSTRÖM

Continued

Step Two:

Press **V** to switch to the Move tool, and then click-and-drag the photo from this document right onto your background photo, positioning it where you want it. It will appear on its own layer (Layer 1) in the Layers palette of your background image.

Step Three:

Press-and-hold the Ctrl (Mac: Command) key and, at the bottom of the Layers palette, click on the Create a New Layer icon. This creates a layer directly beneath your current layer (Layer 1). Now, click back on the top layer, then press **Ctrl-G (Mac: Command-G)** to group your photo with the blank layer beneath it and create a clipping mask. Press the letter **D** to set your Foreground color to black.

Step Four:
Switch to the Gradient tool by pressing **G**, and then press **Enter (Mac: Return)** to bring up the Gradient Picker (it appears below the Gradient thumbnail in the Options Bar). Choose the second gradient in the Picker (this is the Foreground to Transparent gradient) and press Enter again to close the Picker.

Step Five:
Click on the middle (blank) layer in the Layers palette to make it active. Although you can't see your top photo, try to click the Gradient tool near the center of this photo and drag toward the center of the document. The point where you first clicked on the top layer will be at 100% opacity, and the point where you stopped dragging will be totally transparent. Everything else will blend in between. If you want to start over—easy enough—just press **Ctrl-Z (Mac: Command-Z)** to Undo and click-and-drag again. (Be careful: If you drag beyond the image's border, your Foreground color will appear in the gradient.)

Continued

Step Six:

If you want to blend in another photo, click-and-drag that image onto your montage, click on the top layer in the Layers palette, then start again from Step Three. Add as many images as you'd like.

One of the questions I get asked most about my portraits is how do they look so sharp, but at the same time have a soft quality to them? It's because for all portraits of women, children, or families, I apply a three-step Photoshop Elements finishing technique that does the trick. It actually combines two techniques you've already learned, and introduces a third. They're all exceedingly easy—it's just the order you do them in, and the settings you use. Here's exactly what I do:

Scott's Three-Step Portrait Finishing Technique

SCOTT KELBY

Step One:
Once you've color corrected the photo, done any retouching, etc., that's when you add these three finishing steps. The first step is to add a lot of sharpening to the photo (because in the second step, you're going to blur the entire photo). I always use luminosity sharpening for this, so start by pressing **Ctrl-J (Mac: Command-J)** to duplicate the Background layer. Then, go under the Enhance menu and choose Unsharp Mask. The settings I use are pretty strong—Amount: 120%, Radius: 1, and Threshold: 3—but you generally need it. With a small, low-resolution file like this, you might need to lower the Amount to 80%. Click OK.

Continued

Step Two:
Now go to the Layers palette and change the layer blend mode of this sharpened layer to Luminosity (as shown here), so your sharpening is applied to just the luminosity (lightness details) of the photo, not the color areas. Doing this allows you to apply more sharpening to the photo without getting unwanted halos. Next, press **Ctrl-E (Mac: Command-E)** to merge this layer down into the Background layer.

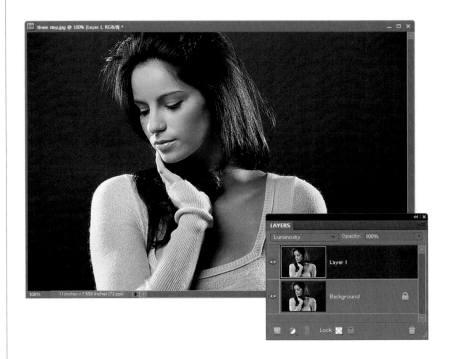

Step Three:
Duplicate the Background layer again, then you're going to apply a pretty significant Gaussian Blur to this layer. So, go under the Filter menu, under Blur, and choose Gaussian Blur. When the dialog appears, enter 6 pixels for a low-res photo (for a regular high-res digital camera file, use 20 pixels), then click OK to apply the blur to this layer.

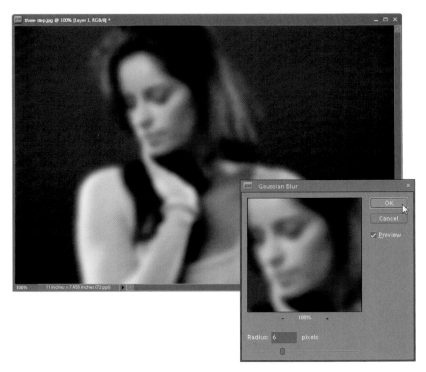

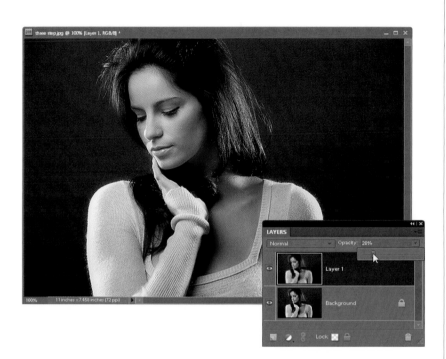

Step Four:
Now, in the Layers palette, lower the layer Opacity of this blurry layer to just 20% (as shown here), which gives the photo almost a glow quality to it, but the glow is subtle enough that you don't lose sharpness (look at the detail in the hair and eyes).

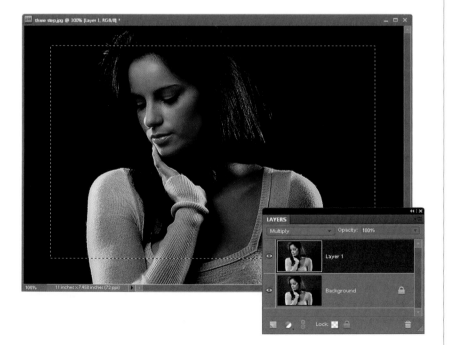

Step Five:
Press Ctrl-E again to merge those two layers together and flatten the photo. Now, you're going to add an edge vignette effect (which looks great for portraits), so start by duplicating the Background layer again. Once you duplicate the layer, change the blend mode of the layer to Multiply (which makes the layer much darker). Then get the Rectangular Marquee tool **(M)** and draw a rectangular selection that is about ½" to 1" inside the edges of your photo (as shown here).

Continued

Step Six:

Now you're going to majorly soften the edges of your rectangular selection, so go under the Select menu and choose Refine Edge to bring up the Refine Edge dialog (shown here). Below the three sliders, click on the icon on the left, so you view your photo as a full-color composite image (as shown here). Now, to soften the edges, drag the Feather slider all the way to 100 pixels (if you're using a high-res file, feather it 200 pixels), and click OK. One advantage of this Refine Edge dialog is you can see the amount of feathering as you move the slider. Now press the Backspace (Mac: Delete) key on your keyboard to knock a soft-edged hole out of your darker Multiply layer (as seen here).

Step Seven:

Press **Ctrl-D (Mac: Command-D)** to Deselect, and you'll see the effect is like a really soft spotlight aimed at your subject. If the edge darkening actually is close enough to their face to matter, get the Eraser tool **(E)**, choose a soft-edged brush, and simply paint over the top of the head and hair (as shown here) to remove the edge vignetting in just that area. The final photo is seen on the next page. Notice the general overall sharpness, but there's also a general overall softness, enhanced even more by that soft spotlight vignette you added at the end.

Before

After (applying all three steps)

Fake Duotone

The duotone tinting look is all the rage right now, but creating a real two-color duotone, complete with curves, that will separate in just two colors on press is a bit of a chore. However, if you're outputting to an inkjet printer, or to a printing press as a full-color job, then you don't need all that complicated stuff—you can create a fake duotone that looks at least as good (if not better).

Step One:

Open the color RGB photo that you want to convert into a duotone (again, I'm calling it a duotone, but we're going to stay in RGB mode the whole time). Now, the hard part of this is choosing which color to make your duotone. I always see other people's duotones, and think, "Yeah, that's the color I want!" but when I go to the Foreground color swatch and try to create a similar color in the Color Picker, it's always hit or miss (usually miss). That's why you'll want to know this next trick.

Step Two:

If you can find another duotone photo that has a color you like, you're set. So I usually go to a stock-photo website (like iStockphoto.com) and search for "duotones." When I find one I like, I return to Elements, press **I** to get the Eyedropper tool, click-and-hold anywhere within my image area, and then (while keeping the mouse button held down) I drag my cursor outside Elements and onto the photo in my Web browser to sample the color I want. Now, mind you, I did not and would not take a single pixel from someone else's photo—I'm just sampling a color.

Step Three:
Return to your image in Elements. Go to the Layers palette and click on the Create a New Layer icon. Then, press **Alt-Backspace (Mac: Option-Delete)** to fill this new blank layer with your sampled color. The color will fill your image area, hiding your photo, but we'll fix that.

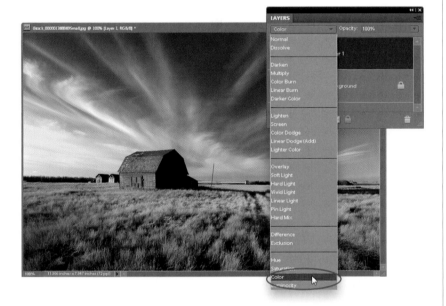

Step Four:
While still in the Layers palette, change the blend mode of this sampled color layer to Color.

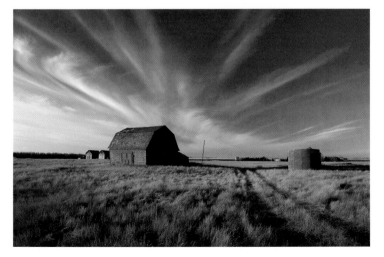

Step Five:
If your duotone seems too dark, you can lessen the effect by clicking on the Background layer, and then going under the Enhance menu, under Adjust Color, and choosing Remove Color. This removes the color from your RGB photo without changing its color mode, while lightening the overall image. Pretty sneaky, eh?

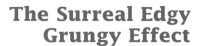

The Surreal Edgy Grungy Effect

Here's an effect that has taken the photography community by storm. It gives a photo a very surreal, almost illustrative effect, and looks pretty darn cool when applied to the right photo. The best part about it is that you can do it all in Camera Raw.

Step One:
Open a photo in Camera Raw. It can be a RAW photo, or even a TIFF or JPEG (see Chapter 2 to find out how to open non-RAW files in Camera Raw). Keep in mind, though, that the photo should be the kind that will look good when it has a very edgy effect applied to it. Photos with dramatic lighting, sports photos, senior portraits, cars, and certain landscapes will work really well. Photos of babies and tiny, soft, fluffy puppies probably won't look so good with this effect applied to it.

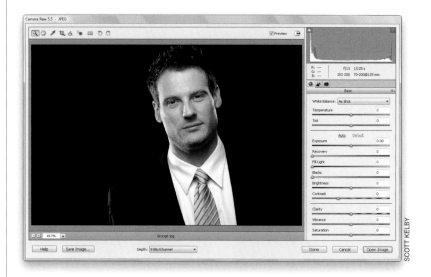

SCOTT KELBY

Step Two:
Leave Exposure and Blacks alone for now—we'll fine tune those last. First, take your Recovery slider and crank it up to 100. Do the same for Fill Light. You should already have a very odd effect in the making.

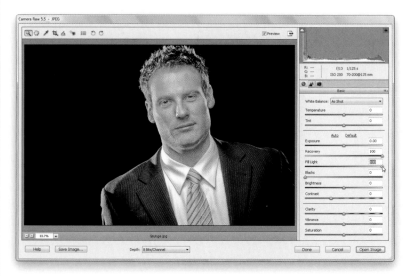

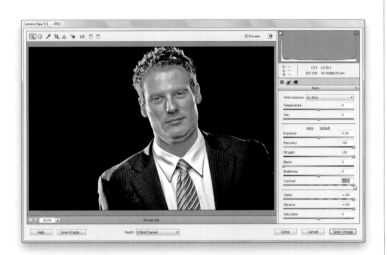

Step Three:
Now try taking the Clarity setting all the way up to 100. Are you seeing a pattern here? Next take the Vibrance slider and move it to, you guessed it, 100. Then move the Contrast slider to 100.

Step Four:
Now you've probably got a really odd-looking photo. Well one of the things that characterizes this effect is a desaturated look. To achieve that, try dragging the Saturation slider toward the left. You don't want to go to –100 but somewhere between –60 and –70 should do the trick.

Step Five:
Finally, the photo should be pretty flat, so trying increasing the blacks just to add a little more contrast here. I've found that a setting around 25–40 (I used 35 here) usually works well, but don't go much higher. You still want a lot of that detail in the shadowy areas to show through. If you find the photo is too light or too dark, then try adjusting the Exposure as a final step here, but again, not too much.

Simulating Film Grain

There's a big difference between digital noise and film grain. Digital noise (those red, green, and blue dots that appear when shooting at high ISOs) is what we want to avoid (or, at the very least, make less noticeable), because it ruins the image. However, simulating the look of traditional film grain (which doesn't have those colored dots) is really becoming a popular effect. In fact, there are third-party plug-ins you can buy that specialize in recreating it, but I still do it myself, right in Elements (but I don't use the lame Film Grain filter, which to me never actually looks like film grain). Here's what I do:

Step One:
Open the photo that you want to add a film grain look to. Go to the Layers palette and **Ctrl-click (Mac: Option-click)** on the Create a New Layer icon at the bottom of the palette to access the New Layer dialog. When the dialog appears, choose Soft Light from the Mode pop-up menu. When you choose Soft Light, you'll see the Fill with Soft-Light-Neutral Color (50% Gray) option (right under the Mode pop-up menu) is now available. Turn on its checkbox and click OK.

Step Two:
This creates a new blank layer filled with gray, but because you set the Mode to Soft Light first, this layer will be see-through. So, if it's see-through, why did we need it in the first place? Well, it's because some filters in Elements won't run on an empty transparent layer (you'd get a "there's nothing there" warning). So, this way, it fools the filter into working, and then we can not only apply the filter to a transparent layer, we can control it after the fact. Sneaky. I know.

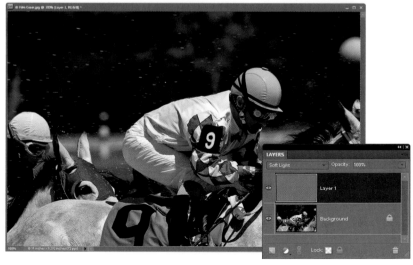

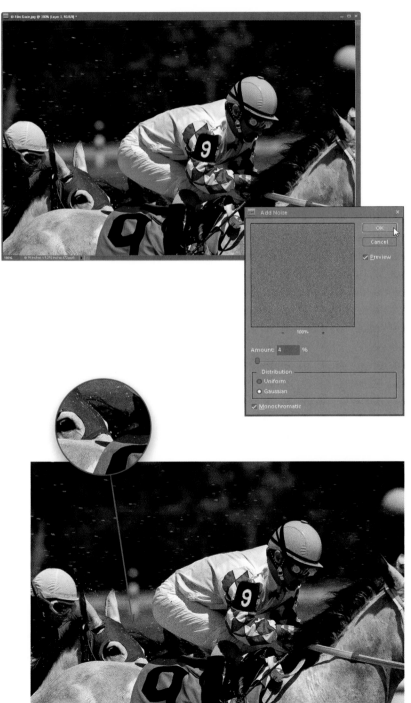

Step Three:

Now, go under the Filter menu, under Noise, and choose Add Noise. When the Add Noise filter dialog appears, we want to make sure that the noise we add doesn't have little red, green, and blue dots, so first choose Gaussian as your Distribution method, then turn on the Monochromatic checkbox at the bottom. Now, lower your Amount to around 4% (or 5% for 12-megapixel images), then click OK. This applies a noise pattern to your gray layer, and since this layer is transparent, you now see this film-grain-like look on your photo (if you don't see it right away—zoom in to 50% or 100%).

Step Four:

If the simulated film grain effect looks a bit too heavy, you can lower the Opacity of this noise layer in the Layers palette, until it blends in nicely (you are supposed to actually see the noise). Also, if you're going to be making a print of this image, let the grain be a little heavier onscreen, because when you print it, much of that grain will be hidden in the printing process. So, if I know I'm going to be printing, I go a little heavier with the Opacity amount, or even go back and redo it with a higher Amount setting (like 5% or 6%, which I did for this example) in the Add Noise filter. If you really want to make the noise more apparent (for effect), in the Layers palette, change the Layer Blend mode of this layer to Overlay (also done here), and it will become much more pronounced (again, don't forget you can control it afterwards using the Opacity slider on that layer). By the way, Overlay mode supports the whole "gray is transparent" trick, too! That's it—simulated film grain made easy.

Photographer: Scott Kelby Exposure: 1/125 Focal Length: 102mm Aperture Value: f/13

Sharp Dressed Man
sharpening techniques

You're about to learn some of the same sharpening techniques used by today's leading digital photographers and retouchers. Okay, I have to admit, not every technique in this chapter is a professional technique. For example, the first one, "Basic Sharpening," is clearly not a professional technique, although many professionals sharpen their images exactly as shown in that tutorial (applying the Unsharp Mask to the RGB composite—I'm not sure what that means, but it sounds good). There's a word for these professionals—"lazy." But then one day, they think, "Geez, I'm kind of getting tired of all those color halos and other annoying artifacts that keep showing up in my sharpened photos," and they wish there was a way to apply more sharpening, and yet avoid these pitfalls. Then, they're looking for professional sharpening techniques that will avoid these problems—

and the best of those techniques are in this chapter. But the pros are busy people, taking conference calls, getting pedicures, vacuuming their cats, etc., and they don't have time to do a series of complicated, time-consuming steps. So, they create advanced functions that combine techniques. For some unexplainable sociological reason, when pros do this, it's not considered lazy. Instead, they're seen as "efficient, productive, and smart." Why? Because life isn't fair. How unfair is it? I'll give you an example. A number of leading professional photographers have worked for years to come up with these advanced sharpening techniques, which took tedious testing, experimentation, and research, and then you come along, buy this book, and suddenly you're using the same techniques they are, but you didn't even expend a bead of sweat. You know what that's called? Cool.

Basic Sharpening

After you've color corrected your photos and right before you save your files, you'll definitely want to sharpen them. I sharpen every digital camera photo I take, either to help bring back some of the original crispness that gets lost during the correction process, or to help fix a photo that's slightly out of focus. Either way, I haven't met a digital camera (or scanned) photo that didn't need a little sharpening. Here's a basic technique for sharpening the entire photo:

Step One:
Open the photo that you want to sharpen. Because Elements displays your photo in different ways at different magnifications, it's absolutely critical that you view your photo at 100% when sharpening. To ensure that you're view-ing at 100%, once your photo is open, double-click on the Zoom tool in the Toolbox, and your photo will jump to a 100% view (to see the actual percentage of zoom, look up in the image window's title bar, tab, or Options Bar, depending on your viewing mode, or look in the image window's bottom-left corner).

SCOTT KELBY

Step Two:
Go under the Enhance menu and choose Unsharp Mask. (If you're familiar with traditional darkroom techniques, you probably recognize the term "unsharp mask" from when you would make a blurred copy of the original photo and an "unsharp" version to use as a mask to create a new photo whose edges ap-peared sharper.)

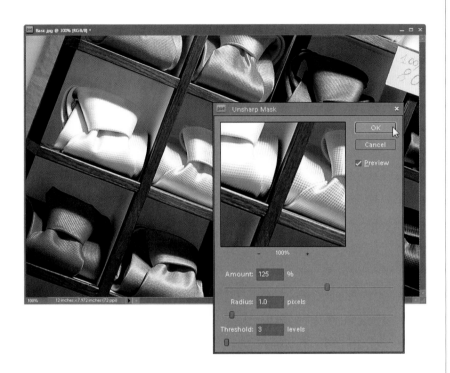

Step Three:

When the Unsharp Mask dialog appears, you'll see three sliders. The Amount slider determines the amount of sharpening applied to the photo; the Radius slider determines how many pixels out from the edge that the sharpening will affect; and the Threshold slider determines how different a pixel must be from the surrounding area before it's considered an edge pixel and sharpened by the filter. Threshold works the opposite of what you might think—the lower the number, the more intense the sharpening effect. So, what numbers do you enter? I'll give you some great starting points on the following pages, but for now, we'll just use these settings: Amount: 125%, Radius: 1, and Threshold: 3. Click OK and the sharpening is applied to the photo.

Before

After

Continued

Sharpening Soft Subjects:
Here are the Unsharp Mask settings—
Amount: 150%, Radius: 1, Threshold:
10—that work well for images where
the subject is of a softer nature (e.g.,
flowers, puppies, people, rainbows,
etc.). It's a subtle application of sharp-
ening that is very well suited to these
types of subjects.

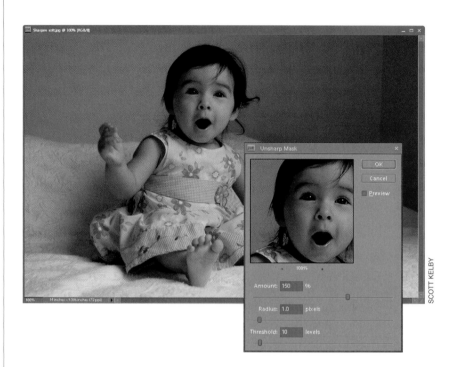

Sharpening Portraits:
If you're sharpening a close-up portrait
(head-and-shoulders type of thing),
try these settings—Amount: 75%,
Radius: 2, Threshold: 3—which applies
another form of subtle sharpening.

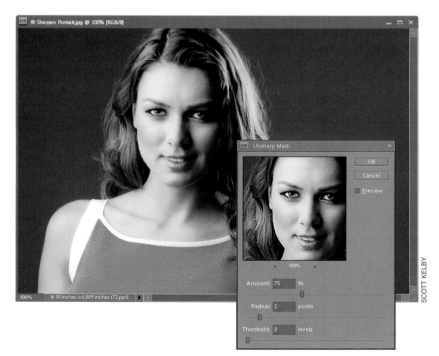

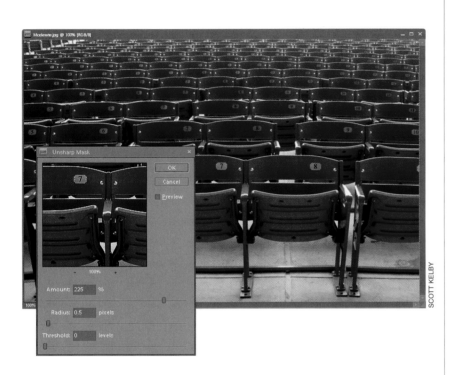

SCOTT KELBY

Moderate Sharpening:
This is a moderate amount of sharpening that works nicely on product shots, photos of home interiors and exteriors, and landscapes. If you're shooting along these lines, try applying these settings—Amount: 225%, Radius: 0.5, Threshold: 0—and see how you like it (my guess is you will).

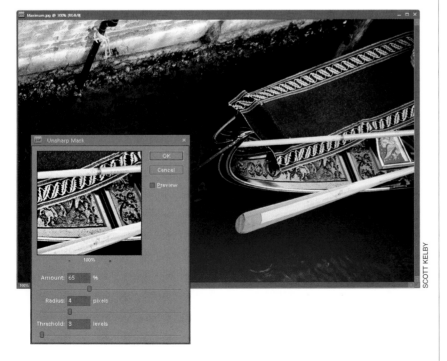

SCOTT KELBY

Maximum Sharpening:
I use these settings—Amount: 65%, Radius: 4, Threshold: 3—in only two situations: (1) The photo is visibly out of focus and it needs a heavy application of sharpening to try to bring it back into focus; or (2) the photo contains lots of well-defined edges (e.g., buildings, coins, cars, machinery, etc.).

Continued

All-Purpose Sharpening:

These are probably my all-around favorite sharpening settings—Amount: 85%, Radius: 1, Threshold: 4—and I use these most of the time. It's not a "knock-you-over the-head" type of sharpening—maybe that's why I like it. It's subtle enough that you can apply it twice if your photo doesn't seem sharp enough after the first application (just press **Ctrl-F [Mac: Command-F]**), but once will usually do the trick.

Web Sharpening:

I use these settings—Amount: 400%, Radius: 0.3, Threshold: 0—for Web graphics that look blurry. (When you drop the resolution from a high-res, 300-ppi photo down to 72 ppi for the Web, the photo often gets a bit blurry and soft.) I also use this same sharpening on out-of-focus photos. It adds some noise, but I've seen it rescue photos that I would have otherwise thrown away. If the effect seems too intense, try dropping the Amount to 200%.

Coming Up with Your Own Settings:

If you want to experiment and come up with your own custom blend of sharpening settings, I'll give you some typical ranges for each adjustment so you can find your own sharpening "sweet spot."

Amount:

Typical ranges go anywhere from 50% to 150%. This isn't a rule that can't be broken. It's just a typical range for adjusting the Amount, where going below 50% won't have enough effect, and going above 150% might get you into sharpening trouble (depending on how you set the Radius and Threshold). You're fairly safe to stay under 150%.

Radius:

Most of the time, you'll use just 1 pixel, but you can go as high as (get ready)—2. I gave you one setting earlier for extreme situations, where you can take the Radius as high as 4, but I wouldn't recommend it very often. I once heard a tale of a man in Cincinnati who used 5, but I'm not sure I believe it.

Continued

Threshold:

A pretty safe range for the Threshold setting is anywhere from 3 to around 20 (3 being the most intense, 20 being much more subtle. I know, shouldn't 3 be more subtle and 20 more intense? Don't get me started). If you really need to increase the intensity of your sharpening, you can lower the Threshold to 0, but keep a good eye on what you're doing (watch for noise appearing in your photo).

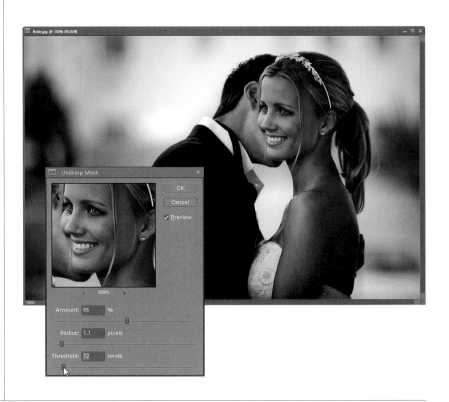

Before

After

One of the problems we face when trying to make things really sharp is that things tend to look oversharpened, or worse yet, our photos get halos (tiny glowing lines around edges in our images). So, how do we get our images to appear really sharp without damaging them? With a trick, of course. Here's the one I use to make my photos look extraordinarily sharp without damaging the image:

Creating Extraordinary Sharpening

Step One:
Open your image, and then apply the Unsharp Mask filter (found under the Enhance menu) to your image, just as we've been doing all along. For this example, let's try these settings—Amount: 120%, Radius: 1, and Threshold: 3—which will provide a nice, solid amount of sharpening.

Step Two:
Press **Ctrl-J (Mac: Command-J)** to duplicate the Background layer. Because we're duplicating the Background layer, the layer will be already sharpened, but we're going to sharpen this duplicate layer even more in the next step.

Continued

Step Three:

Now apply the Unsharp Mask filter again, using the same settings, by pressing **Ctrl-F (Mac: Command-F)**. If you're really lucky, the second application of the filter will still look okay, but it's doubtful. Chances are that this second application of the filter will make your photo appear too sharp—you'll start to see halos or noise, or the photo will start looking artificial in a lot of areas. So, what we're going to do is hide this oversharpened layer, then selectively reveal this über-sharpening only in areas that can handle the extra sharpening (this will make sense in just a minute).

Step Four:

Go to the Layers palette, press-and-hold the Ctrl (Mac: Command) key, and click on the Create a New Layer icon at the bottom of the Layers palette (holding the Ctrl key makes the new layer appear below your currently active layer, rather than above it, like usual).

Step Five:

In the Layers palette, click on your oversharpened layer to make it the active layer (it should be your top layer, with that blank layer you just created appearing directly below it in the stack of layers). Now press **Ctrl-G (Mac: Command-G)**. This groups your oversharpened layer with the empty one beneath it and creates a clipping mask; thus it hides the oversharpened layer in that blank layer.

Step Six:

Here's the fun part—the trick is to paint over just a few key areas, which fool the eye into thinking the entire photo is sharper than it is. Here's how: Press **B** to get the Brush tool, and in the Options Bar, click on the Brush thumbnail to open the Brush Picker and choose a soft-edged brush. Press **D** to set your Foreground color to black. Now, in the Layers palette, click on the blank layer and then start painting on your image to reveal your sharpening. (*Note:* If you make a mistake, press **E** and erase your black brush strokes with the Eraser tool.) In this example, I painted over the guitar. Revealing these few sharper areas, which immediately draw the eye, makes the whole photo look sharper.

Before

After

Luminosity Sharpening

Okay, you've already learned that sharpening totally rocks, but the more you use it, the more discerning you'll become about it (you basically become a sharpening snob), and at some point, you'll apply some heavy sharpening to an image and notice little color halos. You'll grow to hate these halos, and you'll go out of your way to avoid them. In fact, you'll go so far as to use this next sharpening technique, which is fairly popular with pros shooting digital (at least with the sharpening-snob crowd).

Step One:
Open a photo that needs some moderate to serious sharpening.

Step Two:
Duplicate the Background layer by going under the Layer menu, under New, and choosing Layer via Copy (or pressing **Ctrl-J [Mac: Command-J]**). This will duplicate the Background layer onto a new layer (Layer 1).

Step Three:
Go under the Enhance menu and choose Unsharp Mask. (*Note:* If you're looking for some sample settings for different sharpening situations, look at the "Basic Sharpening" tutorial at the beginning of this chapter.) After you've input your Unsharp Mask settings, click OK to apply the sharpening to the duplicate layer.

Step Four:
Go to the Layers palette and change the layer blend mode of this sharpened layer from Normal to Luminosity. By doing this, it applies the sharpening to just the luminosity (lightness details) of the image, and not the color. This enables you to apply a higher amount of sharpening without getting unwanted halos. You can now choose Flatten Image from the Layers palette's flyout menu to complete your Luminosity sharpening.

Continued

Before After

This is a sharpening technique that doesn't use the Unsharp Mask filter but still leaves you with a lot of control over the sharpening, even after it's applied. It's ideal to use when you have an image that can really hold a lot of sharpening (a photo with a lot of edges) or one that really needs a lot of sharpening.

Edge Sharpening Technique

Step One:
Open a photo that needs edge sharpening.

Step Two:
Duplicate the Background layer by going under the Layer menu, under New, and choosing Layer via Copy (or pressing **Ctrl-J [Mac: Command-J]**). This will duplicate the Background layer onto a new layer (Layer 1).

Continued

Step Three:
Go under the Filter menu, under Stylize, and choose Emboss. You're going to use the Emboss filter to accentuate the edges in the photo. You can leave the Angle and Amount settings at their defaults (135° and 100%), but if you want more intense sharpening, raise the Height amount from its default setting of 3 pixels to 5 or more pixels (in the example here, I left it at 3). Click OK to apply the filter, and your photo will turn gray, with neon-colored highlights along the edges.

Step Four:
In the Layers palette, change the layer blend mode of this layer from Normal to Hard Light. This removes the gray color from the layer, but leaves the edges accentuated, making the entire photo appear much sharper.

Step Five:
If the sharpening seems too intense, you can control the amount of the effect by simply lowering the Opacity of this top layer in the Layers palette.

Before

After

Advanced Sharpening Using Adjust Sharpness

I predict that the Adjust Sharpness control will actually replace the long-heralded Unsharp Mask as the sharpening filter of choice. Here's why: (1) it does a better job of avoiding those nasty color halos, so you can apply more sharpening without damaging your photo; (2) it lets you choose different styles of sharpening; (3) it has a much larger preview window so you can see your sharpening more accurately; (4) it has a More Refined feature that applies multiple iterations of sharpening; and (5) it's just flat out easier to use.

Step One:
Open the photo you want to sharpen using the Adjust Sharpness control. (By the way, although most of this chapter focuses on using the Unsharp Mask filter, I only do that because it's the current industry standard. If you find you prefer the Adjust Sharpness control, from here on out, when I say to apply the Unsharp Mask filter, you can substitute the Adjust Sharpness control instead. Don't worry, I won't tell anybody.)

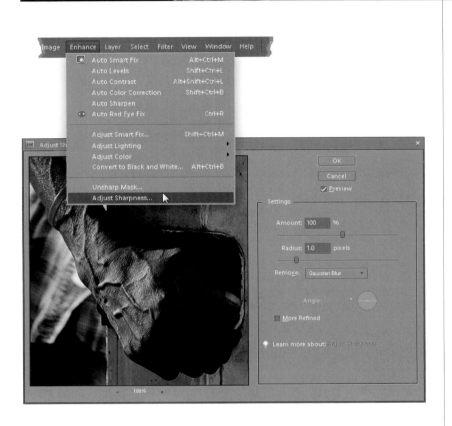

Step Two:
Go under the Enhance menu and choose Adjust Sharpness. When the dialog opens, you'll notice there are only two sliders: Amount (which controls the amount of sharpening—sorry, my editors made me say that) and Radius (which determines how many pixels the sharpening will affect). I generally leave the Radius setting at 1 pixel, but if a photo is visibly blurry, I'll pump it up to 2. (Very rarely do I ever try to rescue an image that's so blurry that I have to use a 3- or 4-pixel setting.)

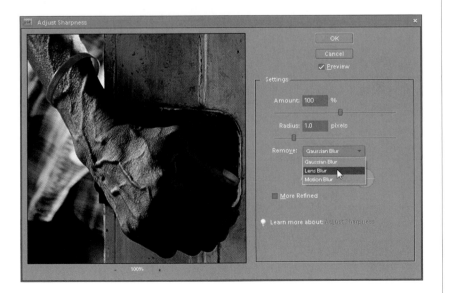

Step Three:
Below the Radius slider is the Remove pop-up menu, which lists the three types of blurs you can reduce using Adjust Sharpness. Gaussian Blur (the default) applies a brand of sharpening that's pretty much like what you get using the regular Unsharp Mask filter (it uses a similar algorithm). Another Remove menu choice is Motion Blur, but unless you can determine the angle of blur that appears in your image, it's tough to get really good results with this one. So, which one do I recommend? The other choice—Lens Blur. It's better at detecting edges, so it creates fewer color halos than you'd get with the other choices, and overall I think it just gives you better sharpening for most images. The downside? Choosing Lens Blur causes the filter to take a little longer to "do its thing." A small price to pay for better-quality sharpening.

Continued

Step Four:
Near the bottom of the dialog, there's a checkbox labeled More Refined. It gives you (according to Adobe) more accurate sharpening by applying multiple iterations of the sharpening. I leave More Refined turned on nearly all the time. (After all, who wants "less refined" sharpening?) *Note:* If you're working on a large file, the More Refined option can cause the filter to process slower, so it's up to you if it's worth the wait. I've also found that with the Adjust Sharpness control, I use a lower Amount setting than I would with the Unsharp Mask filter to get a similar amount of sharpening, so I usually find myself lowering the Amount to around 60% in most instances.

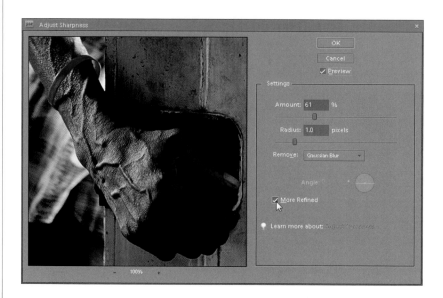

Before

After

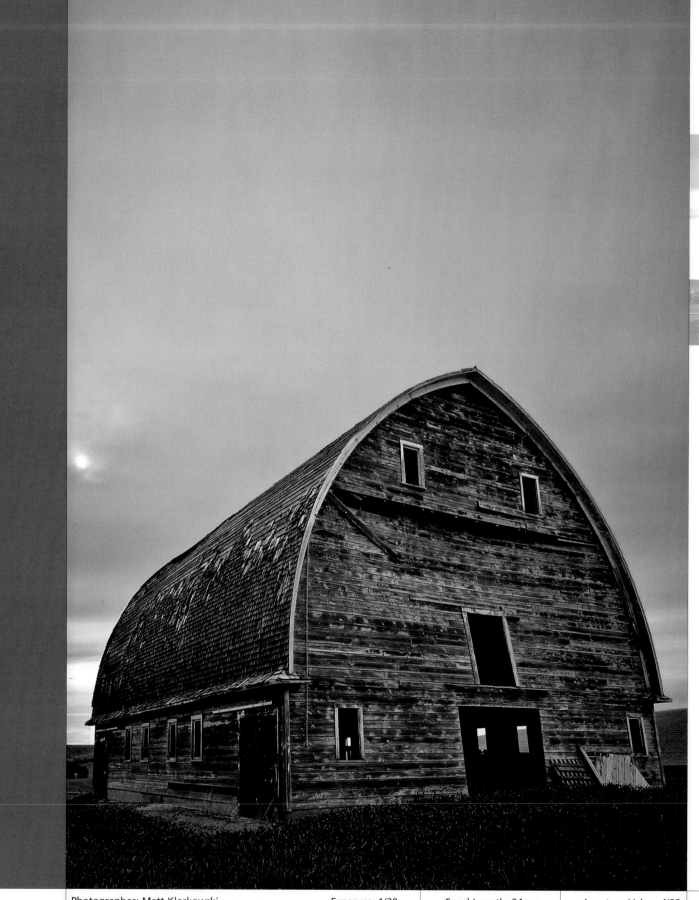

Photographer: Matt Kloskowski Exposure: 1/30 Focal Length: 24mm Aperture Value: ƒ/22

Best in Show
how to show your work

At some point in all of this, you're eventually going to want to show your client, or more likely a potential client, samples (or even finished products) of your work. Make sure you work on this part of the process long before your client is within 100 miles of your studio because (and this is a little-known fact) hard-wired into your color inkjet printer is a small integrated chip that actually senses fear. That's right—if you're on a tight deadline, and you have to get your samples out of the printer right before your client arrives, the tiny electrodes in the chip sense your fear, and as a defense mechanism, it releases millions of tiny silicon wafers into your printer's USB port, which causes your printer to basically go into sort of a prolonged hibernation mode which makes it just sit there and quietly hum. This auto-sleep or shut down mode is called

"mocking mode" and is the digital equivalent of a small child giving you a raspberry. The more freaked out or rushed you get, the more of those tiny silicon wafers it releases, and the sleepier your printer becomes until it gets to the point that it has the operating functionality of a block of cheese. Now, you can fool your printer into printing again, but it's not easy. First, you have to continue to act freaked out, but when the printer's not paying attention you sneak out of the room and use your cell phone to call the studio phone nearest the printer. Once it starts ringing, you rush into the studio, and looking exasperated, you grab the phone and pretend it's the client on the line, and they're calling to cancel today's appointment. When your printer hears this (and trust me, this is true), it will instantly start outputting your prints. Try this—it works every time.

Watermarking and Adding Copyright Info

This two-part technique is particularly important if you're putting your photos on the Web and want some level of copyright protection. In the first part of this technique, you'll add a see-through watermark, so you can post larger photos without fear of having someone download and print them. Secondly, you'll embed your personal copyright info, so if your photos are used anywhere on the Web, your copyright info will go right along with the file.

Step One:

We're going to start by creating a watermark template. Create a new blank document in the Elements Editor (go to File, under New, and choose Blank File) in RGB mode in your typical working resolution (72 ppi for low-res, 300 ppi for high-res, etc.). Click on the Foreground color swatch at the bottom of the Toolbox and choose a medium gray color in the Color Picker, then click OK. Now, press **Alt-Backspace (Mac: Option-Delete)** to fill the Background layer with medium gray. Press the letter **D** to set your Foreground color to black.

Step Two:
Press **T** to switch to the Horizontal Type tool. In the Options Bar, choose a font like Arial Bold from the font pop-up menus, and then click on the Align icon and choose Center Text from the pop-up menu. Click the cursor on the gray background, press-and-hold the Alt key, type "0169" using your numeric keypad, and release the Alt key to create a copyright symbol. (*Note:* On a laptop, press-and-hold the Function key to access your key-pad. On a Mac, press **Option-G**.) Then, press Enter (Mac: Return) to move your cursor to the next line and type the name you want for the copyright on the photo. If needed, adjust the leading (space between lines) by selecting all your text **(Ctrl-A [Mac: Command-A])** and choosing a point size in the Set the Leading pop-up menu in the Options Bar. Now hide the Background layer by clicking on its Eye icon in the Layers palette.

Step Three:
Highlight your name (but not the copy-right symbol) with the Horizontal Type tool and increase its size by using the Set the Font Size pop-up menu in the Options Bar. When your name is at the right size, highlight just the copyright symbol instead, and resize it upward until it's quite a bit larger than your name. Try the type at around 50 points (unless your last name is huge, like mine, then you may need to go with some-thing smaller) and the copyright symbol at 150 points. When you're done, click the green Commit checkmark in the Options Bar.

Continued

Step Four:

Go to the Effects palette (if it's not visible, go under the Window menu and choose Effects), and from the palette's flyout menu, choose Large Thumbnail View. At the top of the palette, click on the Filters icon (the first icon on the left). In the pop-up menu in the palette's upper right-hand corner, choose Stylize. Now double-click on the Emboss effect (as shown here). A warning dialog will appear letting you know that the Type layer must be simplified. Click OK.

Step Five:

In the resulting Emboss dialog, set the Angle to 135°, Height to 3 pixels, and Amount to 100%. Click OK, and this will apply a beveled effect. To smooth the edges of the Type layer, go to the Layers palette and click on the Lock Transparent Pixels icon at the bottom of the palette (the second icon from the right). Then, from the Filter menu, choose Blur, and add a 2- or 3-pixel Gaussian Blur.

Step Six:

Go back to the Layers palette and change the blend mode of this Type layer from Normal to Hard Light. This will make the watermark transparent. Now you can make the Background layer visible again by clicking in the empty box where the Eye icon used to be. You can now see the Emboss and blurring effects clearly.

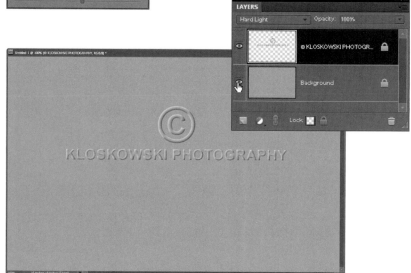

Step Seven:
Open the photo you want to contain this transparent watermark. Make sure this photo and the document with your embossed watermark are both visible within Elements (if not, go under the Window menu, under Images, and choose Float All in Windows).

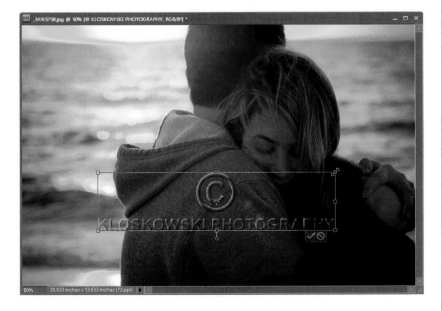

Step Eight:
Press **V** to switch to the Move tool, then click-and-drag the watermark's Type layer from the Layers palette (in the embossed watermark document) and drop it onto your photo (you're dragging a layer between documents). Once the watermark is in your new document, you can resize it as needed. Just press **Ctrl-T (Mac: Command-T)** to bring up Free Transform and click-and-drag one of the corner handles. Add the Shift key to resize the type proportionately, or turn on the Constrain Proportions checkbox in the Options Bar. Press **Enter (Mac: Return)** to complete your transformation.

Continued

Step Nine:

Now go to the Layers palette and lower the Opacity of your Type layer so it's clearly visible, but doesn't dominate the photo. Press **Ctrl-E (Mac: Command-E)** to flatten the image.

Step 10:

Now for the second part—we'll embed your personal copyright info into the photo file itself. Go under the File menu and choose File Info. This is where you enter information that you want embedded. This embedding of info is supported by all the major file formats (such as TIFF, JPEG, EPS, PDF, and Elements' native PSD file format).

Step 11:
In the dialog, click on the Description tab, and change the Copyright Status pop-up menu from Unknown to Copyrighted. In the Copyright Notice field, enter your personal copyright info, and then in the Copyright Info URL field, enter your full Web address. That way, when others open your file in Elements, they can go to File Info, click on the Go To URL button, and it will launch their Web browser and take them directly to your site.

Step 12:
Click OK and the info is embedded into the file. Once copyright info has been embedded into a file, Elements automatically adds a copyright symbol before the file's name, which appears in the photo's title bar. That's it—you applied two levels of protection: one visible and one embedded.

Turning Your Signature into a Brush

One way to personalize your work and make it less "computerish" is to add your own signature to it. In Elements, there's a way to create a custom brush of your signature so that it's always just a click away. When you're done and ready to sign, you just grab the Brush tool, choose your signature brush, click once, and it's there.

Step One:
The first step to all this is getting your signature into Elements. There are basically two ways: (1) take a nice black writing pen, sign your name fairly large on a piece of paper, and then scan your signature (which is what I did here), or (2) if you have a Wacom tablet with its wireless pen, just open a new document (at a resolution of 300 ppi), press **D** to set your Foreground color to black, get the Brush tool **(B)**, then choose a small, hard-edged brush from the Brush Picker, and sign your name at a fairly large size.

Step Two:
Now go under the Edit menu and choose Define Brush. This brings up the Brush Name dialog (shown here), where you give your new signature brush a name (I named mine "My Signature," which is a carefully thought out, highly original name) and click OK. That's all there is to creating your signature brush, and the nice thing is you only have to do this once—it's saved into Elements' Brush Presets for use in the future. Now let's put this new signature brush to use.

MATT KLOSKOWSKI

Step Three:
When you want to apply your signature to a photo, open that photo and get the Brush tool **(B)**. Right-click anywhere inside your image area, and the Brush Picker will appear right at the location of your cursor (as seen here). The new signature brush you just created in Step Two will appear as the last brush in the list of brushes, so scroll all the way down to the bottom, and click on that very last brush (you'll see a tiny version of your signature as the brush's thumbnail).

Step Four:
By default, the brush will be the size it was when you created your Brush preset, so if you need to change the size of your brush, just drag the Size slider in the Options Bar (shown circled here in red). In my case, I needed to drag that slider to the left to make the brush much smaller, because if you look directly under the thumbnail, it shows your brush's size in pixels, and mine was 356 pixels. Kinda big, don'tcha think?

Step Five:
Now that you've got your signature brush, and have adjusted the size, go to the Layers palette and click on the Create a New Layer icon at the bottom. In our example here, the photo has a dark foreground so I'll have to change my Foreground color from black to something easily seen on a dark fore-ground (in this case, I just pressed **X** and changed it to white). Then, take the brush and simply click once where you want the signature to appear (as shown here, where I clicked in the bottom-right corner), and press **Ctrl-E (Mac: Command-E)** to flatten your image.

Getting One 5x7" and Four 2.5x3.5" Photos on One Print

I've often joked that we're now one click away from becoming a Sears Portrait Studio since Adobe invented the Picture Package feature, which lets you gang-print standard, common photo sizes together on one sheet. With Picture Package, Elements does all the work for you. All you have to do is open the photo you want gang-printed, and then Elements will take it from there—except for the manual cutting of the final print, which is actually beyond Elements' capabilities. So far.

Step One:
Select the photo in the Elements Organizer that you want to appear in multiple sizes on one page, and then go under the File menu and choose Print.

Note: On a Mac, this feature works a little differently. For a quick explanation, see the end of this tutorial.

Step Two:
When the dialog appears, on the right-hand side, choose which printer you want to use. Then in section 4, choose Picture Package from the pop-up menu. (*Note:* For more info on your printer settings [section 2], see Chapter 12.)

Step Three:
In the fifth section down, choose the sizes and layout for your Picture Package from the Select a Layout pop-up menu. In this example, I chose Letter (1) 5x7 (4) 2.5x3.5, but you can choose any combination you like.

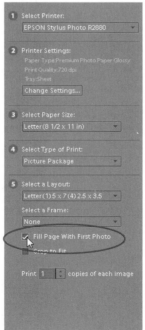

Step Four:
Even though you've chosen a multi-photo layout, only one photo will appear in the layout preview in the center of the dialog, so you'll need to turn on the Fill Page With First Photo checkbox to place your image multiple times.

Continued

Step Five:

When you turn on the Fill Page With First Photo checkbox, Elements automatically resizes, rotates, and compiles your photo into one page that you can then print and cut. This is a simple use of Picture Package, but it's actually more flexible than it looks, as you'll see in the next steps. (*Note:* When you click Print, you may get a printing warning letting you know that the image will be rendered at less than 220 dpi at the requested print size. Just click Continue.)

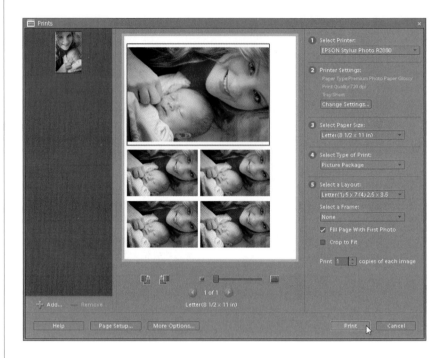

Step Six:

Another option you have is to add a custom frame around the photo in your Picture Package. To add a frame, just choose one from the Select a Frame pop-up menu and your choice will be immediately reflected in the preview.

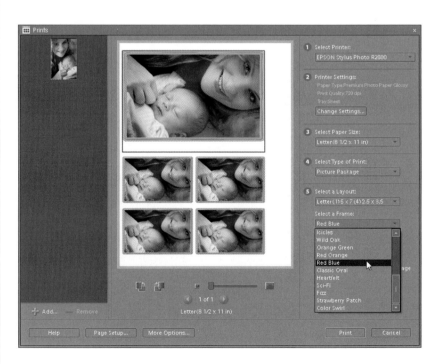

MATT KLOSKOWSKI

Step Seven:
If you'd like to create more Picture Package layouts using your same settings, all you have to do is import another photo. You do that by first clicking on the Add button near the bottom left-hand corner of the dialog. This brings up the Add Media dialog, where you can find the photo you want to import from the Media Browser, your Catalog, etc. (Here I chose to add another photo from this shoot.) Just turn on the checkbox to the left of the image's thumbnail in the dialog, and click Add Selected Media. Once imported, a small thumbnail of your photo(s) will appear in the list of photos on the left side of the Prints dialog (you can see here that I added one more photo). When you're finished adding photos, click Done.

Step Eight:
To see the layout with your new photo, click the right-facing arrow button just below the large preview in the center of the dialog. It will toggle you to a layout for your second photo. If you import several photos, you'll be able to toggle to a layout for each photo.

Continued

Step Nine:

If you're a more advanced user who understands Color Management options and assigning color profiles, you can click on the More Options button, located directly below the preview, and assign a color space to your photos before printing. But if you're not comfortable making these choices, just skip the More Options button (or check out Chapter 12 for more on Color Management).

Step 10:

Click Print for your additional Picture Package output.

FOR MAC:
Picture Package on the Mac is a little different. You'll start at the File menu in the Editor and choose Picture Package. It's all in one dialog, and you basically work from the top down. First, you select the photo you want to create a Picture Package from. Then, in the Document section, select what size paper you're going to print on, and choose your layout. Finally, under Label, you can choose to add the filename of the photo, copyright, or title of the image (plus a few other choices) from the Content pop-up menu. You can also specify what size and color text you want that information to print in. If you want to change the image sizes in the layout or create a new layout, click the Edit Layout button below the preview. That's pretty much it. Click OK, and you'll have a Picture Package ready before you know it.

Using Picture Package Layouts with More Than One Photo

Although the Picture Package feature is most often used for printing one photo multiple times on the same page, you can substitute different photos in different positions, and you can customize their location. Here's how:

Step One:

Once you have the Prints dialog open and you've selected Picture Package as your type of print (see previous tutorial), click the Add button (near the bottom left-hand corner of the dialog) to add additional photos from the Media Browser, your Catalog, etc., until you have a row of thumbnails appearing down the left side of the dialog. Make sure the Fill Page With First Photo checkbox (found on the right side of the dialog, just below the Select a Frame pop-up menu) is turned on.

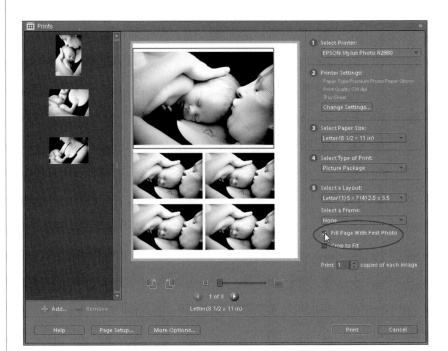

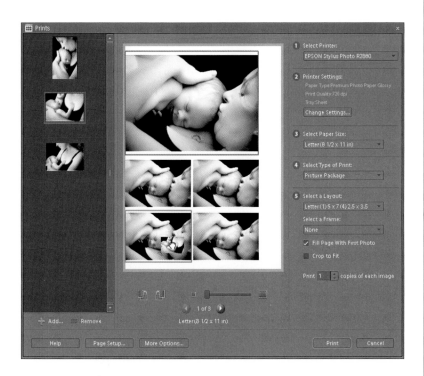

Step Two:

To add a new photo to your Picture Package layout, just click on the image's thumbnail on the left and drag-and-drop it onto the preview area in the center of the dialog on the position you want it to appear. (*Note:* As you drag, you'll notice a highlight around the preset picture position in the preview area.)

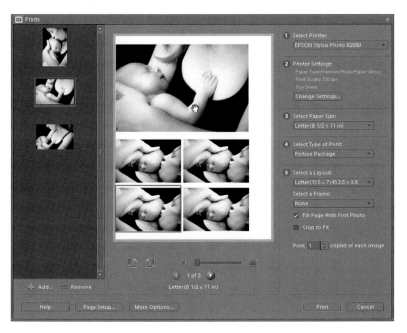

Step Three:

If you want to move a photo to another position, just click directly on the photo in the preview area and drag it to a new position. It will automatically resize if necessary.

Continued

Step Four:

You can have as many different photos as you have positions in your layout, so just continue dragging-and-dropping thumbnails from the left side of the dialog into position within the preview area.

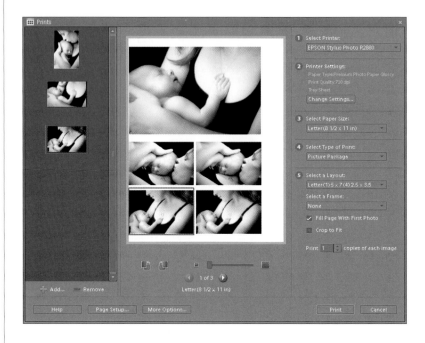

Step Five:

If you'd prefer to just have all your imported photos appear on the page at once (rather than dragging-and-dropping them), turn off the Fill Page With First Photo checkbox and all imported photos on the left of the dialog will automatically flow into place.

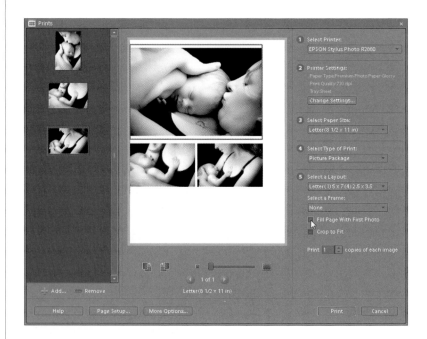

Before we get going, I've separated this tutorial into two parts: Part 1 is about making a full-blown PDF Presentation, where you get total control over everything. If you're the impatient type, though, and you just want a quick PDF slide show for email, then check out Part 2. It doesn't have as many options, but it gets you there in just a couple of clicks. (*Note:* If you're using a Mac, this is done through Bridge, so it's covered in the online chapter mentioned in the book's introduction.)

Creating a PDF Presentation for a Client

Part 1: Creating a Real PDF Presentation (with More Control Over the Presentation Part)

Step One:
Open the photos you want to use in your PDF presentation in the Editor, click on the Create tab at the top of the Palette Bin, and then click on the Slide Show button. (*Note:* You can also Ctrl-click images in the Organizer, and then click the Create tab, and then the Slide Show button.)

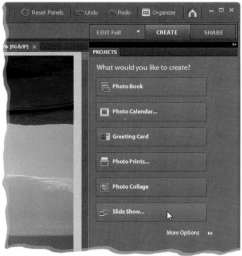

Step Two:
This brings up the Slide Show Preferences dialog, where you choose various options for your slide show. In this case, let's go with the default settings, so click the OK button near the bottom-right corner of the dialog.

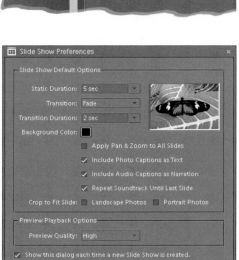

Continued

Step Three:

Clicking OK brings up yet another dialog. At the bottom of the dialog are thumbnails of all the photos that will be included in your slide show. The thumbnails are arranged in the order in which they'll appear, but to change the order, just click-and-drag a thumbnail to where you'd like it to appear. If you want to remove an image, Right-click on its thumbnail and choose Delete Slide from the contextual menu. To add an image, click on the Add Media button in the top center of the dialog, choose Photos and Videos from Elements Organizer or Photos and Videos from Folder, and browse for your image.

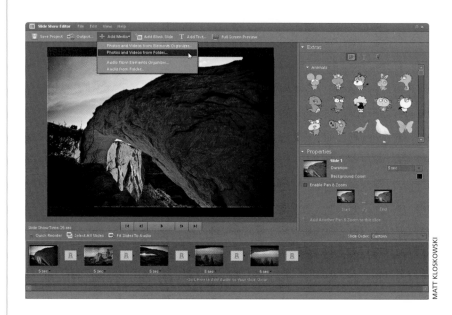

Step Four:

By default, Elements will provide a Fade transition between your slides, but you may want some variety. To choose a different transition, click on the tiny, right-facing arrow to the right of any transition's icon and select a new transition from the pop-up menu that appears. To play it safe, choose something that nearly always works, like Dissolve. To apply this to all of your slides, choose Apply to All from the same menu.

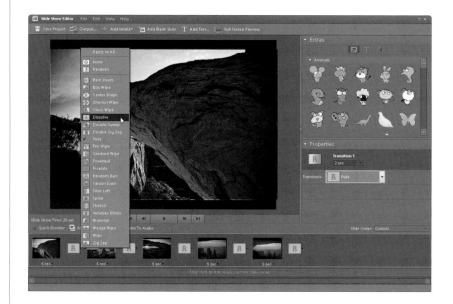

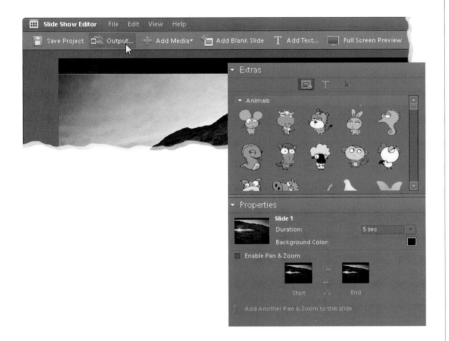

Step Five:
Along the right side of the dialog, in the Properties palette, you can customize your active slide by changing its background color, enabling effects, etc. In the Extras palette, you can add graphics, text, or narration, but since we're doing a simple PDF slide show here, I left the settings at their defaults and clicked the Output button near the top left of the dialog (to learn more about the Slide Show extras, see "Making Full-Blown Slide Shows" later in this chapter).

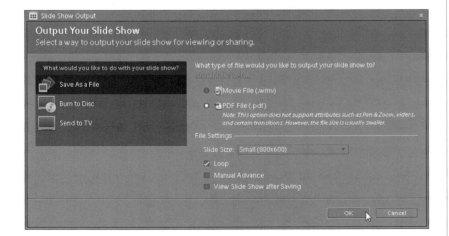

Step Six:
This brings up the Slide Show Output dialog, where you can save your slide show as a PDF. Choose Save As a File from the list of options on the left, and then on the right side of the dialog, click on the PDF File radio button. Here's where you choose your slides' settings. I like to use Small (800x600), but you can choose any size you'd like from the Slide Size pop-up menu (or enter your own preferred size by choosing Custom from the menu). Click OK, choose where you want to save your PDF, and Elements will create a PDF file that's ready for you to email to your client.

Continued

Step Seven:

When your client opens your emailed PDF, it automatically launches Adobe Reader in Full Screen mode (your photos appear centered on a black background), and the presentation begins. The capture here shows the second slide in the PDF presentation in Full Screen mode, right before it transitioned to the next photo. (*Note:* If for some strange reason your client/friend doesn't have Adobe Reader installed, he or she can download it free from Adobe's site at www.adobe.com.)

Part 2: **Creating a Quick PDF Slide Show to Email (with No Control Over the Presentation)**

Step One:

Here's the no-frills way of creating a PDF slide show if you want something quick and don't care about things like how long each slide stays up and the transitions you get in between each photo. First, select the photos you want in your slide show by Ctrl-clicking on them in the Organizer. Then click on the Share tab, and click on the More Options button. Choose PDF Slide Show (as shown here) from the list that pops up.

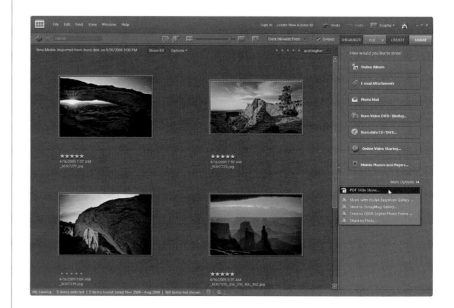

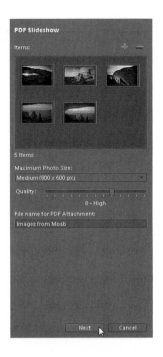

Step Two:
The first time you do this, you will get a dialog asking you to choose your email client. Choose it from the pop-up menu and click Continue. The PDF Slideshow pane will open on the right side of the Organizer. The only settings you get here are how large (Maximum Photo Size) you want the PDF to be and the Quality setting. Here, I've chosen the same size as in the other tutorial (800x600 px) and 8-High for the Quality setting. Give your PDF a descriptive name and click Next.

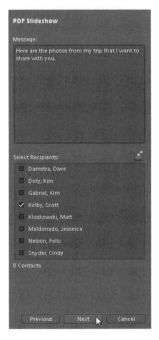

Step Three:
When the next pane opens, feel free to add a custom message to your email using the Message section at the top. Then choose who you want to send this PDF to under Select Recipients. If you've already set up your contacts, then turn on the checkbox next to their name(s). If you haven't, then click on the Edit Recipients in Contact Book button at the top right of the section to add a contact to the list. Finally, click Next, and the PDF automatically will be generated and placed into an email. All you have to do is hit Send in your email program, and your recipients will receive a PDF in their email. When they open it, the PDF will open in Full Screen mode, just like it would in Part 1.

How to Email Photos

Believe it or not, this is one of those most-asked questions, and I guess it's because there are no official guidelines for emailing photos. Perhaps there should be, because there are photographers who routinely send me high-res photos that: (a) get bounced back to them because of size restrictions, (b) take all day to download, or (c) never get here at all because there are no official guidelines on how to email photos. In the absence of such rules, consider these the "official" unofficial rules.

Step One:
Open the photos that you want to email in the Elements Editor. Above the Palette Bin, click on the Share tab and then click on E-mail Attachments. (*Note:* You may get an E-mail dialog asking you to choose an email client as your default. Choose your email client [Microsoft Outlook, etc.] from the pop-up menu and click Continue. On a Mac, your email client will launch and the photos will be inserted into a new message, ready to send.)

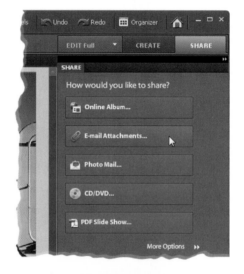

Step Two:
This opens the Organizer, with your photos appearing in the E-mail Attachments Items bin. Choose the size at which you'd like to send your images. You also get to choose a Quality setting. *Remember:* The higher the quality, the larger your file size will be, so try to find a happy medium. Try a 7 or an 8. Only go higher if you know the person to whom you're emailing these photos has a high-speed Internet connection. Now click the Next button.

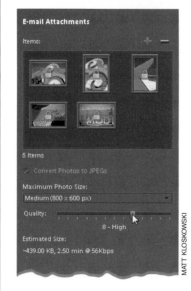

MATT KLOSKOWSKI

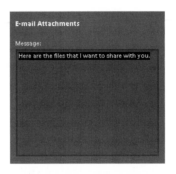

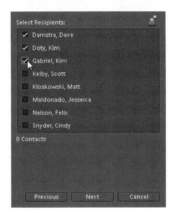

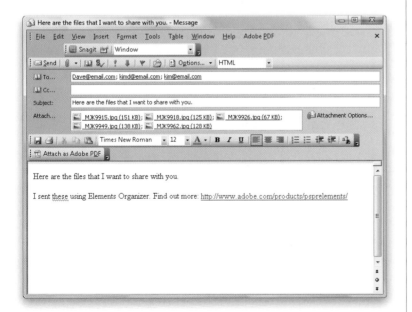

Step Three:
If you'd like to add a message to your email, enter that in the Message section at the top of the pane.

Step Four:
In the next section, you choose who you want to email these photos to. (Adobe calls this simple task Select Recipients, because that makes it sound significantly more complicated and confusing.) To choose who will receive your photos by email, click in the checkbox beside the contacts (who are in your Contact Book. If a contact isn't in the list, click on the Edit Recipients in Contact Book button at the top right of the section to add a contact to the list).

Step Five:
Once your options are set, click the Next button in the bottom of the pane. Clicking Next launches your default email application, and your photos and message are automatically attached. All that's left to do now is click the Send button and they're on their way.

Fine Art Poster Layout

This technique is the perfect thing to do once you're done with a photo and are getting ready to have it printed and framed. It gives you the layout of a pro-quality poster and it's really easy to do.

Step One:
In the Elements Editor, press **Ctrl-N (Mac: Command-N)** to create a new document in the size you want for your fine art poster layout (in our example here, I'm creating a standard-sized 11x14" print). Set your resolution to 240 ppi (for color inkjet printing), then click OK to create your new blank document.

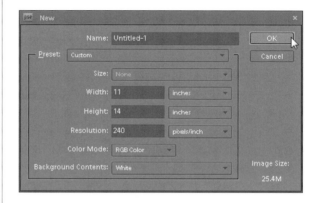

Step Two:
Open the photo you want to feature in your fine art poster layout. Get the Move tool **(V)** and click-and-drag that photo over into your fine art poster layout. Press **Ctrl-T (Mac: Command-T)** to bring up Free Transform. Grab a corner handle, drag inward or outward to size the photo so it fits within your layout like the photo shown here, and then press **Enter (Mac: Return)** to complete your transformation. To perfectly center your photo within the document, in the Layers palette, click on the Background layer, press-and-hold the Ctrl (Mac: Command) key, and then click on the photo layer to select both layers. Then go up to the Options Bar, click on the Align button, and choose Horizontal Centers from the pop-up menu to center the photo side-to-side (as shown here).

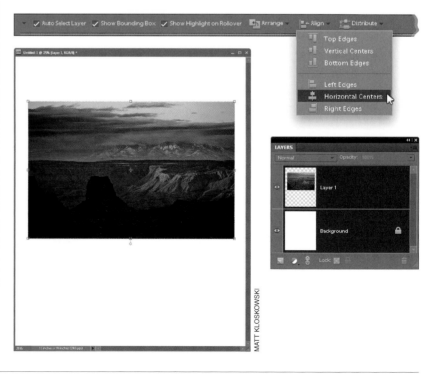

MATT KLOSKOWSKI

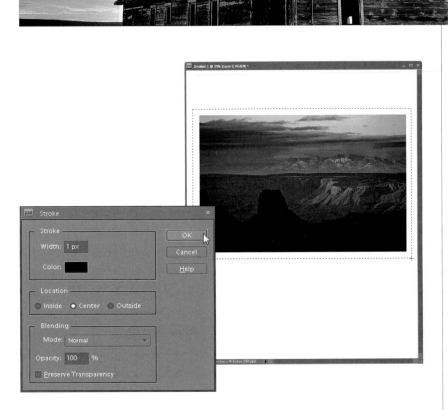

Step Three:
With the Background layer selected, click on the Create a New Layer icon at the bottom of the Layers palette to create a new blank layer between your two layers, then get the Rectangular Marquee tool **(M)** and click-and-drag out a selection that is about ¼" larger than your photo (as shown here). You're going to turn this selection into a fake mat. Press **D** to set your Foreground color to black, then go to the Edit menu and choose Stroke (Outline) Selection. Enter 1 pixel for the width, choose Center for the location, and click OK. Press **Ctrl-D (Mac: Command-D)** to Deselect.

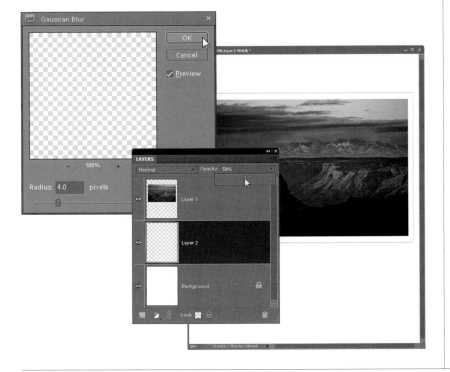

Step Four:
To create the mat effect, we'll need to blur the stroke. From the Filter menu, choose Blur, and then choose Gaussian Blur. Enter 4 for the Radius setting and click OK. Then lower the Opacity of this blurred stroke layer to 50% (as shown here) to create the subtle shadow of a beveled mat (since the stroke is so thin, it is hard to see here, but you'll be able to see it in your layout).

Continued

Step Five:

At this point, you'll see the mat-like effect is in place around your photo. Although you want the photo centered side-to-side, you don't want the photo centered top-to-bottom. Fine art posters generally have the photo well above the center of the poster, at what is called the "optical center," which is the area just above the center. To move the photo up, go to the Layers palette and Ctrl-click (Mac: Command-click) on both the photo layer and the mat layer beneath it to select them. Then get the Move tool, and use the **Up Arrow key** on your keyboard to nudge the photo and mat upward until they are well above the center top-to-bottom (as seen in the next step).

Step Six:

Now it's time to add your poster text. Press the letter **T** to get the Horizontal Type tool to add your text (i.e., the name of your studio, the name of the poster, whatever you'd like). I chose the font Trajan Pro at 24 points in black, and I typed in upper- and lowercase. The extra space between the letters adds an elegant look to the type. To do that, hit the Spacebar once between each letter in a word and add three spaces between each word.

Step Seven:
The easiest way to add more type is to switch to the Move tool, press **Ctrl-J (Mac: Command-J)** to duplicate the Type layer, then use the **Down Arrow key** to move the new line of type down. Switch back to the Type tool, highlight the type to change the text, and change the size of it. Add additional lines of text if you want (as I did here, where I added lines underneath the top line for the location and date the photo was taken. Then I duplicated the Type layer again and added the bottom line of text). To center all four lines of type side-to-side perfectly within your image area, click on the Background layer in the Layers palette, and then Ctrl-click on each Type layer, so all five layers are selected. Press V to get the Move tool again, and in the Options Bar, click on the Align button and choose Horizontal Centers from the pop-up menu to center your text beneath your image.

Step Eight:
Lastly, you can add your signature (either after it's printed, or right within Elements itself if you have a scan of your signature or a Wacom tablet, where you can just use the tablet's wireless pen to create a digital signature. See the "Turning Your Signature into a Brush" tutorial earlier in this chapter). Here's the final photo with my signature added under the right corner, and the letters "A/P" under the left corner, which stands for "Artist Print," indicating the print was output by the photographer him/herself.

Simple Three-Photo Balanced Layout

So far, you've seen ways to create a print that shows off one photo at a time. But what about those times when you want more than one image on a print? Here's a really simple layout that works great at showing off several photos on the same print.

Step One:

In the Elements Editor, press **Ctrl-N (Mac: Command-N)** and create a new document that is very wide (the one shown here is 11" wide by 3" deep). Go to the Layers palette, click on the Create a New Layer icon at the bottom of the palette, and then get the Rectangular Marquee tool **(M)**. Press-and-hold the Shift key and, on the left side of the document, click-and-drag out a square selection (since you're holding the Shift key—don't worry—it will be perfectly square) that is almost as tall as the document itself (leave approximately ½" of white space at the top, left, and bottom). Press **D** to set your Foreground color to black, and then press **Alt-Backspace (Mac: Option-Delete)** to fill your selection with black. Don't deselect yet.

Step Two:

Press **V** to get the Move tool from the Toolbox. Press **Ctrl-Alt-Shift (Mac: Command-Option-Shift)**, and click-and-drag yourself a copy of your selected black square. Drag it all the way over to approximately the same position on the right side of your document, as shown here (holding Ctrl-Alt makes a duplicate of your square, and holding the Shift key keeps it perfectly aligned with the other square as you're dragging to the right).

Step Three:
Deselect by pressing **Ctrl-D (Mac: Command-D)**. Switch back to the Rectangular Marquee tool, but this time don't hold the Shift key (that way, you can draw a rectangle). Now, draw a rectangular selection between the two squares, leaving approximately the same amount of space between your shapes (as shown here). Then fill that long rectangle with black (press Alt-Backspace). So, what you have is (from L to R) a black square, a long black rectangle, and another black square. Now deselect.

Step Four:
Open the photo you want to appear over the square on the left. Get the Move tool and drag-and-drop it onto your three-square document. Once the photo appears, press **Ctrl-T (Mac: Command-T)** to bring up Free Transform. Now you'll resize the photo (probably making it smaller) so it's slightly larger than the square on the left (as shown here), and then press **Enter (Mac: Return)** to lock in your resizing. *Note:* If you can't see the Free Transform handles, press **Ctrl-0** (zero; **Mac: Command-0**) to zoom out to where they will show.

MATT KLOSKOWSKI

Step Five:
Now press **Ctrl-G (Mac: Command-G)** to mask your rectangular photo into that black square (as shown here). You can get the Move tool and reposition your photo inside that black square by just clicking-and-dragging on it. Don't freak out if you see part of your photo appearing in the center rectangle, because we'll cover that with a different photo layer.

Continued

Step Six:
Now repeat the last two steps, opening two other photos, dragging-and-dropping them onto your three-square document, and resizing them so that they're slightly larger than the boxes they're going to be masked into. Once one of them is sized, press Ctrl-G to mask it into the shape. Then do the same for the other photo. If, when you're done, any one of those photos extends into a different box, just go to the Layers palette and move that layer down one (or two) layers until that extra area is hidden behind one of the other masked photos.

Step Seven:
Now, unless the three photos were taken in almost the exact same light, chances are at least one of them is going to look a bit funky (colorwise), so you might want to consider creating a tint over all three (it's an easy way to ensure the colors match). Click on the top layer in your layer stack, then choose Hue/Saturation from the Create New Adjustment Layer pop-up menu at the bottom of the Layers palette (as shown here).

Step Eight:
When the Hue/Saturation controls appear in the Adjustments palette, turn on the Colorize checkbox, then set the Hue to 25 and the Saturation to 25 to add this slightly reddish-yellow sepia tone effect to all three photos at once. By the way, this is a great combination for instantly adding a sepia tone effect to wedding photos.

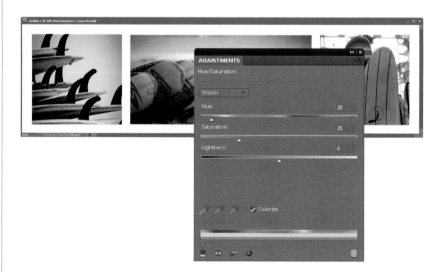

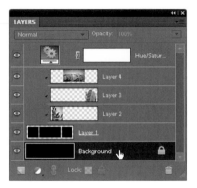

Step Nine:
The final step is to go to the Layers palette, and click on the Background layer to select it (as shown here). Press D to set your Foreground to black, and then press Alt-Backspace (Mac: Option-Delete) to fill the Background layer with black.

Step 10:
Here's the final image, and I think what makes it work is the balance and visual interest between the two square shapes on the ends and the longer rectangle shape in the middle. One more thing: remember, you could always save this as a template (the black squares and rectangle, that is), then open it again later and repeat Steps Four through Nine with different photos (just choose Save As from the File menu, and then choose Photoshop from the Format pop-up menu in the Save As dialog). This way, you don't have to go creating those black squares and that rectangle over and over again.

Multi-Photo Look from Just One Photo

Here's a slick way to show off your work because it's a little out of the ordinary. Usually we're used to seeing the photo in the middle of the page, right? This is a little different because it uses several boxes, each with part of the same photo in it. The separation between the boxes draws your eye in, and even though you're just using one photo here, it looks like you're using more.

Step One:

Press **Ctrl-N (Mac: Command-N)** to create a new document in the size and resolution you want for your final print. Go to the Layers palette and click on the Create a New Layer icon at the bottom. Get the Rectangular Marquee tool **(M)**, and click-and-drag out a small square box over to the far-left side (you're going to fit five of these boxes across, so keep that in mind when choosing how big to make your first box; press-and-hold the Shift key while you drag to make it square). Once your box selection is in place, press **D** to set your Foreground color to black, then press **Alt-Backspace (Mac: Option-Delete)** to fill your square selection with black (as shown here). Deselect by pressing **Ctrl-D (Mac: Command-D)**.

Step Two:

Press **Ctrl-J (Mac: Command-J)** to duplicate the square layer. Get the Move tool **(V)**, press-and-hold the Shift key (to keep your alignment straight), then click-and-drag the copy of this square straight over to the right, leaving a small gap between the two squares (as shown here).

Step Three:

Repeat Step Two three more times. Now you'll have five squares in a row (as shown here). One more thing, though: Click on the bottom square layer in the Layers palette to select it, then Shift-click on the topmost square layer to select it, along with all of the square layers in between. From the Layers menu, choose Merge Layers (or just press **Ctrl-E [Mac: Command-E]**) to merge them all into one layer.

Step Four:

Now, to perfectly center this row of five squares within your document, first click on the Background layer in the Layers palette, then press-and-hold the Ctrl (Mac: Command) key and click on the five-squares layer to select it, as well. Once both layers are high-lighted (as you see here), get the Move tool, then go up to the Options Bar, click on the Align button, and choose Horizontal Centers from the pop-up menu (as shown here).

Continued

Step Five:

Next we're going to bring in our photo, so just go under the File menu and choose Open. Get the Move tool and drag-and-drop your photo into your five-square document. Once the photo appears, press **Ctrl-T (Mac: Command-T)** to bring up Free Transform. Now you'll resize the photo (probably making it smaller) so it's a little larger than the five black squares, then press **Enter (Mac: Return)** to lock in your resizing.

MATT KLOSKOWSKI

Step Six:

To get your photo inside those five boxes, start by making sure that in the Layers palette, your photo layer is at the top of the layer stack. Now either go under the Layer menu and choose Create Clipping Mask or use the keyboard shortcut **Ctrl-G (Mac: Command-G)**.

Step Seven:

When you choose Create Clipping Mask (or use the keyboard shortcut), it masks your photo layer inside the five boxes on the layer below it (as shown here, where the photo is clipped into those five boxes).

Step Eight:

The final step is to add your studio name over a scan of your signature (just sign your name with a thick black pen on a white piece of paper, and scan it on a flatbed scanner. Of course, if you have a Wacom tablet and wireless pen, you can just get a small, hard-edged brush and sign your name right in your document). Position your signature so it's centered at the bottom of the five boxes, about halfway between the bottom of the document and the bottom of the boxes. Lower the opacity of its layer to around 40% or 50%, so it looks like a medium gray color. Now, take the Horizontal Type tool **(T)** and add your studio's name (or your name), and position this type centered, right over your signature (here I used the font Trajan Pro). To add a little elegance to this type, try adding a space between each letter and several spaces between each word.

Step Nine:

Don't forget, just like the last tutorial, you can save the black squares as a PSD file. In other words, you're creating a template. The next time you want to use this technique, all you'll have to do is open the PSD file you saved and repeat Steps Five through Eight using another photo. It sure beats making all those little squares again.

MATT KLOSKOWSKI

Instant Pano Layout

I originally saw this idea while watching Scott create a custom print template in Adobe Photoshop Lightroom. He showed me, and I loved it. He showed a crowd of 800 people, and they went crazy over it. So we knew that we had to find a way to do it in Elements. Well, here it is:

Step One:

In the Elements Editor, press **Ctrl-N (Mac: Command-N)** to create a new document in whatever size and resolution you'd like. In my example, I created a wide letter-sized document (11x8.5") at a resolution of 240 ppi (for inkjet printing). Once you've created the document, choose Solid Color from the Create New Adjustment Layer pop-up menu at the bottom of the Layers palette (it's the half-black/half-white icon, as shown here).

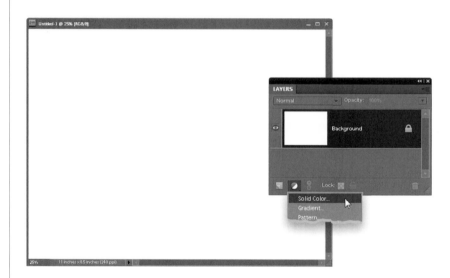

Step Two:

This brings up the Color Picker, prompting you to Pick a Solid Color. Since our background is white (which is the default setting in the New document dialog), choose white as your solid color (as shown here), and click OK. This fills your new adjustment layer with solid white (okay, it's kind of hard to see a white-filled layer on top of a white background, so you'll just have to trust that it worked. Well, for now anyway).

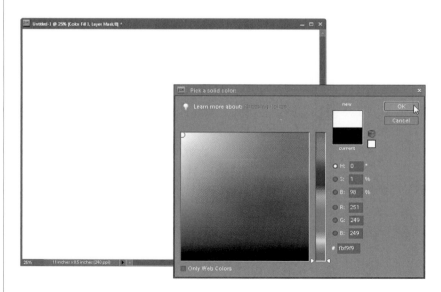

MATT KLOSKOWSKI

Step Three:
Get the Rectangular Marquee tool from the Toolbox, or just press **M**, and click-and-drag out a wide rectangle about 2" from the top of the document (as shown here). Don't make the selection too deep (in fact, while you're dragging out your selection, try dragging it out in the shape of a panorama—wide, but not very deep). Once your selection is in place, press the letter **X** on your keyboard until your Foreground color is black, then press **Alt-Backspace (Mac: Option-Delete)** to fill your selected area with black. Now, you're only filling the white Solid Color adjustment layer's mask with black, so you won't see anything change onscreen. To confirm that your black fill worked, take a look in the Layers palette, and you should see a black rectangle in the adjustment layer's mask thumbnail (as shown circled here). Press **Ctrl-D (Mac: Command-D)** to Deselect.

Step Four:
Click on the Background layer, then go under the File menu and choose Open. Now, locate the photo you'd like to have become an instant pano, and click OK to open that photo. Get the Move tool **(V)** and drag-and-drop your photo into your pano document. Press **Ctrl-T (Mac: Command-T)** to go into Free Transform, then click on one of the corner handles to drag inward or outward and scale the photo to size. You want to make it so it's just slightly larger than your pano opening.

Continued

Step Five:

Once you have it sized the way you'd like it, you can click in the center and drag it up or down to reveal a different part of the image, then press the **Enter (Mac: Return) key** to complete your resizing. The cool thing is it already looks like a pano, because all you can see of it is that wide, not very tall opening (which was the selected area you filled with black).

Step Six:

Now that your photo is in place, you can add any poster-style text you'd like using the Horizontal Type tool **(T)**. Here, I added the text-and-signature look that I showed you how to create in the previous tutorial.

Step Seven:

Now, we're going to add a thin border around our photo that you'll be able to turn on/off—depending on how it looks with the particular photo you've imported—with just one click. Go to the Layers palette and Ctrl-click (Mac: Command-click) on the layer mask thumbnail to the right of the Solid Color adjustment layer. This loads everything but that rectangle as a selection.

Step Eight:

From the Select menu, choose Inverse to invert the selection so just the rectangle is selected. Now, in the Layers palette, click on your top layer and then click on the Create a New Layer icon to add a new layer on top of all the others. From the Edit menu, choose Stroke (Outline) Selection. In the Stroke dialog, set the Width to 1 pixel, set the Color to black, set the Location to Inside (this makes the corners of your stroke nice and square), then lower the Opacity to 40% (this makes your stroke appear thinner). Click OK when you're done. Deselect, and you now have an outline on a separate layer that you can turn on and off depending on the photo.

Continued

Step Nine:

At this point, you've created an instant pano template that can be used again and again. Just make sure you choose Save As from the File menu and save it as a Photoshop PSD file. Now, let's say it's a week or so later and you want to turn a different photo into an instant pano. Open your template, then go to the Layers palette and delete the layer with the photo on it. Now you should only have the Background layer, the Solid Color adjustment layer, your signature and Type layers, and the layer with the outline on it (as shown here). Click once on the Background layer to select it.

Step 10:

Now choose Open from the File menu and open a different photo you'd like to see as an instant pano (here's the photo that we're going to use—I'm just showing it to you here so you can see the full photo before it's brought into the template).

MATT KLOSKOWSKI

Step 11:

With the Move tool, drag-and-drop the photo into your template document. Since we selected the Background layer back in Step Nine, the new photo should pop in right under the Solid Color adjustment layer (just where we want it to). Now go back and repeat Steps Four and Five if you'd like to resize or reposition the photo in the pano layout.

Step 12:

Oh yeah, remember that thin black border we added (well, at 40% opacity it actually looks gray)? Once you've imported your photo, you can decide whether it looks better with or without a border, and you can turn that border on/off with just one click. In the Layers palette, just click the little Eye icon next to the outline layer to toggle it on and off.

Step 13:

Here's the final image. Now, since you've created a template, at this point you'd want to flatten the image (choose Flatten Image from the Layers palette's flyout menu), then choose Save As from the File menu, and give your file a different name. That way, your template stays intact, and the next time you want to try a different photo as an instant pano, you just open the original template and replace the photo. Once you've set this up like this, instant panos are about 30 seconds away.

Creating with Your Photos

There is an entire area of Elements dedicated to creating projects with your photos. By projects, I mean transforming your photos from just prints into "creations" like photo collages, greeting cards, photo books, slide shows, and even CD/DVD covers and jackets. Here, we'll take a look at the overall process of making these types of creations, because they all pretty much work the same. But since there are so many variations on what you can actually make, we've also put a video online (**www.kelbytraining.com/books/elements8**) that goes into them in more detail and shows how you can use Elements' online services to order them.

Step One:
There are about half a dozen ways to get to the Create section of Elements, but the easiest and most visible way to get there is to just click on the purple Create tab that appears above the Palette Bin in the Elements Editor (or at the top right of the Organizer on a PC) and a list of "creations" will appear (as shown here. On a Mac, your options are slightly different). If you click on More Options, you'll see even more creations. *Note:* You don't have to have a photo open to build a creation—you can add the photo(s) after you've built the creation. I know, this sounds weird, but you'll see why this works in just a few moments.

Step Two:
When you choose a creation from that list (I chose Photo Collage here), the Palette Bin changes to where you can customize the way your final creation will look. Generally, you'll start by choosing the size of your creation (from the Page Size pop-up menu at the top). Then you choose whichever theme you'd like, and you get a preview of how each one looks. Next, you have the option to choose a custom layout for your photo(s), and finally you get to choose any additional options in the fourth and final step. If you just start at the top and work your way down, it's really pretty easy.

©ISTOCKPHOTO/SEAN LOCKE

Step Three:

When you click Done, Elements builds a new document using your custom settings, and it leaves a gray square where your photo(s) will appear. To get your photo in that gray square, you have two choices: (1) open the photo in Elements, then get the Move tool **(V)** from the Toolbox, click-and-drag the photo from the Project Bin onto the gray square, and it automatically fits inside your layout. Or, (2) you can click on the gray square and the standard Open dialog appears asking you to find the photo on your hard disk that you want to open. Once you choose a photo (or drag-and-drop one onto the gray square), a small resizing slider appears in the upper-left corner of your placed photo. Drag this slider to change the size of your photo within the layout. When the size looks good to you, click the green Commit checkmark beside the slider. If you don't want to resize the photo, just click the red international symbol for "No!" (the circle with a slash through it). That's it!

Note: You can always go back later and resize or reposition the photo within that frame by double-clicking directly on the photo. Or you can re-place the photo by simply dragging a photo from the Project Bin and dropping it right on the existing photo. This makes swapping out photos very quick and easy.

TIP: Themes Are Optional

If you don't choose a theme in Step Two, the layout you chose will appear on a white background. You can always drag-and-drop the photo layers onto the background of your choice, or simply fill the Background layer with a different color.

Making Full-Blown Slide Shows

Earlier in the chapter, we looked at how to create a simple slide show from photos open in the Editor. But that tutorial was really geared toward creating a PDF slide show that you'd email to someone. If you really want to create a slide show masterpiece (complete with titles, cool transitions, pans and zooms, and even music), this is where you come. Unfortunately, the full-blown slide show feature is currently not available in the Mac version of Elements 8.

Step One:
You start by clicking once on the Create tab in either the Elements Organizer or the Editor, and then clicking on the Slide Show button (as shown here). Choosing the Slide Show creation from the Editor will launch the Organizer because this particular feature is actually part of the Organizer.

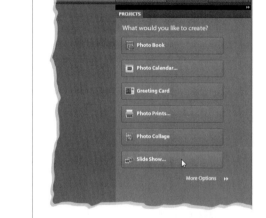

Step Two:
So, once the Organizer appears on-screen, the Slide Show Preferences dialog will also appear. This is where you choose how you want your slide show set up. For example, at the top you choose how many seconds each slide will appear onscreen. Below that you choose the transition between slides (will it be a soft dissolve or a quick cut between photos?), and how long your transition will last. A popular transition effect is called Pan & Zoom (which slowly moves [pans] your images across the screen), and to turn this on, turn on the checkbox for Apply Pan & Zoom to All Slides.

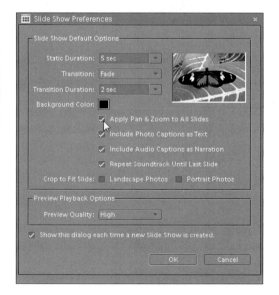

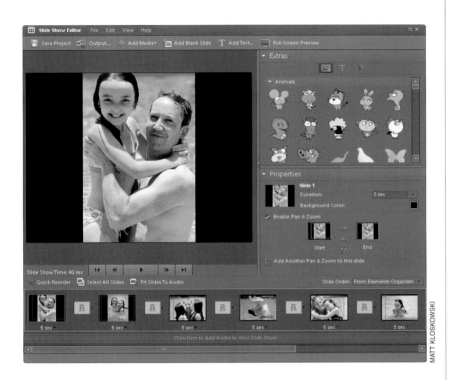

MATT KLOSKOWSKI

Step Three:
Once you click OK, the Slide Show Editor appears, and this is where you'll create your magic (okay, "magic" is probably pushing it a bit, but this is where you'll "do your stuff"). If you opened photos in the Editor (or selected them in the Organizer) before you chose Slide Show, these photos will appear in the Slide Show Editor's Photo Bin at the bottom of the dialog, as shown here (which means you can skip Step Four). If not, you'll notice that the Photo Bin is empty, except for the prompt Click Here to Add Photos to Your Slide Show. So, click there (I know, that seems pretty obvious) to bring up the Add Media dialog (shown in the next step).

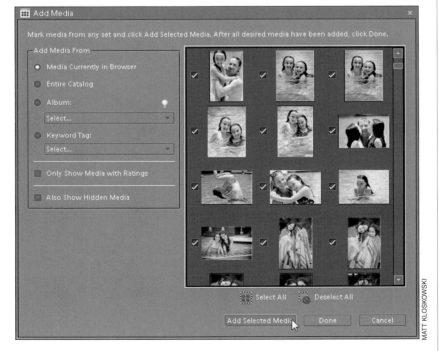

MATT KLOSKOWSKI

Step Four:
Basically, here's where you choose which photos will wind up in your slide show. *Note:* Again, if you opened photos in the Editor (or selected them in the Organizer) before you chose Create's Slide Show option, you can skip this step, because photos will already be imported into your slide show—you'll only use Add Media if either (a) you don't have any photos in your slide show yet, or (b) you want to add another photo (or more) to your existing slide show. Turn on the checkbox beside each photo you want in your slide show, then click the Add Selected Media button at the bottom of the dialog and click Done.

Continued

Step Five:

To see a quick sample of what your slide show looks like at this point (before you start customizing it), click the Play button beneath the main preview window. You'll see a slide show of your imported photos in the order they were imported, with whichever transitions you chose in the Slide Show Preferences dialog. To stop, click the Pause button (which appears where the Play button used to be). If you're not thrilled with your slide show, it's probably because you're only seeing the default slide show: the slides aren't in order, there's no background music, and you haven't customized the slide show your way. Well, that's about to change, because it's time to tweak your slide show.

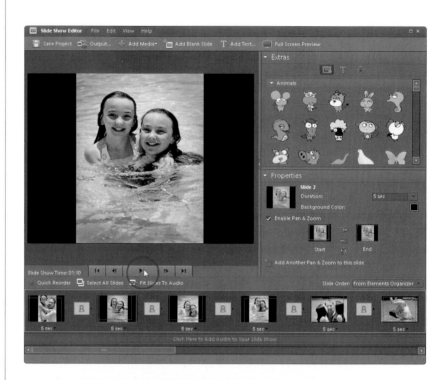

Step Six:

The first thing to do is put the slides in the order you want them. To do that, just click on a thumbnail in the Photo Bin at the bottom of the dialog and drag it where you want it (the slides play from left to right, so if you want a particular slide to be first, drag that slide all the way to the left). As you drag slides around in the Photo Bin, you'll see a blue bar indicating where the slide will appear when you release the mouse button.

Step Seven:
With the slides in order, take a look directly beneath your photo thumbnails in the Photo Bin. You'll see "5 sec." That's telling you that this slide will stay onscreen for 5 seconds. If you want it onscreen for a shorter amount of time, just click directly on that number and a pop-up menu of duration times will appear. If you want to apply a particular duration to all your slides (for example, you want them all to appear onscreen for 3 seconds), after you choose 3 sec for one slide, click on the time again for that slide and choose Set All Slides to 3 sec. If you choose Custom, you can type any number in the Set Slide Duration dialog.

Step Eight:
Finally, the fun part—choosing your transitions. You can go with the one you originally chose in the Slide Show Preferences, or you can choose a new one. To do that, click directly on the little right-facing triangle that appears to the right of the square transition box (which is between your slides in the Photo Bin). This brings up a pop-up menu of transitions—just choose the one you want and it changes only that transition between those two slides. If you want that transition applied to all your slides, after you choose it, choose Apply to All at the top of the pop-up transition menu. (By the way, if you choose None, the international symbol for "No!" [a circle with a slash through it] will appear between your slides instead, but you can change that by clicking on the right-facing triangle next to it and choosing a transition from the pop-up menu.)

Continued

Step Nine:

To change the duration of one (or more) of your transitions, click on the transition, then in the Properties palette (on the right side of the Slide Show Editor dialog), change the Transition time (which is measured in seconds) in the pop-up menu.

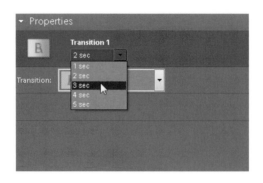

Step 10:

Okay, what's even cooler than transitions? Pan & Zoom (in fact, you can have transitions and Pan & Zoom). Pan & Zoom brings movement to your slides, and this movement makes your slide show feel less static, as the photos move slowly left to right, top to bottom, while they slowly zoom in and out. That's why this effect is so popular. If you turned on the Apply Pan & Zoom to All Slides checkbox in the Slide Show Preferences (when you first opened your slide show), then all you have to do to edit a Pan & Zoom is click on a slide and the Pan & Zoom controls will appear in the Properties palette on the right side of the dialog.

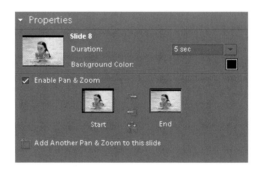

Step 11:

If you didn't turn on Pan & Zoom for all slides from the start, it's easy to turn it on now. Just click on the slide you want to apply it to, and then in the Properties palette, turn on the checkbox for Enable Pan & Zoom. (Needless to say, to turn off the Pan & Zoom for any slide, just click on the slide and turn off the Enable Pan & Zoom checkbox in the Properties palette. I know, I said "needless to say," but then I said it anyway. It's a personality disorder.)

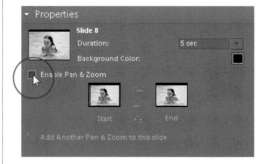

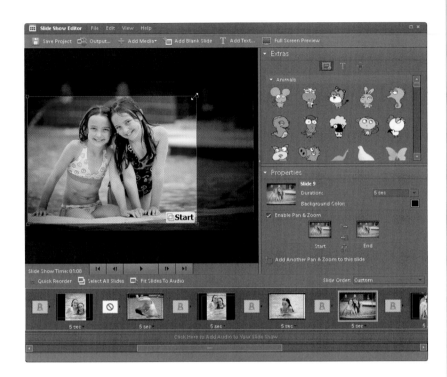

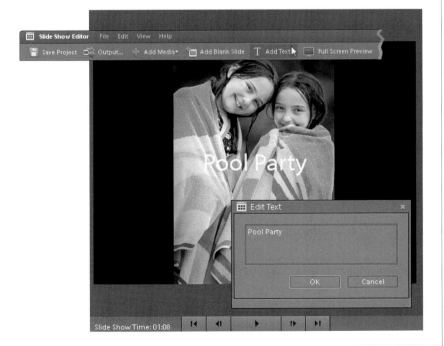

Step 12:

Once you've got Pan & Zoom turned on, you can tweak it in three very distinct ways: (1) When you turn on Pan & Zoom, a green square appears in the preview window, and the word "Start" appears in the bottom-right corner. You can reposition the location and size of this green square (shown here) to where you'd like the panning and zooming to start. In the Properties palette, if you click on the End thumbnail, you can position the panning end point by moving (and/or resizing) the red square. (2) You can swap the positions of these squares by using the three little buttons between the Start and End thumbnails in the Properties palette. (3) You can add an additional Pan & Zoom, which essentially duplicates your slide, and lets you add another Pan & Zoom segment, so you could have your photo pan from left to right, then in the second segment, zoom from large to small. To do this, click on the Add Another Pan & Zoom to This Slide prompt at the bottom of the Properties palette.

Step 13:

Now, on to adding titles: If you want to add a title to the beginning of your slide show, click on the first slide in the Photo Bin, and then click the Add Text button at the top of the Slide Show Editor. This brings up the Edit Text dialog, in which you enter your text. As you begin typing, your text appears onscreen.

Continued

Step 14:
Once you click OK in the Edit Text dialog, you can reposition your text by just clicking-and-dragging it where you want it. You can also now choose which font, size, style, opacity, and color you want for your text (and a host of other type tweaks) in the Properties palette on the right side of the dialog. If you need to edit your text, just click on the Edit Text button in the Properties palette or change your font, style, etc., in the bottom of the palette.

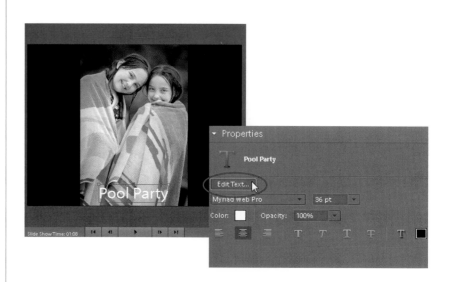

Step 15:
If you want your title to appear over a blank slide, rather than over a photo, you can create your title over a blank background by clicking the Add Blank Slide button at the top of the dialog. This creates an empty black slide after your first slide (you'll have to click-and-drag it before your first slide). Now you can either click the Add Text button to create the text that will appear over your black slide, or you can click on the Text icon in the Extras palette (on the top right of the window), which reveals a list of pre-designed type treatments, including text with shadows (which are about impossible to see over a black background, by the way).

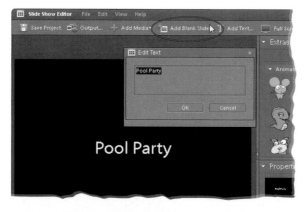

Step 16:
If you want to change the color of your blank slide (from the default black color), you can do that by clicking on the blank slide (in the Photo Bin), and then in the Properties palette you'll see a black color swatch named "Background Color." Click on it to bring up the Color Picker, where you can choose a different color. Once you've chosen a new color, click OK, and your currently selected slide's color will be changed.

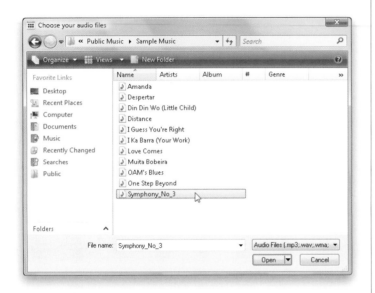

Step 17:
All right, the slides are in order, the transitions have been chosen, and the title has been created. Now, for the finishing touch—music. To add some background music to your slide show, click on the gray bar directly beneath the Photo Bin with the words "Click Here to Add Audio to Your Slide Show." This brings up a dialog prompting you to choose your audio file. You can browse for your own music files or choose from the music files in Elements' sample catalog. When you find a song you like, click on its name in the list, and then click the Open button.

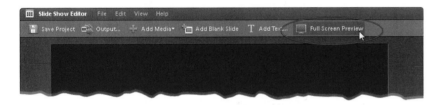

Step 18:
Now it's time to preview the finished slide show. Click the Full Screen Preview button on the top-right side of the Slide Show Editor's task bar, then sit back, relax, and enjoy the "magic." If, while watching your preview, you see something you want to change, just press the Esc key.

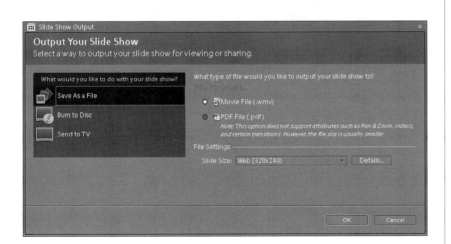

Step 19:
When the show is tweaked to perfection (or your personal satisfaction, whichever comes first), it's time to output it into its final form. Click on the Output button in the Slide Show Editor's task bar to bring up the Slide Show Output dialog. Now you just click to choose what you want to do with your final show: save it as a file, burn it to CD or DVD, email your slide show to a friend (in which case, you'll choose Save as a File and choose the PDF option), or watch it on TV. When you click on your choice, some options for that choice will appear on the right side of the dialog. When you're done, click OK.

Creating Your Own Photo Website

If you want to expand the reach of your photos to a wider audience, there's no better way than to create a photo gallery online, and once again Elements does all the hard work for you. All you have to do is basically choose which photos you want, which layout you want, and it does the rest. (*Note:* If you're using a Mac, this is done through Bridge, so it is covered in the online chapter mentioned in the book's introduction.) Here's how to go global with your photos:

Step One:
Open the Organizer and Ctrl-click on the photos you want to appear in your online Web gallery. Then, click on the Share tab at the top right of the Organizer, and click on the Online Album button (as shown here).

Step Two:
This brings up the first section of the Online Album wizard, where you decide whether you want to share an existing album or create a new one (here, I'm choosing to create a new one). Next, you'll choose how you want to share the online album. The options are listed in the Share To section, and this determines how the gallery is exported (to Adobe's free/pay service Photoshop .com, to a CD/DVD, to your FTP site for uploading to the Web, or to a hard disk). Click on the radio button for the one you're going to use and click the Next button at the bottom.

©ISTOCKPHOTO/JENNIFER TRENCHARD

Step Three:
This brings up the next section (shown here), and the photos you selected in the Organizer appear inside the Content bin. If you want to add more or remove any, this is the place to do it. To add a photo, select it in the Organizer's Media Browser, then click the + (plus sign) at the bottom right of the Content bin. To remove a photo, select it in the Content bin, and click the − (minus sign). You can also click-and-drag your photos around in the Content bin to change their order. You'll need to give your gallery a descriptive name, so go ahead and do that before moving on.

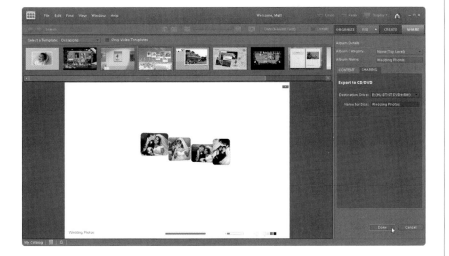

Step Four:
Now, click on the Sharing tab near the top of the Album Details section. As soon as you do that, Elements builds a preview using its default online album, and you'll see it in the center of the Organizer window. If you're using Photoshop.com, then skip to the next step. If not, then enter any settings for the sharing method you've chosen (this may require you to sign in to Photoshop.com) and click Done at the bottom. Photoshop Elements takes care of the rest. It even saves a copy of your new album right into the Organizer's Albums palette, so you can find it again easily.

Continued

Step Five:

If you choose to share to Photoshop .com, when you click on the Sharing tab, you'll want to turn on the Share to Photoshop.com checkbox at the top, and sign in to Photoshop.com from the dialog that appears. Once you sign in, you'll be presented with a few more options. The first specifies whom you want to share the album with—your choices are everyone or just specific friends. If you want to share your images publicly, then also turn on the Display in My Gallery checkbox, but if you only leave the Share to Photoshop.com checkbox turned on, then you have to select which contacts you'd like to email this album to by turning on the checkboxes next to their names in the Send E-Mail To section. Just above this section, you can also include a message.

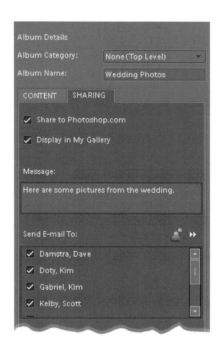

Step Six:

There's also a neat feature at the bottom that lets your album's visitors: (1) download the photos from your online album directly to their computer, and (2) order photo prints directly from your online album, so they don't have to go through you to get them. Pretty nifty, huh?

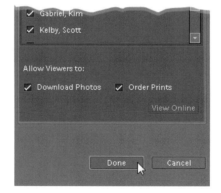

Step Seven:

Once you've chosen your Sharing options, you can change the template that you want to use for your online album by double-clicking on another template in the filmstrip that runs across the top of the Preview area. These templates include pre-designed animations and interactive websites where the people viewing your photos actually get involved in the process. There are some built-in templates that come with Photoshop Elements and if you've got a Photoshop.com Plus membership (this one has an annual fee), you can see others by clicking on the Select a Template pop-up menu at the top left and choosing Plus Members Only. The ones that are on your computer within Elements are listed by category in the Select a Template pop-up menu, so you can choose to only show those categories, only show Photoshop.com Plus content, or Show All content. It's usually easiest to choose Show All here.

Step Eight:

For our example here, I'm going to go with the 4x5 Transparency template that's shown second from left in the filmstrip (and also when you choose Classic from the Select a Template pop-up menu). So double-click on that template in the filmstrip. Elements thinks for a moment while it builds the preview, then you'll see the new online gallery appear in the Preview area with the same photos you selected back in Step One.

Continued

Step Nine:
Remember back when I mentioned that with some of these templates, the viewer interacts with them? This template's a great example. You can click on the photos and rearrange them, moving them around on the page. You can also click on the left and right arrows at the top right of the preview to scroll through the photos one by one.

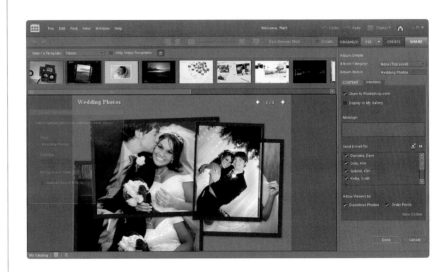

Step 10:
In the Slideshow Settings dialog (which, for certain templates, appears dimmed and floating on the left side of the window), you can replace any dummy text with real text of your own. Just move your cursor over the dialog and you can give the site a title, a subtitle, and even change the background color of the online gallery. Below that is a checkbox to have sound effects included on your webpage that happen when your visitors move or interact with the photos. The sounds are kinda cute at first, but get old fast, so you might want to try it once with the sounds, and see if they don't get on your nerves in short order. Once you've customized your gallery, click the Refresh button. You'll see a live preview of your gallery, with your selected photos, your new text and color, and sound effects, just like the public will see it. You can click on the photos and move them around the page, and interact with it just like it was live.

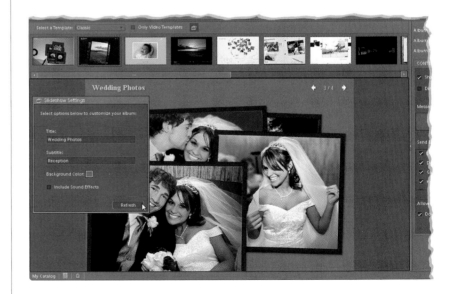

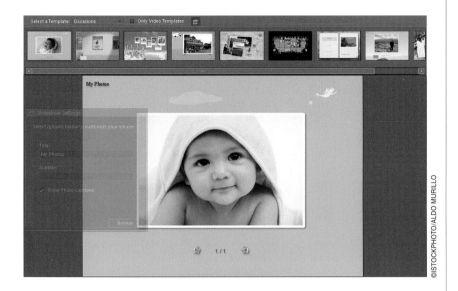

©ISTOCKPHOTO/ALDO MURILLO

Step 11:
Normally you'd be ready to move on and save the gallery, but I wanted to take a quick look at some of the other templates because they're just so darn cool. Try going under the Occasions category in the top Select a Template pop-up menu. The first of the templates (the baby theme) is great if you've just had a baby—double-click on it to see your photos in that template.

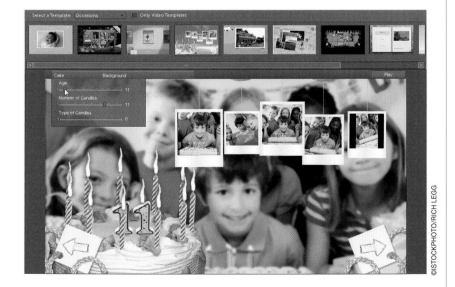

©ISTOCKPHOTO/RICH LEGG

Step 12:
Let's try something else. You've got to try the birthday one (the fourth one from the left) to see what these things are really made of. Double-click on it to see how you can actually change the number of candles, the number (age) candle itself, and lots of other things from the pop-up menus at the top of the Preview area. Try it, I'll wait (I don't mind waiting while you have fun. I'll just wait over here). Okay, you done playing around? See, it's pretty cool, eh? When the page looks the way you want it to, it's time to save it, so click Done and, in a few moments, your Album is uploaded to Photoshop .com (or emailed to your contacts, if that's the option you chose), ready to view. Just visit Photoshop.com to see the album (or get the link from Photoshop.com to share it with others) and you're in business.

Fit to Print
step-by-step printing and color management

Okay, there are entire books written on the subject of color management in Photoshop Elements, so how am I going to condense everything you need to know into one chapter? It's easy—I'm not. You see, color management is like quicksand—the more you try to understand it, the deeper it sucks you down into the muck. What we need (you, me, us, we, you again, then me) is less about color management. That's right. This chapter puts a new spin on color management by actually giving you "less." Less about all the different color spaces (in fact, I barely mention them), less about color gamuts (same here), less about soft proofing (I don't cover that at all), less about profiles, less about warnings, less about theory (there is none), less graphs and charts (there are none), and less about all the stuff you really don't care about. In fact, not only do we need a chapter that has less pages, we need one with less words, less ink, less spell checking, less editing, less royalties (less royalties?), less paper fiber, and less binding—and doggone it, I'm just the guy to do it. (For the record, I've never used the phrase "doggone it" in print before. This is the kind of groundbreaking stuff I'm talking about.) Anyway, here's my plan: If it's not a part of Elements' color management (that you're not directly going to change, adjust, or otherwise mess with in some meaningful fashion), I'm just gonna ignore it. That way, we can focus on just one thing: setting Elements up so the prints that come out of your personal, color inkjet printer match exactly what you see onscreen. One thing. That's it. See, less is more. More or less. I think.

Setting Up Your Color Management

Most of the color management decisions in Elements come later, in the printing process (well, if you actually print your photos), but even if you're not printing, there is one color management decision you need to make now. Luckily, it's a really easy one.

Step One:
Before we do this, I just want to say that you only want to make this change if your final prints will be output to your own color inkjet printer. If you're sending your images out to an outside lab for prints or your final images will only be viewed onscreen, you should probably stay in sRGB, because most labs are set up to handle sRGB files. Your best bet: ask your lab which color space they prefer. Okay, now on to Photoshop Elements. In the Editor, go under the Edit menu and choose Color Settings (or just press **Ctrl-Shift-K [Mac: Command-Shift-K]**).

Step Two:
This brings up the Color Settings dialog. By default, Elements is set to Always Optimize Colors for Computer Screens, which uses the sRGB color space. However, if you're going to be printing to your own color inkjet printer (like an Epson, HP, Canon, etc.), you'll want to choose Always Optimize for Printing, which sets your color space to the Adobe RGB color space (the most popular color space for photographers), and gives you the best printed results. Now just click OK, and you've done it—you've con-figured Elements' color space for the best results for printing.

To have any hope of getting what comes out of your color inkjet printer to match what you see onscreen, you absolutely, positively have to calibrate your monitor. It's the cornerstone of color management, and there are two ways to do it: (1) buy a hardware calibration sensor that calibrates your monitor precisely; or (2) use the free system software calibration, which is better than nothing, but not by much since you're just "eyeing" it. We'll start with the freebie calibration, but if you're serious about this stuff, turn to the next technique.

Calibrating Your Monitor (The Lame Freebie Method)

Freebie Calibration:
This is the worst-case scenario: you're broke (you spent all available funds on the Elements 8 upgrade), so you'll have to go with the free system software calibration. Macintosh computers have calibration built in, but Windows PCs use a utility from Adobe called Adobe Gamma (that came standard with Elements 5 and earlier versions). We'll start with that. If you had an earlier version of Elements, you'll find Adobe Gamma in Windows Vista at C:\ Program Files\Common Files\Adobe\ Calibration. Double-click on the Adobe Gamma.cpl file. In Windows XP, from the Start menu, go to the Control Panel and double-click on Adobe Gamma. *Note:* If Adobe Gamma didn't load, you'll have to copy the files from the Goodies\Software\Adobe Gamma folder on the earlier version's installation CD to the Calibration folder. If you did not upgrade from a previous version of Elements, you can download Adobe Gamma for free from a number of websites. Just search the Internet for "Download Adobe Gamma." Once you download it, save it to your desktop and then double-click on it.

Continued

Step One (PC):

This brings up the Adobe Gamma dialog. Choose Step By Step (Wizard), which will lead you through the steps for creating a pretty lame calibration profile. (Hey, I can't help it—that's what it does. Do you really want me to sugarcoat it? Okay, how's this? "It will lead you through the steps for proper calibration" [cringe].) *Note:* Results will vary depending on whether your monitor is a CRT, LCD, etc.

Step Two (PC):

Click the Next button and you'll be asked to name the profile you're about to create. Now, it's possible that when you first hooked up your monitor, a manufacturer's profile was installed at the same time. Although that canned factory profile won't do the trick, it can save you some time because it will automatically answer some of the questions in the dialog, so it's worth a look to see if you have one. Click on the Load button, then navigate your way to the ICC profiles in your system (you should be directed to them by default). If you see a profile with your monitor's name, click on it and then click Open to load that profile. Click Next again.

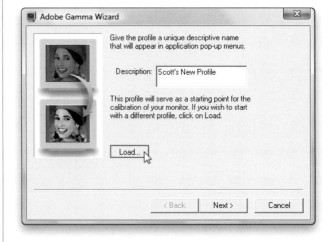

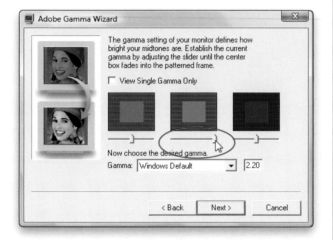

Step Three (PC):
From here on out, you'll be prompted with various directions (some with little square graphics with sliders beneath them). It asks you to move the sliders and then judge how the colors look. This is the very essence of the term "eyeing it," and it's why pros avoid this method. Everyone sees color and tone differently, and we're all viewing these test squares under different lighting conditions, etc., so it's highly subjective. But hey—it's free.

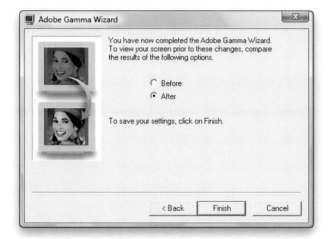

Step Four (PC):
The questions will continue (along the lines of the Spanish Inquisition) until it completes the calibration process, and then it offers you a before and after. You can pretty much ignore the Carmen Miranda before/after photo—that's just for looks—your before and after will be nothing like that, but after you're prompted to save your profile, you're done.

Continued

Step One (Mac):
Now for the freebie calibration on the Macintosh: To find Apple's built-in monitor calibration software, go under the Apple menu and choose System Preferences. In the System Preferences dialog, click on the Displays preferences, and when the options appear, click on the Color tab. When the Color options appear, click on the Calibrate button to bring up the Display Calibrator Assistant window (shown in the next step).

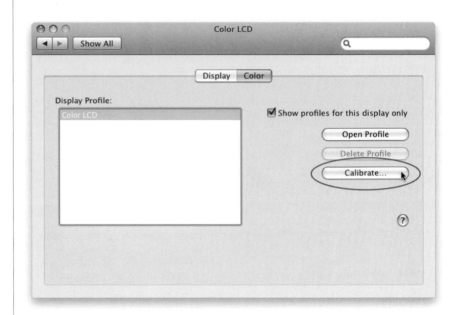

Step Two (Mac):
Now, at first this seems like a standard Welcome screen, so you'll probably be expecting to just click the Continue button, but don't do that until you turn on the Expert Mode checkbox. I know what you're thinking: "But I'm not an expert!" Don't worry, within a few minutes you'll be within the top 5% of all photographers who have knowledge of monitor calibration, because sadly most never calibrate their monitor. So turn on the checkbox and click the Continue button with the full confidence that you're about to enter an elite cadre of highly calibrated individuals (whatever that means).

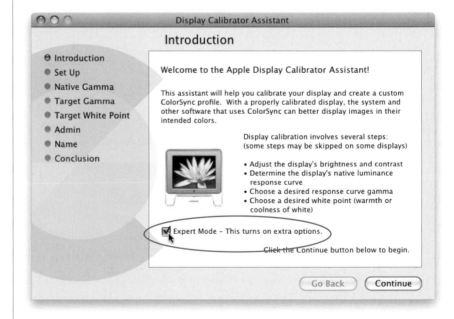

Step Three (Mac):

The first section has you go through a series of five different windows, and each window will ask you to perform a simple matching test using a slider. It's a no-brainer, as Apple tells you exactly what to do in each of these five windows (it's actually the same for all five windows, so once you've read the first window's instructions, you're pretty much set). Just follow Apple's easy instructions to get through these five windows, then I'll join you right after.

Step Four (Mac):

Okay, so you survived the "five native response windows of death." Amazingly easy, wasn't it? (It even borders on fun.) Well, believe it or not, that's the hard part—the rest could be done by your 5-year-old, provided you have a 5-year-old (if not, you can rent one from Apple's website). So here we are at a screen asking you to select a target gamma (basically, you're choosing a contrast setting here). Apple pretty much tells you "it is best to use the Mac Standard gamma of 1.8," but it has no idea that you're a photographer and need something better. Most digital imaging pros I know recommend setting your gamma to 2.2 (the PC Standard), which creates a richer contrast onscreen (which tends to make you open the shadows up when editing, which is generally a good thing detail-wise). Drag the slider to PC Standard and see if you agree, then click Continue.

Continued

Step Five (Mac):

Now it asks you to select a white point. I use D65 (around 6500 Kelvin, in case you care). Why? That's what most of the pros use, because it delivers a nice, clean white point without the yellowish tint that occurs when using lower temperature settings. With the slider set at D65, you can click the Continue button. The next window just asks if you're sharing your computer with other users, so I'm skipping that window, because if you are, you'll turn on the checkbox; if you're not, you won't. Snore.

Step Six (Mac):

When you click Continue again, you'll be greeted with a window that lets you name your profile. Type in the name you want for your profile, and click the Continue button. The last window (which there's no real reason to show here) just sums up the choices you've made, so if you made some egregious mistake, you could click the Go Back button, but seriously, what kind of huge mistake could you have made that would show up at this point? Exactly. So click the Done button and you've created a semi-accurate profile for your monitor (hey, don't complain—it's free calibration). Now, you don't have to do anything in Elements for it to recognize this new profile— it happens automatically (in other words, "Elements just knows." Eerie, ain't it?).

Hardware calibration is definitely the preferred method of monitor calibration (in fact, I don't know of a single pro using the freebie software-only method). With hardware calibration, it's measuring your actual monitor and building an accurate profile for the exact monitor you're using, and yes—it makes that big a difference. I use X-Rite's Eye-One Display 2 (after hearing so many friends rave about it), and I have to say—I'm very impressed. It's become popular with pros thanks to the sheer quality of its profiles, its ease-of-use, and affordability (around $200 street).

The Right Way to Calibrate Your Monitor (Hardware Calibration)

Step One:
You start by installing the Eye-One Match 3 software from the CD that comes with it (the current version was 3.6.2 as of the writing of this book). However, once you launch Match 3 for the first time, I recommend clicking the Check for Updates button (as shown here) to have it check for a newer version, just in case. Once the latest version is installed, plug the Eye-One Display into your computer's USB port, then relaunch the software to bring up the main window (seen here). You do two things here: (1) you choose which device to profile (in this case, a monitor), and (2) you choose your profiling mode (where you choose between Easy or Advanced. If this is your first time using a hardware calibrator, I recommend clicking the Easy radio button).

Continued

Step Two:

After choosing Easy, click the Right Arrow button in the bottom right, and the Monitor Type screen will appear. Here you just tell the software which type of monitor you have: an LCD (a flat-panel monitor), a CRT (a glass monitor with a tube), or a laptop (which is what I'm using, so I clicked on Laptop, as shown here), then click the Right Arrow button again.

Step Three:

The next screen asks you to Place Your Eye-One Display on the Monitor, which means you drape the sensor over your monitor so the Eye-One Display sits flat against your monitor and the cord hangs over the back. The sensor comes with a counterweight you can attach to the cord, so you can position the sensor approximately in the center of your screen without it slipping down. There is a built-in suction cup for use on CRT monitors.

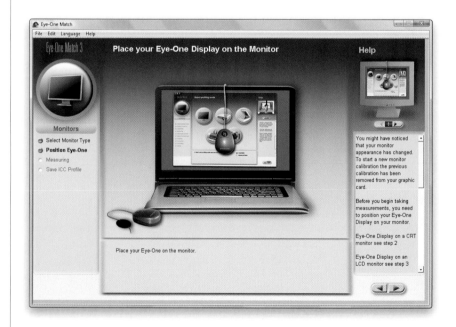

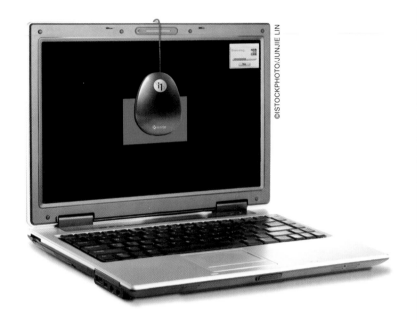

©ISTOCKPHOTO/JUNJIE LIN

Step Four:
Once the sensor is in position (this takes all of about 20 seconds), click the Right Arrow key, sit back, and relax. You'll see the software conduct a series of onscreen tests, using gray and white rectangles and various color swatches, as shown here. (*Note:* Be careful not to watch these onscreen tests while listening to Jimi Hendrix's "Are You Experienced," because before you know it, you'll be on your way to Canada in a psychedelic VW Microbus with only an acoustic guitar and a hand-drawn map to a campus protest. Hey, I've seen it happen.)

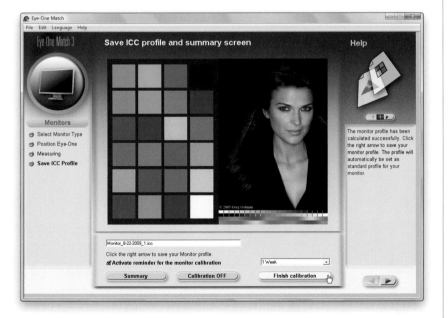

Step Five:
This testing only goes on for around six or seven minutes (at least, that's all it took for my laptop), then it's done. It does let you see a before and after (using the buttons on the bottom), and you'll probably be shocked when you see the before/after results (most people are amazed at how blue or red their screen was every day, yet they never noticed). Once you've compared your before and after, click the Finish Calibration button and that's it—your monitor is accurately profiled, and it even installs the profile for you and then quits. It should be called "Too Easy" mode.

The Other Secret to Getting Pro-Quality Prints That Match Your Screen

When you buy a color inkjet printer and install the printer driver that comes with it, it basically lets Elements know what kind of printer is being used, and that's about it. But to get pro-quality results, you need a profile for your printer based on the exact type of paper you'll be printing on. Most inkjet paper manufacturers now create custom profiles for their papers, and you can usually download them free from their websites. Does this really make that big a difference? Ask any pro. Here's how to find and install your custom profiles:

Step One:

Your first step is to go to the website of the company that makes the paper you're going to be printing on and search for their downloadable color profiles for your printer. I use the term "search" because they're usually not in a really obvious place. I use two Epson printers—a Stylus Photo R2880 and a Stylus Pro 3800—and I generally print on Epson paper. When I installed the 3800's printer driver, I was tickled to find that it also installed custom color profiles for all Epson papers (this is rare), but my R2880 (like most printers) doesn't. So, the first stop would be Epson's website, where you'd click on the Drivers & Support link for printers (as shown here). *Note:* Even if you're not an Epson user, still follow along (you'll see why).

Step Two:

Once you get to Drivers & Support, find your particular printer in the list. Click on that link, and on the next page, click on Drivers & Downloads. On that page is a note linking you to the printer's Premium ICC Profiles page. Here's what Epson says right there about these free profiles: "In most cases, these custom ICC profiles will provide more accurate color and black and white reproduction than with the standard profiles already shipping with every printer." So, click on that Premium ICC Profiles link.

Step Three:

When you click that link, a page appears with a list of ICC profiles for Epson's papers and printers. I primarily print on two papers: (1) Epson's Ultra Premium Photo Paper Luster, and (2) Epson's Velvet Fine Art paper. So, I'd download the ICC profiles for the Glossy Papers (as shown here), and the Fine Art Papers (at the bottom of the window). They download onto your computer, then you just click the installer for each one, and they're added to your list of profiles in Elements (I'll show how to choose them in the Print dialog a little later). That's it—you download them, double-click to install, and they'll be waiting for you in Elements' print dialog. Easy enough. But what if you're not using Epson paper? Or if you have a different printer, like a Canon or an HP?

Continued

Step-by-Step Printing and Color Management | **Chapter 12** | 451

Step Four:
We'll tackle the different paper issue first (because they're tied together). I mentioned earlier that I usually print on Epson papers. I say usually because sometimes I want a final print that fits in a 16x20" standard pre-made frame, without having to cut or trim the photo. In those cases, I use Red River Paper's 16x20" Ultra Satin Pro instead. So, even though you're printing on an Epson printer, now you'd go to Red River Paper's site (www.redriverpaper .com) to find their color profiles for my other printer, the Epson 3800. (Remember, profiles come from the company that makes the paper.) On the Red River Paper homepage, click on the Click Here link for Premium Photographic Inkjet Papers. Then click on the Color Profiles link under Helpful Info on the left side of the page.

Step Five:
Under the section named Epson Wide Format, there's a direct link to the Epson Pro 3800 (as shown here), but did you also notice that there are ICC Color profiles for the Canon printers? The process is the same for other printers, but although HP and Canon now both make pro-quality photo printers, Epson had the pro market to itself for a while, so while Epson profiles are created by most major paper manufacturers, you may not always find paper profiles for HP and Canon printers. At Red River, they widely support Epson, and have some Canon profiles, but there's only one for HP. That doesn't mean this won't change, but as of the writing of this book, that's the reality.

Step Six:
Although profiles from Epson's website come with an installer, with Red River (and many other paper manufacturers), you just get the profile (shown here) and instructions, so you install it yourself (it's easy). Just Right-click on the profile and choose Install Profile. (*Note:* If you're using Windows XP and this doesn't work, you'll have to drag the profile into the Profiles folder at C:\Windows\system32\spool\drivers\color.)

Step Seven:
You'll access your profile by choosing Print from Elements' File menu. In the Print dialog, click on the More Options button in the bottom left, then click on Color Management on the left of the More Options dialog. Change the Color Handling pop-up menu to Photoshop Elements Manages Color, then click on the Printer Profile pop-up menu, and your new color profile(s) will appear. Here, I'm printing to an Epson 3800 using Red River's Ultra Pro Satin paper, so that's what I'm choosing here as my printer profile (it's named RR UPSatin 2.0 Ep3800.icc). That's it, but there's more on using these color profiles next in this chapter.

TIP: Custom Profiles for Your Printer
You can also pay an outside service to create a custom profile for your printer. You print a provided test sheet, overnight it to them, and they'll use an expensive colorimeter to measure your test print and create a custom profile, but it's only good for that printer, on that paper, with that ink. If anything changes, your profile is worthless. You could do your own personal printer profiling (using something like one of X-Rite's Eye-One Pro packages), so you can re-profile each time you change paper or inks. It's really just up to you.

Making the Print

Okay, you've hardware calibrated your monitor (or at the very least—you "eyed it") and you've set up Elements' Color Management to use Adobe RGB (1998). You've even downloaded a printer profile for the exact printer model and style of paper you're printing on. In short—you're there. Luckily, you only have to do all that stuff once—now we can just sit back and print. Well, pretty much.

Step One:
Once you have an image all ready to go, just go under the Editor's File menu and choose Print (as shown here).

Step Two:
When the Print dialog appears, let's choose your printer and paper size first. At the top right of the dialog, choose the exact printer you want to print to from the Select Printer pop-up menu (I'm printing to an Epson Stylus Photo R2880). Then, on the bottom-left side of the dialog, you'll see a Page Setup button. Click on it to bring up the Page Setup dialog (shown here). Now you'll choose your paper size from the Size pop-up menu (in this case, a 13x19" sheet) and you can also choose your page orientation here. Click OK to return to the Elements Print dialog, and from the Select Print Size pop-up menu (in the middle right), be sure that Actual Size is selected.

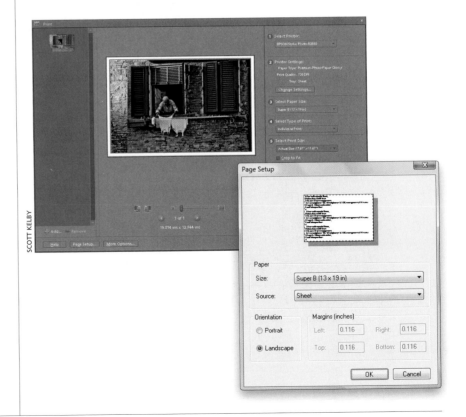

SCOTT KELBY

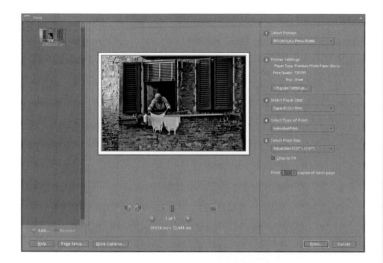

Step Three:
In the Print dialog, you'll see a preview of how your photo will fit on the printed page, and at the bottom of the column on the right, there's an option for how many copies you want to print.

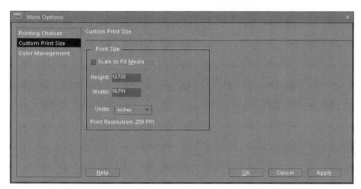

Step Four:
Click on the More Options button (at the bottom left) and then click on Custom Print Size on the left. Here you can choose how large the photo will appear on the page (if it's a photo that's too large to fit on the paper, just turn on the Scale to Fit Media checkbox and it will do the math for you, and scale the image down to fit).

Step Five:
Now click on Printing Choices at the top left of the More Options dialog. Here you can choose if you want to have your photo's filename appear on the page, or change the background color of the paper, or add a border, or have crop marks print, or other stuff like that—you have but only to turn the checkboxes on (you like that "you have but only to" phrase? I never use that in normal conversation, but somehow it sounded good here. Ya know, come to think of it— maybe not). Anyway, I don't use these Printing Choices at all, ever, but don't let that stop you—feel free to add distracting junk to your heart's content. Now, on to the meat of this process.

Continued

Step Six:

Click on Color Management on the left to get the all-important Color Management options. Here's the thing: by default, the Color Handling is set up to have your printer manage colors. You really only want to choose this if you weren't able to download the printer/paper profile for your printer. So, basically, this is your backup plan. It's not your first choice, but today's printers have gotten to the point that if you have to go with this, it still does a decent job. However, if you were able to download your printer/paper profile and you want pro-quality prints (and I imagine you do), then do this instead: choose Photoshop Elements Manages Colors from the Color Handling pop-up menu (as shown here), so you can make use of the color profile, which will give you the best possible color match.

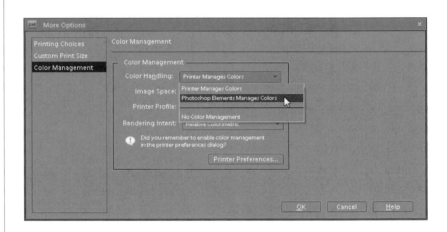

Step Seven:

Below Rendering Intent, you'll see a warning asking if you remembered to disable your printer's color management. You haven't, so let's do that now. Click the Printer Preferences button that appears right below the warning (as shown here). (*Note:* On a Mac, once you click the Print button in the Elements Print dialog, the Mac OS X Print dialog will appear, where you can go under Printer Color Management and set it to Off [No Color Adjustment].)

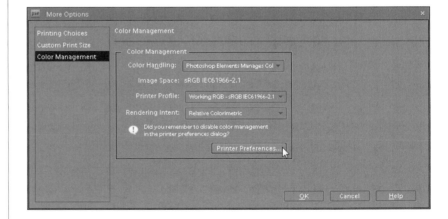

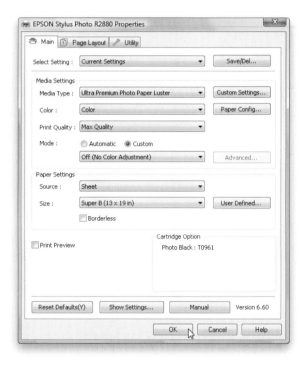

Step Eight:
In your printer's Properties dialog (which may be different depending on your printer), you will turn off your printer's color management, but you have other stuff to do here, as well (on a Mac, you will do this in the OS X Print dialog, as mentioned in the previous step). First, choose the type of paper you'll be printing to (I'm printing to Epson Ultra Premium Photo Paper Luster). Then for the Print Quality setting, choose the best quality (I know, that was pretty obvious). Now, be sure that the Custom radio button is chosen and Off (No Color Adjustment) appears in the Mode pop-up menu. Click OK to save your changes and return to the More Options dialog.

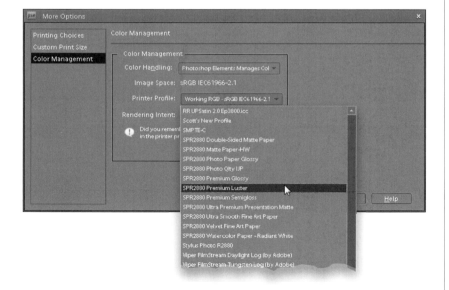

Step Nine:
After you've turned off your printer's color management (and chosen photo quality paper), you'll need to choose your color profile from the Printer Profile pop-up menu in the Color Management section. I'm going to be printing to an Epson Stylus Photo R2880 printer, again using Epson's Premium Luster paper, so I'd choose SPR2880 Premium Luster. Doing this optimizes the color to give the best possible color print on that particular printer using that particular paper.

Continued

Step 10:
Lastly, you'll need to choose the Rendering Intent. There are four choices here, but only two that I recommend—either Relative Colorimetric (which is the default setting) or Perceptual. Here's the thing: I've had printers where I got the best looking prints with my Rendering Intent set to Perceptual, but currently, on my Epson Stylus Photo R2880, I get better results when it's set to Relative Colorimetric. So, which one gives the best results for your printer? I recommend printing a photo once using Perceptual, then printing the same photo using Relative Colorimetric, and when you compare the two, you'll know. Just remember to add some text below the photo that tells you which one is which or you'll get the two confused. I learned this the hard way.

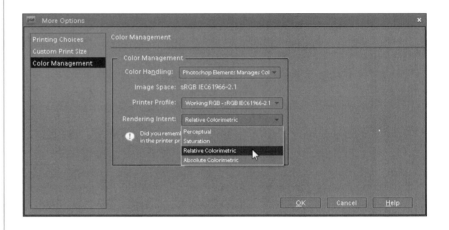

Step 11:
Now click the OK button, then click the Print button at the bottom of the Print dialog, and when you do, your system Print dialog will appear. Choose your printer again (yes, this is the second time you've chosen your printer; this is also where, on a Mac, you'll choose the options we talked about in Step Seven and Step Eight), and click Print.

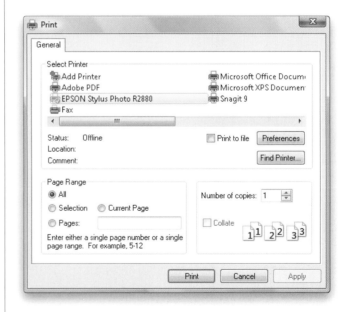

One of the questions I get asked the most is "What is your suggested digital workflow?" (Which actually means, "What order are you supposed to do all this in?" That's all "digital workflow" means.) We wrote this book in kind of a digital workflow order, starting with importing and organizing your photos, correcting them, sharpening them, and then at the end, showing your work to friends and/or clients. But I thought that seeing it all laid out in one place (well, in these five pages), might be really helpful, so here ya go.

My Elements 8 Workflow from Start to Finish

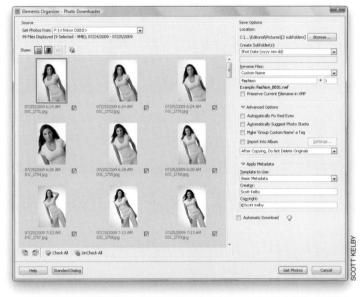

SCOTT KELBY

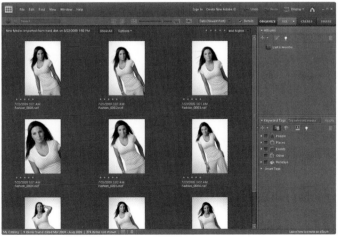

Step One:
You start your workflow by importing your photos into the Organizer (Mac: Bridge). While you're in the Photo Downloader (shown here), I recommend adding your metadata (your name and copyright info) during this import process. Also, while you're in the Photo Downloader, go ahead and rename your photos now, so if you ever have to search for them, you have a hope of finding them (searching for photos from your trip to Hawaii is pretty tough if you leave the files named the way your camera named them, which is something along the lines of "DSC_1751.JPG"). So give them a descriptive name while you import them. You'll thank me later.

Step Two:
Once your photos appear in the Organizer (Mac: Bridge), first take a quick look through them and go ahead and delete any photos that are hopelessly out of focus, were taken accidentally (like shots taken with the lens cap still on), or you can see with a quick glance are so messed up they're beyond repair. Get rid of these now, because there's no sense wasting time (tagging, sorting, etc.) and disk space on photos that you're going to wind up deleting later anyway, so make your job easier—do it now.

Continued

Step Three:

Once you've deleted the obviously bad ones, here's what I would do next: go through the photos one more time and then create an album (Mac: collection) of just your best images. That way, you're now just one click away from the best photos from your shoot.

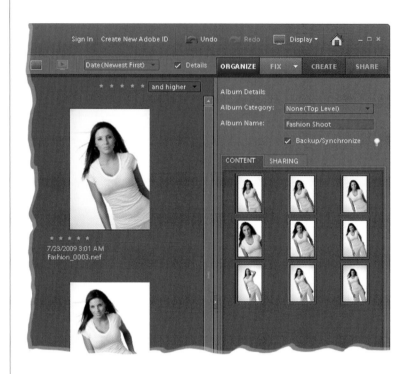

Step Four:

There's another big advantage to separating out your best images into their own separate album: now you're only going to tag and worry about color correcting and editing these photos—the best of your shoot. You're not going to waste time and energy on photos no one's going to see. So, click on the album, then go ahead and assign your keyword tags (Mac: keywords) now (if you forgot how to tag, it's back in Chapter 1). If you take a few minutes to tag the images in your album now, it will save you literally hours down the road. This is a very important step in your workflow (even though it's not a fun step), so don't skip it—tag those images now!

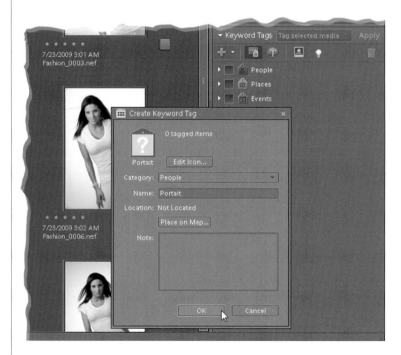

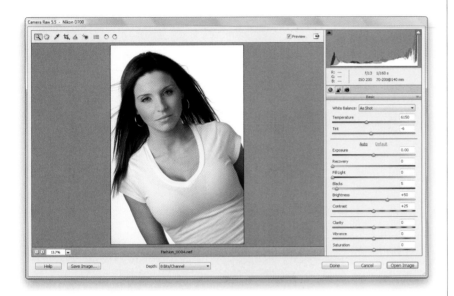

Step Five:

Now that you've got your best photos in an album and they're tagged, it's time to start editing the best images. So let's say you open an image that you can tell needs editing in the Elements Editor to look the way you want it to look. What do you do first? Generally, I try to deal with the biggest problem first (whatever you see as the biggest problem). If you feel like the photo is too dark, start with that. If it has a distracting color cast and you won't be able to concentrate on anything else, then fix that first. Underexposure, overexposure, your subject is in the shadows, white balance (color) problems (as seen here)— all that can be fixed within Camera Raw if your image is in RAW, JPEG, or TIFF format. So, I'd go there (see Chapter 2 for opening JPEGs and TIFFs in Camera Raw). If you'd prefer to skip Camera Raw, then go to the Editor to work on things like general color correction using the Enhance menu options or even Quick Fix.

Step Six:

After all your color correction is done, now you can add any special effects or finishing moves like softening, or vignetting effects, or duotones, or basically any of the things found in "Special Effects for Photographers" (Chapter 9). Here, I've done my three-step portrait finishing technique.

Continued

Step Seven:
After all the effects you want have been added (*Tip:* Don't get carried away by using too many effects. When it comes to effects, less is more), it's time to sharpen the photo using either the Unsharp Mask filter or the Adjust Sharpness control (see Chapter 10 for settings). We save this until the final editing stage (after fixing problems, after color correction, after special effects). Now, the photo is essentially done and you can add border effects, frame edges, and other presentation effects (see Chapter 11) around or behind your photo (you normally don't have to sharpen them—just the photo, so you can add these after sharpening the photo).

Step Eight:
Lastly, now that you have a complete and final image, you can turn your final image into a creation (photo collage, online album, slide show, etc. [see Chapter 11]), or just simply print your finished image on your color inkjet printer (see the "Making the Print" tutorial earlier in this chapter for a refresher on that). Well, there you have it, a Photoshop Elements 8 workflow from import to output, done in the same order I do it myself. Hope this helps. :-)

Before

After

Index

Make **Your Pictures** *Look Their Best!*

The Perfect Companion to Adobe Photoshop Elements

Only $69.99

> Improve the color of your photos quickly and easily

> Remove unwanted backgrounds

> Add an edge effect to frame your photos

> Draw the viewer's eye exactly where you want it

> Enlarge pictures for poster size prints!

onOne Photo Essentials is a collection of five tools that painlessly correct color, remove unwanted backgrounds, add photographic effects and enlarge your photos. These easy-to-use tools will allow you to quickly get the job done in Adobe® Photoshop® Elements.

1 Make It Better

Turn your snapshots into professional images.Automatically fix brightness, contrast, color and sharpness.

2 Cut It Out

Love the subject but not the background? Paint it away with the magic brush and slide in a new one.

3 Make It Cool

Easily add cool effects to any image. Includes dozens of effects that will give your photo the professional look.

4 Frame It

For that perfect finishing touch to your photos. Add one or more frames to your photo.

5 Enlarge It

Get sharp, poster sized prints out of your photos no matter how small they might be.

onOne software

www.onOnesoftware.com